APR '09

WITHDRAWN

Natural Wonders
of the Jersey Pines *and* Shore

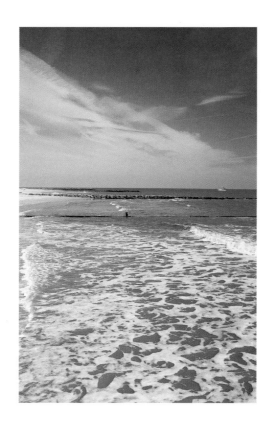

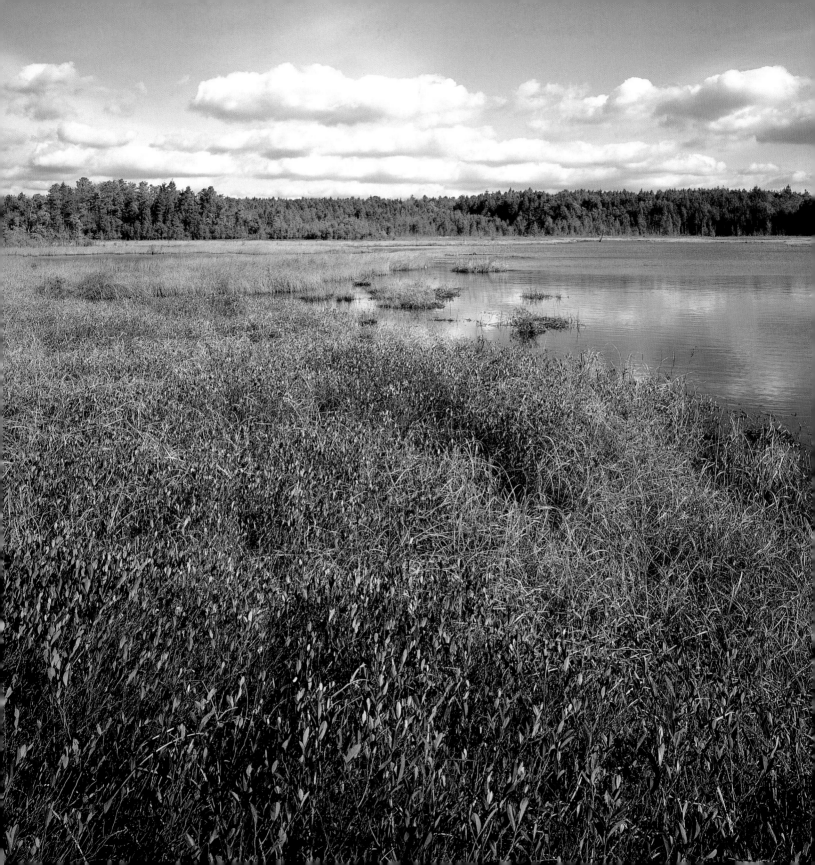

Natural Wonders
of the Jersey Pines and Shore

By Robert A. Peterson

With Selected Photographs by
Michael A. Hogan

Additional Photographs by Steve Greer

Plexus Publishing, Inc.

Medford, New Jersey

First printing, January 2005

Copyright © 2005 text by Robert A. Peterson
Copyright © 2005 photos by Michael A. Hogan
Copyright © 2005 photos by Steve Greer (as credited in captions)

Library of Congress Cataloging-in-Publication Data
Peterson, Robert A.
 Natural wonders of the Jersey pines and shore / Robert A. Peterson ; with selected photographs by Michael A. Hogan.
 p. cm.
 ISBN 0-937548-48-0 (hardcover)
 1. Nature photography--New Jersey--Pine Barrens. 2. Natural history --New Jersey--Pine Barrens. 3. Pine Barrens (N.J.)--Pictorial works. I. Title.
 TR721.P435 2003
 508.749--dc22

2003015651

Printed and bound in Hong Kong.

Publisher: Thomas H. Hogan, Sr.
Editor-in-Chief: John B. Bryans
Managing Editors: Amy M. Holmes, Deborah R. Poulson
Graphics Department Director: M. Heide Dengler
Sales Manager: Patricia Palatucci
Copy Editor: Pat Hadley-Miller
Proofreaders: Sandra R. Sutton, Dorothy Pike
Indexer: Sharon Hughes

Cover photo of Goshen Pond at sunset by Michael A. Hogan
Interior photos by Michael A. Hogan and Steve Greer
(photos by Michael A. Hogan unless otherwise credited)
Flap photo of Robert Peterson by Michael Ein, The Press of Atlantic City. ©1996 The Press of Atlantic City. Used by permission.

Cover and interior design by Erica Pannella

The publisher wishes to express its appreciation to the many individuals whose generous and sage counsel helped move this project forward under extremely difficult circumstances: the sudden loss of our friend and author, Bob Peterson, during the book's production. First and foremost, we are grateful to Howard P. Boyd for invaluable, ongoing advice and support. Thanks also are due to Susanna Peterson, Judy Bouchard, Ray Bouchard, George Flemming, Gordon Stull, Stew Farrell, Dave Miles, Mike Kennedy, Karl Anderson, Rod Tulloss, Frank B. Salisbury, and Marilyn Schmidt.

For more information about books from Plexus Publishing, Inc., call (609) 654-6500 or visit our Web site at www.plexuspublishing.com

To our fathers, who passed away while we were finishing this book ...

Robert A. Peterson, Sr.,
who taught me to appreciate the Pine Barrens
and the old ways in which he was reared ...

and

Ronald Hogan,
who took me camping, canoeing, and fishing
in southern New Jersey ...

Robert A. Peterson and Michael A. Hogan

Contents

Foreword by Howard P. Boyd *ix*

Acknowledgments .. *xiii*

Introduction ... *xv*

Part 1: Wonders in the Deep

Chapter One: *Shellfish* .. 3

Chapter Two: *Blue Claw Crabs* 11

Chapter Three: *Horseshoe Crabs* 15

Chapter Four: *The Bays* ... 17

Chapter Five: *Streams and Rivers* 25

Chapter Six: *Blue Holes* ... 33

Part 2: The Fowls of the Heavens

Chapter Seven: *Bird Migration* 37

Chapter Eight: *Geese* .. 41

Chapter Nine: *Bald Eagles* 45

Chapter Ten: *Hawks* ... 49

Chapter Eleven: *Great Blue Herons* 53

Chapter Twelve: *Woodpeckers* 57

Chapter Thirteen: *Owls* .. 61

Chapter Fourteen: *Turkey Vultures* 65

Chapter Fifteen: *Purple Martins* 69

Chapter Sixteen: *Monarch Butterflies* 73

Part 3: Earth ... Wind ... and Fire

Chapter Seventeen: *Sand* .. 79

Chapter Eighteen: *Weather* 83

Chapter Nineteen: *Wind* .. 93

Chapter Twenty: *Tides* .. 99

Chapter Twenty-One: *Water* 105

Chapter Twenty-Two: *Ice* .. 109

Chapter Twenty-Three: *Snow* 113

Chapter Twenty-Four: *Fire* 119

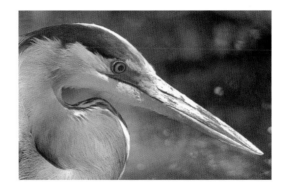

Part 4: All the Trees of the Wood Rejoice

Chapter Twenty-Five: *Pine Trees* 127

Chapter Twenty-Six:
Atlantic White Cedar Trees 133

Chapter Twenty-Seven: *American Hollies* 139

Chapter Twenty-Eight: *Oak Trees* 143

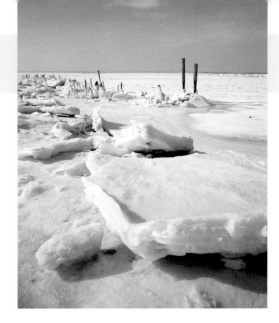

Part 5: The Lilies of the Field

Chapter Twenty-Nine: *Laurels* *151*

Chapter Thirty: *Wild Orchids* *155*

Chapter Thirty-One: *Water Lilies* *163*

Chapter Thirty-Two: *Bog Asphodel* *165*

Chapter Thirty-Three: *Swamp Pink* *167*

Chapter Thirty-Four: *Pine Barrens Gentian* *169*

Chapter Thirty-Five: *Sphagnum Moss* *171*

Chapter Thirty-Six: *Mushrooms* *175*

Chapter Thirty-Seven: *Lichens* *181*

Chapter Thirty-Eight: *Carnivorous Plants* *189*

Chapter Thirty-Nine: *Wild Herbs* *197*

Part 6:
A Land That Floweth with Milk and Honey

Chapter Forty: *Beaches* *203*

Chapter Forty-One: *Wetlands* *209*

Chapter Forty-Two: *Salt Hay* *215*

Chapter Forty-Three:
Salt Marsh Flowers and Grasses *219*

Chapter Forty-Four: *Bog Iron* *227*

Chapter Forty-Five: *Maize* *231*

Chapter Forty-Six: *Garden Flowers* *235*

Chapter Forty-Seven: *Cranberries* *241*

Chapter Forty-Eight: *Blueberries* *245*

Chapter Forty-Nine: *Honeybees* *249*

Part 7: Beasts of the Earth

Chapter Fifty: *White-Tail Deer* *253*

Chapter Fifty-One: *Frogs* *257*

Chapter Fifty-Two: *Turtles* *261*

Chapter Fifty-Three: *Beaver* *267*

Chapter Fifty-Four: *Ducks* *271*

Chapter Fifty-Five: *Eastern Wild Turkeys* *275*

Chapter Fifty-Six: *Red Foxes* *279*

Chapter Fifty-Seven: *Gray Squirrels* *283*

Bibliography .. *285*

About the Author ... *286*

About the Photographers *289*

Index .. *291*

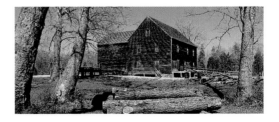

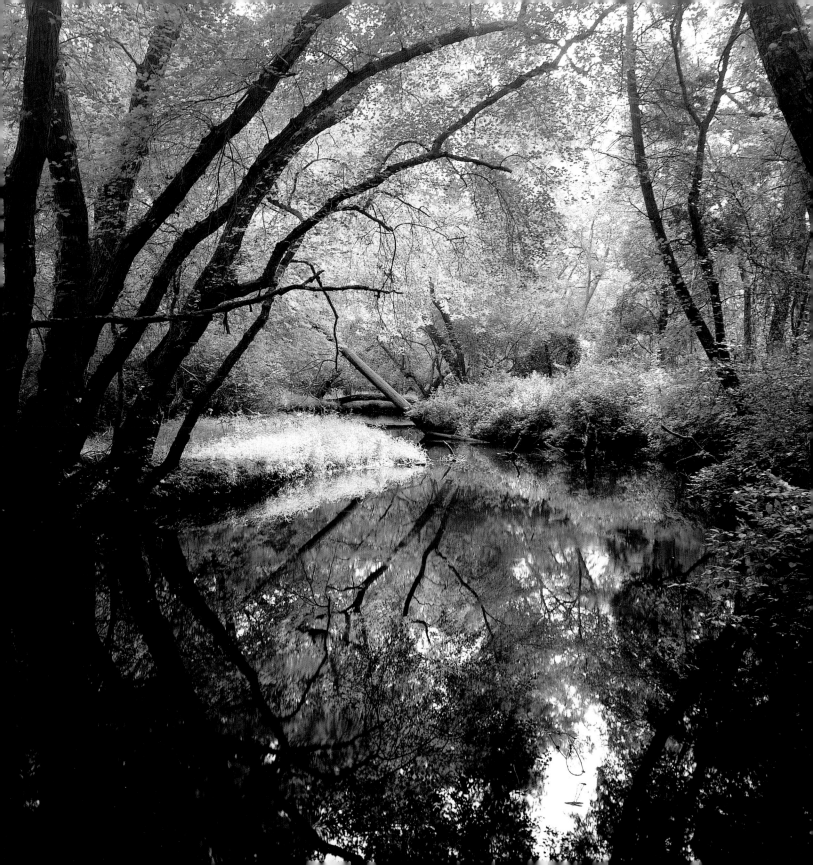

Foreword

Stretching east across southern New Jersey, from the lower Delaware River and Bay to the Atlantic Ocean, and south from Long Beach Island to Cape May, lies a vast land of sandy seashores, fertile farmlands, and a world-renowned Pine Barrens. Comprising the eight southernmost counties in New Jersey, southern New Jersey is a land filled with history, adventure, and beauty.

Contained in this expanse of over 3,700 square miles, or 42 percent of the total area of the entire state of New Jersey, is a great variety of natural features that support and enrich our daily lives on this coastal plain: barrier islands and sandy beaches along the seashore for fishing and recreation; tidal inlets, flats, and creeks for crabbing, clamming, and oysters; tons of sand that we use in manufacturing and construction; fertile soils that support our many agricultural communities; acid soils that provide an ideal habitat for the cultivation and production of our native cranberries and blueberries; rivers, streams, and lakes for recreation; more than a dozen state parks, forests, and recreational areas for hiking, hunting, bird watching, and other nature-oriented activities; and yes, we even have mountains (Mt. Holly, Mt. Laurel, Mt. Misery, Arney's Mount, and others), though these may be small when compared with more majestic ones elsewhere.

Each spring, the shores of the Delaware Bay teem with thousands of horseshoe crabs that come ashore to lay millions of eggs. Due to predation and other factors, only a relatively few will ever develop into mature crabs, but of equal import, many of these eggs will be devoured by the thousands of migrating shorebirds that stop off here to replenish their food supply and their energy so they can continue their northward migration to their breeding grounds. And speaking of bird migration, Cape May Point is world famous as a major focal area for birds during spring and fall migrations up and down the Atlantic flyway, while the Point is also a well-known gathering and resting area for hundreds of monarch butterflies as they prepare to cross the Delaware Bay en route to their winter roosting sites down in Mexico.

Located centrally in this southern New Jersey area is a most unique natural feature: the Pine Barrens of New Jersey, an area of more than 2,000 square miles, more than half the area of the eight counties in southern New Jersey. Here, in this largest such natural area to be found anywhere along our eastern seaboard, are forests of pitch pines and oaks in sandy uplands, and stands of Atlantic white cedar in bogs of reddish brown cedar water. Here is a vast variety of native plants, wildflowers, and wildlife, including more than a dozen plants of northern origin brought down to New Jersey by the glaciers, and over one hundred plants of southern origin that have moved north as our area warmed up after the retreat of the glaciers. Here, in these unique Pine Barrens, are several unusual plants we call carnivorous or insectivorous (pitcher plants, sundews, bladderworts) because of their ability to trap insects and absorb their nutrients into their tissues. Perhaps surprisingly, many species of orchids are also found in these Pine Barrens, some of which are rare and endangered. It is here in these pines that hikers can walk and camp along the 50-mile Batona Trail from Ong's Hat in Brendan Byrne State Forest to Lake Absegami in Bass River State Forest, and

canoeists can paddle down any of the dozen or so swift-flowing streams of cedar water, all the way to the tidal marshes inland from the ocean, or to the Delaware River.

In the more than fifty essays included in this volume, Bob Peterson takes us to many of these natural resources, interestingly describes them, and invites us to visit and enjoy these natural features for ourselves. It is unfortunate that Bob did not live long enough to see the fulfillment of his dream in this beautiful book which is so well illustrated with striking photographs by Michael Hogan and Steve Greer. Together, these three have collaborated to provide us with a descriptive and photographic overview into our wonderful southern New Jersey shores, coastal plain, and pine barrens.

<div style="text-align: right;">
Howard P. Boyd

July 2004
</div>

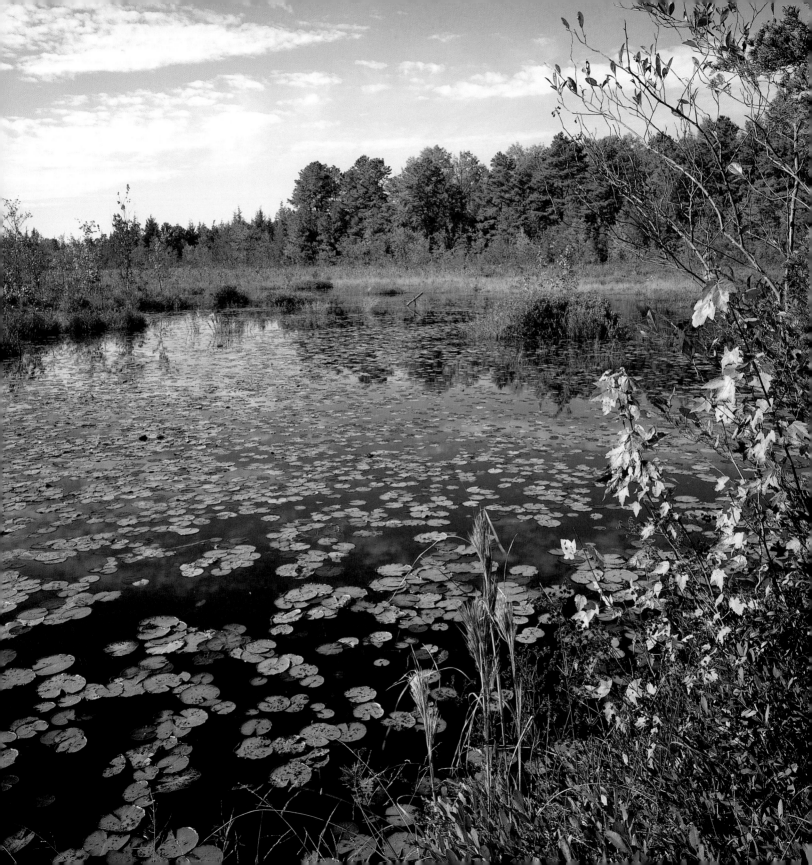

Acknowledgments

A book of this scope would not have been possible without the help of many people and organizations.

Mary Adkisson deserves our thanks for help in keyboarding and formatting certain sections of the manuscript. As assistant to the Headmaster at The Pilgrim Academy, Mary brought many skills to our project, and for that we are indebted.

Many individuals aided and advised Michael in photographing the beauty of South Jersey. Without their help, some of these shots would not have been possible. Thanks in particular to Ted Gordon, Aileen Hogan, Jill Baxter, Jack Carnell, John Carlano, George Vail, Howard Alber, Joseph Arsenault, Emile DeVito, Howard Boyd, Paul Stankard, Jay Laubenguyer, Keith Seegers, Bertuzzi's Farm Market, and Atlantic County Parks.

Organizations that aided in making the photographs possible include Delaware Riverkeepers Network, New Jersey Conservation Foundation, New Jersey Chapter of the Nature Conservancy, Environmental Commission of Camden County, Federation of Gloucester County Watersheds, Old Pine Farm Natural Lands Trust, Washington Township Environmental Commission, Deptford Township Environmental Commission, Whitesbog Preservation Trust, Weymouth Township Environmental Commission, Atlantic County Department of Parks, and Batsto Citizens Committee.

We would also like to thank the Egg Harbor Historical Society and Pilgrim Academy Library for use of their resources in preparing the manuscript. Authors and works that inspired us are included in the bibliography at the end of the book.

Dave Genter, science teacher at Pilgrim, read the manuscript and offered ideas and further leads on some of the topics in the book. Lynn Lyon, another Pilgrim teacher, reviewed the manuscript in minute detail and helped eliminate many errors. Whatever you may think of the final product, it is definitely a better book because of Lynn's suggestions.

South Jersey Naturalist Howard Boyd, whom we both hold in great esteem, read the manuscript and made many valuable suggestions. His pioneering work in Pine Barrens ecology, along with his books, inspired us throughout our work on this project.

We want to recognize the excellent work of several people at Plexus Publishing Inc., notably managing editors Deborah Poulson and Amy Holmes, who steered the book with a steady hand, graphics department manager Heide Dengler, whose expertise in book production is evident on every page, and—especially—Erica Pannella, whose inspired design made our vision come to life.

Bob would also like to thank his newspaper editor, Norlynne Lubrano, for allowing him to explore some of these themes in his weekly newspaper column.

Finally, we would like to thank John Bryans, our editor at Plexus Publishing, Inc. John was the catalyst who brought our writing and photography together, and he offered excellent encouragement and support to both of us along the way.

<div style="text-align: right;">
Robert A. Peterson

Michael A. Hogan
</div>

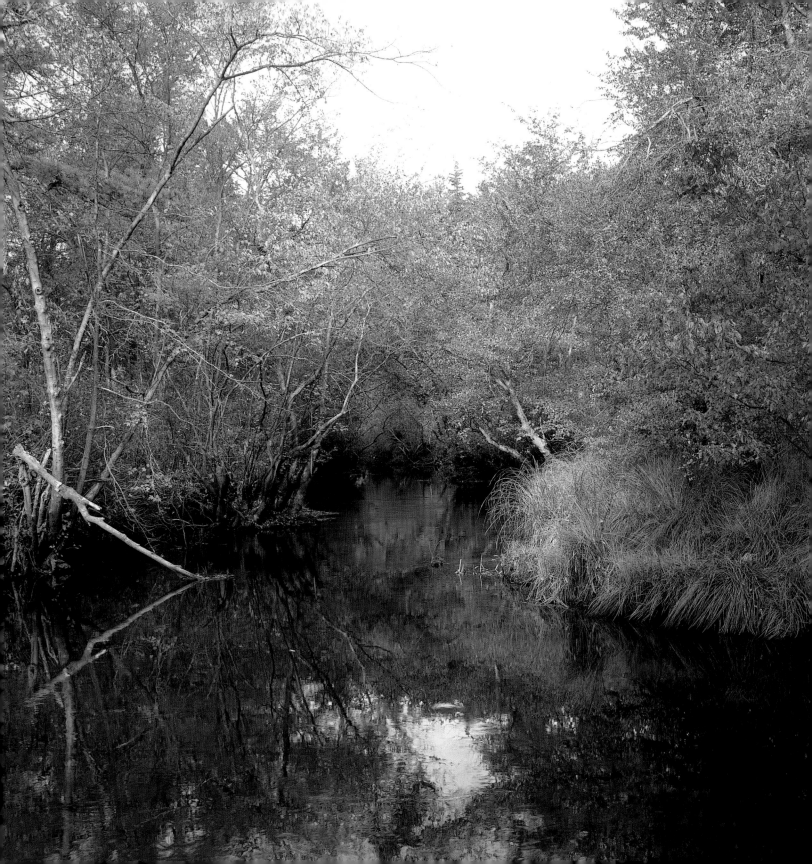

Introduction

Russell Conwell, founder of Philadelphia's Temple University, told all incoming first year students his famous "Acres of Diamonds" story. It seems that a Persian farmer, Ali Hafed, was successful at farming and had more land than most men. One day a visitor told him how diamonds were formed, and that they could be found wherever a river runs through white sands between high mountains. Ali Hafed became so captivated with the thought of diamonds that he sold his farm and put his family in the care of a neighbor. He searched the world over and exhausted all his money. Reaching the seacoast in Spain, he gave up in despair and committed suicide by plunging into the ocean.

A few years after Ali Hafed's death, a hard-working farmer found diamonds—acres of them—right in Ali Hafed's back yard. Thus was discovered the famous Golconda mine, one of the most magnificent in the world.

People in Philadelphia, New York, and New Jersey are often like Ali Hafed. When they want to search for America's national beauty, they head out West, to New England in the fall, or to Florida's sunny beaches. Yet right here, in our own backyard, the Pine Barrens and Jersey Shore are filled with "acres of diamonds" in terms of natural wonders.

Few areas of the country, for example, have more birds than does Cape May during the fall migration. In good birding years, these birds literally darken the sky.

New Jersey's 126 miles of sandy beaches, which rival any in the world, played host to the nation's first seaside resorts, while the back bays have served as the nursery of the Atlantic Ocean for centuries.

South Jersey sand was used to make America's first successful glass products, and today South Jersey glass is known throughout the world.

The great abundance of ducks created a local hunting industry, where guides would escort hunting parties from New York and Philadelphia. This led to the decoy-carving trade, which eventually became a highly developed art form. Today, there are more duck carvers per square mile in South Jersey than anywhere else in the world.

The Pine Barrens, covering more than a million acres, is the largest undeveloped tract between Maine and Florida. (In this book, "Pine Barrens" and "Pinelands" are used interchangeably to refer to the area in the widest possible sense.) Life in the Pine Barrens is made possible by the existence of a great underground reservoir of water, the Cohansey Aquifer. Experts estimate that it contains more than 17 trillion gallons of water as pure as melted glacier ice. The swamps and streams fed by the Cohansey Aquifer support a diverse range of plant and animal life. Sphagnum moss is just one

example; many times more absorbent than cotton, it was used for medical dressings in World War I.

Scientists travel from as far away as Japan to study South Jersey's wild orchids, while rare insect species such as the Bucholz dart moth can only be found in the Pine Barrens. The pygmy pine forests near Warren Grove represent one of only two such forest areas on Earth. Biologists still can't fully explain why its trees won't grow taller than eight to twelve feet.

This is the kind of beauty that Revolutionary War chaplain Phillip Vickers Fithian was speaking of when he visited the area in the late 1700s. In his diary he wrote, "There is something grand, charming and desirable in this vulgarly despised country … the sand, the pines … it is Nature stark naked."

In the pages that follow, we have tried to capture the beauty and wonder of this seemingly barren yet bountiful land. Along with the photographs, we have tried to describe how each plant, animal, or natural resource has interacted with humans. We do not believe that anyone walking among these creatures and natural forces can fail to gain an appreciation for the "acres of diamonds" that surround us.

Part One

"Wonders in the Deep"

Psalm 107:24

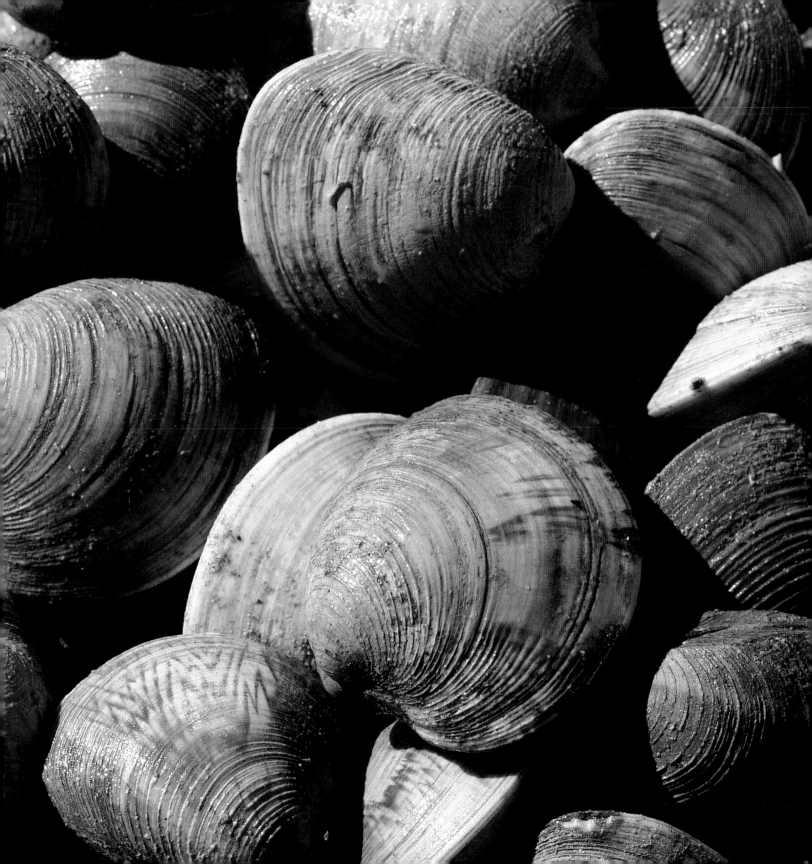

Chapter One

Shellfish

South Jersey has long been known for its seafood. From the time of the Lenape Indians to the present, residents have enjoyed mussels, clams, scallops, and oysters. In our local seafood restaurants, they are the stars of the menu, and Italian-American cooks in Hammonton, Vineland, and other South Jersey towns have used them to create a unique and tantalizing cuisine.

Clams and oysters in particular have an important history as a South Jersey staple and resource. European settlers apparently found the clams as delectable as did the Native Americans. The clamming industry brought hard cash into the region, and many young men got their first taste of entrepreneurship clamming in the local bays. Bivalve, New Jersey, is named after the oyster, and Tuckerton was for many years known as Clam Town. Clambakes have become part of our culture, and many tourists to the area wouldn't think of ending a visit without stopping at a clam bar. When a shore dweller is especially content, old-timers describe the person as "happier than a clam at high tide."

Clams

Many roads in Cumberland, Ocean, and Cape May Counties are covered with clamshells—a cheap and plentiful material. The shells make a beautiful road surface, especially when glistening in the sun. The only downside is that because they are so lightweight they frequently wash away during major downpours.

In the 1960s and early 1970s, pollution in the back bays prompted the state of New Jersey to close many of what were among the most productive shellfish areas in the nation. In recent years the construction of regional sewage treatment plants has largely ended this pollution problem, and clamming has made a significant comeback.

For the purposes of consumption, the hard clam, or *Mercenaria mercenaria*, is identified according to size. Clams between two and three inches across are referred to as "littlenecks," "cherrystones" are three to four inches across, and clams wider than four inches are called "quahogs," or chowders, because they are often cut up for chowder. The hard clam has a thick white shell with a purple coloration on the inside. This shell was greatly admired by Native Americans, who used it to make wampum.

The clam is a model of filtering efficiency. As with other bivalves, the hard clam's body filters about 100 gallons of water a day, taking in oxygen and food particles and eliminating waste. Clams thrive in water that has a minimum of 15 percent salinity.

Clams usually reproduce in July, when the water reaches about 78 degrees. Both male and female clams emit a cloud of spawn, which mingle and form millions of larvae. Within hours, following specific directions in the clam's genetic code, the tiny creatures begin forming shells, causing them to drop to the ocean bottom. Burrowing into the mud with their feet, they remain there for the rest of their lives.

Clams have many predators, including crabs, starfish, and, of course, humans. Historically, clammers have used clam rakes to harvest their catch from the bottom of bays, inlets, and coastal waters.

Today, the state of New Jersey issues upward of 7,000 recreational clamming licenses and about 1,350 commercial licenses annually.

The oyster (*Crassostrea virginica*) has also played an important role in New Jersey, particularly in the south. Over the past 50 years, oyster gatherers have not been as successful as clammers, largely due to the effects of disease on the native oyster beds. Yet, at one time, the area in Cumberland County around Port Norris, Port Elizabeth, and Bivalve was purported to have the highest per capita income in the nation. Each week,

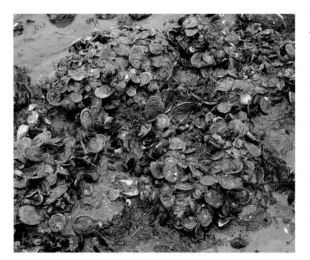

Above and at right: Delaware Bay oysters

some 90 railroad cars were filled with chilled oysters bound for market in New York and elsewhere.

From colonial times until the mid-20th century, "oystering" and oyster dishes were part of life along the South Jersey coast, particularly on the Delaware Bay side of the peninsula. In the early 1700s, the Swedish-American settler James Steelman was the first overseer of the oyster harvest. The Lenape harvested oysters and enjoyed them on their summer excursions along the coast, leaving behind enormous shell piles. These piles, in turn, were used by early colonists as a source of lime for the flux needed for their charcoal-fired iron furnaces.

In colonial times, oyster-harvesting methods were simple, with hand-held rakes and tongs deployed from shallops and small sloops. In the 1800s, oyster dredges were used to scrape oysters off the bottom of the bay. The original dredges were crude affairs, wound in by hand from aboard the sailing ships of the oyster fleet based in Port Norris. While waiting to be shipped, the oysters would be placed on "board banks" on the shore where the tides would keep them fresh. By the late 1800s, more than 300 dredge boats were involved in the oyster industry, with iced sacks and barrels of oysters shipped to major markets by express rail service.

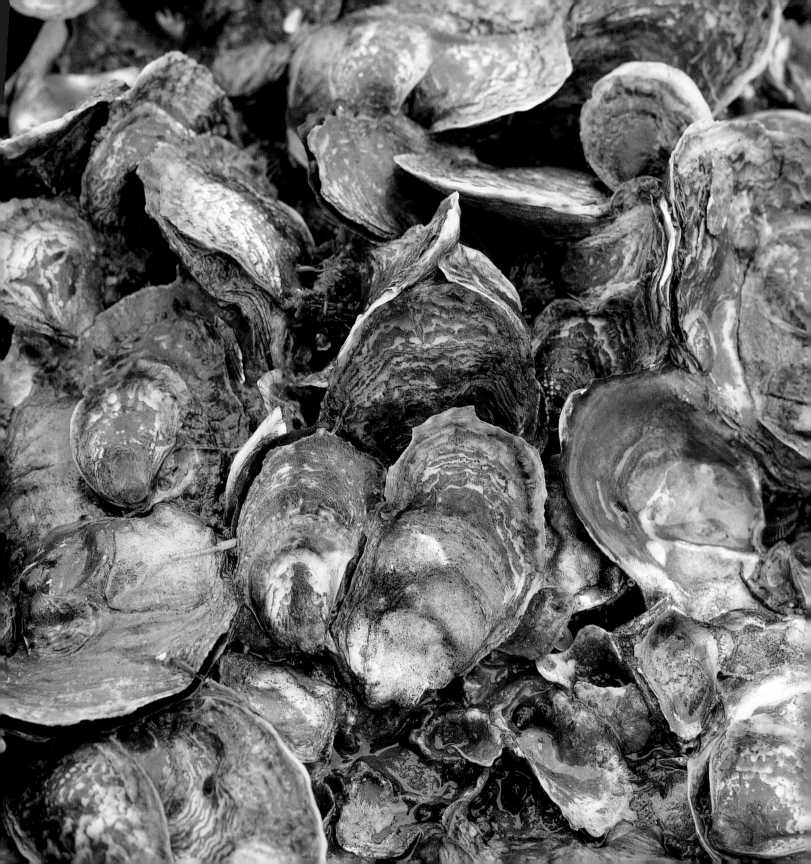

| 6 |
Shellfish

Shellfish

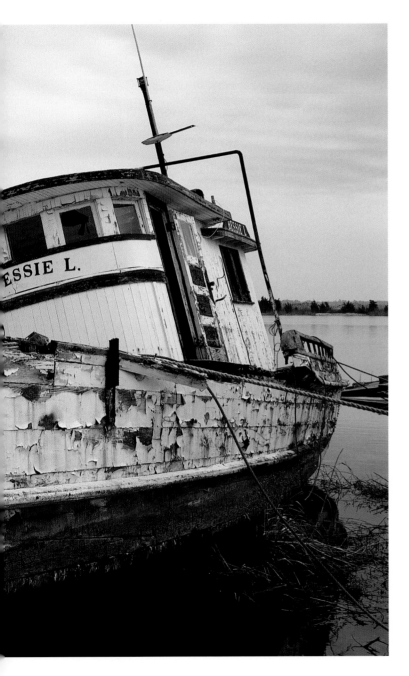

Left: South Jersey oyster boat

Eventually, oyster boats were equipped with diesel engines to pull in the dredges. Once the oysters were dumped on deck, they would be separated and sorted according to size. A specially designed hammer, known as a culling iron, was used to break apart clumps of oysters. When a boat could hold no more, it would return to port where its harvest would be sold to the highest bidder.

In March 1835, a load of New England oysters was dumped in a cove near New Haven, Connecticut, because the haul had arrived at market out of season and could not be sold. The following year, it was discovered that the oysters had grown significantly, and out of this came the idea for oyster "farming." South Jerseyans obtained seed oysters from Chesapeake Bay and from natural beds in the Cohansey River and placed them in Delaware Bay. After four years, mollusks were ready for harvesting.

Regionally, oysters became so plentiful in the 1800s that virtually every restaurant from Philadelphia to Egg Harbor served them. (One popular entrée was chicken salad and fried oysters.) When British writer Matthew Arnold visited the United States, he wrote: "The Americans have an abundance of two things: oysters and ice."

Unfortunately, two protozoan parasites, MSX (*Haplasporidium*) and Dermo (*Perkinsus marinus*) killed almost all the New Jersey oysters in the late 1950s, essentially destroying the state's oyster fishing

| 8 |
Shellfish

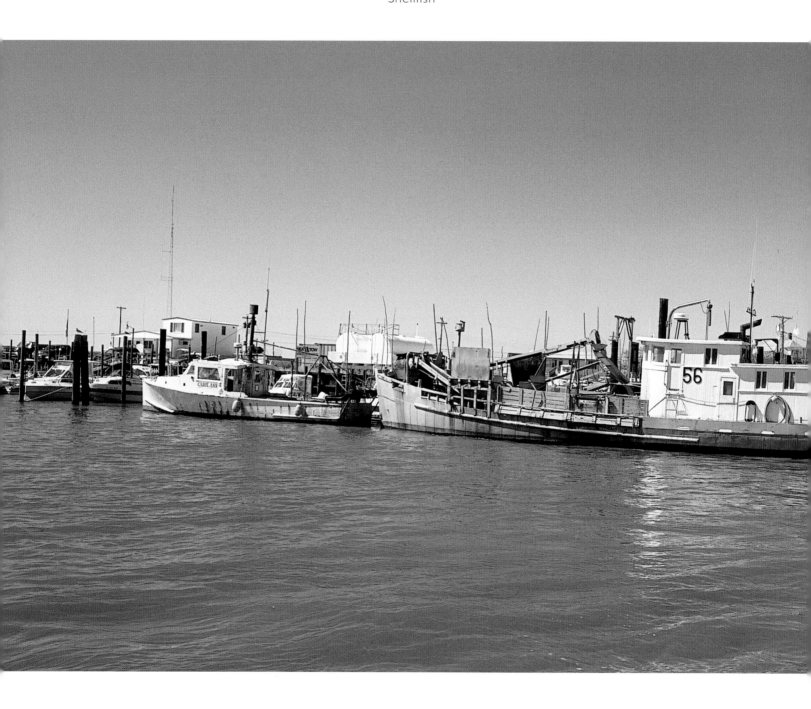

industry. Today, research conducted at Rutgers University on these two parasites, which are harmless to humans, hopes to find a solution and perhaps resurrect the oyster harvesting industry.

The glory days of South Jersey's oyster industry are documented in museums at Wheaton Village in Cumberland County and Historic Cold Spring Village in Cape May County, and by the Delaware Bay Schooner Project. In this latter initiative, the 1928 oyster schooner *A. J. Meerwald* has been renovated to serve as a floating classroom to educate the public about the ecology and resources of Delaware Bay.

Left: Oyster and fishing boats along the wharf at Bivalve, Delaware Bay

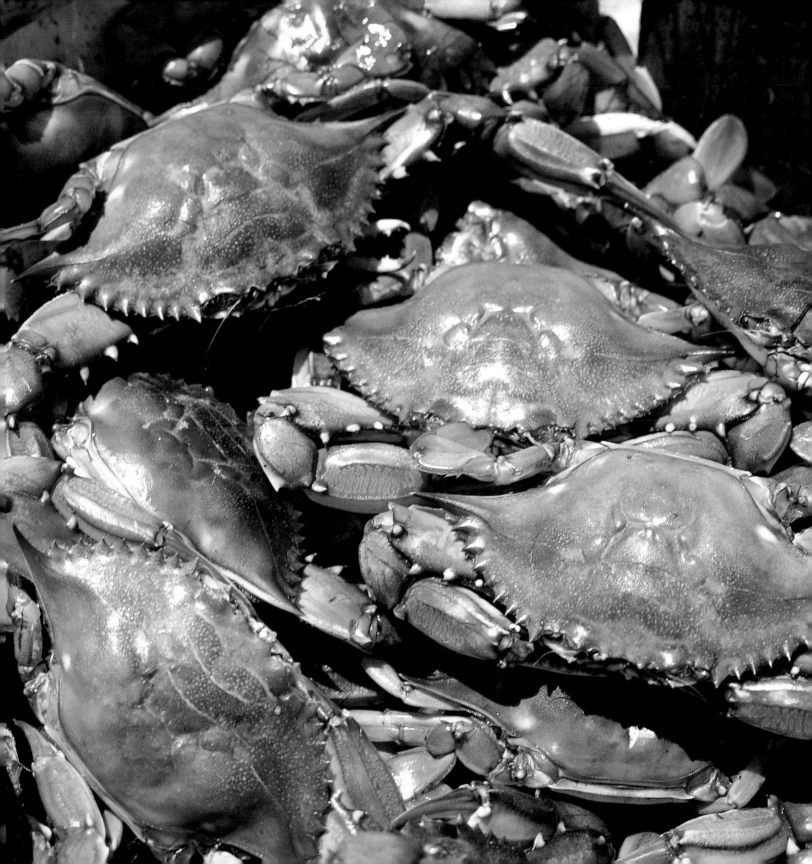

Chapter Two

Blue Claw Crabs

Long regarded as a local delicacy, blue claw crabs may have been eaten by the Lenape Indians hundreds of years before the arrival of European explorers and settlers. Today, families along the Jersey coast and rivers still make sport of "crabbing." Using traps or bait lines, and nets with chicken necks or bits of fish as bait, crabbers pursue the tasty crabs from bridges, piers, boats, and river banks.

From the time a South Jersey crabber first puts out the bait to the time the crabmeat is eaten, crabbers must exert considerable energy, as most operate 5 to 10 bait lines and check them every few minutes or so. When a crab finally tugs on the line, the crabber retrieves the line slowly and steadily until the feeding crab can be scooped up with a long-handled dip net.

Once caught, the crab needs to remain in water until it is put on ice, because, like lobsters, crabs are always cooked alive to ensure freshness. Meantime, the water must be changed frequently, lest the crab use up all the available oxygen and suffocate.

Traditionally, many South Jerseyans catch crabs during the crabs' soft-shelled stage by wading into shallow water with a scoop net. (Of course, this has to be done when the water is clear and calm.) Crabs can also be scooped up from riverbanks and around pilings and bulkheads.

Once the crabber has a "mess" of crabs, he then needs to keep them alive while transporting them to his kitchen. In the past, a bushel basket with a lid was used and kept in a cool place. Today, crabbers usually fill a cooler with ice to stun the crabs but still keep them alive.

Once the crabs are brought into the kitchen, they are rinsed, inspected to see if any are dead, then dropped into a large pot of boiling water to cook for eight to ten minutes. Along Delaware Bay, most crabbers have traditionally added black pepper, cayenne pepper, and crushed red pepper to make the crabmeat spicy. Today, crabbers will typically add Old Bay seasoning or perhaps something even more exotic.

Once cooked, the job is still not finished—the crab must be cleaned. First, the crabber removes the carapace shell by lifting the apron and pulling forward. The mouth parts, legs, and claws are snapped off, and the internal organs washed out. Finally the crabber gets his reward: delicious, delicate white meat from the claws and the shelled compartments on either side of the body. The compartments are cut

Blue claw crabs

open with a knife, and the claws are usually broken open with a nutcracker.

Is it worth it? Apparently so, because according to the New Jersey Division of Fish and Wildlife more effort is expended in catching the blue claw crab than for any other single species. A recent survey indicated that crabbing accounts for 30 percent of all marine fishing activity. Although not as famous as Maryland crabs, South Jersey's crabs are every bit as delicious.

The blue claw crab is compelling in its natural state. It has a hard shell, or carapace, which is made of chitin, which is hardened with calcium and can range in color from olive, brown, or reddish to varying shades of blue. (Recently, some supplement manufacturers have been touting chitin pills as a

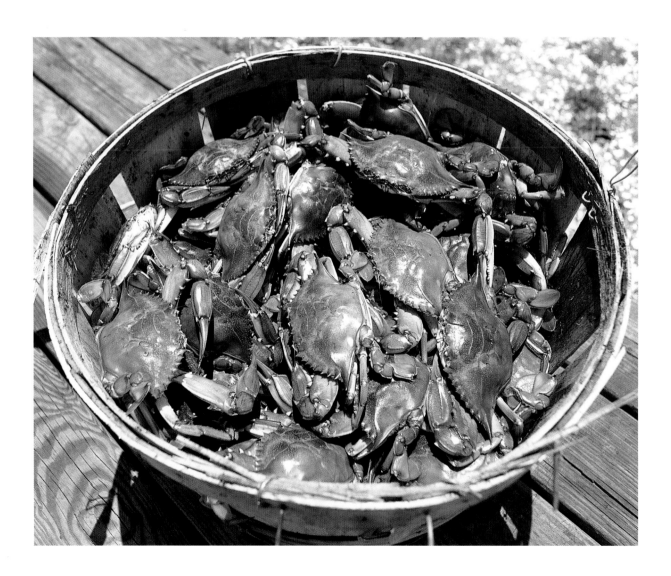

weight loss aid, with claims that if you take chitin during a meal, the fat binds to it and is not absorbed by the body. Critics claim that it absorbs important nonfat nutrients, as well, and shouldn't be used.)

The blue claw crab's compound eyes, which rest on short stalks, see even the smallest of movements in almost all directions. It has five pairs of legs which, in the male, are bluish-gray in color. The female, however, has legs with reddish-orange tips.

The crab's first pair of legs sport sharp claws that are used to capture and hold food, and also to defend itself. When trying to escape from a predator, the crab can allow its claw to break off. It then simply grows another through a growth process called molting. During molting, all of the hard outer shell is lost; a new, softer shell swells and hardens in seawater to a larger size. Each time the crab molts, any missing limb grows a little larger until it is fully formed again.

While the next three pairs of legs are used for walking, the rear pair is modified into flattened paddles which enable the blue claw crab to swim—an ability not found in all crabs.

Blue crabs mate from June through October. During courtship, the male, called a "jimmy," puts on a dance, waving his pair of swimming paddles. The female is apparently impressed with this, and allows the male to move over her and hold her beneath him. (A male carrying a female in this manner is called a "doubler.") The female is then released so that she may molt. After molting, the female is extremely weak and vulnerable, and tries to hide in protected areas such as marshes or grass beds. During this critical period, before the new shell hardens, mating occurs. The male then protects the molted female for some time afterward.

When the crab's eggs hatch, as few as two out of millions may live to reproduce. The larvae are two millimeters in length and spend the first stages of their lives among the plankton. In one of the great mysteries of nature, the crabs follow explicit instructions contained in their genetic code and go through a rapid series of molts. The female molts twenty-one times, while the male molts continuously throughout its life.

Blue claw crabs are scavengers, eating edible waste and preying on clams, oysters, and mussels. They also eat certain types of marsh grasses and seaweeds.

Because of its unique attributes, both in nature and our local cuisine, the blue claw crab has been given the Latin name *Callinectes sapidus*, meaning "beautiful swimmer that is savory"—a tribute to this creature's contribution to the economy and culture of South Jersey.

Freshly caught crabs

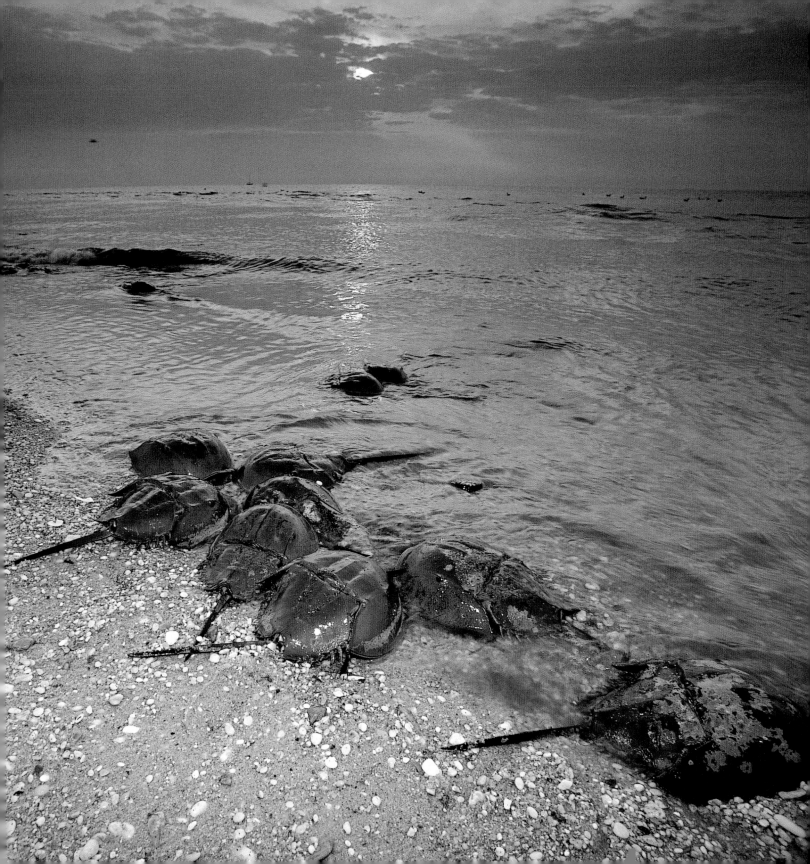

Chapter Three

Horseshoe Crabs

Humans have learned to eat just about anything, from snails to fish eggs (caviar). But for some reason, our forebears never developed a taste for the horseshoe crab or its eggs. Instead, our frugal ancestors, always on the lookout for local resources that could help them survive, harvested horseshoe crabs to use as bait to catch eels and conchs (whelks). Today, these same crabs are used in the biomedical industry, while regions bordering Delaware Bay credit bird migration—dependent on horseshoe crab eggs—with bringing in millions of dollars in ecotourism each year.

So what is a horseshoe crab and what role does it play in South Jersey ecology? According to scientists, today's horseshoe crab looks the same as in prehistoric times. These creatures lived when dinosaurs walked the Earth but, unlike the dinosaurs, somehow managed to survive our last great ice age. What's more, though this crab is a supposedly simple lifeform, it has a myogenic heartbeat—a heartbeat that originates in the heart instead of the brain, as it does in humans. The fact that the horseshoe crab is unchanged since ancient times has raised important questions about evolutionary theory.

The horseshoe crab (*Limulus polyphemus*) defies aesthetic theory, as well. Most people consider the crab to be quite ugly, with a face only a mother (or dedicated marine biologist) could love. The crabs spend their days foraging for marine worms and small clams in the soft sediments along the eastern coastline of North America, especially in and around Delaware Bay. They walk along the bottom, often using their horseshoe-shaped shells to bulldoze bottom sediments. Sifting through the loosened material with their five pairs of legs, they grind up the food with the legs' spiny segments and push it into their mouths, located between the legs.

In the summer, horseshoe crabs stay close to shore, feeding in tidal marshes and mudflats. As the water cools, they retreat into deeper waters.

Horseshoe crabs lay their eggs in what biologists call low activity beaches—areas protected from the open oceans. Each female lays a cluster of up to 3,500 eggs. Close behind are the males, who shed milt (sperm) onto the eggs. As the tide comes in, the seawater washes the milt over the eggs, fertilizing them. When the eggs hatch, the larvae are mobile and spend a week swimming before settling to the bottom to molt.

Today, environmentalists and bird watchers are concerned about overharvesting of horseshoe crabs and the impact it may have on the health of the bird population. It is to be hoped this species is allowed to survive, and thrive, because while humans may never develop a taste for them, horseshoe crabs play a key role in the ecology of Delaware Bay.

Horseshoe crabs (Photograph by Steve Greer)

Chapter Four

The Bays

In the mid-20th century, Tuckerton, New Jersey, went through difficult times. Once an official port of entry for the United States and a bustling center of industry, the town was in decline as activity on the Barnegat and Little Egg bays decreased. Today, however, the town is on the rise again. Homebuyers appreciate its rural atmosphere, while the new Tuckerton Seaport Museum attracts thousands of visitors annually.

Working as a bayman was once a common occupation in Tuckerton and other coastal areas of New Jersey. But you won't find "bayman" talked about much in today's career forums or in the help wanted ads. Perhaps that's because a bayman's job description was simply this: Do anything you can to make money from the bay.

A bay may be defined as any large indentation of land bordering the ocean. Chesapeake and Delaware bays are further defined as estuaries, river valleys submerged by the sea. Their strategic position between land and sea, freshwater and saltwater, causes them to teem with life.

South Jersey has many bays, including Barnegat Bay, Little Egg Bay, Great Egg Bay, and Delaware Bay. Many South Jersey people have worked their entire lives on one of these bays. Early settlers were first attracted to the bays for the opportunity to fish. When the fishing was slim they turned to clamming and oystering.

In Europe, oysters were a rarity, very expensive, and considered a delicacy. In this country, so many oysters were harvested that some Europeans considered their abundance a leading indicator of American wealth and bounty. Here, even average people could afford oysters. Oysters and chicken salad, a dish popular with early South Jersey settlers, is still served in local restaurants like the Sweetwater Casino on the Mullica River.

In Port Norris, Cumberland County, some baymen became fabulously wealthy by harvesting oysters. At one time, the abundance of shellfish made this one of the richest areas in America. Well into the 19th century, the wealth of South Jersey's bays seemed inexhaustible.

Baymen used a special rake with a wide bottom and twenty-two teeth for raking clams. Today, it is called a Shinnecock rake, named after Shinnecock Bay in Long Island. The tongs work like huge blunt scissors, digging into the bottom of the bay where the clams lay buried. It was tough work, but there was always a market for the shellfish.

Fortescue Beach on Delaware Bay

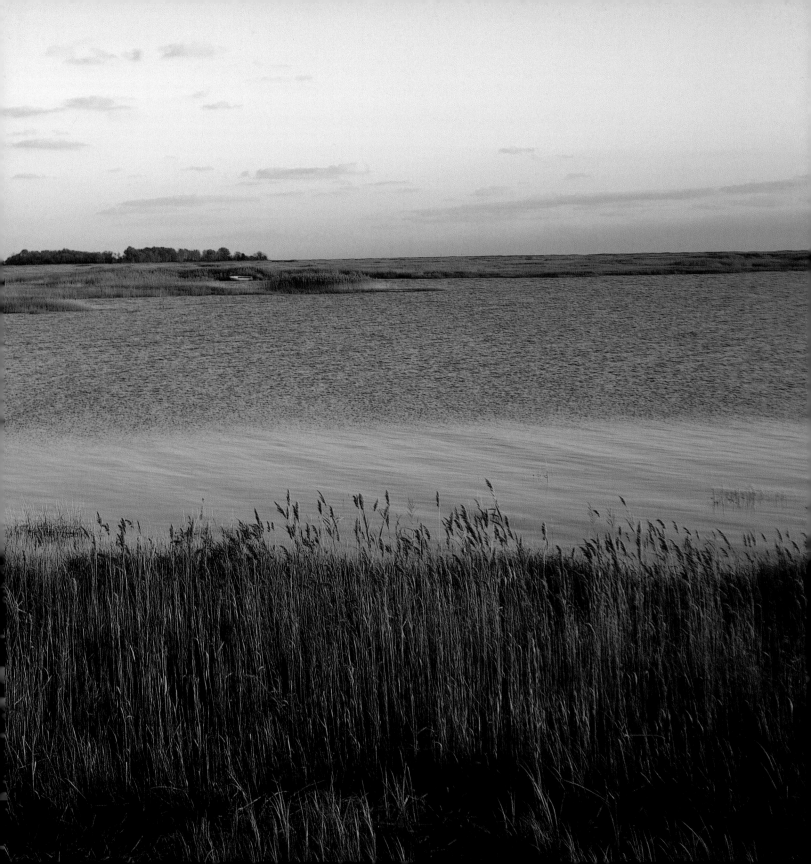

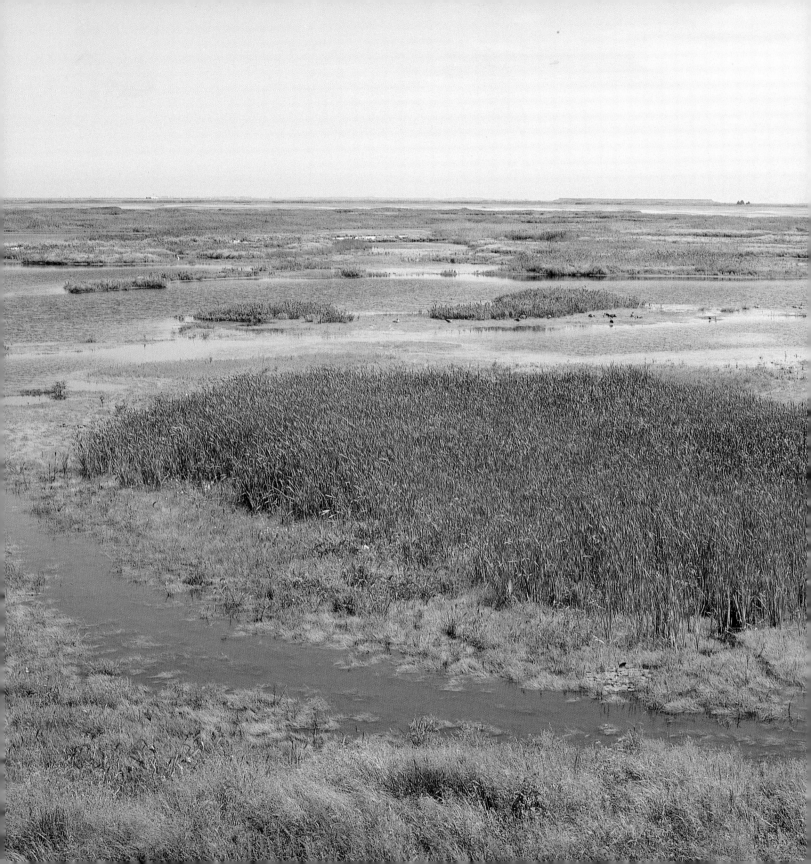

Baymen supplemented their income by hunting waterfowl; trapping eels, turtles, and muskrats; and serving as guides for hunting parties. Duck hunters came from New York, North Jersey, and Philadelphia, giving rise to another bayman's craft—decoy carving. Baymen would take blocks of white cedar and transform them into canvasbacks or black ducks. These would then be sold to duck hunters as part of the guide's "sales and service business." Today, duck carving is very seldom utilitarian; it has evolved into a local art form. South Jersey now boasts more bird carvers per square mile than anywhere else in the world. In fact, many South Jersey bird carvers have never set foot in the bay, yet they owe their craft to the rugged baymen who carved decoys for just a few dollars apiece. Today, thousands of collectors around the country spend about $10 million annually on carved birds. One carver described the process by saying, "You simply carve away everything that doesn't look like a duck!"

South Jersey baymen also gave rise to a small boat-building industry, developing such boats as the garvey, the catboat, and the sneakbox. The sneakbox was invented in New Jersey in the early 1800s by Hazeton Seaman. Nicknamed "the Devil's Coffin," it was lightweight and low-decked, perfect for "sneaking" through the back bays, needing only a little water to float. In fact, an old South Jersey saying is that "a sneakbox can follow a mule as it

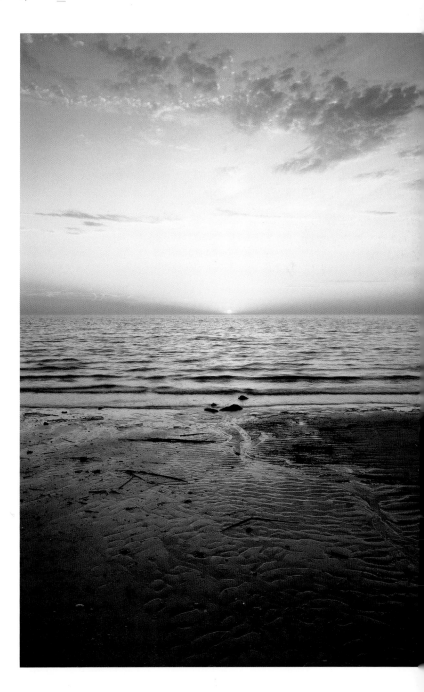

Pages 18-19: View of Bayside on Delaware Bay
Left: Reservoir at the Edwin Forsythe National Wildlife Refuge
Right: Kimbles Beach, Delaware Bay

sweats up a dusty road." Baymen used boats like this to ply their trade.

Many of the oyster beds are gone now, having been destroyed by the MSX parasite that struck in the 1950s, and so are most of the baymen who pioneered South Jersey living and left a legacy that includes seafood, decoy carving, and the sneakbox.

With sound environmental policies, the magnificent bays of South Jersey will continue to hold their place among our most important natural resources. Meantime, the museum in Tuckerton will do much to preserve the bayman's heritage and that of the bays.

Below: Delaware Bay near Artificial Island
Right: Low tide, Delaware Bay

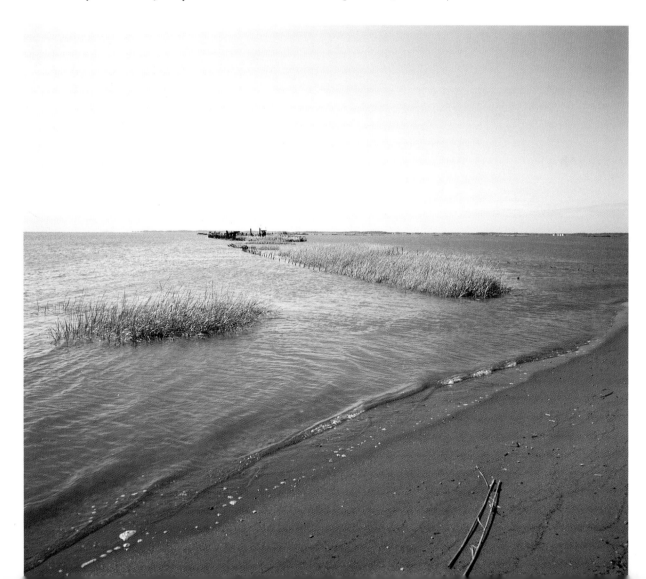

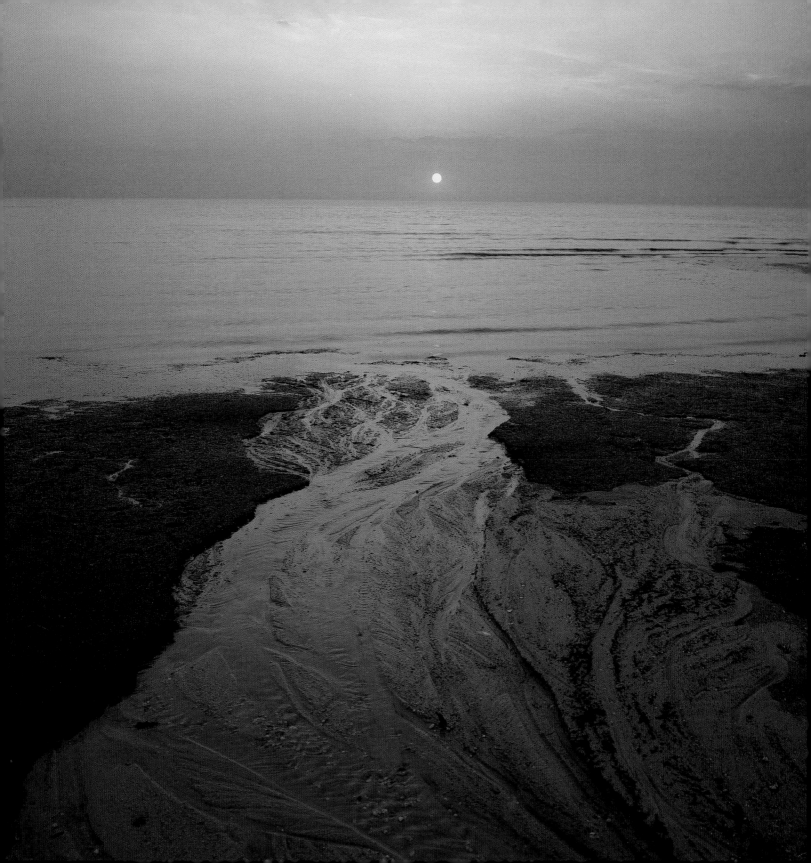

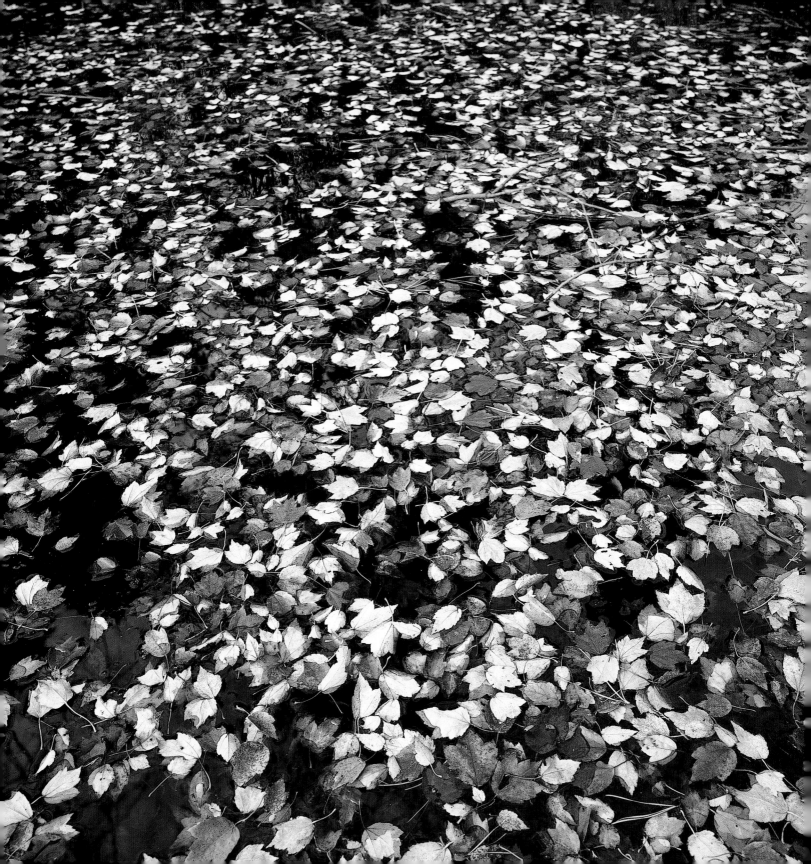

Chapter Five

Streams and Rivers

One of the most beautiful sights in the Pine Barrens is that of a woodland stream, its tea-colored water flowing gently through stands of cedars and banks of sugar-colored sand.

Such streams—often referred to by locals as creeks or "cricks"—attract not only animal life but human development as well. At one time there was a Native American encampment on Neschochague Creek, near Pleasant Mills, in Atlantic County. Other South Jersey streams were extensively traveled by Native Americans in their dugout canoes.

When the European settlers came, many settled along streams or creeks, and many towns took their names from a strategically located creek—West Creek, Mott's Creek, Dividing Creek, English Creek, and so on.

The banks of streams were abundant in natural resources. Big Timber Creek, which empties into the Delaware River and was named for the large oak trees that lined its banks, was used to supply the Philadelphia Navy Yard with lumber in the early years of our nation. The timber here was used to build everything from small flat-bottomed boats to 300-ton sailing ships.

Leaves coat the Mullica River

Boatyards were often built on stream and river banks—far enough from the ocean to avoid damage from coastal storms yet close enough to easily float newly constructed boats down to the sea. Sometimes a builder had to wait for high tide in order to move a larger boat down to the river, bay, or ocean.

In the early 1900s, Dr. Charles Smith arrived in Egg Harbor City, claiming that the cedar waters of Union Creek possessed special healing powers. Smith diverted the stream, creating serpentine canals that can still be seen behind Egg Harbor City's Municipal Building. To each patient, Smith would prescribe a certain number of laps in the healing waters of the cedar stream or canal. The Round House, which in Smith's day had windows all around and was where patients went to dry after a dip, was eventually remodeled and became the home of the Egg Harbor City Historical Society.

In and around South Jersey's scenic rivers may be found a wide variety of flora and fauna. Deer herds graze along the rivers' lengths, and many are still inhabited by river otter. Broad marshes attract all kinds of raptors, and at the rivers' mouths thousands of birds congregate in spring and fall. Swamp pink, water lilies, marsh grasses, wild rice, Parker's pipewort, and hundreds of other types of plants grow on and near the river banks. Along the Maurice River in Cumberland County

you'll find the world's largest stand of the globally rare joint vetch.

The abundance of natural resources, along with the rivers' use in human transportation, encouraged South Jersey's first inhabitants to settle close to them.

Named for Swedish-Finnish explorer, Eric Mullica, the Mullica River was visited frequently by the Lenape, who would dine on fish and crabs. The Mullica also played an important part in the Revolutionary War. Pleasant Mills, located near the river's source, was an important industrial center serving the colonial cause. During the British blockade of New York and Philadelphia, the Batsto forges and furnaces were, for a time, the chief source of cannonballs for the Continental Army.

To wipe out this "nest of rebel pirates" on the Mullica, as one British military report called it, several gunboats were sent to the mouth of the river. They destroyed much of what is now Port Republic, but were held back from attacking Batsto by the quick reaction of General Washington, who sent troops to defend it.

Clarks Landing, seven miles below Pleasant Mills, was settled at the beginning of the 18th century and became a community of more than fifty homes within a few years. The Mullica River basin was also the haunt of Revolutionary War bandit Joe Mulliner, who later was captured and hanged for robbery and murder. Eventually, the Mullica became a center for shipbuilding—a tradition still carried on by Ocean Yachts in Weekstown.

North of the Mullica is the Wading River, which once supported the now-defunct Harrisville papermills, cranberry bogs, blueberry fields, and 17th-century shipyards. Other rivers that drain the greater Pine Barrens area include the Oswego, which empties into the Mullica, and also the Rancocas, which empties into the Delaware River.

At the southern end of Atlantic County is the beautiful and still somewhat wild Great Egg Harbor River. American writer Henry Van Dyke wrote of his friends and "their secret find of a little river in South Jersey, less than an hour from Philadelphia, where one could float in a canoe through mile after mile of unbroken woodland, and camp at night in a bit of wilderness as wildly fair as when the wigwams of the Lenape were hidden among its pine groves. ... Alders and pussy willows, viburnums, clethras, chokecherries, swamp maples, red birches and all sorts of trees and shrubs that are loving, made an intricate labyrinth for the stream to thread." Van Dyke

Above: Great Egg Harbor River
Right: Blue flag at the Mullica River

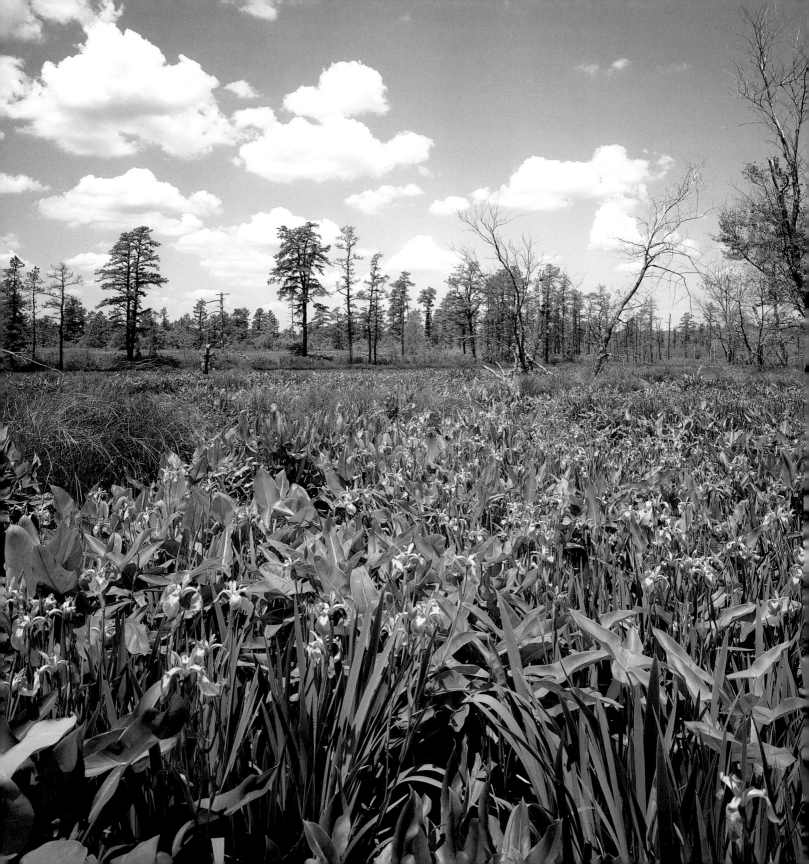

| 28 |
Streams and Rivers

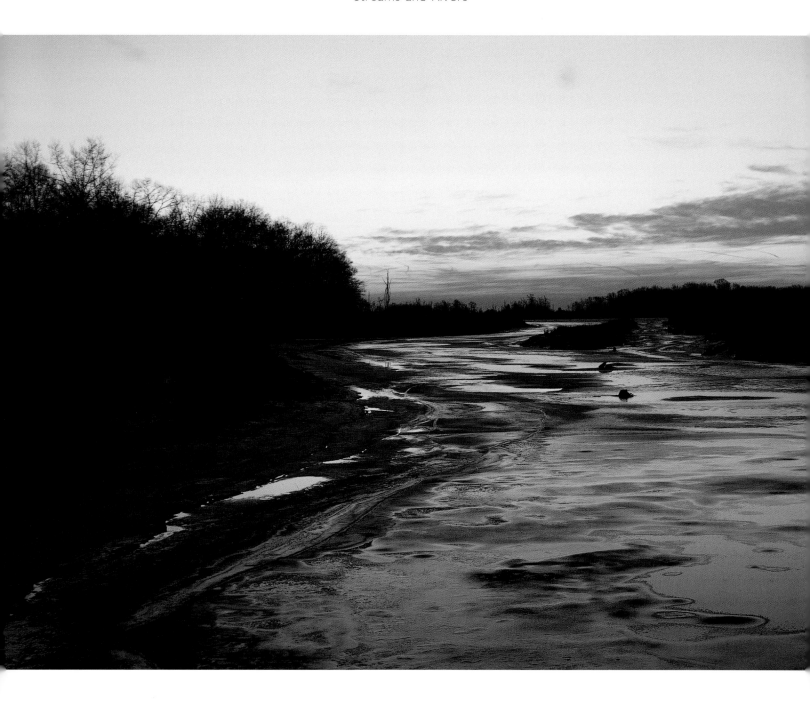

Streams and Rivers

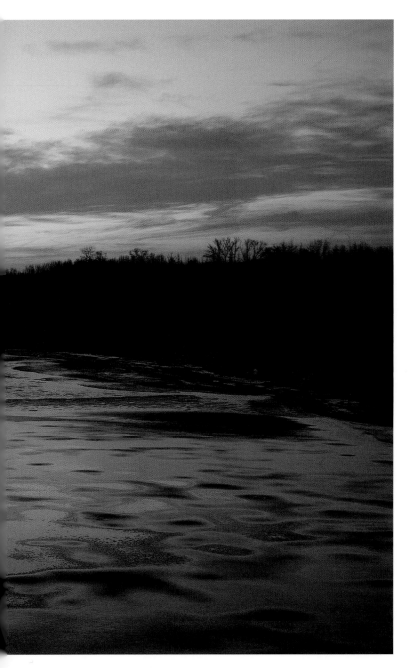
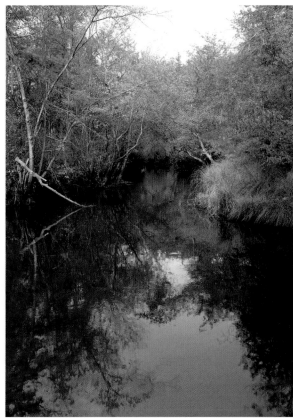

referred to Hammonton as "Humminton" and Weymouth as "Watermouth," to keep the river secret from those who might despoil it.

The Great Egg Harbor River has its origin above a cluster of houses called Penny Pot. Penny Pot, just off Route 322 south of Hammonton, was named after a town in England in 1686 and is distinguished by its unique teakwood dam. Originally built to control the

Left: Frozen Newport Creek
Above: Batsto River above Quaker Bridge

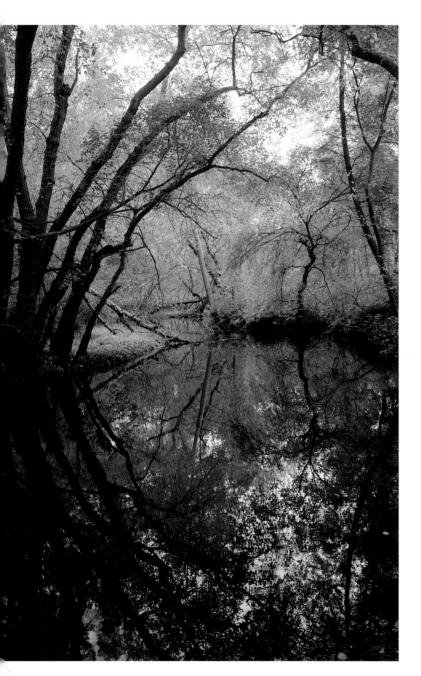

waters for a cranberry bog, the dam was rebuilt of teak timber salvaged from old warships, making it one of the most expensive dams in the United States for its size, since rainforest teak is such a costly building material today.

The Great Egg Harbor River flows through Weymouth, where munitions such as grapeshot and cannonballs were made for the U.S. Navy during the War of 1812. It passes through Mays Landing, and finally ends at Somers Point—once an official port of entry for the young United States.

The Maurice River flows into Delaware Bay. Beginning near Glassboro as a stream, it becomes a river near Millville, where a dam has created one of the many artificial lakes to be found in South Jersey. The mouth of the Maurice was once the headquarters of the South Jersey oyster fleet.

South Jersey's streams and rivers were critical to our ancestors, as they now are for us both recreationally and ecologically. Robert Louis Stevenson (who once visited the South Jersey coast) might have been thinking of South Jersey when he wrote: "There is no music like a little river's! It plays the same tune over and over again, and yet does not weary of it like men fiddlers."

With careful management, South Jersey rivers will forever play their tunes.

Left: Nescochague branch of the Mullica River
Right: Great Egg Harbor River

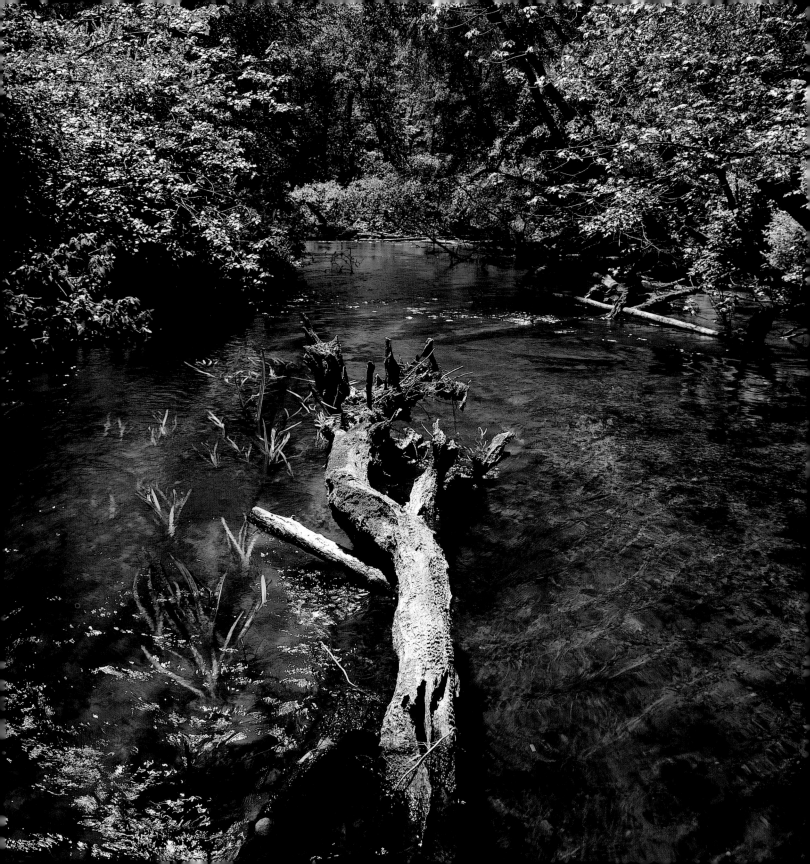

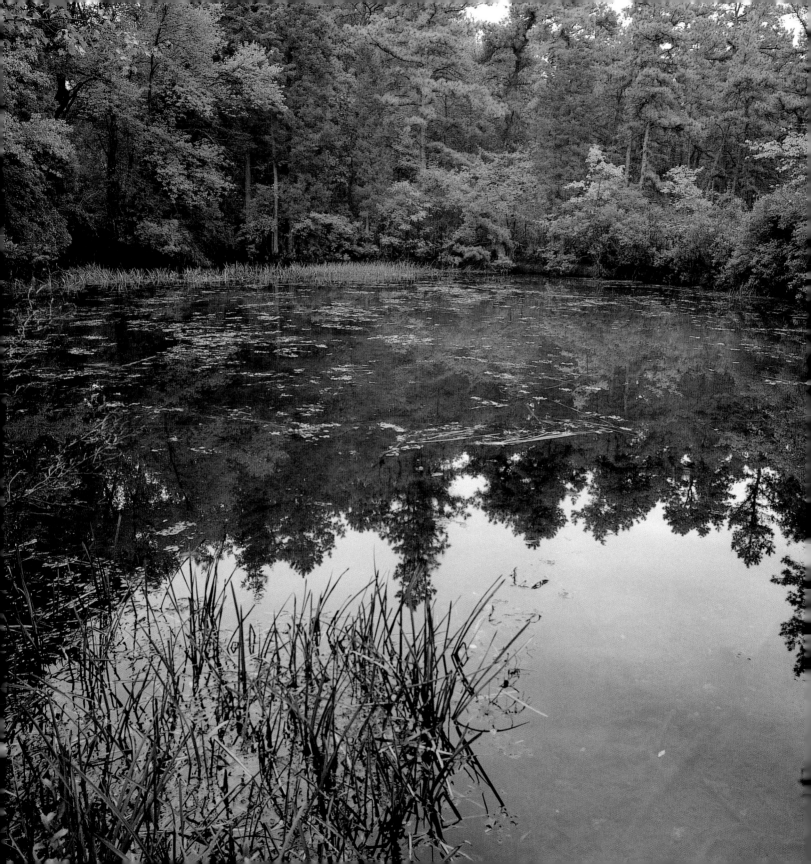

Chapter Six

Blue Holes

In remote parts of the Pine Barrens, there exist what locals call "blue holes"—woodland ponds that reflect the blue sky and are exceptionally deep. Shrouded in legend, most locals consider them unsafe for swimming.

In Buena Vista Township, one of these mysterious blue holes was the site of a tragic drowning in the 1950s. According to the tale, six brothers and sisters were frolicking in the water when one of the brothers was caught in a whirlpool. Despite the efforts of the siblings to form a chain and pull the brother to safety, his hand slipped and he was never seen again.

Another well-known blue hole can be found between Winslow and Cecil on the border between Camden and Gloucester counties. Locals claim the Jersey Devil lives here, and refer to the hole variously as "the Devil's Puddle," "Beelzebub's Pit," and "Apollyon's Pool." Measuring about 150 feet in diameter, this blue hole is located off Piney Hollow Road at a place called Inskip—named in honor of John Inskeep who built a home and sawmill here in 1762.

Blue hole in Monroe Township along Great Egg Harbor River

A visitor to this blue hole was heard to say, "If the Jersey Devil does live here, he sure has good taste." The area is unspoiled and its foliage includes wild orchids, hyacinths, rose pogonia, and various ferns.

Unlike South Jersey's lakes, many of which were created when European settlers dammed up streams to harness power for their mills, blue holes go back to Native American days. According to Lenape legend, the holes were created from the tears of a Lenape Indian maiden when her lover proved faithless, causing her untimely death. As she went to join with the Great Spirit, her tears dropped from the sky and formed the hollows.

Stories abound of investigators trying to find the bottom of a particular blue hole, with no luck. Almost all folk accounts agree that blue holes are bottomless, cold, and often contain a whirlpool. The Egg Harbor Township Tercentenary Committee history book records this story by Hattie Adams Anderson: "One must tell of the legend of Stony Brook. In the back of Charcoal Hill, there was one spot that seemed bottomless and with a whirlpool to make it seem even more dangerous and sinister. When men and their dogs were out hunting for the Devil and came near to the whirlpool, the dogs dropped dead. The spot became known as Dog Heaven. The footbridge used over that particular

portion of stream disappeared some thirty years ago and is probably forgotten by many and never known by most."

One scientific explanation of blue holes is that they are pingos, or depressions, that occur when a mixture of ice and water forms beneath the ground surface. When the climate warms, the ice melts and leaves a depression that may be filled by groundwater.

Some have suggested that the Lenape may have dug the blue holes to store food and furs below the frost line. But the explanation could lie in archeologists' discoveries. First, the blue holes are not bottomless—in 1994, Mike Hogan walked across the blue hole in Winslow and found it was only three to five feet deep. Most likely, since archeologists confirm this location was once a Native American camp, the Indians were digging in a seam of clay and hit an artesian well. The 50-degree water coming from this deep well would have contrasted sharply with the 75-degree water around it, and someone swimming in the water would be immediately shocked (but not necessarily hurt) by the temperature drop. If a child swam in the cold part for any length of time, hypothermia could result.

Though the blue holes may today be explained scientifically, it's likely settlers created the legends in order to discourage their children from playing in or near them.

If you go into the Pine Barrens to study nature, to exercise, or just to play you should never forget that people have drowned in blue holes, and care should be taken if you swim in any unfamiliar body of water. The tears of the Native American maiden may be a legend, but the drowning in Buena Vista is not.

Above: Blue hole, Monroe Township

Part Two

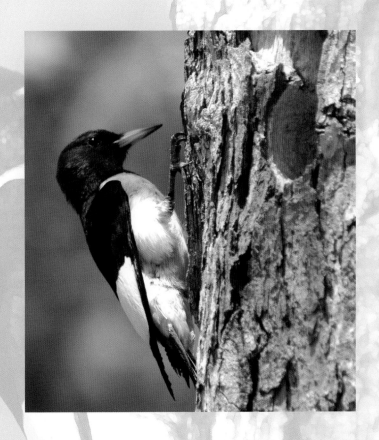

"The Fowls of the Heavens"

Psalm 104:12

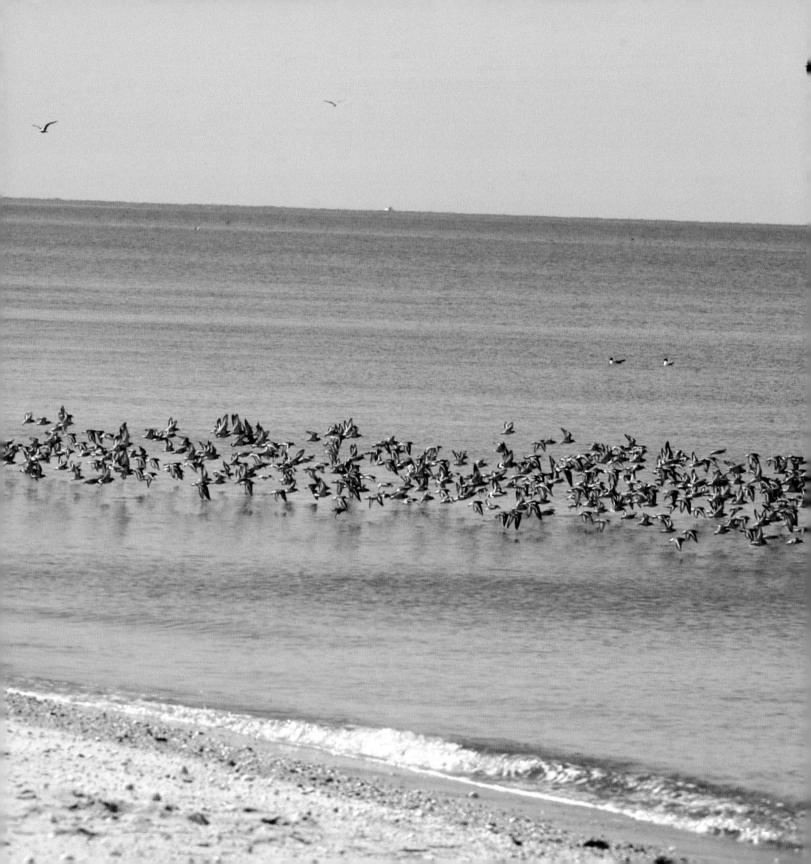

Chapter Seven

Bird Migration

When David Peterszen DeVries, one of the first Dutch explorers, examined the Jersey coast, he saw so many bird eggs he supposedly exclaimed, "Truly this is an Egg Harbor." The name stuck, giving South Jersey one of the most unusual place names in the country. We have Egg Harbor City, Egg Harbor Township, Great Egg Harbor River, Great Egg Bay, Little Egg Harbor River, Little Egg Bay, and more. (The only other Egg Harbor is in Wisconsin, north of Green Bay.)

The large number of birds made South Jersey an excellent location for hunting, decoy carving, and bird-watching. Today, the annual Christmas Bird Count, held by the National Audubon Society for more than 100 years, takes place in the same area where DeVries saw so many birds in the 1600s—at the Edwin B. Forsythe National Wildlife Refuge at Brigantine. Seeing beautiful migratory birds has been a part of life in South Jersey since the days of the Lenapes. Biologists recently observed as many as 350,000 shore birds in one two-hour survey along Delaware Bay.

Many birds rely on habitats along the coast and in the Pine Barrens when traveling from as far north as the Arctic tundra to South America. To survive this journey and return in good condition to mate, birds must find food resources of exceptional quantity and quality. Island Beach State Park, the Forsythe Refuge, and Higbee Beach are among the coastal feeding grounds they depend on. Cape May, the launching point for the journey across Delaware Bay, is considered one of the five best bird-watching sites in the country.

Many kinds of brightly colored warblers and many species of hawks pass through the Cape May area during their spring and fall migrations. These attract thousands of birders who try to spot and identify each species, to be added to their "Life List" of birds seen. These birders spend millions of dollars in the area every year, contributing significantly to its economy.

Endangered songbirds, in particular, depend on undisturbed wild land for their survival. Given their small body size and high metabolic rate, songbirds lose body fat quickly and thus cannot survive long flights without stopping frequently to rest. Songbirds are less visible than other birds and generally migrate at night, so biologists are still learning about their routes and habitat needs. Years ago, ornithologists would stay up all night counting migrating birds as they passed in front of the moon's disk. Today, high-tech radar can detect a bird's heartbeat, and bird watchers no longer have to work by the light of the moon.

Birds that migrate down the Atlantic Flyway—from eastern Canada, south down along the Atlantic

Flock of ruddy turnstones, laughing gulls, and peregrine falcon, Delaware Bay

coast, to the West Indies—are propelled by dominant northwest winds. At Cape May, the birds refuel and wait for wind conditions that will favor a successful crossing of Delaware Bay. But the trip across the bay is nothing compared to the journey some birds take. The Arctic tern, for example, flies from pole to pole. One banded tern was known to have traveled some 565,000 miles over the course of 26 years. The ruby-throated hummingbird, which weighs the equivalent of 60 postage stamps (three grams), flies 2,000 miles from the eastern United States to Central America every year. This epic voyage includes a 600-mile non-stop trip across the Gulf of Mexico. Hummingbirds can frequently be seen at Leaming's Run Gardens in Cape May County in August and September.

Researchers have discovered that birds use several methods of navigation. First, they follow features such as rivers, mountain chains, or coastlines. They especially have to avoid getting blown out over the trackless Atlantic Ocean. Built-in directional finders let them navigate by the sun during the day, and, like ancient mariners, they also use the stars at night. These compasses are probably activated by internal clocks, which are set by the birds' perceptions of day and night.

Like some fish species, migratory birds also use the Earth's magnetic field to guide them. For example, in homing pigeons a tiny chain of magnetic crystals lies between the skull and brain. Electric currents are set up within the bird's nervous system as it moves its head in relation to the Earth's magnetic field. The currents are processed as flight instructions, though the process remains little understood by scientists.

New Jersey is still the home and refueling place for millions of birds, just as it was in DeVries's day. It's good to know that in this ever-changing world, some wonderful things remain constant.

Below: Pine warbler
Right: Sanderlings (Photograph by Steve Greer)

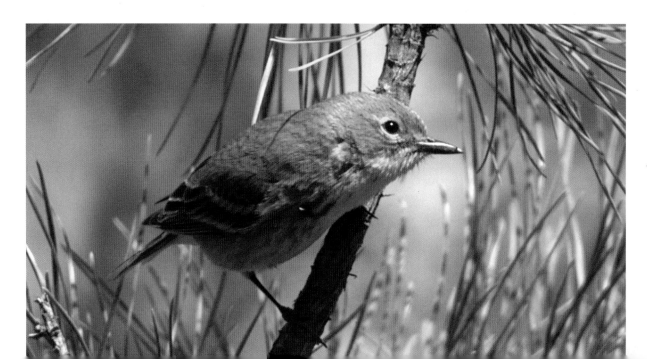

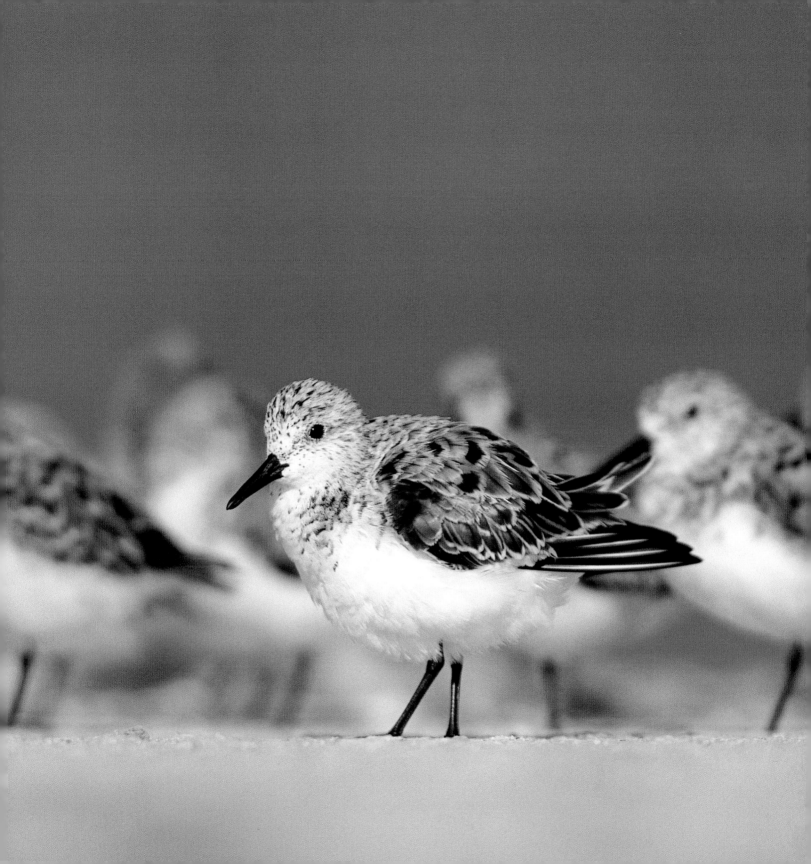

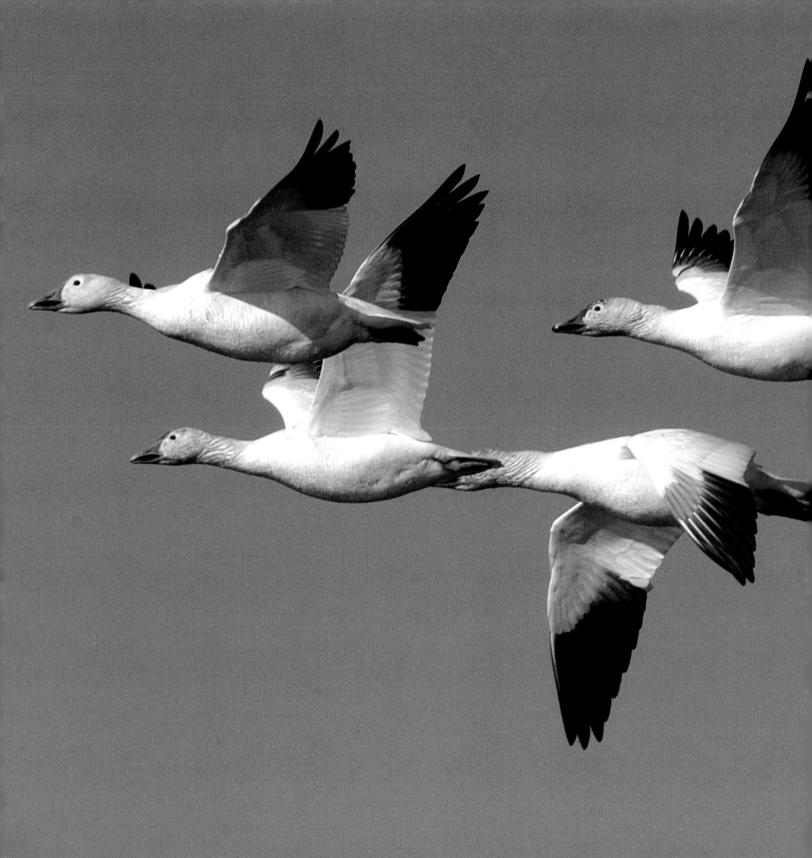

Chapter Eight

Geese

According to an old European legend, a young man named Martin had so distinguished himself with pious living that the people wanted him to be a bishop. Martin, however, was a modest type, and he hid from those who would so honor him. When a goose revealed Martin's hiding place through its loud honking, he was hauled out by his supporters and made a Christian leader. Since that day, St. Martin's Day—or Martinmass—has been celebrated in early November with (you guessed it) roasted goose.

There are about sixteen species of true geese, eight of which are found in the United States. Technically, goose is the name for the female, while males are called ganders. Hence the old saying that emphasizes equality between the sexes: "What's good for the goose is good for the gander."

The large number of geese that visit the New Jersey coast contribute to its reputation as a haven for birds. Along Delaware Bay, large numbers of snow geese stop to refuel on their long journey south or to stay for the winter. One of South Jersey's most beautiful natural spectacles is that of hundreds of snow geese taking off across a Salem County farm field.

Snow geese

The most well known goose to South Jerseyans is the Canada goose. In the fall, when flocks of Canada geese appear in the sky, it is a sign of the coming of winter; in the spring the geese are a welcome sign of warmer days to come. These relatively large birds were a good food source for the Indians, who also utilized their feathers, and have been hunted by baymen and Pine Barrens dwellers throughout South Jersey history.

The traditional migration patterns of Canada geese have been changing in recent decades, and New Jersey is playing host to ever-increasing numbers of the birds. These geese used to winter in North and South Carolina, but increasingly they are finding everything they need to survive in southern New Jersey. In the Pine Barrens and surrounding areas, Canada geese can find winter wheat and rye in the harvested fields and lawn grasses at public parks, golf courses, and corporate business parks. The large Canada goose population delights hunters and bird-watchers alike.

Not everyone is happy, however. Complaints about geese range from the noise they make, to damage to farm crops, to ganders that are overly aggressive. There are some instances where geese have nested in shrubbery near the entrance to a business, with the ganders threatening and even attacking people going in and out of the building. By far the biggest complaint involves goose droppings. It's more than just an eyesore: Over the past several years, many freshwater lakes in South

Jersey have been closed to the public due to fecal contamination; ball fields and parks have also been affected.

Geese are a member of the family Anatidae, which consists of swans, geese, and ducks—commonly known as waterfowl. They gravitate to small water surfaces that provide cover for breeding pairs and shelter from winds. They mate while swimming, after which the female builds the nest for her young. Down feathers from the breast are used to line the nest. Once hatched, the chicks become "imprinted" with their mother's appearance and voice—this has led to many stories about goslings imprinting themselves to creatures and objects other than their mothers.

When geese fly, they move in an aerodynamic V formation. Since the lead goose takes the brunt of the wind and air and inevitably tires, other geese move up from the rear to take turns at the front; it's all done by instinct, as is finding the location of their winter or summer homes. Moreover, Canada geese, before making their migration, have been observed to ingest a small number of round pebbles. Ornithologists suggest that by increasing their body weight the birds are adding to their inertia and thus improving the action of their wings. A very light bird with a strong thrust in its wings would inevitably lose a fair proportion of this thrust if the effect was to lift the body each time rather than to depress the wing. By increasing the inertia of the body, the thrust of the wings is favored and the bird's forward movement is made more effective.

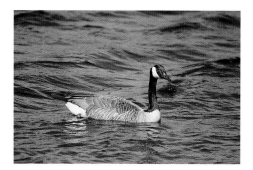

Geese work together in another interesting way. When geese land and nest, they orient themselves as much as possible so that each individual has a certain amount of free space, or "facial distance," as it has been called, in front of it. And though it may take some time for a large flock to settle down in this way, the birds respect the individual need and avoid conflict. Even if, for example, a wire fence creates extreme crowding, the peripheral birds will all turn outward, taking up a position that allows them to achieve the required facial distance by looking through the wire fence. Thus, the central birds have a better chance to achieve a position of no conflict. It seems from this example that even in unnaturally stressful conditions these creatures will do all they can to keep the peace—calling into question Charles Darwin's 19th-century theory that animals are in a constant state of war.

Most people don't eat goose as they did years ago, at Martinmass, Thanksgiving, or Christmas. But you can enjoy these birds by watching them at the Forsythe National Wildlife Refuge, along Delaware Bay, or any number of places in South Jersey where, increasingly, they spend the winter.

Above and Right: Canada geese

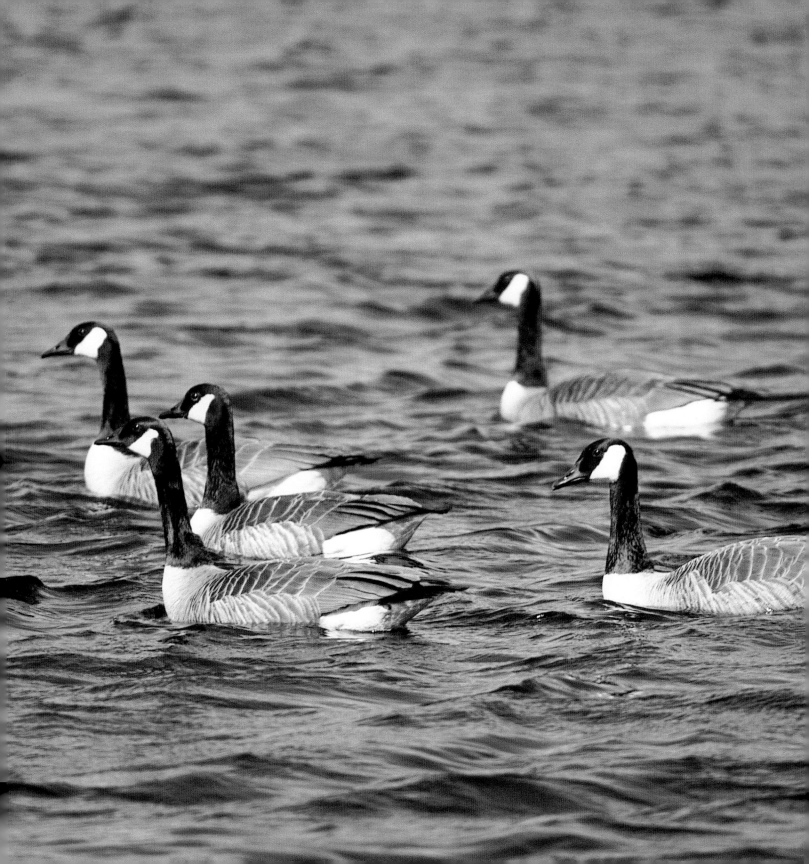

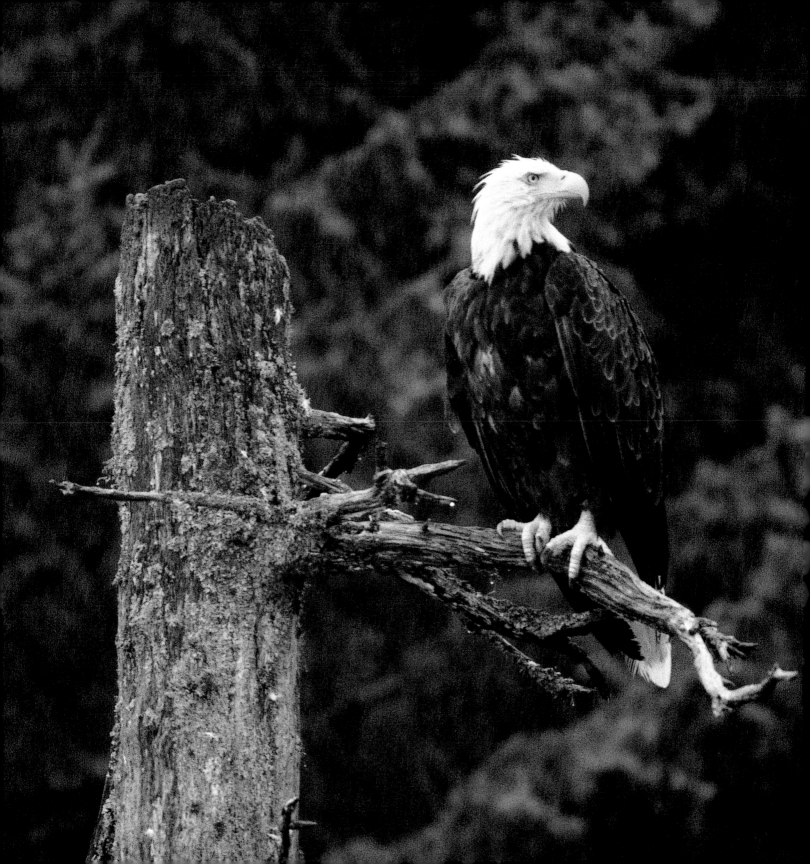

Chapter Nine

Bald Eagles

Since early in the 17th century when Henry Hudson first saw bald eagles (or white eagles, as they were then called) fly off the Palisades in North Jersey, Americans have been impressed with the high-flying raptor. Because bald eagles eat mostly fish, they have always been found near large bodies of water. Thus, this eagle would become a fitting symbol for our new nation, for America would gain much of its wealth and security from the sea.

Today, we know that the bald eagle is attached to its home, is faithful to its mate, and spends more time training its young than any other bird. Although driven by instinct like all animals, and having no choice in the matter, bald eagles represent the kind of "middle class values" that built America into the world's most powerful nation.

The bald eagle is an endangered year-round resident of the Pine Barrens and has been seen along the lower Mullica and Batsto Rivers and the Wading-Oswego River ecosystems. According to the Department of Environmental Protection (DEP) its volunteers counted 165 bald eagles in the state in 2002, a dramatic increase from earlier decades. Scientists believe that DDT use, beginning in World War II and continuing after, compromised the eagle's reproductive ability. Essentially, DDT was ingested by smaller organisms, then passed up the food chain. Animals at the top of the food chain, including birds like ospreys, eagles, and falcons, became storage reservoirs for this dangerous chemical. As a result, the shells of eagles' eggs became so thin that they cracked during normal incubation. By the 1970s, only one documented eagles' nest remained in New Jersey. Banning DDT, passing new laws to protect our national symbol, and the introduction of bald eagles from Canada helped to reverse the situation. In one well-publicized case, naturalists took an at-risk egg and placed it in an incubator. The egg cracked, but was repaired with Super Glue and wax, and ultimately produced a healthy chick.

Eagles are monogamous, and only death causes a couple to part. Courtship begins in November and lasts until June. An eagle never leaves its home except to seek a mate or when lack of food forces it to migrate. New nests are built on top of old ones, and, because an eagle can live as long as thirty years, the nest grows and grows.

After the female lays her eggs, she will sit on them for up to seventy-two hours. When weary, she will call to her mate, who then takes his turn at incubating.

Eaglets take a long time to develop—a testimony to their highly developed form as adults. They do not mate until the fourth or fifth year of life, at which time they have a wingspread of seven to eight feet and primary feathers up to twenty inches long. The wing tips are slotted, meaning that an eagle can spread them like fingers.

Bald eagle (Photograph by Steve Greer)

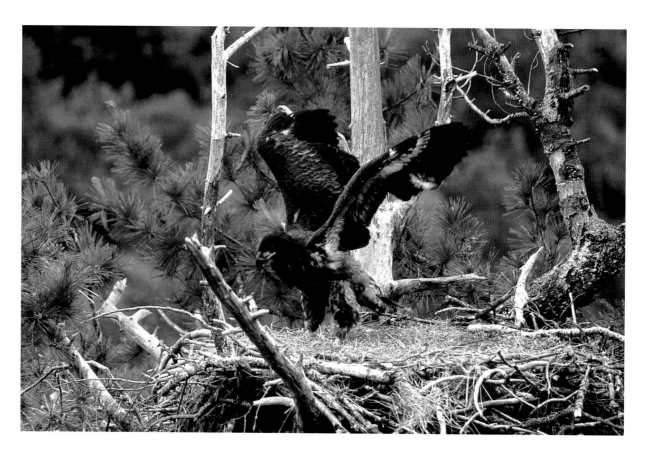

The slotted wing tip is a feature of all birds that soar without flapping their wings. It acts as an anti-stalling device. With such equipment, the eagle is the absolute master of flight. Pilots have seen eagles flying as high as 10,000 feet above the Earth. The eagle's sharp eyes have been known to detect a fish three miles from the spot where it was soaring; it then captures the fish in one long dive-bomb attack. All other raptors stand in awe of the eagle; its power allows it to force a fish hawk or osprey to drop a fish, which the eagle then catches before it hits the ground.

Our ancestors were wise to choose the eagle as our national symbol. Considering its many noble attributes, what creature could better represent the land of the free and the home of the brave?

Above: Juvenile bald eagle in nest (Photograph by Steve Greer)
Right: Juvenile in tree (Photograph by Steve Greer)

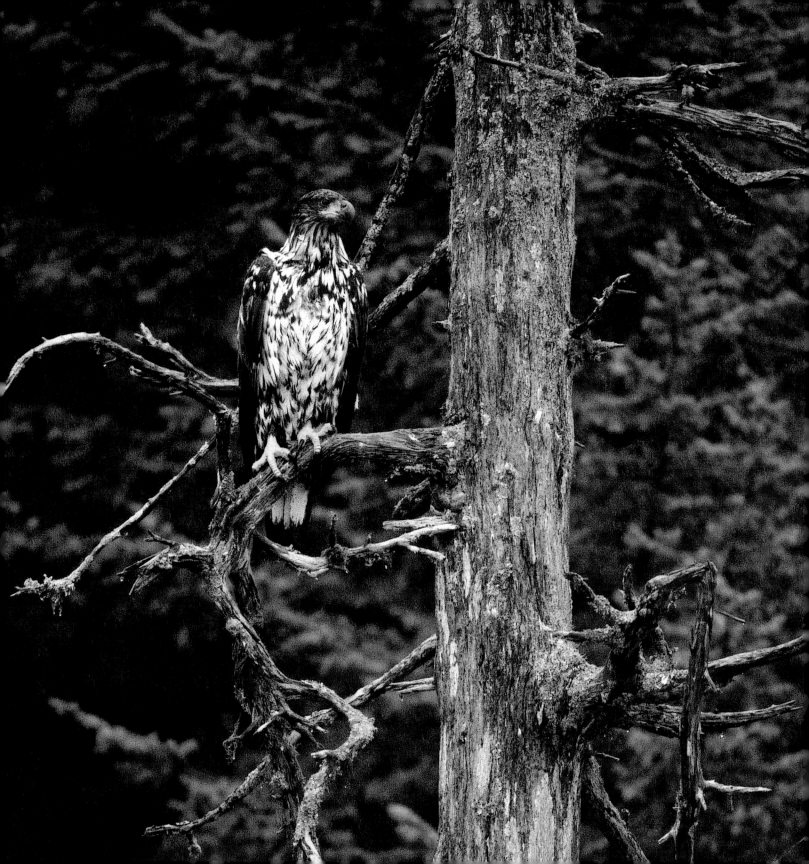

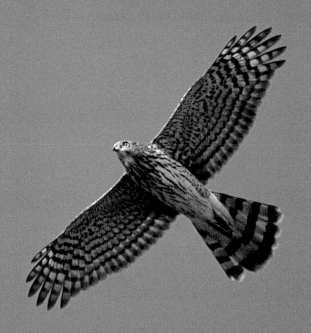

Chapter Ten

Hawks

If human beings could see as well as the hawk, we would be able to read a newspaper headline from a quarter of a mile away. In fact we would be able to see so many things in such detail that it might prove distracting and cause all kinds of accidents. The hawk, however, handles this uncanny ability to see with ease.

The hawk's amazing sight comes primarily from the size of its eyeballs, which are as large as a human's and extend far back into the skull. The hawk's retina is twice as thick as a human's and is packed with millions of minute visual cells. A thin coating of yellow oil covers the eyes, minimizing the effect of the sun's glare.

A hawk can see a grasshopper 100 feet away and pluck it off a leaf in a matter of seconds. While flying high alone, the hawk's eyes are like a telescope; by the time it plummets to its prey, the lens shape alters to resemble that of a microscope.

It is this unique ability to see, coupled with its speed and maneuverability, that makes the hawk such a great hunter. Of the thirty-two species of hawks found in North America, four are year-round residents of New Jersey: the red-tailed hawk, the sharp-shinned hawk, the broad-winged hawk, and the Cooper's hawk.

For years, farmers thought hawks were a nuisance, wantonly killing chickens and other poultry for sport. Today, we know otherwise: Hawks only kill when hungry. An exhaustive study by the U.S. Department of Agriculture, based on an analysis of the stomach content of 2,690 hawks and owls, reveals that hawks seldom prey on chickens or even game birds. Instead, their diet consists almost entirely of rodents and insects harmful to man. If it weren't for hawks, the fertility of such rodents and insects could overwhelm our food production. In 1964, University of Michigan professor Harrison B. Tordoff estimated that a single hawk saves farmers $110 per year in rodent damage (and that was in 1964 dollars).

Hawks apparently represent very little threat to farm animals and pets. In Lambertville, New Jersey, physician and naturalist Paul Fluck once placed a wounded red-tailed hawk in a pen of chickens. For three months, until it was healthy enough to be released, the hawk lived peacefully among the chickens, with not a single chicken hurt. One thing did change in that pen however: At the end of the three months there wasn't a rat or a mouse to be found.

Cooper's hawk in flight (Photograph by Steve Greer)

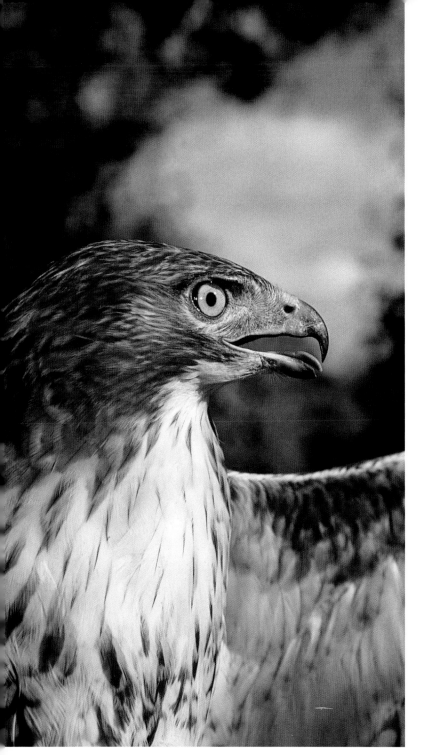

Humans will never possess the visual acuity of the hawk. But in truly understanding the raptor's important role in South Jersey's ecology, perhaps we can develop a better vision for preserving this fascinating species.

Left: Red-tailed hawk (Photograph by Steve Greer)
Right: Sharp-shinned hawk (Photograph by Steve Greer)

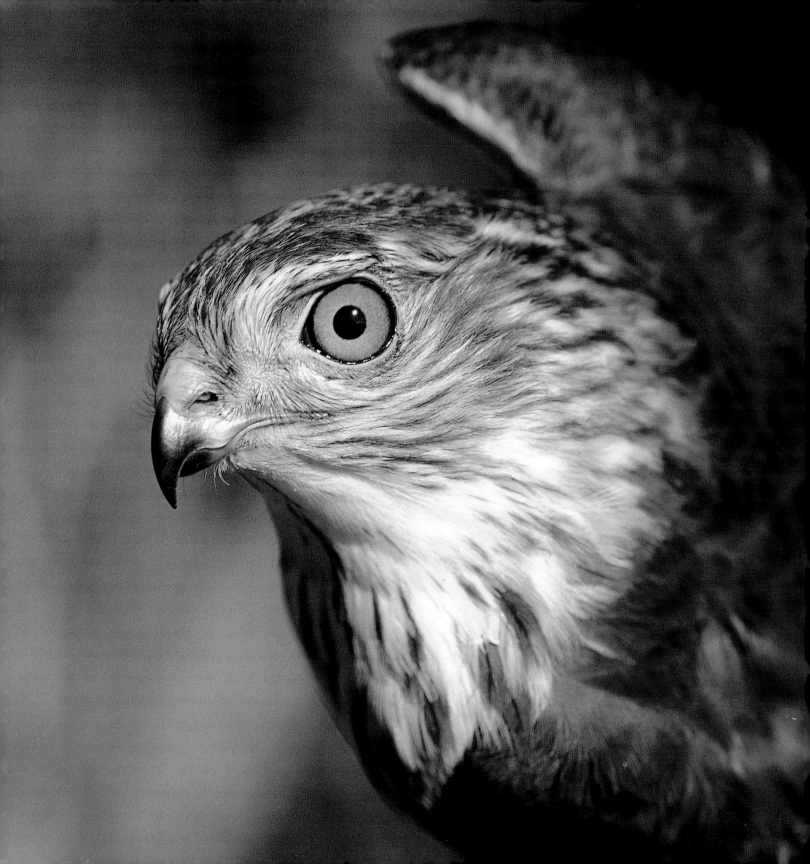

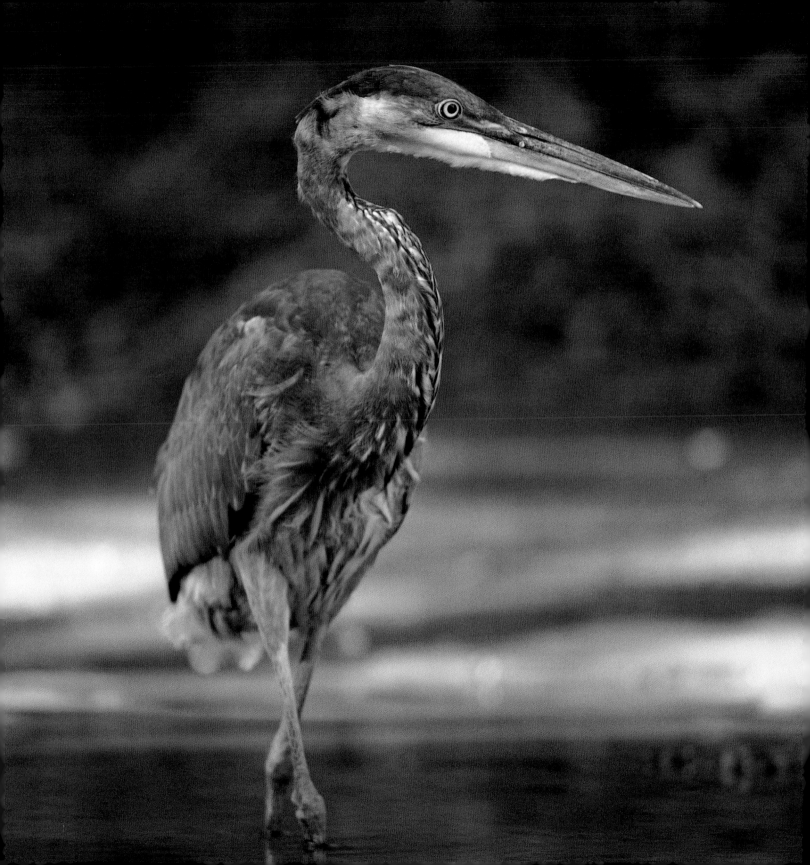

Chapter Eleven

Great Blue Herons

The attractive young couple had a serious fight, but finally made up on the shores of a beautiful lake. After a seafood dinner, they danced into the evening. Is this the story line of some romantic classic or soap opera? Actually, it describes the courtship ritual of the magnificent great blue heron. Before two of these herons mate, they go through a violent interaction where sometimes the female stabs at the male, followed by a graceful courtship dance.

The great blue heron, which belongs to the family Ardeidae, is the largest heron native to the Pine Barrens. It's a real treat for a bird-watcher or hiker to get a glimpse of this beautiful but increasingly rare bird. The head is whitish, with two black plumes. The rest of the plumage is grayish-blue, hence its name.

This remarkable bird hunts by standing or walking slowly in shallow water and marshes. Its longer legs create an advantage over other carnivorous birds since it can wade into deep water. Occasionally, you will see a heron rapidly bobbing its head up and down; some ornithologists believe this bobbing allows their eyes to compensate for the refractive index before they strike for food below the water's surface. The heron is also known to spread its wings over the water, shading it from the sun and thus reducing glare.

Great blue herons begin their foraging in ponds, lakes, and swamps early in the day and continue until the late afternoon. Prey might include fish, tadpoles, frogs, snakes, crayfish, and occasionally small mammals and birds. Because of the flexibility of its neck, this bird can swallow a fish many times wider than would seem possible. Herons generally hunt alone, although they live, mate, and nest in colonies.

The great blue heron has special feathers that crumble to form a powder, which is rubbed on its other feathers to make them clean and water repellent. The herons are apparently particular about cleaning their fish before eating them, because this powder is also used to clean slime from fish.

When developer Ole Hansen and Sons built a golf resort in Atlantic County, they named it "Blue Heron Pines" in honor of this beautiful South Jersey bird. Ironically, this type of development contributes to the heron's rarity. The bird was designated as a threatened species in New Jersey, but has recently been delisted due to growing populations. Nevertheless, human development rightly remains a cause of concern for those interested in the preservation of the species.

Great blue heron (Photograph by Steve Greer)

Great Blue Herons

The Lenape Indians hunted and trapped these magnificent birds, making whistles out of the hollow leg and wing bones, and necklace beads from its bones. Feathers were used to make dust brooms.

When two blue herons come together to mate, it doesn't end with the aforementioned dance. Eventually they point their bills to the sky, sway their heads back and forth, and softly wail. Finally, they lift their feathers and lower their heads, signaling they are ready to mate. Each time one mating pair is successful, it is another step in the survival of this wonderful bird for future generations.

Right: Great blue heron (Photograph by Steve Greer)
Below: Great blue heron, Maurice River

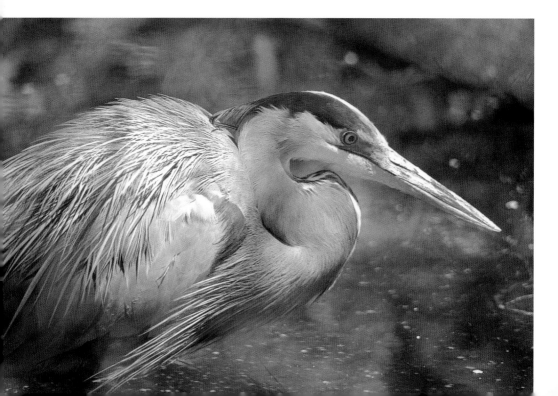

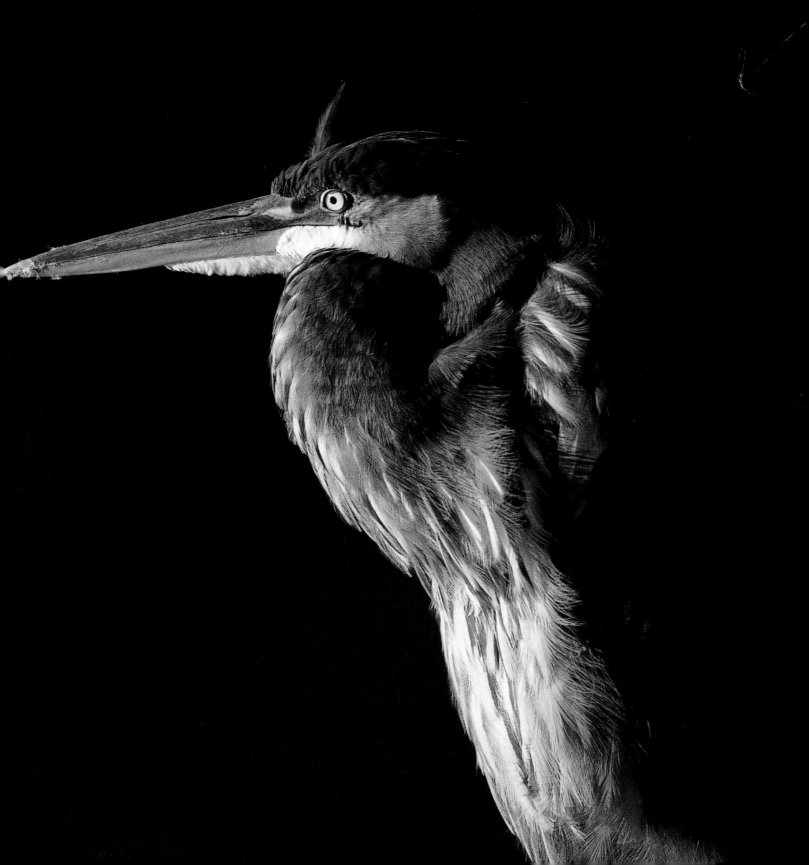

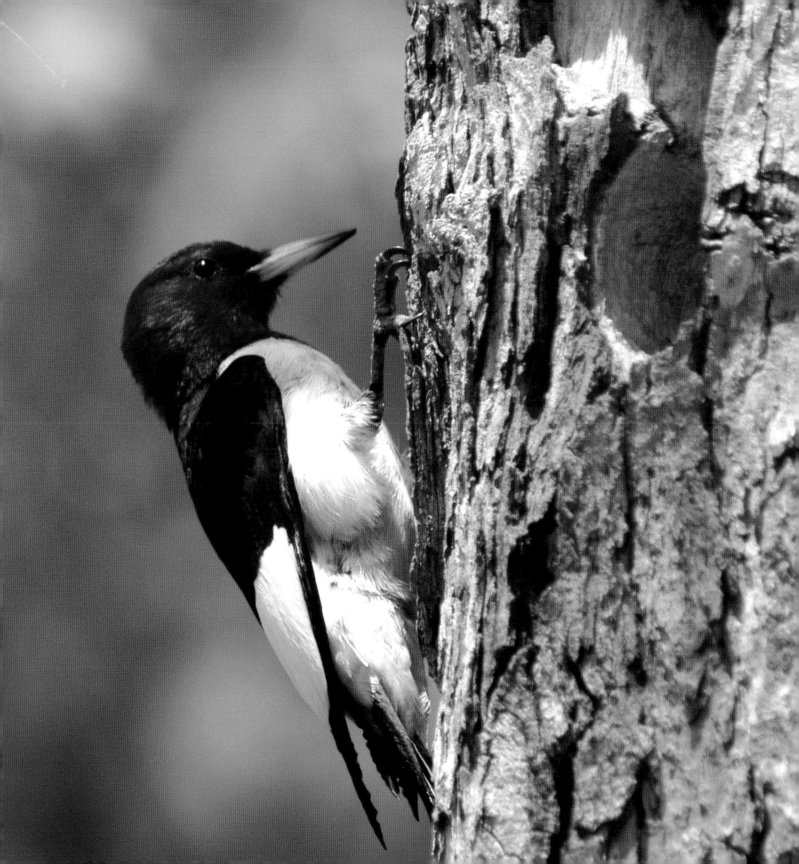

Chapter Twelve

Woodpeckers

In the 19th century, many farmers and woodsmen considered the woodpecker a danger to the forest. The theory was that trees were killed because of woodpecker holes that invited bugs and infectious diseases. Subsequent research has shown, however, that woodpeckers benefit trees. They eat harmful insects by the thousands, including carpenter ants, insects that carry Dutch elm disease, and the codling moth—a particular danger to trees in Canada. Woodpeckers drill their holes at an upward angle, which minimizes rot damage to the tree that could be caused by the collection of rainwater.

Woodpeckers seem specially designed for their role as the natural tree surgeons of the forest, spending much of their time spiraling up tree trunks searching for insects. This bird's ability to move so efficiently on a tree relies on two backward facing toes and an associated arrangement of tendons and leg muscles, sharp claws, and stiff tail feathers tipped with spines that act as a prop while it climbs.

Because the woodpecker expends so much energy, it is a voracious feeder—one bird can eat as many as 1,000 ants at a single sitting. To find its meal, a woodpecker hammers wood at the rate of fifteen to sixteen times a second—a rate of fire nearly twice that of a submachine gun. The suddenness with which the head is brought to a halt during each strike results in stress equal to 1,000 times the force of gravity. This is more than 250 times the force that an astronaut is subjected to during Earth lift-off.

To withstand such intense pressures, the woodpecker's skull is reinforced with bone. Its strong, chisel-tipped bill turns wood into sawdust, which is prevented from entering its respiratory system by a set of slit-like nostrils covered by fine feathers.

In most birds, the bones of the beak are joined directly to those of the cranium. If this were true of the woodpecker, he would literally "blow his brains out" when hammering for any length of time on a given tree. Instead, a sponge-like tissue between the cranium and the beak acts as a shock absorber—one that, according to scientists, is far superior to any shock absorber made by man. This bird also has special muscles that pull its brain case away from its beak every time it strikes a blow.

The woodpecker has superbly coordinated neck muscles to keep its head perfectly straight. If the head were to twist even a little while hammering, the torque would tear the bird's brain from its base.

Consider also the woodpecker's long tongue, which it uses to reach deep inside the holes it drills

Redheaded woodpecker

to retrieve insects. Special glands in the tongue secrete a sticky substance, and insects and worms stick to it like flies to flypaper.

The tongue of a woodpecker—four times longer than its beak—is too long to be anchored in the back of its beak, as with other birds. Instead, the tongue is anchored in its right nostril. After it emerges from the right nostril, it splits into two halves. Each half passes around one side of the skull underneath the beak, entering the beak through a hole.

The redheaded woodpecker—featured on New Jersey's "Conserve Wildlife" license plate—is designated as a threatened species in the state. The Pine Barrens support about half the known New Jersey population of these beautiful, all-too-rare birds.

Fortunately, hairy, downy and red-bellied woodpeckers remain common in South Jersey. It's always a treat to see these birds in flight. When they take off, they make three or four repeated wingbeats, which carry them upward, followed by a downward glide. Their visits to suet feeders on the fringes of the Pine Barrens are a bird-lover's delight.

Below: Left: Downy woodpecker (Photograph by Steve Greer)
Right: Redheaded woodpeckers
Opposite Page: Red-bellied woodpecker (Photograph by Steve Greer)

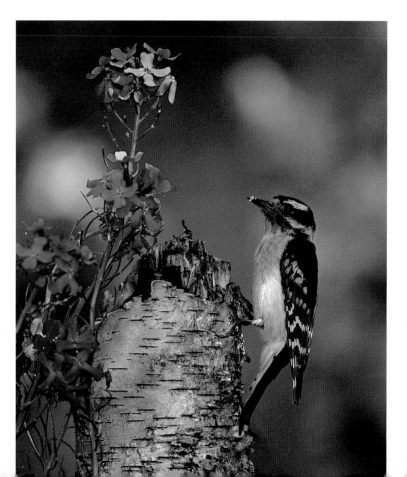

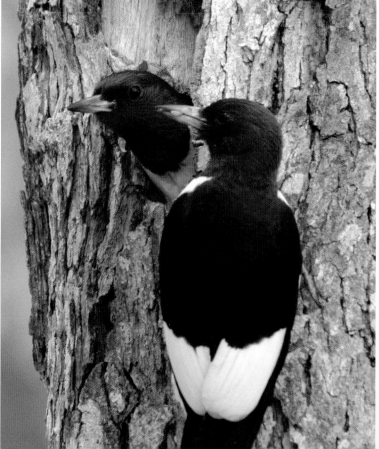

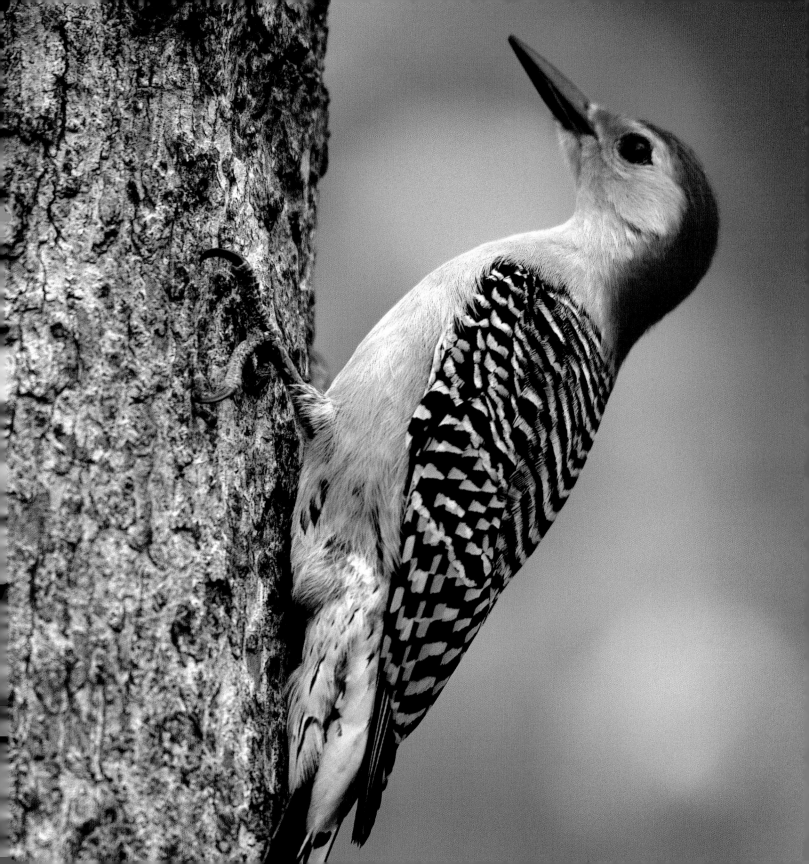

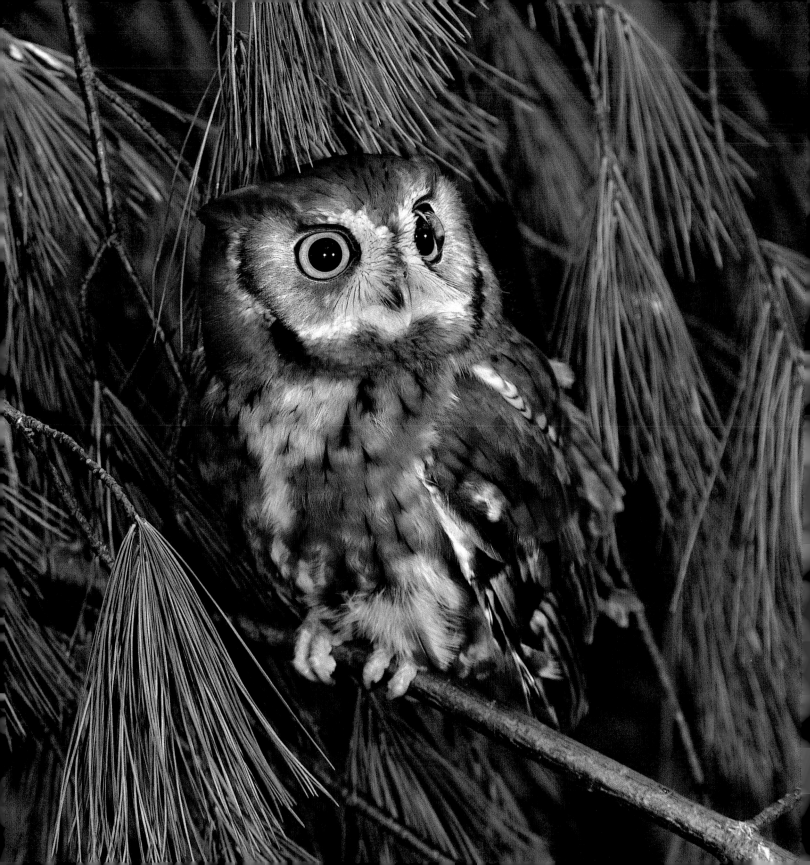

Chapter Thirteen

Owls

From ancient fables to A. A. Milne's *Winnie the Pooh*, storytellers have traditionally associated owls with wisdom and scholarship. But, truth be told, these raptors are so unique that they need no literary embellishment.

The owl's eyesight is legendary. Its binocular vision allows it to zero in on its prey from over 100 yards away. The owl, which does most of its hunting after dark, has a retina that is densely packed with rod cells, providing excellent night vision. If that weren't enough, this bird's iris expands or contracts more dramatically than any other creature's to adapt to available light.

The owl has three eyelids; its unique third eyelid regularly cleanses and moistens its eyes, acting like a built-in wiper blade with wiper fluid. By keeping the eyes from becoming dry, this eyelid helps preserve the owl's keen vision and accuracy for hunting. In the case of the great horned owl, the eyes are essentially immovable, which explains this owl's ability to follow any movement with an unblinking stare. To compensate, the great horned owl possesses specialized neck muscles which allow the head to rotate 270 degrees.

In addition to their visual gifts, owls have extremely acute hearing. In fact, the circles of feathers around an owl's eyes have nothing to do with sight: these facial discs enhance the bird's hearing. The feathers channel high-frequency sounds (such as the squeaking of a mouse) into the owl's ears, which lie behind the discs. (The "ears" on top of some owls' heads are no more than tufts of feathers.) Because an owl's right ear opening is slightly larger and higher than the left, each ear receives the same sound at a different volume and angle, allowing the bird to pinpoint a sound source with uncanny accuracy through triangulation.

Owls have extremely soft plumage, allowing them to make a near-silent gliding assault. Frayed edges break up the air passing over the wings, significantly reducing the sound level of the flapping.

Finally, the owl's extremely sharp talons ensure that its prey will be killed almost on contact, and that it will not be dropped or lost in transit. No mouse is safe in the forest when an owl is hunting.

Six different types of owls are either year-round or regular residents of the Pine Barrens and surrounding areas: the saw-whet owl, the barred owl, the barn owl, the screech owl, the great horned owl, and the long-eared owl. The latter two species are designated as threatened in New Jersey.

The great horned owl is the largest and perhaps best-known of North American owls. Known as the "tiger of the woods," it roosts deep in the forest by

Eastern screech owl (Photograph by Steve Greer)

day and comes to hunt in clearings at night. Great horned owls are useful to humans because they dine heavily on harmful rodents. Their diet also includes rabbits, snakes, and even the occasional skunk.

Perhaps it is a good thing that A. A. Milne gave his *Winnie the Pooh* owl character a smattering of wisdom combined with a professor-like absent-mindedness. If he had endowed "Owl" with authentic characteristics, a number of the other animal characters in the story might have soon disappeared!

Below: Great horned owl in flight (Photograph by Steve Greer)
Right: Barred owl (Photograph by Steve Greer)

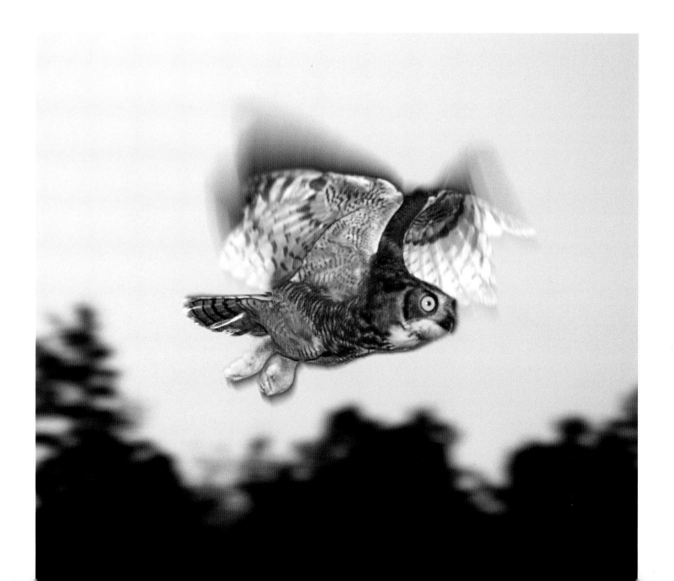

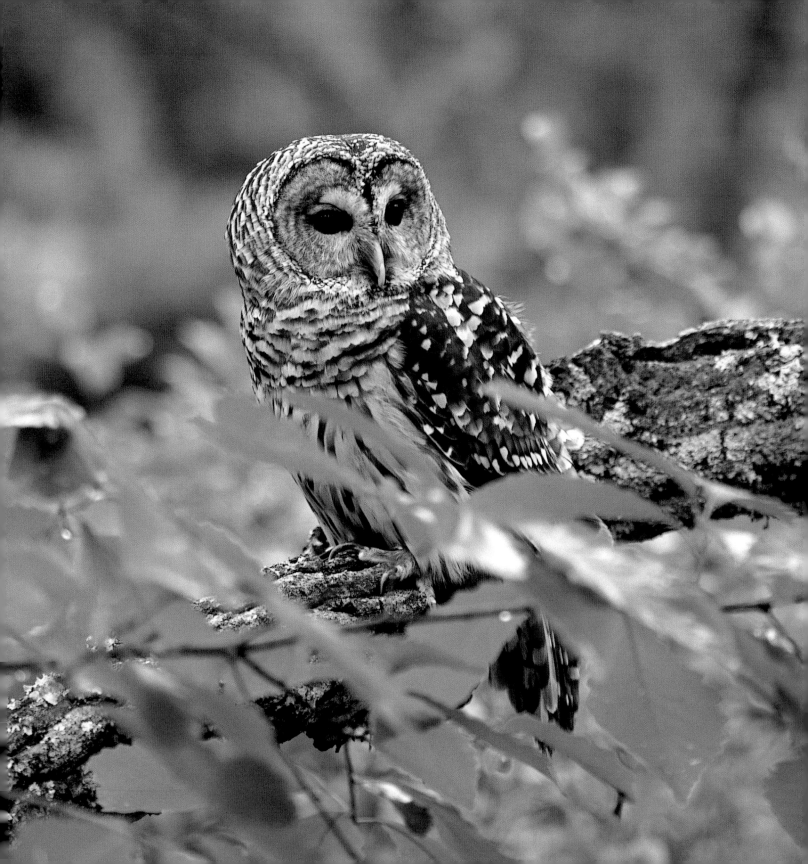

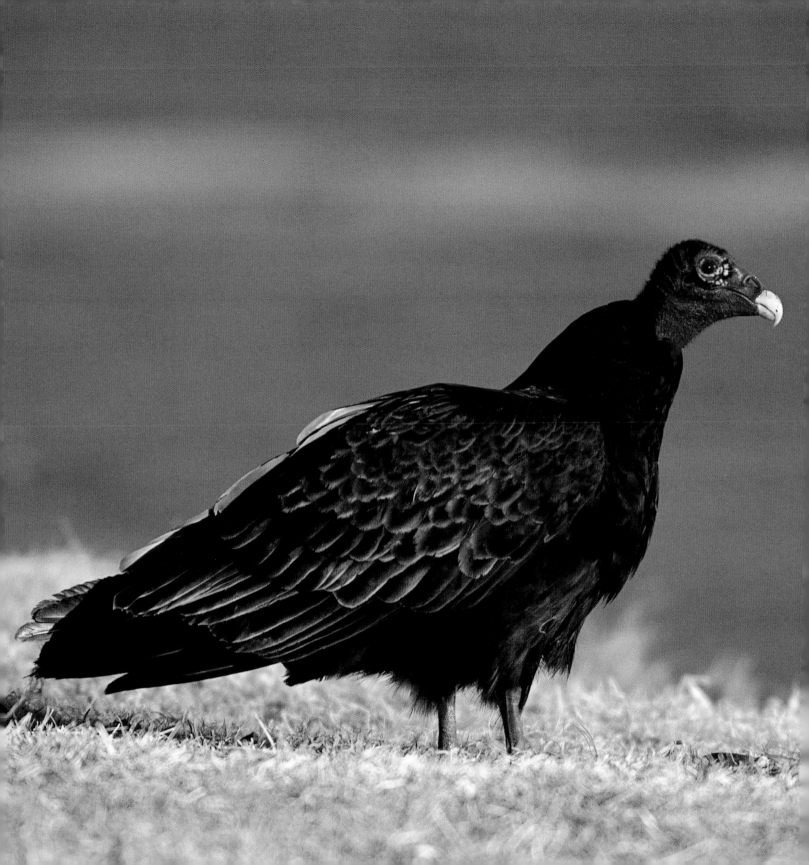

Chapter Fourteen

Turkey Vultures

The story is told of how a group of engineers was searching without success for a leak in a gas pipeline when one of the men hit on the idea of capitalizing on the turkey vulture's excellent sense of smell. They flushed ethyl mercaptan (the odor-causing substance in decaying flesh) into the pipeline and, soon after, turkey vultures—also known as buzzards—were seen circling overhead. The leak was found, and a potential catastrophe was avoided.

Many people consider the turkey buzzard one of the world's ugliest creatures. With a dark and foreboding body, and an even uglier head—devoid of feathers or hair—this bird specializes in finding and feeding on dead carcasses. Yet despite its bad reputation it plays an important environmental role and is unique in many ways.

First, turkey vultures are masters of flight—gliding and soaring majestically as they circle overhead on their six-foot wingspreads. Flying with their wings raised in a slight dihedral angle to form a shallow "U," they sometimes appear to rock slightly from side to side. No matter your opinion of their eating habits, seeing these birds in flight is an impressive spectacle.

Turkey vulture (Photograph by Steve Greer)

Typically, buzzards roost in trees through the night and into the late morning hours—rarely up at the crack of dawn like other birds. Perhaps they instinctively know that other creatures have to be out facing the cruel world, and sometimes losing, in order that they may find a meal later in the day. More likely, however, the vulture's late rising has to do with air currents. After the sun rises and warms the ground, rising air currents called thermals help lift these large birds high into the sky. By using thermals, the vultures preserve the energy they require to soar high above the forest in the quest for food.

Despite a perceived lack of beauty and the grizzly nature of their business, turkey buzzards serve a valuable function. As nature's rapid clean-up crew, they help stem the spread of disease. All animal carcasses will eventually decompose; by speeding up the process, turkey buzzards limit the danger of water and air contamination. Their remarkable eyesight allows them to spot a meal from high above the forest floor or roadside.

Several years ago, Californians grew alarmed about the dwindling numbers of California condors—a large relative of our native turkey vulture. The California Highway Department had become so efficient in cleaning up roadkills that there was little left for the condors to eat. From this example, it is clear how the

Turkey Vultures

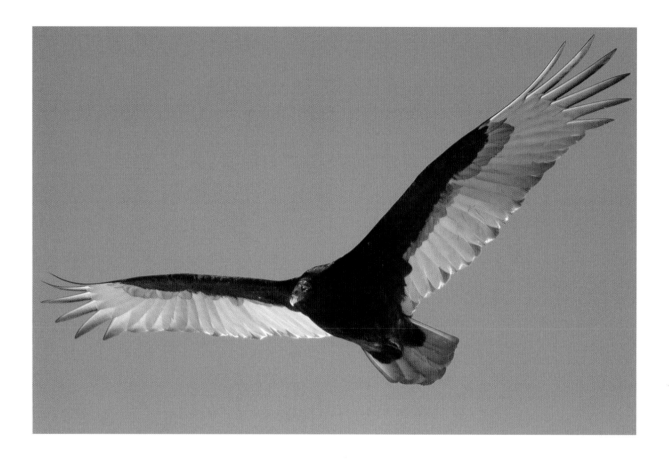

well-intentioned efforts of humans can sometimes affect our natural world in unexpected ways.

Its appearance may be unsettling, but the turkey vulture has much to teach humans—about flight, about ecology, and, yes, even about locating gas leaks.

Above: Turkey vulture in flight
Right: Turkey vultures roosting

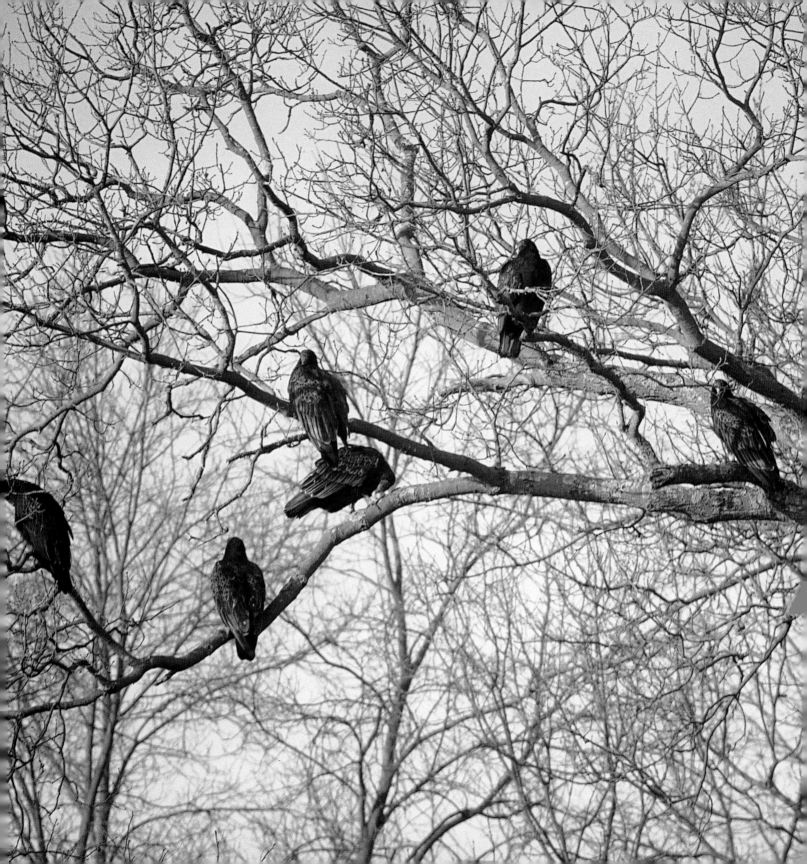

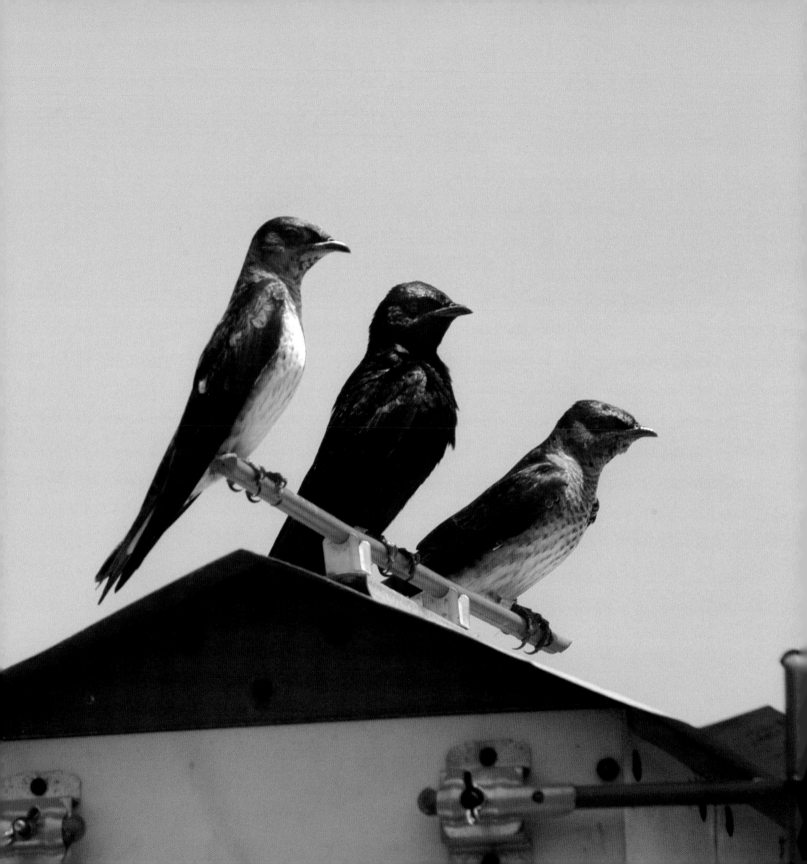

Chapter Fifteen

Purple Martins

The purple martin has helped provide a natural solution to one of New Jersey's greatest ecological frustrations (and wonders): the prolific mosquito. Why does such a small area like New Jersey produce so many mosquitoes and how can these insects be controlled?

One of the first entries about South Jersey mosquitoes comes from colonial Swedish botanist Peter Kalm. In 1748 he wrote in his journal: "The gnats, which are very troublesome at night here, are called mosquitoes … in daytime or at night they come into the houses, and when people have gone to bed they begin their disagreeable humming, approach nearer and nearer to the bed, and at last suck up so much blood that they can hardly fly away. … The chimneys have no dampers for shutting them up and afford the gnats a free entrance into the houses." When he visited the Atlantic seashore, Kalm wrote, "The people hereabouts are said to be troubled in summer with immense swarms of gnats or mosquitoes, which sting them and their cattle. This was ascribed to the low swampy meadows, on which these insects deposit their eggs, which are afterwards hatched by the heat."

Purple martin house at the Edwin Forsythe National Wildlife Refuge

When Charles Latrobe wrote his *History of the Swedes in South Jersey* in 1832, he was of the opinion that enduring the mosquitoes was one of the Swedish pioneers' greatest accomplishments. In his journal he wrote: "They seem to have made choice of the rich low tracts of land on either side of that deep bay; to have built their little forts, mounted their few pieces of cannon, and sat down with the best will in the world to sow and reap, in spite of the bites of the mosquitoes."

From the days of the first Swedish settlers, South Jerseyans have tried everything—from fire and smoke to cedar shavings to sphagnum moss—to try to repel mosquitoes. But over the years, by far the best natural protection comes from a little swallow called the purple martin. Ornithologists have observed that the average purple martin can eat over 2,000 insects a day.

The purple martin is an American species of bird in which the male is uniformly blue-black above and below, while the female is light-bellied. It has a short, broad flattened bill, which can be opened to a very wide gap forming a most efficient insect trap. The purple martin is not native to South Jersey—instead, it spends its summers here after wintering in South America.

Attracting these birds began with the Lenape, who, it is believed, removed most of the branches from tall saplings and hung gourds on them as birdhouses. Locals still prepare gourds today to attract purple

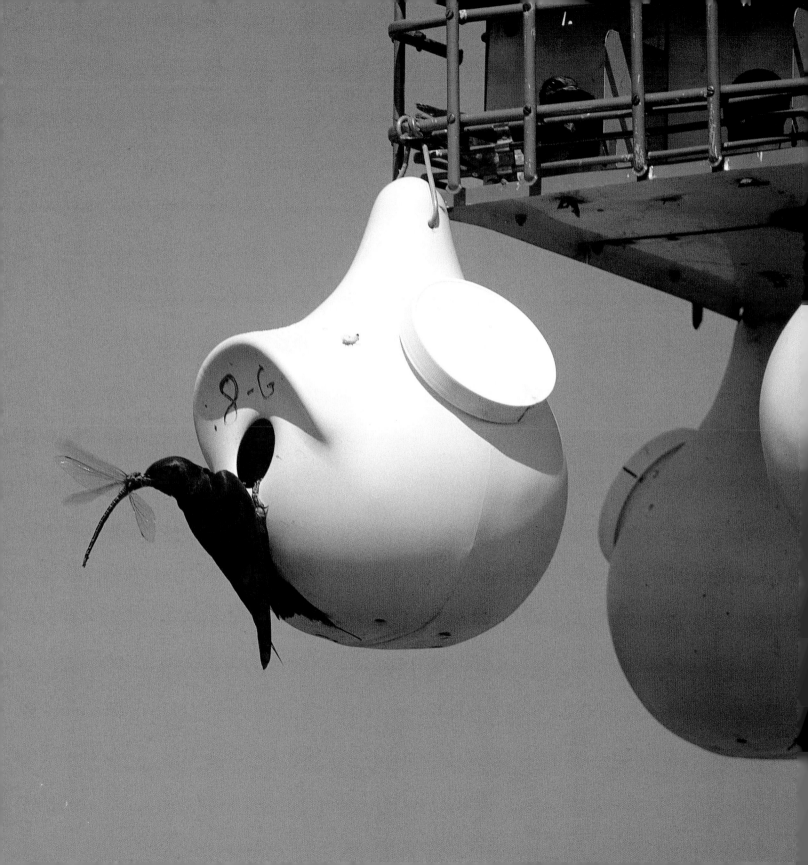

martins—a species beloved by New Jerseyans for its interesting flying habits, usefulness to humans, and its call, which is said to sound something like the German name "Dietrich." Elaborate gable-roofed houses are often built for them. These birdhouses appear above the landscape in the open spaces near meadows, bogs, and blueberry fields in and around the Pine Barrens. The Noyes Museum in Galloway Township has had one of the world's largest and most elaborate purple martin houses on display for years.

Yes, South Jerseyans may have to endure some of the country's worst mosquitoes, but if it weren't for these insects, we might never have the chance to enjoy the purple martin.

Left: A dragonfly makes a meal for a purple martin
Below: Mating pair

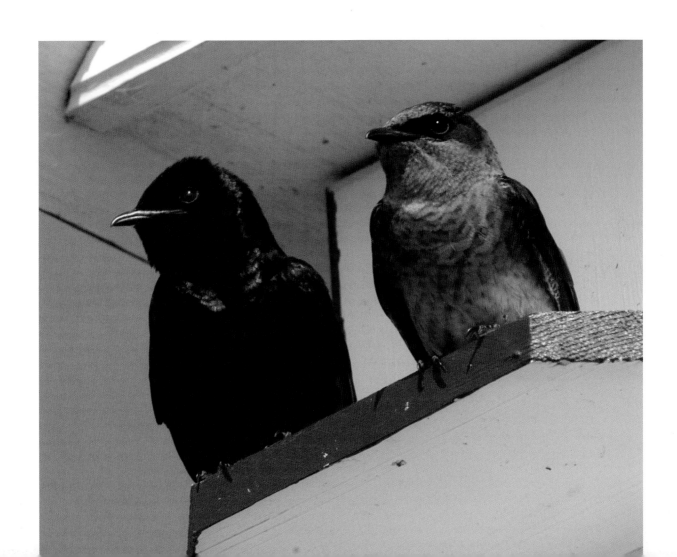

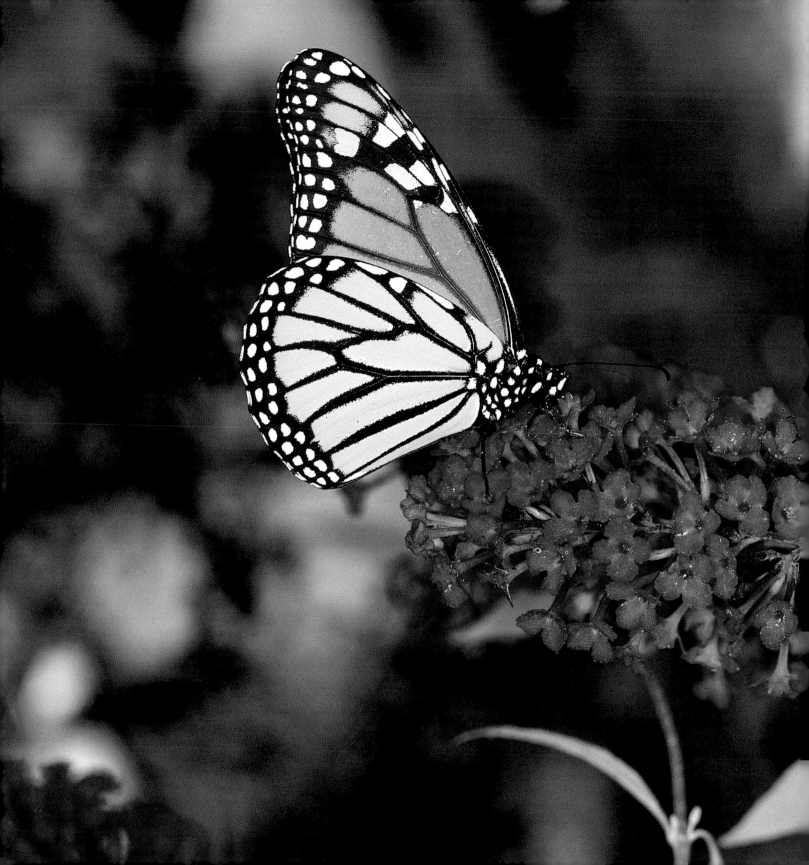

Chapter Sixteen

Monarch Butterflies

Each August and September, monarch butterflies by the thousands stop in Cumberland County and Cape May. Many monarchs can be seen in other parts of South Jersey, but it is here that they refuel for their long journey across Delaware Bay on their way to Mexico.

Until recently, South Jerseyans who enjoyed the annual spectacle had no idea where the monarchs were going, but in 1975 an American living in Mexico finally discovered the monarchs' winter retreat.

Described by Canadian zoologist Fred Urquhart as "a marvelously intricate pattern of behavior, baffling in many of its aspects," the monarch's migration is not unlike that of many birds. The insects begin their journey in the U.S. and Canada, flying south in the fall and covering more than 2,000 miles. In Mexico they settle on tree branches, half asleep. As they regain their energy, they mate, then head north. The female butterflies deposit their eggs on the undersides of leaves of milkweed plants, after which they die, leaving a new generation to continue the northward migration. These monarchs reach the northernmost fields (where milkweeds grow) in time to lay the eggs that will continue the journey. The milkweed that the monarch caterpillars feed on contains a poison that, while safe for the insect, makes it distasteful to birds. In the spring and early summer there are several generations that last only a few weeks. Finally, in July, there comes a generation that will last up to six months and make the migration to Mexico.

As early as 1937, Urquhart and other scientists began experimenting with ways to tag these delicate, featherweight insects to track their journeys. Eventually, the same type of adhesive label used for price tags on glass items was found to be the most effective means of identification. By 1971, thousands of interested scientists and butterfly enthusiasts were taking part in the Insect Migration Association. In 1973, Ken Brugger, an American living in Mexico, joined the effort. Traveling in his motor home with his dog, Kala, he crisscrossed the Mexican countryside searching for the monarchs' winter home. Focusing on areas where tagged butterflies had been found, he knew he was getting close when he found hundreds of dead and tattered insects—suggesting that birds had been feeding on large flocks of butterflies (the milkweed poison had apparently worn off). On January 9, 1975, Brugger called Urquhart. "We've found them!—millions of monarchs—in evergreens beside a mountain clearing."

The monarchs' winter hideaway turned out to be northeast of Mexico City in the famed Sierra Madres

Monarch feeding on butterfly bush

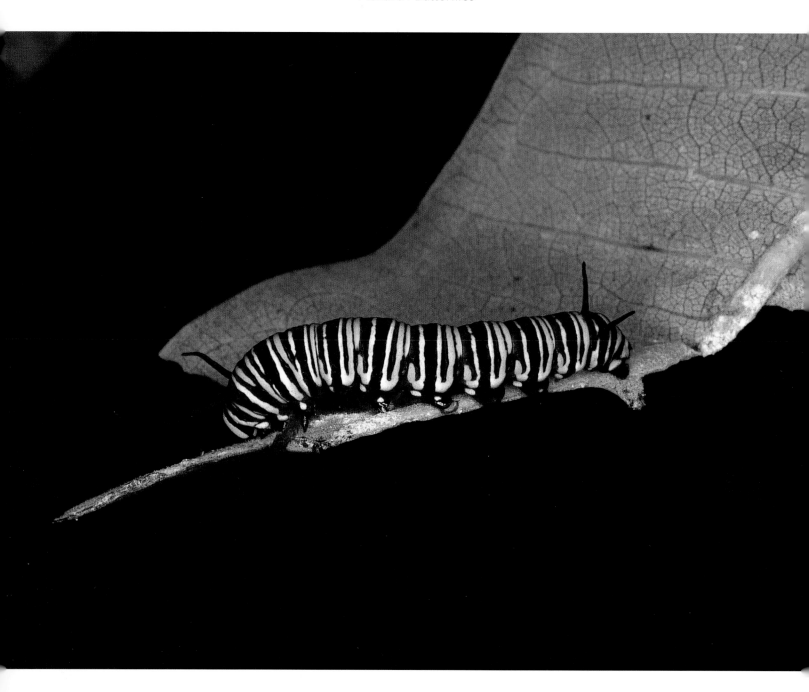

Monarch Butterflies

in an area just 20 miles square, at 10,000 feet above sea level. In the Sierra Madres, the monarchs rest, tank up on nectar, and mate, then begin their journey home. No one teaches them how to do this or shows them the journey home. The effort, akin to bird and fish migrations, is only dimly understood and ranks as one of the great wonders of creation.

In one of Humphrey Bogart's classic films, *The Treasure of the Sierra Madre*, the hero leads a group of American adventurers on a search for gold in Mexico. In their quest, they lose their honor, fight among themselves, and only two survive. Bogart's character dies as a result of his greed. In the end, very little gold is found—just enough to help one of the widows. In other words, there really was no treasure of the Sierra Madres. That is, until the real treasure was discovered in 1975—the winter home of the monarch butterfly.

Pages 74-76: From caterpillar to butterfly

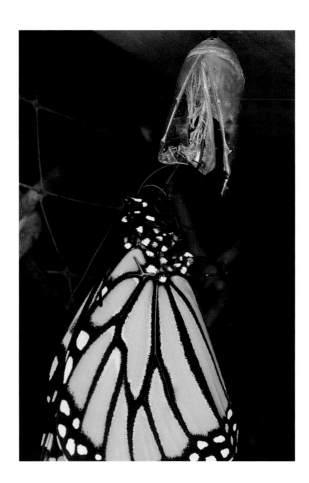

Part Three

"Earth...Wind...and Fire"

I Kings 19:11,12

Chapter Seventeen

Sand

When Alexander Boardman set up his hotel in Atlantic City in the late 1800s, he wanted it to exude luxury in every way. Along with drapes, expensive furniture, and other amenities, he brought in special carpet at great expense. Unfortunately, his guests tracked in sand from the beach, which started to ruin the carpet. Boardman spent many hours trying to get rid of the sand, and probably cursed the day he built a luxury hotel in what was at the time a pioneer town. But then he hit upon an idea: Why not create a long wooden runway that would prevent the sand from reaching the hotel? The result was the world's first boardwalk. In this way, Absecon Island's sandy beaches became an asset rather than a burden to Boardman and his hospitality business.

When the English Quakers came to South Jersey two centuries before Boardman, they found sand in abundance and looked for a way to turn it into a profit. Not many crops would grow well in sandy soil, but Philadelphia businessman Caspar Wistar—a prosperous maker of brass buttons—recognized that South Jersey had everything needed to make glass. In Wistar's day, glass was made from a "batch" consisting of silica, lime, and soda, which had been mixed with broken glass. Silica came from sand, lime was plentiful in nearby Valley Forge, Pennsylvania, and cordwood for fuel was readily available in the Pines. (The jagged edges of beach sand make it unsuitable for glassmaking, but deposits of the ideal sand are found in various places in South Jersey.) Salt hay harvested nearby was ideal as a packing material. Only the soda would have to be imported from outside the region.

Wistar set up his operation in Salem and called his glass house "Wistarburg." A German immigrant himself, Wistar brought four skilled glassblowers from Germany to teach the art of glassmaking to him, his 12-year-old son Richard, and, according to the contract, "no one else." This was a valuable skill and technology, and Wistar wanted the proprietary rights. When not instructing, the glassblowers would blow glass to be sold. Because their trade was so highly respected—glassblowers were treated like aristocrats in parts of Europe—they had the upper hand in negotiating the contract and received a third of all profits, plus meals and personal servants.

On days when glass was made, everyone—artisans and laborers alike—would mix the batch. Once the melting process had begun, the blowers went home where they awaited the knock on their doors proclaiming that the "white metal" awaited their pipes. The blowers then returned to work their magic.

Sand in the Pine Barrens

As German artisans and apprentices arrived in America in increasing numbers, they plied their trades first at Wistarburg, then fanned out into the countryside at large. The seven Stanger brothers, for example, started "Glass House," or Glassboro, New Jersey. Unfortunately, the brothers lost their glassworks during the turmoil of the Revolution because they accepted payment in worthless Continentals. After the war, Colonel Thomas Heston bought the business at a bargain price. Some of the Stangers stayed on. Records show that Jacob Stanger blew 268 mustard bottles at Glassboro in a single day in 1802. As glassblowers left South Jersey and brought their skills to other states, South Jersey became known as "the cradle of American glassmaking."

By 1840, New Jersey had 23 glassworks and was producing 31 percent of all American glass products, making it the leader in glass production. Almost all of this glass was made in South Jersey—in Glassboro, Salem, Vineland, Bridgeton, and Millville.

South Jersey's glassblowers were also responsible for a number of significant innovations and achievements. A Vineland man by the name of J. L. Mason blew the first of his famed "Mason jars" at Crowleytown on the Mullica River. Victor Durand, also of Vineland, blew the nation's first thermo jug. Meanwhile, Millville's T. C. Wheaton opened a drug store in the 1880s and, to supplement his business, started blowing his own bottles. So successful was he that, in 1888, he went full-time into making glass. This was the origin of the internationally known Wheaton Glass and Plastics Company. In the early 1900s, Liberty Cut Glass in Egg Harbor City cut glass for Kaiser Wilhelm II, then the emperor of Germany. In 1903, Michael Owen of Toledo, Ohio, invented the automatic bottle maker, initially putting many glassblowers out of business. Eventually, however, glassblowers began running the machines, plying their ancient craft with new tools.

Wheaton Village Glass Museum in Millville chronicles this important period in American history, when South Jerseyans took sand—one of the most abundant substances on Earth—and used it to create objects of lasting beauty and value.

In the 20th century, a new use was discovered for sand—silicon chips. Computers, which once relied heavily on copper, now use chips made from sand, making them affordable to the average consumer. If Caspar Wistar were alive today, entrepreneur that he was, no doubt he'd be in the computer industry—still working, in a sense, with sand.

Above: Wheaton Village
Right: Glasshouse Museum at Wheaton Village

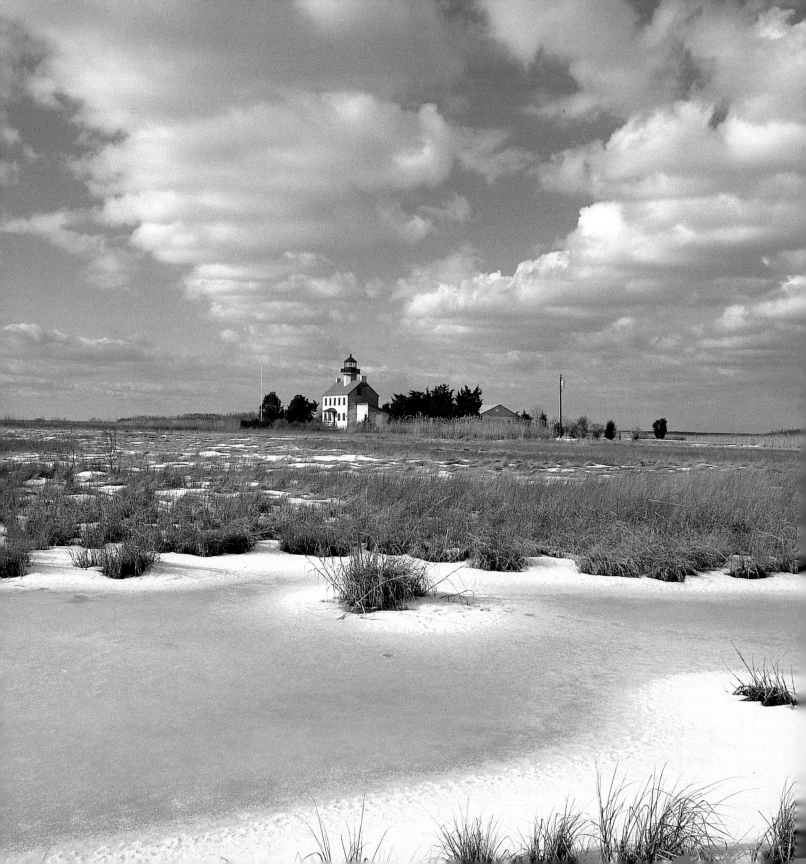

Chapter Eighteen

Weather

Until the twentieth century, most people lived "close to the land," depending upon nature's cycles for their livelihoods. And up until the middle of that century, most people were well acquainted with the cycles of the moon, the ebb and flow of tides, and the hours of sunset and sunrise. How times have changed. Today, the normal routine is to work in a climate-controlled office, shop in a climate-controlled mall, and return home in a climate-controlled car. For most modern humans, little attention needs to be given to the forces of nature.

Not so for our colonial and Victorian ancestors. For them, a successful harvest, a safe journey, or even a good day's work depended on an intimate knowledge of the weather. (And of course, without modern communications, our forebears had no idea what kind of weather their contemporaries were getting in Virginia, down the coast, or even in nearby Philadelphia.) Planning a successful harvest, for example, might depend on how soon and hard the winter would come. If the farmer saw signs of an early winter (more acorns, stronger animal nests), he could speed up his harvest. As far as trips go, our great-grandparents had to give much thought to which day they might choose to travel because wheels didn't turn in the old-time road mud. (The early soft-dirt roads of America were completely useless in or after a heavy rainfall. The problem was compounded by the addition of manure from horses and other beasts of burden.) Sometimes, almanacs were used to help plan such trips. If a clamdigger knew it was going to rain on Friday, working late on Thursday would make up for projected lost time.

To better predict the weather, our ancestors developed weather lore based on their close observations of nature. This resulted in a number of old sayings, most of which still hold true today. Here are some of them, along with commentary as to the truthfulness of the saying: "When drops collect on soap, for rainfall you can hope." This is not so much true of modern soap, but what it refers to are the large cakes of homemade soap that people made years ago. When humidity would increase and with it the chance of rain, drops would appear on the soap—particularly after a long dry spell.

"When smoke descends, good weather ends." A visible change in smoke patterns was rightly considered a harbinger of a change in the weather. Basically, what happens is that the instability of prestorm pressures and humidity keeps chimney and bonfire

Left: Weather at East Point Light, Delaware Bay
Pages 84–85: Ice at abandoned cranberry bog, Whitesbog

smoke from rising quickly. Typically, smoke curls downward in the face of storm winds.

"When ditches and cellars smell most, a long rain is near." Just as the weight of high-pressure (fair weather) atmosphere tends to keep odors trapped, a lessening of pressure (as before a storm) will release odors from walls, swamps, ditches, and cellars. As one almanac put it: "When the ditch offends the nose, look for rain and stormy blows."

Pages 86–87: Fog-shrouded Delaware River
Left: Frost on wetlands grasses
Above: Rain on Maple Lake in Estel Manor, Atlantic County

"When the stars begin to hide, soon the rain it will betide." What this refers to is that increasing humidity and haze precede a spell of rain and cause the stars to fade from view.

"A sunshiny shower won't last out the hour." If the rain clouds are so scattered and confined as to admit sunshine between them, the cloud cover is indeed breaking up and the storm is about to cease.

"Trees grow dark before a storm." Generally speaking, the landscape reflects the sky. Thus, when the sky grows dark, so do the trees.

"You can tell the temperature by how fast crickets chirp." This is indeed true in the case of the snowy

tree cricket: count the chirps for fourteen seconds, then add forty.

"Thunder curdles cream." This is just an old South Jersey wive's tale.

"The higher the clouds, the better the weather." This is generally true, as higher clouds indicate both dryness of air and higher atmospheric pressure. Both of these qualities are present, of course, with fair weather.

"A west wind, like an honest man, goes to bed at sundown." This favorable wind is lessened by the cooling off of land areas after the sun lowers and sets.

"A west wind is a favorable wind." This is an East Coast saying that assumes that any wind coming in from the east could be a harbinger of a nor'easter. The west wind is the wind that follows all storms and is associated with clearing and with brighter spirits between men. Thus Ben Franklin in nearby Philadelphia wrote: "Do business with men when the wind is in the west, in other words, when the barometer is high."

Because of South Jersey's proximity to the Atlantic Ocean, and at the tail end of the eastward-moving weather patterns in the U.S., one old saying about our weather will probably always ring true. It goes like this: "If you don't like the weather, wait a few hours—it will surely change!"

Left: Rain on Maple Lake
Right: Frozen Delaware River at Gloucester

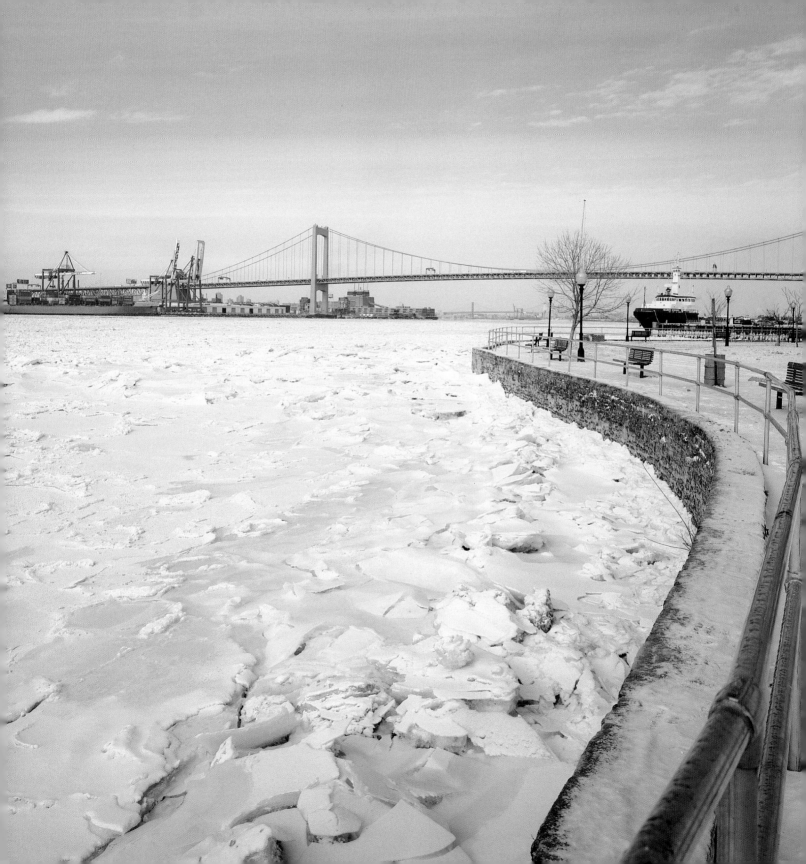

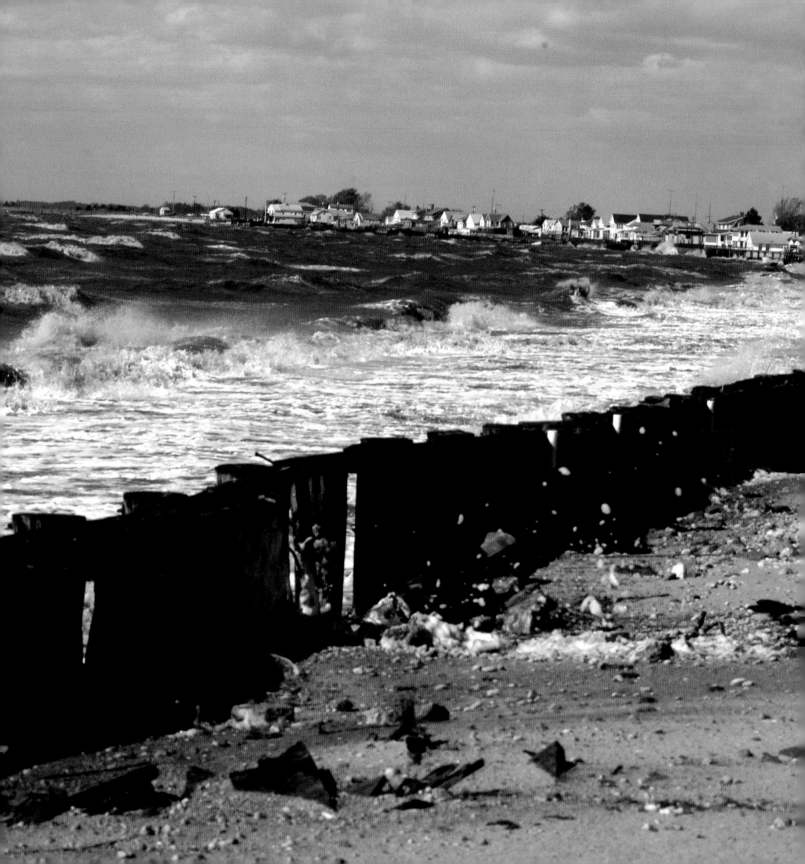

| Chapter Nineteen |

Wind

When we were children, many of us learned the nursery rhyme, "Who has seen the wind? Neither you nor I/But when the trees bow down their heads/The wind is passing by." Although unseen, wind is very powerful and has played a major role in the ecology and history of New Jersey.

The importance of wind is reflected in its many names—worldwide, more than 10,000 of them. In the English language alone there are hundreds of names for wind. In New England, when the wind is gentle, people refer to it as a "cat's paw" because it is said to be like a cat playing with its reflection on the water. Such a wind creates barely a ripple. In Germany, a piercing rain is called a steppenwind, while on the East Coast of the U.S. it is called a squall.

Throughout South Jersey history, we have had our share of different types of wind—from gentle sea breezes which relax us and blow away the gnats, to hurricane force winds that reshape the barrier islands and beaches. In South Jersey, the wind has been both bane and blessing.

Today, some visitors to the Jersey coast find fun and relaxation in windsurfing or flying various types of kites along the shore. Our forebears sought to harness the wind for something more practical—the milling of grain and other products, the cutting of lumber, and the drawing up of water from wells. Whereas inland breezes generally only blow up to ten miles an hour, a breeze along the shore generally blows sixteen miles an hour. Since it takes a minimum wind speed of ten miles per hour to make a windmill cost-effective, most New Jersey windmills were built along the coast.

The first recorded windmill in South Jersey was built in Cape May County in 1706 for Thomas Press. Many other windmills would soon follow, including Springer's Mill in Goshen, Cape May County. Springer is credited with inventing the movable windmill top, which allowed millers to turn the entire top of the windmill into the wind as the winds shifted back and forth. In Cold Spring, also in Cape May County, where historic Cold Spring Village now stands, David Cresse built a windmill in 1830. Meanwhile, Lemuel Ewing ran a grist windmill in West Cape May in the mid-1800s.

In early South Jersey and early America, the miller and his mill were the link between farm and industry. An important cog in the story of American enterprise, the miller was a price-setter, buyer, seller, business counselor, banker, and often the busiest man in town. He was also the first weatherman. Sailors on the

Wind on the Delaware Bay at Fortescue

| 94 |
Wind

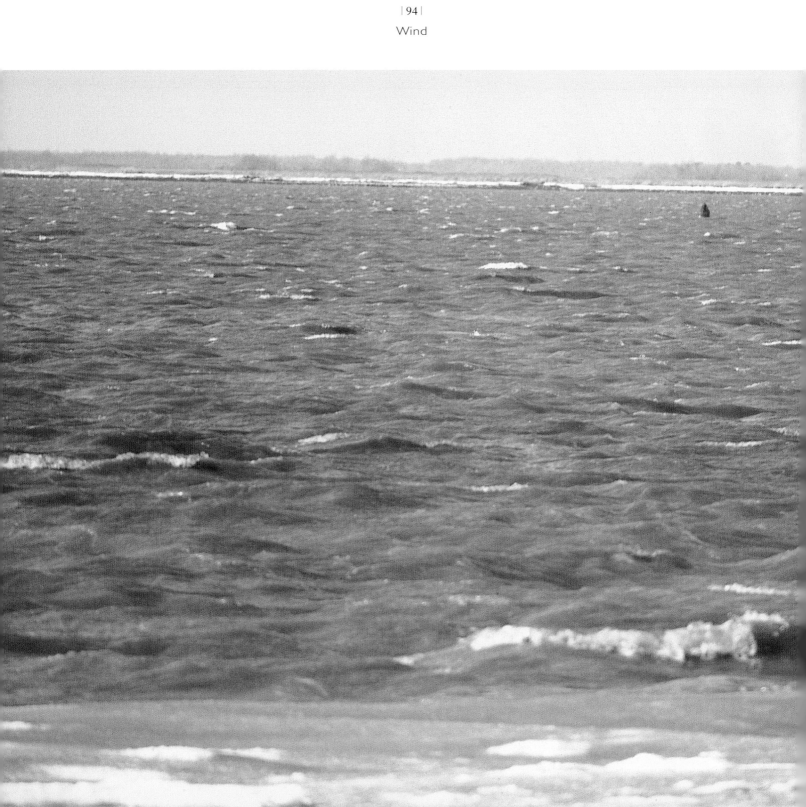

Jersey coast used windmills as weathercocks, setting their sails according to the direction of the mill-sails. Ferries in North Jersey advertised their services as "operating daily, except when the windmills on the opposite shore have taken down their sails."

Today, windmills have disappeared from the Jersey coast, but perhaps some day high-tech windmills will return. Scientists estimate that in the near future the world could get 10 percent or more of its electricity from wind turbine generators.

While South Jerseyans have had some success in harnessing the wind, there have been many times when it has been too powerful to handle. In 1806, hurricane winds hit South Jersey so hard that the sails of a windmill on Windmill Island in the Delaware River were ripped to shreds, inland peach orchards were destroyed, and ships capsized. In 1821, the *Cape May County Gazette* reported: "The force of the wind was so great that the spray of salt water carried 12–14 miles inland. Leaves of orchard trees were turned brown and appeared as if scorched and dead, while on the other side, the leaves were green and beautiful." So powerful was this 1821 storm that when the Garden State Parkway was paved in 1954, road crews uncovered a section of an ancient cedar forest that had been knocked down by the wind. Some of the trees had been buried in the marshland and preserved whole in the oxygen-poor mud, leaving us the telltale evidence.

Left: *Wind at East Point on the Delaware Bay*

During the Blizzard of 1888, high winds blew the snow into huge drifts that covered houses and blocked trains. The storm of 1962 saw wind-driven waves as high as three and four story buildings. It took years to repair the damage.

Wind may be defined as air set in motion by one of two forces: convection, or the rotation of the Earth. When air is heated, it rises; meanwhile, cold air rushes in to replace the warm air. The result is a convection current or wind. (The little Christmas carousels invented in Germany, powered by candles, give us a small-scale example of the creation of wind.) On a larger scale, convection produces the sea breezes that we so much enjoy. During the day, a sea breeze blows into the shore from the ocean. At night, it reverses direction. Why the change? When water and land are heated by sunlight, the land warms more quickly than the water. During the daytime, air over the land is heated and rises. As cooler air from over the sea flows in to take its place, a breeze blows from sea to land. At night, the situation is reversed. The land cools more quickly than the sea. Warmer air over the sea rises and cooler air from the land flows in to take its place. The result is a land breeze.

The other force that causes wind is the rotation of the Earth, which creates the prevailing easterly and westerly trade winds. Many of our South Jersey ancestors used these predictable and reliable winds to power their sailing ships, which brought some of the first real wealth back to South Jersey.

In 1776, the Delaware Valley, including South Jersey, was the largest shipbuilding region in the nation. At least half of the men in Atlantic County listed their occupation as "sailor" whenever a census was taken in the early 1800s. These sailors and traders named some of our towns after distant places they had visited including Malaga, Marmora, and Palermo.

In the Pine Barrens, there was generally not enough wind to power windmills, so most mills were powered by water or, in some cases, by animals. In the early 1900s, windmills appeared on farms in Salem, Atlantic, Burlington, and Ocean counties when farm supply companies began selling windmills for water pumps and generators. As rural electrification proceeded apace, these windmills eventually became obsolete.

Above: Wind in the sails of the oyster schooner A. J. Meerwald
Right: Delaware Bay near the mouth of the Maurice River

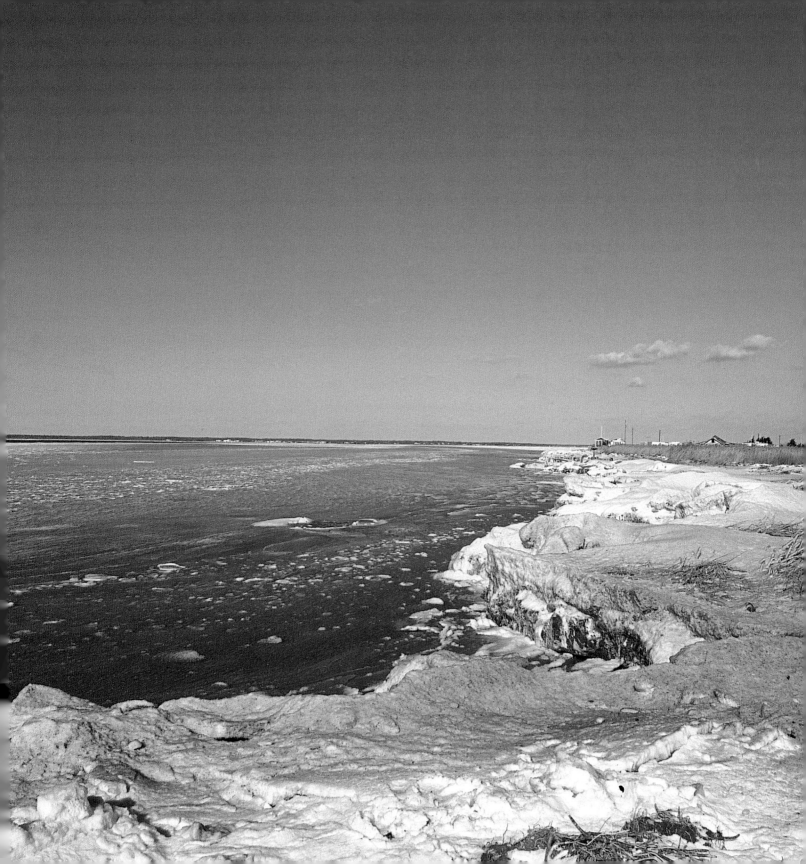

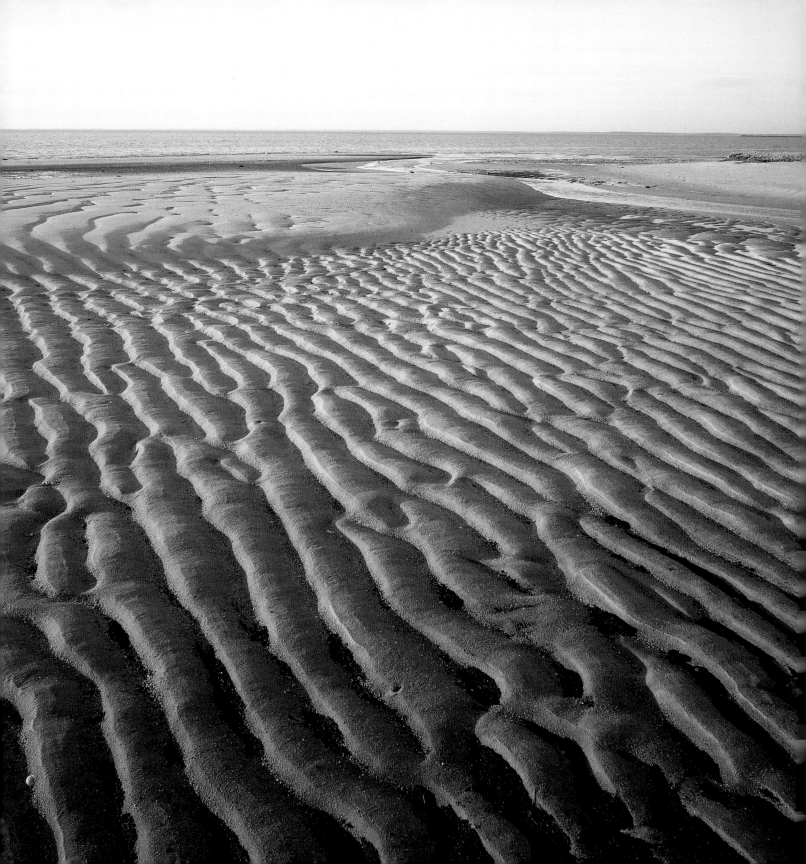

Chapter Twenty

Tides

At one time, there was hardly a man, woman, or child living along the Jersey coast who didn't know the schedule for high and low tides, spring tides, and neap (weak) tides. To pursue one's livelihood, which may have included fishing, clamming, or shellfishing, an intimate knowledge of tides was essential. After the catch was brought in, the tides continued to play an important role: Oysters were stored on oyster rafts where shifting tides would keep them fresh.

The barrier islands, wild and rugged and covered mostly with laurel, bayberry, and small trees, were used to confine and graze cattle, horses, and other livestock. Ferrying back and forth across the bay, their tenders had to know the tides and seasons to avoid being stranded on Peck's Island (Ocean City), Absecon Island (Atlantic City), or Long Beach Island.

Tides were used in the shipbuilding process. To avoid the dangers of Atlantic hurricanes, ships were often built as much as five miles inland. In English Creek, the Van Sant Boatyard built sea-going vessels. When completed, the builders would work the boat down tidal streams until it reached the Great Egg Harbor River. Sometimes it would take days to float a boat down to open water. The Forks, at the confluence of the Batsto and Mullica rivers, was the site of another Van Sant-owned boatyard. Their ships were built nearly eight miles inland here.

Tides were also used to trap salt along the beaches. Such salt works were precarious, however, as historical records reveal they were often destroyed by coastal storms.

Throughout history, tides have played a major role in human civilization. Rising tides allow ships to enter relatively small rivers, supporting the growth of important centers of trade. What tale of swashbuckling adventure doesn't include the exclamation, "We sail at high tide!"

The first successful attempts to harness the surging power of tides into energy were made by mill owners. Trapping water at high tide, the millers then released the water slowly to turn mill wheels to grind grain into flour.

Despite the powerful interplay between tides and humans, tides were little understood until modern times. Usually, writers begin a scientific topic by describing what the Greeks thought about it. When it came to tides, however, the Greeks said little, because they lived on the shores of the relatively tide-less Mediterranean Sea. Since the Mediterranean is practically land-locked, the surge of a high tide from the Atlantic is filtered out as it tries to squeeze through the

Low tide at Kimble's Beach, Delaware Bay

| 100 |
Tides

Tides

Strait of Gibraltar. Tides of the Mediterranean are thus too slight to be noticed under ordinary circumstances.

The first invasion of England failed because the Greeks and Romans were unfamiliar with tides. Julius Caesar had enjoyed a string of military victories until he sailed out of the Mediterranean to invade England. He anchored his ships near land during low tide. The tide turned, smashing the ships against the rocky shores, and the invasion failed.

Navigators eventually tried to develop tide tables for the busy ports of maritime Europe, but tides came at different times in different ports, and no two tides were exactly alike. Real progress could only be made once the science of tides was understood.

The unraveling of this mystery was left for the greatest genius of all time, Sir Isaac Newton. Galileo, earlier in the 17th century, had considered all the facts and dismissed the moon as the cause of tides. Newton, however, had a flash of inspiration. One day an apple fell from the tree and banged on his worktable in the orchard. As he picked up the apple, he noticed the half-full moon, which had risen. Newton guessed that the moon didn't fly out into space because, like the apple, it was held in place by the pull of the Earth's gravity. The moon's gravity, in turn, attracts two heaps of water on opposite sides of the Earth. As the Earth rotates, these bulges of water stay in place. But to a person on the surface of the Earth, the bulges of water seem to move as the Earth rotates. Hence the tide "comes in."

Left: Tidal creek, Delaware Bay

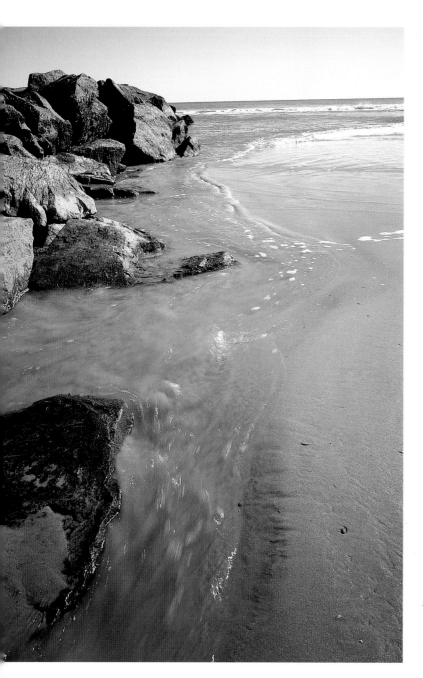

The sun also influences the tides, but because it is so far away, it only exerts half the pull of the moon. The highest high tide and the lowest high tide occur one right after another when the pull of the sun, moon, and Earth is in a straight line. Called spring tides, they occur all year long—not just in spring. The smallest tides, neap tides, occur when the sun and moon cancel each other's pull.

Here's another way to understand what tides are: As the continents move, they plow through the oceans. When the water heaps up due to the moon's gravity, the landmass pushes through the water. The contour of the land determines how high or low the tide is going to be.

Not only do tides help keep bays and rivers fresh, but they are important in the life cycles of many animals. The horseshoe crab, for example, depends on tides to carry milt over the females' eggs. Numerous species of fish rely on tides to carry them out to sea after hatching in protected bays and river mouths.

As long as South Jerseyans and others earn their livings from the sea, and animals depend on it for part of their life cycle, tides will be respected as an essential natural force.

Left: Low tide, jetty at Stone Harbor
Right: High tide at Bayside, Delaware Bay

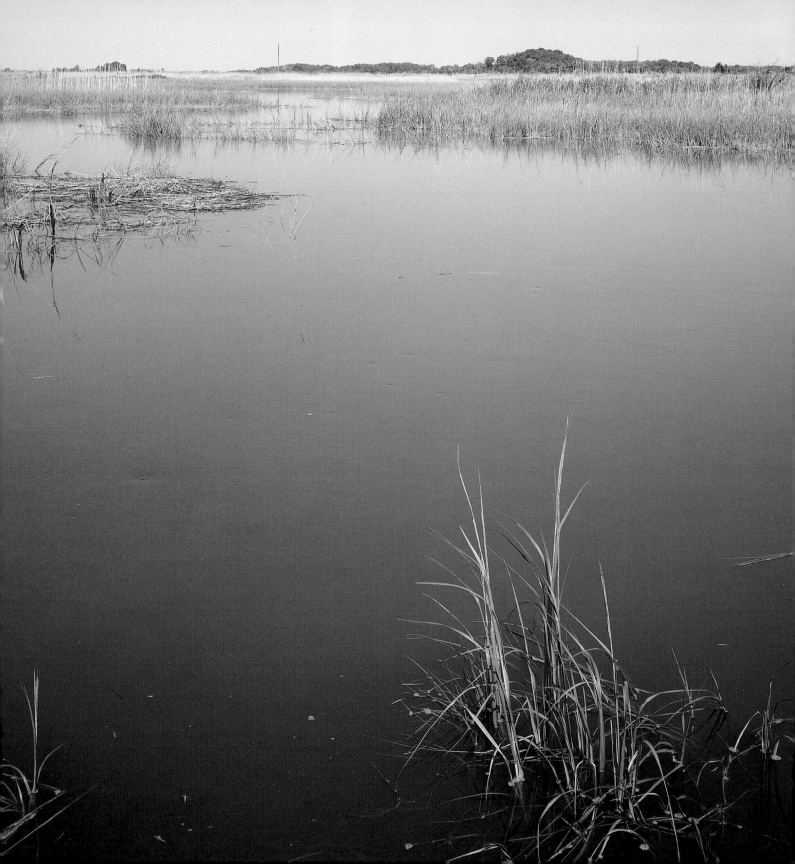

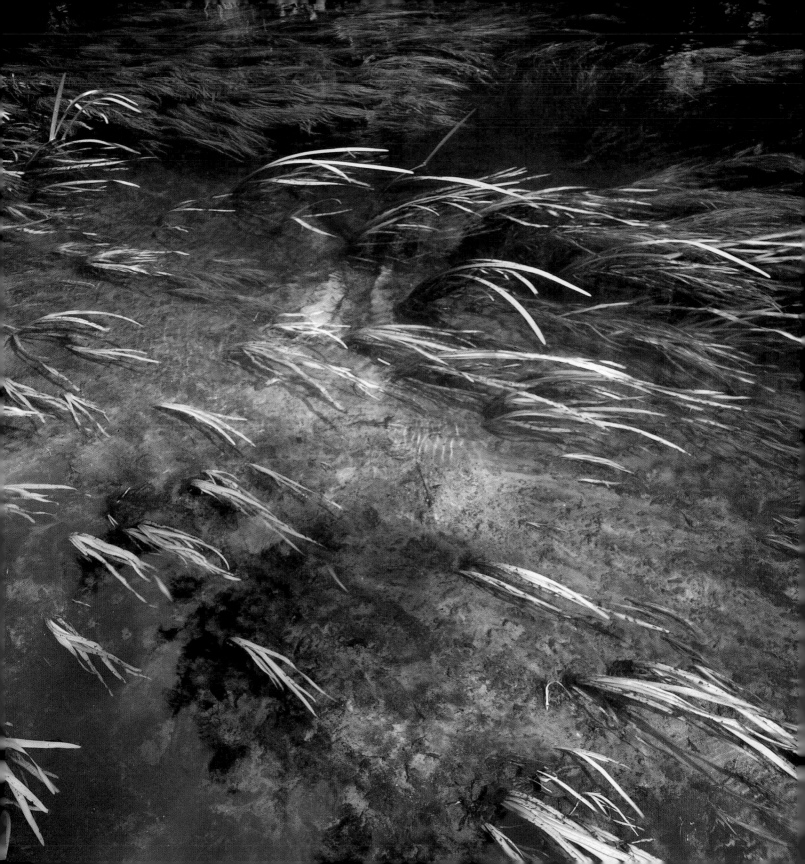

Chapter Twenty-One

Water

"One doesn't know the wealth of the water," said Benjamin Franklin, "until the well runs dry."

Fortunately, the "well" below South Jersey—the Cohansey Aquifer—hasn't dried up, at least not yet. Roads have been named after some Native Americans, like Chief White Horse (the White Horse Pike), and lakes after others, like Nummy, King of the Lenapes. But our greatest resource was named after a Native American Chief, Cohansey, who lived in the Bridgeton area.

The Cohansey Aquifer is believed to have a storage capacity of 17 trillion gallons of fresh water. The Cohansey Sand, which holds the water, is composed of soils that are coarse, loose, and low in nutrients. The area has a very high rate of infiltration so that the soil absorbs even the heaviest rainfalls and very little is lost through run-off. The waters of the Cohansey lie at or near the surface, feeding bogs, marshes, and streams and making it easy for well-drillers to find water.

John McPhee, author of the classic book *The Pine Barrens*, wrote: "The water of the Pine Barrens is soft and pure, and there is so much of it that, like the forest about it, it is an incongruity in place and time. In the sand under the pines is a natural reservoir of pure water that, in volume, is the equivalent of a lake 75 feet deep with a surface of a thousand square miles. … The Pine Barrens rank as one of the greatest natural recharging areas of the world."

Without water, no region can be settled or developed. The American Southwest was for many years a place of death for humans because of the lack of water. The Reader's Digest book, *Back to Basics*, which includes a chapter on building a homestead, states: "In assessing country property the most important single consideration is the availability of an adequate supply of fresh, potable water. With water virtually anything is possible; without it virtually nothing."

Consider how important water is today. New Jersey's homes, industries, businesses, and farms use about 1.5 billion gallons of water daily. The average home (two to three people) in the U.S. uses 107,000 gallons of water every year, the equivalent of running eight baths a day. In the course of a day, the average American uses 170 gallons of water. Brushing your teeth can consume up to two gallons of water, running a dishwasher up to eight. Washing and rinsing dishes by hand, surprisingly, uses about twenty gallons of water.

Farming requires enormous quantities of water. A horse drinks between six and twelve gallons a day, a milk cow about thirty-five, and to maintain a 500-square-foot kitchen garden requires thirty-five gallons a day. To grow two pounds of cherries, it takes 715 gallons of water, while to grow two pounds of rice 570 gallons are required.

South River in Weymouth Township

Industry, meanwhile, also uses lots of water. An oil refinery consumes eight gallons of water to produce one gallon of gas, and 40,000 gallons of water goes into cleaning and milling a ton of wool. Although four trillion gallons of water falls on the U.S. each year in the form of precipitation, much of that disappears in evaporation. Meanwhile, the U.S. withdraws 339 billion gallons of surface and groundwater each year. Ninety-seven percent of the water in the world is salt-water. Only three per cent is fresh, and two-thirds of that is in the form of ice.

Michael Parfit, a *National Geographic* writer, has expressed our need for water eloquently: "Like good health, we ignore water when we have it. But, like health, when water is threatened, it's the only thing that matters. Fresh water is the blood of our land, the nourishment of our forests and crops, the blue and shining beauty at the heart of our landscape. Religions bathe their children and their saved with water. Greek philosophers described water as one of the four elements that made up the earth. To the Kogi Indians of Columbia, the three things at the beginning of life are mother, night, and water. The Koyukan Indians of Alaska define cardinal directions not as north or south but as upstream or down. Where there is no water, there is no life. A healthy human being can live for a month without food, but will die in less than a week without fresh water. We live by the grace of water."

Early settlers in Hammonton touted pure waters from the Cohansey Aquifer—particularly as delivered by an iron spring at the foot of Hammonton Lake—as a major selling point. According to a promotional brochure: "The drinking water on the Hammonton tract is particularly pure and wholesome; many of the wells and springs are highly tonic, similar to the iron spring at Schwalbach, Prussia." Egg Harbor City founders sunk a deep well, then touted the city's "excellent drinking water."

The value of the Cohansey Aquifer was recognized by shrewd businessman Joseph Wharton, who bought Batsto and planned to sell water to Philadelphia. Wharton's plan was to connect a series of shallow ponds, reservoirs and canals and sell the water from the vast underground reserves. Fortunately, the New Jersey Legislature learned of this plan and passed a bill preventing the export of any of the state's water. It was the protection of these same rich water reserves that prompted the State of New Jersey to purchase the 97,000-acre Wharton tract in 1954 and 1955 and establish the present Wharton State Forest.

The Cohansey Aquifer, with its rich reserves of fresh water, is really what made life and development in South Jersey possible. Unfortunately, that very development now compromises the quality of the water as well as the supply. As scientists, conservationists, citizens, and businesspeople work together, it is to be hoped we'll do whatever it takes to protect the "wealth of the water" that distinguishes South Jersey.

Above: Delaware River near Bull's Island
Right: Oswego River

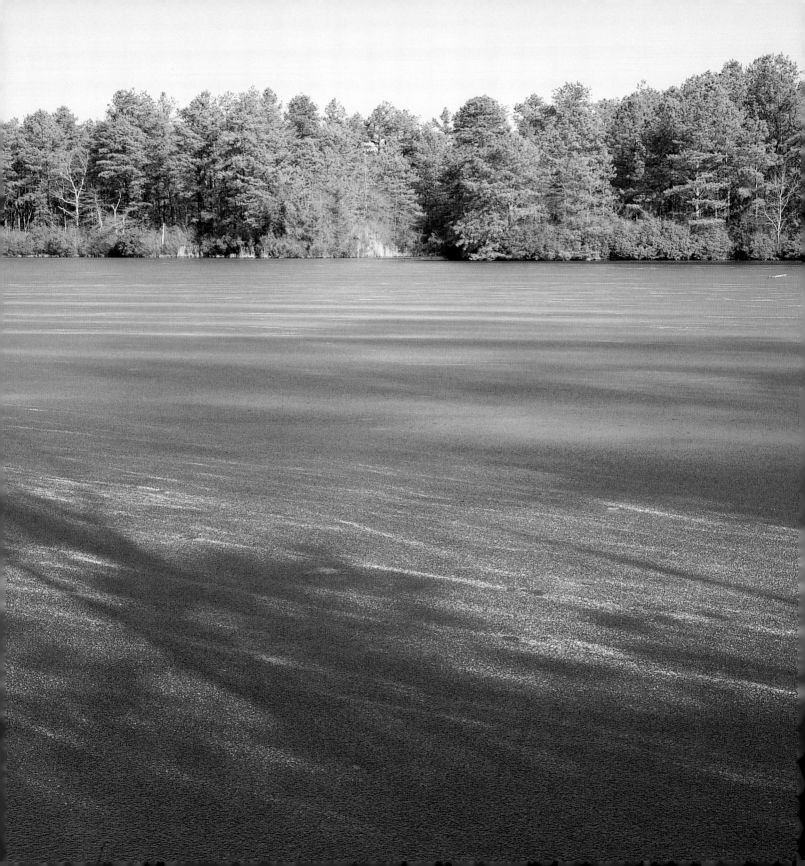

Chapter Twenty-Two

Ice

In winter, South Jersey's lakes and ponds are periodically covered with ice. The formation of this ice is one of the most remarkable processes that takes place anywhere on Earth. One of the most well known scientific facts is that as liquids cool, their density increases. Like all liquids, water obeys this law—but only up to a certain point. Just before water becomes solid, the process reverses itself and water begins to expand. Lighter by volume than liquid water, ice floats on the surface, acting as a layer of insulation that prevents bodies of water from freezing solid and, thus, protects the living creatures below. (If lakes froze solid, only the ice fish, which has a natural form of antifreeze and no hemoglobin, could survive. But this fish lives only in Antarctica.) The colder the temperature gets, the thicker the blanket of ice becomes. In other words, because water freezes from the top down, aquatic life is preserved. No other liquid behaves in this manner (though some solids are known to expand upon cooling).

Sir Ambrose Fleming, a British scientist, describes the process rather eloquently:

> If we consider what happens when a pond or lake freezes on a cold night, we find that as the cold wind blows over the surface the top layers of water first contract, and sink down, and the process is repeated until all the water has been reduced to 40 degrees F., approximately.
>
> Then, on further cooling, owing to the expansion which takes place, the water freezes merely on the surface and a thin sheet of ice is formed, though the general body of the water does not fall in temperature below 40 degrees F., and hence aquatic animals, fish, etc., are not frozen in the ice and killed.
>
> If it were not for this peculiar behavior of water, in having a temperature of maximum density above its freezing point, all lakes and ponds would in a long winter become solid ice from the bottom upwards, and all aquatic life would be destroyed. Hence this behavior of water has an object or purpose, or is teleological, and has an end in view. It can hardly have arisen by accident.

Water behaves in this manner because it is an "odd" solid. Most solid substances are denser than their liquid form. To form a solid, molecules move closer to one another and link up. But when water molecules link to form the regular patterns of an ice crystal, their odd shape creates a gap between them, increasing the amount of space they take up. Ice is thus less dense than water. Otherwise, ice cubes wouldn't float, they'd sink.

Frozen Harrisville Lake in the Pine Barrens

America's earliest settlers didn't know about the molecular structure of ice, but they knew it was a resource that could be tapped and used in their homes and farms. It was also considered a cash crop. As early as 1665, a patent was issued to Sir William Berkeley, governor of Virginia, "to gather, make and take snow and ice … and to preserve and keep the same in such pits, caves, and cool places as he should think fit." George Washington built an icehouse with advice from Revolutionary War finance minister Robert Morris. A few years later, Mrs. Basil Hall, an English visitor, found that iced drinks were being served by Quakers in Philadelphia.

Ice harvesting began in South Jersey and other parts of the Northeast as a community event, like the old-fashioned barn raising. Farmers would get together and measure, mark and score, and then cut the ice on nearby ponds and lakes and fill icehouses with their harvest. Preserved below the ground and covered with sawdust (to provide insulation) the "crop" would last all winter. At first, nobody got paid for the work—they merely divided up the ice. Eventually, ice-harvesting evolved into a commercial business, a multimillion dollar one, in fact. Soon in every community could be heard the words, "The iceman cometh!"

In old South Jersey, ice cutting was a common sight. Old timers and old records tell of ice cutting on both the Hammonton and Egg Harbor City lakes.

Historic Batsto Village has an icehouse that was used by those who dwelt in the mansion during the 18th and 19th centuries.

Today, it may seem we have less ice in winter than in years passed, and to some extent, that's true. We're currently in a warmer period of history. The late 1800s was the tail end of what is known as the "Little Ice Age" (1456–1850). The years 1881 and 1882 were some of the coldest on record. In 1814, the Thames River froze all the way up to London. Prior to this, during the Medieval Optimum, the weather was generally warm. Grapes were grown in England, and the Vikings sailed to America on an iceberg-free ocean.

But the colder weather of 19th-century America made ice-harvesting a viable industry. Our ancestors would begin the ice-harvesting process by measuring the ice to see if it was thick enough to support the weight of the workers and, in some cases, horses. A cut would be made in the ice using special "ice saws." The first cuts created a channel, through which the ice would be floated from the ice field to a wooden chute at a shallow end of the lake. After the channel was finished, the ice field would be marked out in rectangular patterns, with each section typically measuring 22 inches by 32 inches. An ice saw then cut the rectangular sections of ice, a pike pushed the ice

Above: Icehouse at Batsto Village
Right: Icehouse interior

down the channel, and a hook pulled it to the end of the chute. Then tongs were used to load the ice on a wagon, which transported it to the icehouse. The ice was layered, with sawdust dividing each layer. Stored properly, only about 30 percent would be lost through melting over the warm months until the following winter.

Home ice boxes, or ice chests, were commonplace by the middle of the 19th century. A Maryland farmer, Thomas Moore, invented the double-walled box for storing perishables with ice in 1803. He called it a refrigerator. The icebox was usually located on a back porch or cellar so that the iceman could deliver without entering the house itself. In an earlier South Jersey, the iceman was a familiar sight.

Keeping food and drinks cool wasn't the only reason for harvesting ice; a good portion of early America's ice was destined for preserving fish. Beginning around 1830, England imported great quantities of American ice, which enabled English fishing trawlers to travel greater distances and stay at sea longer without loss of catch. And thereby hangs another tale: Modern refrigeration saves countless lives around the globe each year by keeping food fresh and safe while it is being transported.

A few living history farms still harvest ice in the depths of winter, but as a commercial venture the practice virtually disappeared after the advent of modern refrigeration.

The next time you want a cold drink, go ahead, participate in the breaking of one of the laws of nature and use ice. But don't try to defy any other laws of nature, such as gravity, or you might get hurt.

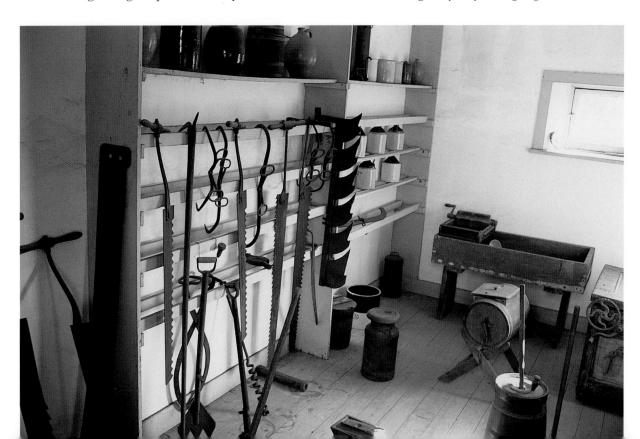

Chapter Twenty-Three

Snow

In the early 1880s, American poet John Whitaker Watson wrote a poem entitled "Beautiful Snow," which became quite popular. Yet after the Great Blizzard of 1888, one newspaper half-jokingly offered a reward for Watson's arrest and conviction!

South Jersey farmers say that a blanket of snow helps to insulate the ground so that the process of topsoil making can go on, but years ago snowdrifts made it difficult to feed and care for animals. Howard Boyd points to the beneficial effect of snow on plant and animal life in his excellent book, *A Pine Barrens Odyssey*: "Snow provides protection to the earth and the forms of life within it. The temperature of the atmosphere often becomes much colder than that of the earth, causing the surface of the ground to freeze, sometimes to depths of several feet. A good blanket of snow helps maintain the warmer temperatures of the earth, the ground is not frozen as deeply, and the soil around the roots of plants is kept warmer so that plants and animals living in the soil have a better chance of surviving the winter."

Because of South Jersey's location near the Atlantic Ocean, which acts as a great heat engine and helps to moderate temperature, the area has a broad diversity of weather. One day it's sixty degrees, and the next it's below freezing and snowing.

Snow covered wetlands along the Mullica River

The greatest snowstorm in South Jersey history, and the one to which all others are compared, was the Great Blizzard of 1888. My great-grandfather, Edmund Einsiedel, recalled that snowdrifts were so high in Atlantic County that trains couldn't get through for four days. Adolphus Greeley, noted Arctic explorer and head of the War Department's Signal Service, had predicted fair weather for the mid-Atlantic states for the week of March 11, 1888. Unfortunately, a storm coming up the coast combined with a blast of Arctic air right over the area and stood there, swirling like a giant top, for the better part of a week. First, the wind came. According to one Egg Harbor City resident, "It blew with the force of a hurricane at intervals, doing considerable damage to property." Then the temperature dropped—in Tom's River, by thirty degrees in forty-eight hours. The rain changed to snow and fell for three days. The *New Jersey Courier* reported that people were awakened by the "rocking of their houses upon their foundations." Before it was over, scores of people from Virginia to Connecticut were dead. (There were no deaths in Atlantic County, however.) Off Camden's docks, blizzard winds and low tide made the Delaware so low that ships scraped bottom and were grounded for days. The water level was so low that Camden's water pumps would not work, and the city was gripped by a severe water shortage.

Snow

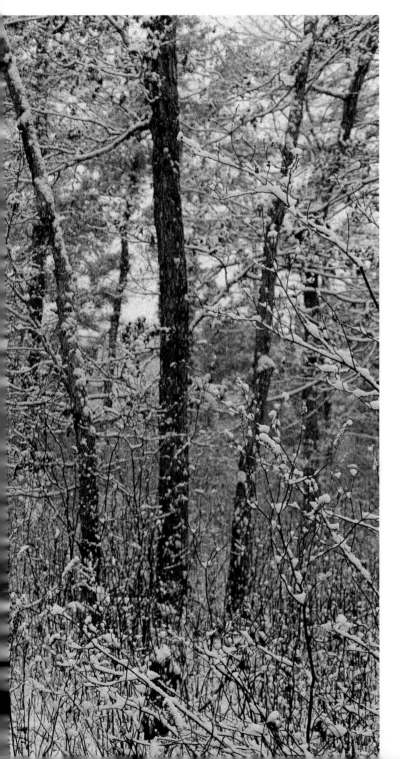

This was an international weather event. The storm intensified as it roared across the Atlantic and, on March 19, 1888, it reached Berlin, Germany, whipping the city with heavy snow and high winds. The floods brought by the storm wiped out nearly three dozen Hungarian villages.

Snow is the name given to ice crystals that form when the water vapor in clouds freezes. As individual crystals of snow become massed together, they trap particles of air between them; it is the refraction of light through this air that causes the snow to appear white. Microscopic plants may change the color of snow after it has fallen: in Greenland and other places in the Arctic, red or green snow is sometimes seen on the ground.

Snowflakes always form as tiny six-sided crystals. So interesting are their patterns that lace makers have used photographs of snowflakes to create new designs for tablecloths and window curtains, and Tiffany's has modeled gold pendants and brooches after them. Because snow falls in only about one-third of the world, millions of people have never seen a snowflake.

The classic research that asserted the uniqueness of each snowflake was done by Wilson Alwyn Bentley of Vermont in the early twentieth century. "Snowflake" Bentley had no scientific training, but he photographed thousands of snowflakes—a hobby he enjoyed for 40 years. When he died in 1931, he left behind a collection of more than 5,000 snowflake photographs.

Snow in forest, Weymouth Township

Subsequent research has served to confirm Bentley's finding that no two snowflakes are alike.

Many people cite the snowflake as an example of how nature can improve upon itself, transforming from a less ordered state to a more ordered state. Actually, the opposite is true, because ultimately the snowflake obeys the Second Law of Thermodynamics, which states that everything tends to go downhill, into a less ordered state.

When snow is formed, energy is lost and goes into entropy, never to be used again. Moreover, when atmospheric water changes into snowflakes, the "system" loses information because the original water is actually more complex than the snowflake. Yet, winter after winter the process goes on, as if filling some preordained pattern, while all the time energy is being forever lost to entropy.

It is unlikely that we will ever again have a snowfall in South Jersey like that of the Great Blizzard of 1888. But as long as there are possible "snow days," school children will be hoping for something akin to it.

Below: Snow begins to fall
Right: Batsto Lake after the blizzard of 1996

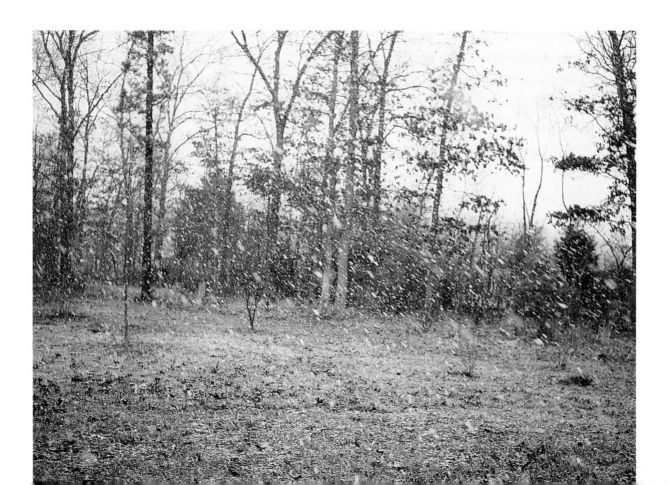

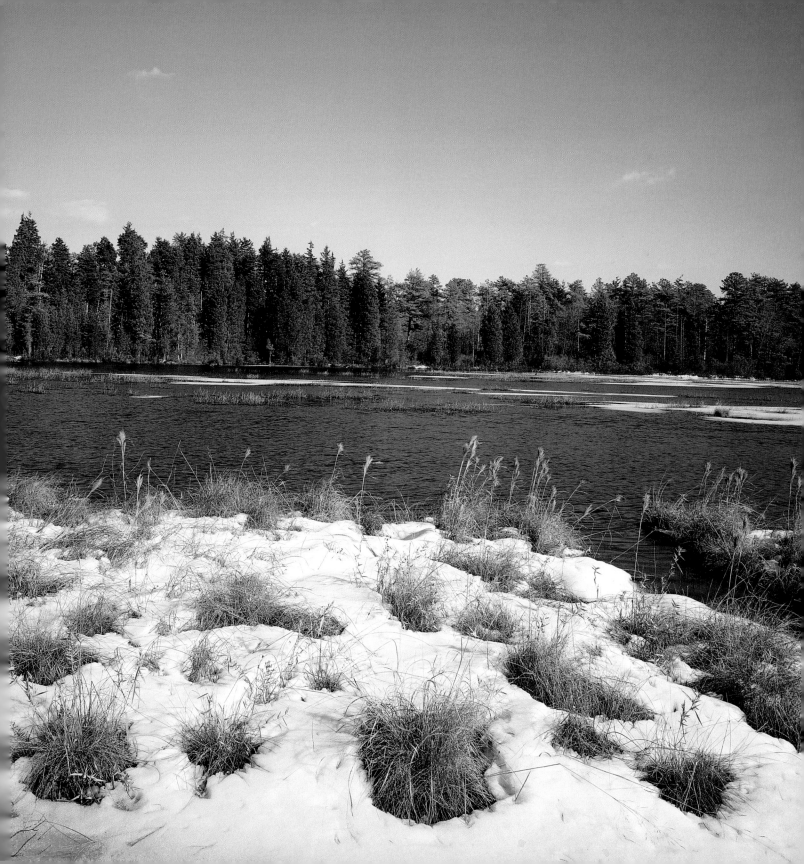

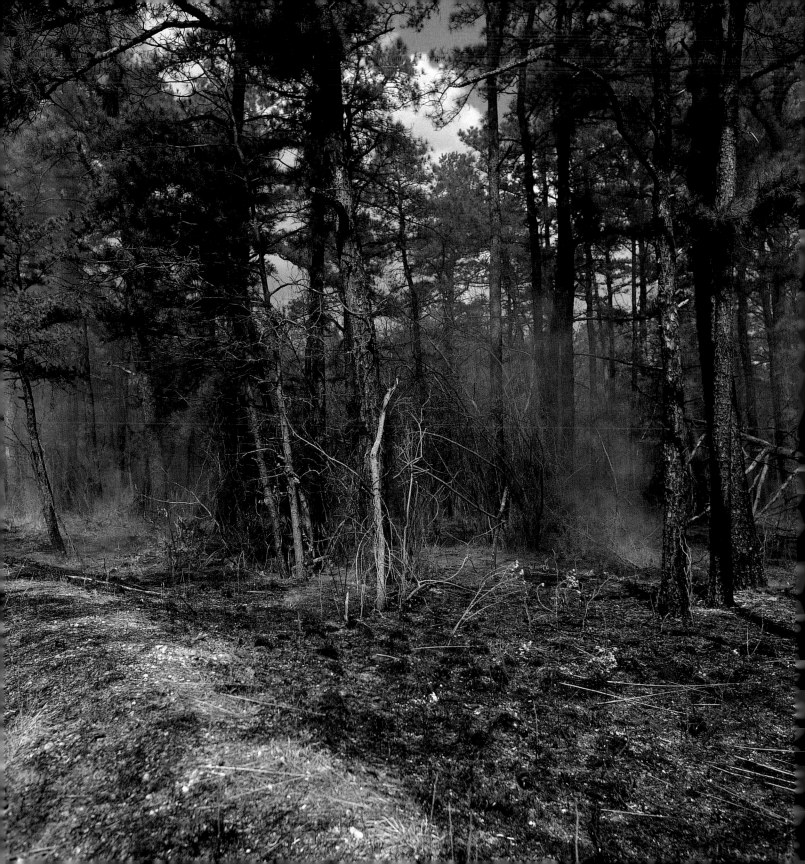

Chapter Twenty-Four

Fire

According to Greek mythology, one of the most momentous events in history took place when Prometheus stole fire from the gods. So valuable was fire that the gods punished Prometheus by chaining him to a rock and having ravens continually pluck at his liver.

Prometheus might well have been a Piney, for fire has been critical both for humans and nature in the Pinelands. Indeed, it could be argued that without fire there would be no Pine Barrens forest or history as we know it. Not only is fire necessary to open the cones of the pitch pine so that it can propagate, but at one time fire was a key ingredient in South Jersey bog iron forges and glass houses. As a result, it could be said that much of South Jersey history has been forged in fire.

Scientists describe fire as heat and light resulting from the rapid combination of oxygen with other materials. The flame is composed of glowing particles and gaseous products that are luminous above certain temperatures.

Only humans can make fire and benefit from the process. In a 1968 article in *American Scientist*, Dr. F. W. Went explained:

> A wood or coal fire above the critical size produces just the right amount of heat to warm man in a cave or a room or a camping site. But ants or small rodents would have to keep too far away to make a fire economical, or rather, they would be unable to bring up enough wood to keep the fire going.
>
> Animals below a certain size have been forced to adopt other methods of keeping warm, by very high food intake or by continuous activity or allowing the deep body temperature to fall and become dormant—or by limiting their habitat to areas within the temperate zone. Because man is able to make a fire on account of his hands and completely vertical posture, he can be ubiquitous.

With fire as one of their tools, the first settlers in South Jersey established hearth and home and a number of rural industries. The iron forges at Etna, Batsto, Weymouth, Atsion, and other places used fire to smelt iron. Less intense, slow-burning fire was needed to produce charcoal, the fuel that was used in the iron forges and on Delaware River coal boats.

Fire is also essential in producing glass, a famous South Jersey product. Carl Sandburg, the poet and biographer of Lincoln, on a visit to South Jersey, wrote: "Down in southern New Jersey they make glass. By day and by night, the fires burn on in Millville and bid the sand let the light in." In the glasshouses,

Fire in the Pine Barrens

Fire

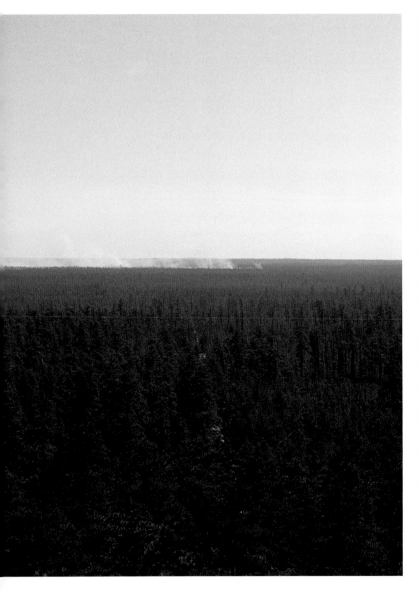
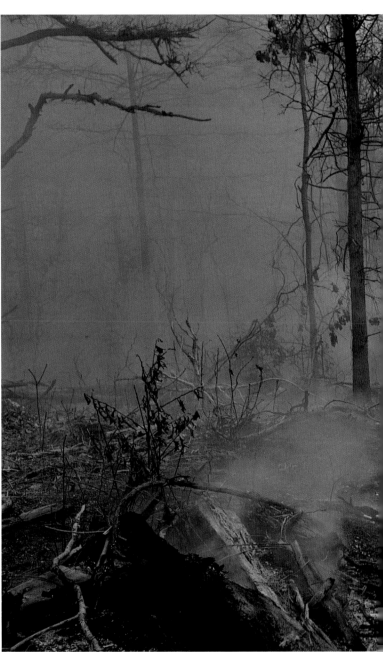

Top: View of fire from Apple Pie Hill
Right: Fire in the Pine Barrens

Fire

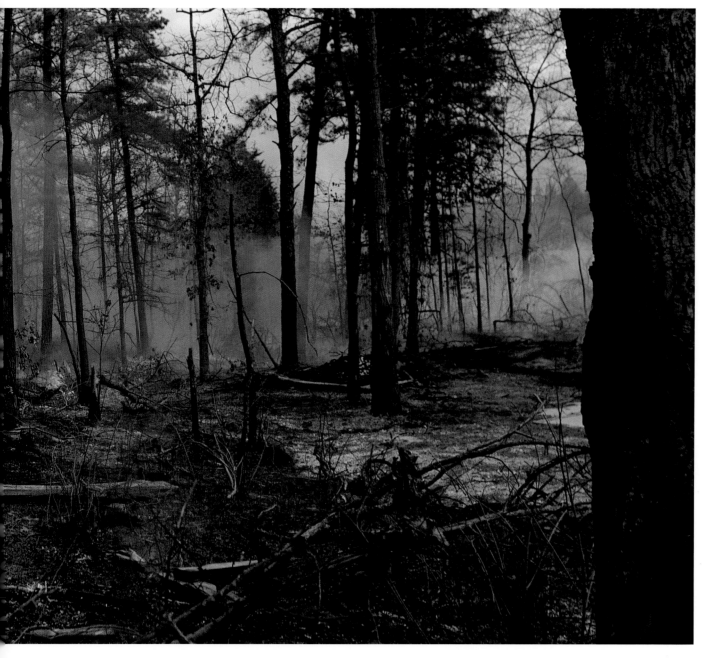

the fiery "glory hole" would transform sand and flux into beautiful and useful objects.

In the ecology of the Pine Barrens, fire is essential. Pitch pines, like most pine species, are fire resistant. They actually need fire to propagate: it opens the cones to release seeds and clears dead leaves from the forest floor. When pine cones open and release their seeds, they face a tremendous obstacle at ground level: "Duff," which is essentially layer upon layer of leaves and pine needles, can become so thick that the seeds are unable to reach the earth below. Fires are necessary to burn away the duff so the light pine seeds can take root and sprout. (Acorns, which are larger and more durable, germinate despite the duff.)

The Buchholz's dart moth, found only in the Pine Barrens, also needs fire to live. The larvae of this rare moth feeds on pixie moss that grows in open, sandy areas created by fire.

Some fires are caused by lightning strikes, but many are caused by human error or on purpose. Some 19th century woodcutters set fire to land so that they could purchase it cheaply and harvest it years later. At the time, woodcutters were mainly interested in pine, which was used as fuel in Pinelands' industries. Reports in the *New Jersey State Geologist* from the late 19th century are filled with descriptions of fires that burned ten, twenty, or thirty thousand acres at a time. Yet, every twenty years, the wood choppers and colliers gathered

The aftermath of fire in the pines

123
Fire

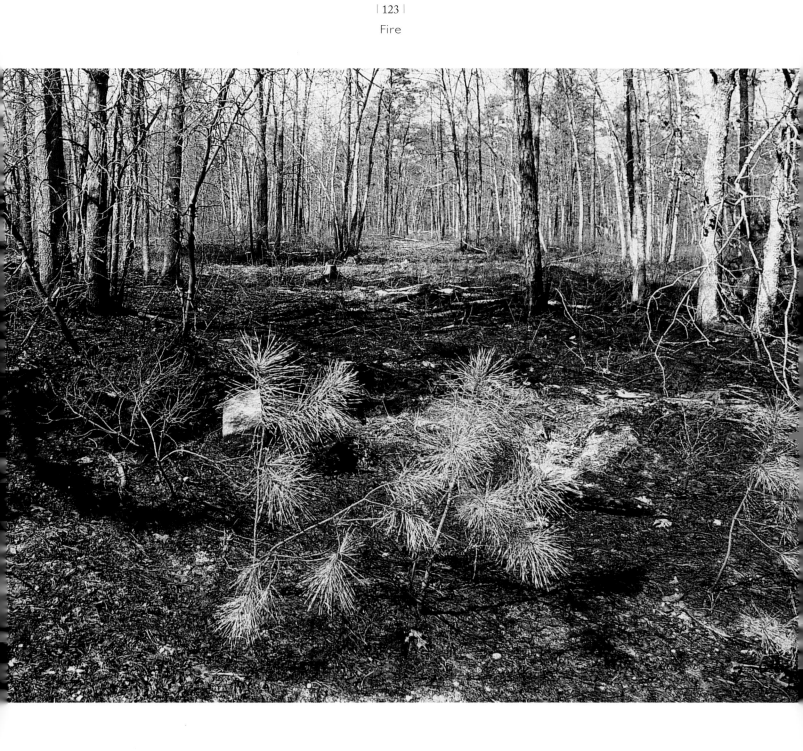

their harvest on a given site, and the cycle continued until the industries died.

As the Prometheus myth shows, harnessing fire was critical to the development of civilization. Without the "fire" in your car engine or the flame in your stove or heater, civilized life would not be possible. And without forest fires, the unique Pine Barrens ecosystem would not exist as we know it.

Regrowth begins at the forest floor

Part Four

"All the Trees of the Wood Rejoice"

Psalm 96:12

Chapter Twenty-Five

Pine Trees

The greatest danger to any tree or forest is fire. Yet the pitch pine, as pointed out in the previous chapter, actually needs fire in order to survive. Scientists have estimated that on average fires need to burn an area not less than once every twenty to forty years to maintain the pine forests. Without fire, oak trees would eventually take over, and the Pine Barrens would disappear.

Several types of pine trees grow in the Pine Barrens. First, there's the pitch pine. In no other region of North America does the pitch pine cover such an extended area as in New Jersey. This tree virtually defines the Pine Barrens. Then there's the scrub pine, also known as the Virginia pine. This tree grows in poor, sandy soils around the edges of the Pine Barrens, but not in the interior. Another pine that grows in sandy soils is the short-leaf, or yellow pine, a large tree with reddish-brown bark. Finally, there are the pygmy pitch pines, which grow in the dwarf forests near Warren Grove, Ocean County. These unique specimens reach a height of just eight to twelve feet. Only one other place on Earth has a similar forest. To this day, no one knows for sure why the growth of these pitch pines is stunted. Most experts agree, however, that it must be due to a combination of factors such as poor soil, exposure to constant wind, and repeated and intense fires. On average, fire occurs in these dwarf pine forests every ten to twenty years.

The pine tree has been described by some biologists as "primitive" or "simple," yet it is anything but. Consider the following: The bark of a pitch pine is so thick that it is resistant to all but the most intense fires. Its needles are woody and tough, protected from decay by resin and heavily coated with weatherproof wax. The pine tree loses its needles just like other trees, but it does so gradually, throughout the year. Hence they are known as evergreens. The needle leaf allows the pine tree to survive South Jersey's hottest, driest summers as well as its coldest winters. To put it simply, it is designed to slow down transpiration, the loss of water. On a warm day a pine tree loses only one-tenth the amount of water transpired by a broad-leaf tree of the same size. By the same token, its needles are virtually unaffected by freezing. Evergreen trees such as the pine provide needed cover for birds and other animals in winter when other foliage is scarce.

The cones of conifers like pine trees are also unique. Simple, tough, and durable, the cone is a highly effective reproductive organ. It has no soft parts like stamens and pistils that can be damaged. Instead, two seeds—no more, no less—live protected at the end of each woody scale that

Pitch pine

is curved upward like a scoop so that windblown pollen can do its work.

The tight spiral of the cone provides maximum protection in minimum space. No seed overlaps another one; each seed gets an equal share of nutrients. When the seeds reach maturity, in one to two years, the resin melts and the scales open wide. If fire has kept the forest floor relatively free of duff, then the seed can germinate and make the Pine Barrens a continuing reality.

The dynamic spiral of a pine cone is a marvel of design. It allows the cone to grow at one end, increasing its size without changing its proportions. Essentially, the diameter of each coil increases at a constant rate with each spiral, as distinguished from the spiral discovered by Archimedes, which may be represented by a coiled rope (calculus was around long before Newton and Leibniz!).

The dynamic spiral of the cone may also be seen in the pine tree itself. Again, when things are designed using the dynamic spiral, they can grow larger without changing their proportions. This is not only important aesthetically, but structurally as well. This basic phenomenon of life can be seen in many living things, including seashells, spider webs, the center of many flowers, and the curve of a beaver's tooth. It can even be glimpsed in the curve of an ocean wave or the spiral galaxies of outer space. These examples in nature seem to represent intelligent design, not accidental occurrence. As Shakespeare put it, "There is a divinity which shapes our ends, rough hew them as we will."

Left: Pitch pine forest (Photograph by Steve Greer)
Right: Pitch pines

Pine Trees

South Jersey's settlers had little time to contemplate the marvels of the pine tree—they were too busy just trying to survive. Those settlers used the pine tree to make pitch for the shipping industry; the trees were also used as fuel in Pine Barrens industries. Pine was preferred for making charcoal and was also used as firewood for heating homes. Its importance and significance in early American life was reflected in the Pine Tree shilling, a colonial coin, and in the Revolutionary War's Pine Tree flag.

Pine trees will continue to dominate in many parts of South Jersey as long as forest fires burn away the duff on the forest floor and burn hot enough to open the pitch pine's cones. In a state as populated as New Jersey, fire cannot be allowed to burn as it did centuries ago—thus, controlled burning may be an important part of any plan designed to preserve the Pine Barrens, whether the land is publicly or privately owned.

Above and at right: Pitch pine bark releasing sap

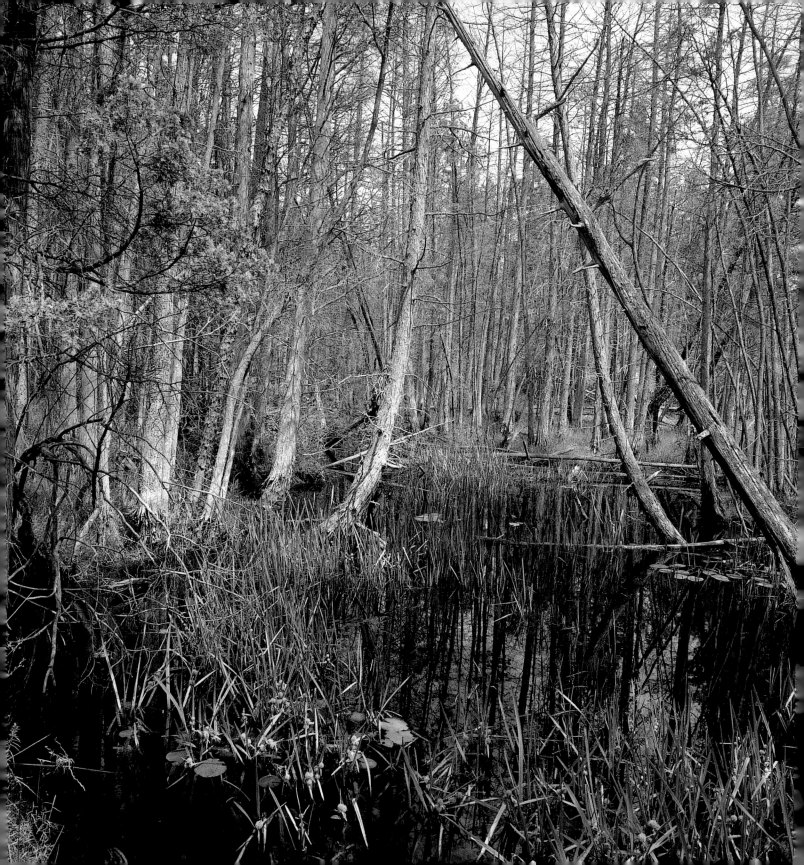

Chapter Twenty-Six

Atlantic White Cedar Trees

Underneath Great Swamp at the headwaters of Dennis Creek, Cape May County, lies perhaps the largest sunken forest in America. As far as anyone knows, the cedar logs may have been there—preserved in the muck—for centuries. Stretching through the northern part of Cape May, the swamp is about seventeen miles in length. The soil contains black, peaty earth, composed of vegetable matter, which when dry will burn. It varies in depth from two or three feet to twenty feet or more. It was this swamp that gave birth to shingle mining. In the late 1700s and early 1800s, shingle miners roamed the marshes with slender, pointed iron rods called progues. Miners would probe the ground with these rods until they hit a submerged log. Using a long saw, a small piece of the log was cut and pulled up out of the muck. The sample was then examined to see if the rest of the log was worth bringing up.

Cedar shingle miners broke the logs down into two categories. Trees that had apparently been blown down by the wind and were in prime condition when they fell, were called "windfalls." Rotted trees that had settled into the mud were called "broken downs." "Broken downs," of course, were less valuable than "windfalls," and only the most able shingle miners were adept at distinguishing between the two.

In 1855, a report was published that said, "for the past five years the average number of these shingles sent from Dennisville, is not far from 600,000 a year. They are worth from $13 to $15 a thousand."

In 1897, when Philadelphia's Independence Hall needed a new roof, contractor John Annelsy decided to use the best product available: cedar shingles. Formed and protected in the bottom of a South Jersey swamp, this most unusual of products went on to protect vital national treasures for decades to come. A less glamorous but also important use of these trees was in Philadelphia's colonial sewer systems, some of which flowed through hollowed-out South Jersey white cedars.

In the early 1900s, asphalt shingles were developed and mass-produced, thus ending commercial shingle mining. Nevertheless, the story of the cedar mining industry pays tribute to the ingenuity of the men and women who settled South Jersey. It's also a tribute to the deceptively rich bounty of resources to be found here.

When Peter Kalm visited South Jersey in 1749, he was amazed by the number and beauty of the cedar trees he saw: "A tree which grows in the swamps here," Kalm wrote, "goes by the name of the white juniper tree. Its trunk indeed looks like one of our tall, straight

Left: Atlantic white cedar swamp
Pages 134–135: Atlantic white cedar trees

juniper trees in Sweden, but the leaves are different, and the wood is white. The English call it white cedar." He added that it was hard to get to because it "always grew in swamps."

Early settlers prized cedar for use in building fences and outdoor structures. Not only does it resist rotting, but it planes well, doesn't split off, and has a long grain that is well-suited for boat-building.

The Atlantic white cedar typically reaches 80 feet in height, though at least one such tree was measured at 120 feet. This species grows in stands so dense that the only live branches appear near the top of the canopy. The trees are frequently found growing along the course of Pine Barrens streams, eventually spreading out into large sphagnum and cedar swamps.

Cedar swamps are found throughout the Pine Barrens with its meandering rivers and streams. In these swamps, trunks of white cedar trees stand, their bases forming islands on which you can nearly always find a dry spot to rest. Above, the tree canopy is typically so dense it almost completely conceals the sky. The trees grow so closely together that they block the sun and wind, creating an oasis in the otherwise hot South Jersey summer. When you enter a cedar swamp in July or August, the temperature feels like it has dropped as much as ten degrees. In winter, cedar trees take on an even greater beauty, as they are evergreen and stand out in a forest that has lost most of its foliage. Cedar trees also contribute to the tea-colored waters so common in the Pine Barrens. The color of this "cedar water" is due partly to its high iron content, and partly to absorbed vegetative dyes such as tannin from the cedar trees. Early South Jersey mariners discovered that cedar water tended to stay fresh and palatable on the high seas, perhaps because of these dissolved ingredients. Captains who anchored their ships along the Jersey coast were known to send sailors inland to fill barrels with this prized water.

Along with providing contrast to the sandy, flat, pine-covered terrain of the Pines, cedar swamps provide a buffer and safety zone during times of wildfire. Although fire plays an important part in the life cycle of the Pines, it poses a threat to people and animals. Cedar swamps do not prevent fire, but, in acting as natural firebreaks they play an important role in containing it.

Left: Portable shingle mill at Batsto Country Living Fair

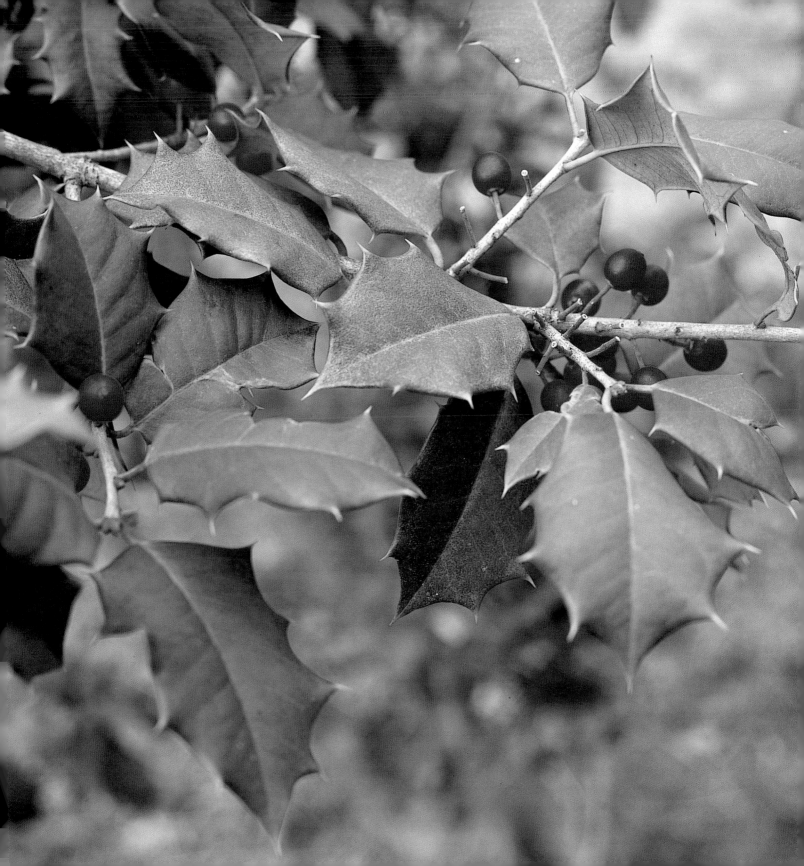

Chapter Twenty-Seven

American Hollies

Because holly grows so well in New Jersey's acidic soil, South Jersey was once the headquarters of the world's largest holly farm. In the mid-1900s, the "Millville Holly Farm" as it was called, sent cuttings all over the world in anticipation of Christmas.

Holly trees in the wild also helped create one of New Jersey's great natural wonders: Holly Forest on Sandy Hook. Many experts consider the Sandy Hook forest to be the most significant stand of holly on the East Coast. One thing that sets this stand apart is that it grows in beach sand on the edge of the vast Atlantic Ocean. Wind-borne salt spray creates what is known as a "salt spray horizon," where the growth of any tree is killed above an imaginary 15-degree line measured vertically from the water's edge. This natural pruning gives the forest a flat top roof. Holly Forest's location on the Atlantic Flyway makes it an excellent layover for birds headed farther south or north.

The Holly Forest wasn't always protected by the National Park Service (it's now part of the Gateway National Recreation Area). In the late 1800s, people gathered holly boughs by the hundreds for their Christmas celebrations and to sell in city markets.

Closeup of American holly branch

This was a serious threat to the health and survival of the forest. Thankfully, in 1900 the U.S. Army (which had a base on Sandy Hook to protect New York Harbor) came to the rescue, posting guards at the southern approaches of the military reservation where the hollies grew.

During World War II, security on Sandy Hook was tightened once again, effectively ending any holly harvesting. In 1941 the *Asbury Park Press* reported: "… it would take an act of Congress for even the President to have Sandy Hook holly in the White House for Christmas."

The American holly is a common sight on the mainland in the Pine Barrens and at other spots along the New Jersey coast. The holly tree likes moist woodlands, stream banks, and barrier islands. It is the female tree that produces the distinctive red berries in the fall.

Holly's association with Christmas goes back many centuries. Its festive berries, set against glossy green leaves, ripen to a bright red in December, just in time for the holiday. The American name for the tree derives from its earlier European designation as "the holy tree." To many Christians, the red berries symbolize the blood of Christ, which according to the Bible's New Testament was shed for man's sins.

The ideal conditions in New Jersey for growing holly led to a number of noteworthy commercial operations.

Elizabeth White, who gave us the world's first cultivated blueberries in 1917, also tried to make a commercial success of holly growing. For many years she propagated American, Japanese, and English holly at her nursery called Holly Haven. She obtained many rare specimens, including the famous and now lost (in the wild) Franklinia tree. This tree had been discovered on the banks of the Altamaha River in Georgia in 1765 by John and William Bartram, who brought it back to their native Philadelphia. After 1790, the Franklinia was never again seen in the wild. Miss White obtained specimens descended from the Bartrams' trees, and began marketing them as a specialty item. Today, a few Franklinia shrubs struggle for survival at the site of the old nursery near Whitesbog.

The other venture was in Millville, at the aforementioned holly farm. Clarence Wolf, owner of the Silica Sand Company, couldn't bear to see his workers destroy the wild hollies in his sandpits, so he ordered them to replant the trees on a protected part of the property. In 1926, as Christmas approached, Wolf hit upon the idea of sending cuttings as gifts to his customers.

The gift holly was so well received that Wolf began planting other varieties, including English, Chinese, and Japanese strains. In the center of his orchard he built Holly House, a showroom featuring the world's largest collection of hand-painted holly glassware. He also founded the Holly Society of America, which eventually had more than 8,000 members. South Jersey holly was soon being used all over the world at Christmas. Today, the Millville Holly Farm is owned by an electrical utility, where other trees and shrubs are grown in a nursery for use in landscaping the company's properties. The cultivation and marketing of holly has long-since ceased, but the city of Millville is still referred to as "The Holly City"—a reminder of the days when it was truly the "Holly Capital of the World."

Left: American holly
Right: American holly tree in uplands forest

Chapter Twenty-Eight

Oak Trees

When John Fenwick came to South Jersey in the 1600s, both as a peaceful Quaker and a practical man, he wanted to make peace with the Native Americans. After the appropriate inquiries and initial negotiations, he chose an oak tree as the spot to sign his treaty, perhaps because it symbolized sturdiness, strength, and longevity.

Along with the pitch pine, the oak is a dominant tree in the New Jersey Pinelands. There are many different kinds of oak, including the white oak, red oak, black oak, scarlet oak, chestnut oak, and post oak. The red oak is New Jersey's official tree, while the white oak is prevalent throughout South Jersey. There are 275 species of oak worldwide, from the Malay Peninsula to China to northern Europe. The main feature that sets oaks apart from other trees is the acorn. Generally, these trees are not found in exceedingly cold regions of the world.

Because of its many uses, oak was a commodity prized by South Jersey's earliest settlers. Indeed, one of the area's first industries was that of lumbering. Early lumbering operations appeared in the Batsto area, Medford, Salem County, Gloucester Landing, and many other sites in the Pine Barrens.

White oaks and black huckleberry in autumn

While lumber was shipped out of South Jersey to England, New York, and Philadelphia, much of it remained here for heating homes and for use in industry. The iron furnaces at Batsto required about 6,000 cords of wood per year.

In pre-Christian Europe, oaks were sacred. In many areas they were dedicated to the god Thor. After Saint Boniface routinely cut down sacred oaks during his missionary thrusts into Germany, people no longer feared the oak but came to cherish it as both a building material and a symbol of strength. The shrine of Edward the Confessor, in Westminster Abbey, was built of oak, and observers say the wood is as sound today as it was 1,000 years ago. The Anglo-Saxons invaded England in ships made with oak planks, while the Mayflower, which carried the Pilgrims, was framed in oak. The little acorn and the giant oak tree also became symbolic of long-term growth or achievement. Ben Franklin, writing from Philadelphia, said, "Little strokes fell great oaks."

In early South Jersey, the Lenape Indians used meal made from white oak acorns. They would first crush the nuts and then wash them in water to remove bitter-tasting material. The nuts were dried, ground into meal, then pressed into cakes. Most other acorns are too bitter for human consumption, though farmers have used them to feed hogs. When William the Conqueror made the "Domesday Book" (a tax roll for

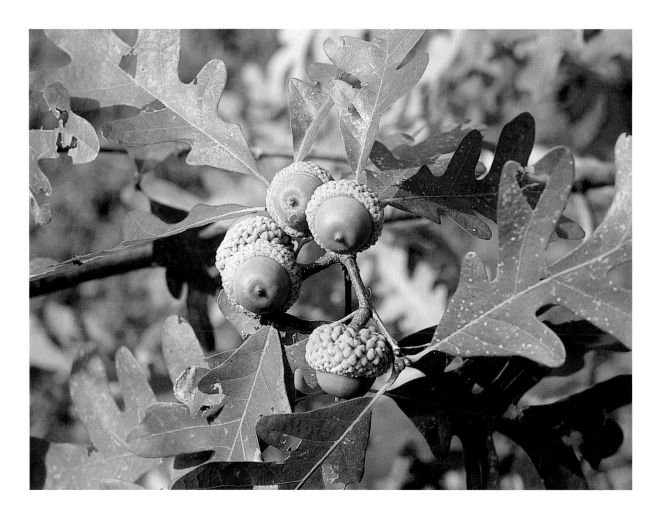

English villages) the woodlands were valued according to the number of swine that could be supported by the acorns found there.

Acorns are also eaten by squirrels, wood mice, game birds, pigeons, and crows. The acorn crop—like the apple harvest—varies each year. A good year is called a "mast year."

In colonial and 19th-century America, oak was the main source of tannic acid, which was used to tan hides and make leather. Whenever oak was felled, bark was carefully stripped and stacked with its outer surface upward to dry. Later, at the tannery, the bark was steeped in water to release the tannin. Sometimes oak bark

Above: White oak branch with acorns
Right: White oak tree

brought even higher prices than the timber. Because the tannin in oak reacts with iron, causing discoloration in the wood, iron nails could not be used in ornamental oak.

It is this tannin in the wood that makes oak exceptionally durable out of doors. Oak was the main wood used in shipbuilding before the advent of steel, providing naturally curved beams for framing ships' hulls and supporting decks. Local families like the Leeks on the Mullica and the Van Sants along the Great Egg Harbor relied on oak to build their fleets.

On the homestead and in small business, oak was long the standard building timber not only in New Jersey but throughout the U.S. The wood was used to make posts, beams, clapboards, roof shingles, and even rafters in large buildings. Oak was also used for fencing, wheel spokes for horse-drawn carts, and ladder rungs, since it was strong enough to take all strains. Young oak growth, called coppice, was used in barrels, for pole wood, and in basket making. Oak chests were used to hold valuables, and men sat on oak benches to dine at oak

Below: Post oak
Right: Fall oak canopy

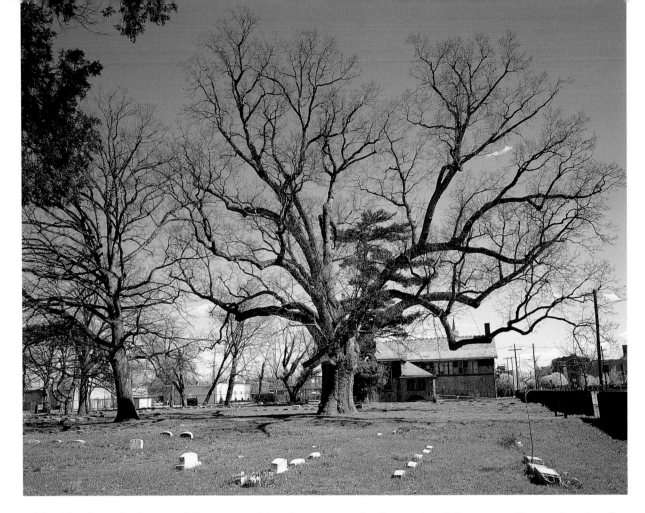

tables. Hand-made chairs and dressers surviving from the old days are highly valued for their simple integrity of design and workmanship.

During the 19th century's Industrial Revolution, oak timber was also used in mining, bridge making, wagon construction, and dock and harbor work. Before coal came into widespread use, oak charcoal was the main fuel for bog iron smelting. Many of South Jersey's earliest settlers were either sailors or charcoal burners. In fact, so many Pine Barrens' activities depended on oak and other trees that hardly a man or woman was born in the forest who, at one time or another, did not fell trees or cut wood.

As firewood, oak has an excellent rating. It splits easily, produces a great deal of heat, and burns cleanly.

And what of Fenwick's oak tree? It still stands today in downtown Salem, a testimony to the oak tree's longevity and sturdiness. Like any living organism, this particular tree has suffered the effects of age. Fortunately, officials have been able to shore up the ancient tree with cables and other props, helping to ensure its role as a historical monument for years to come.

Above: Salem oak

Part Five

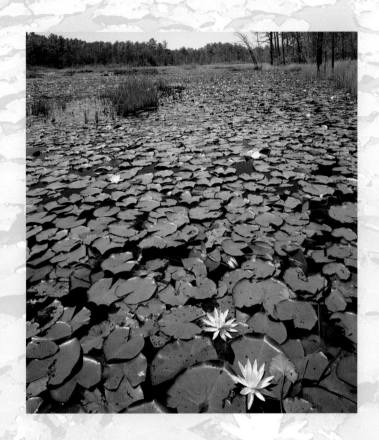

"The Lilies of the Field"

Matthew 6:28

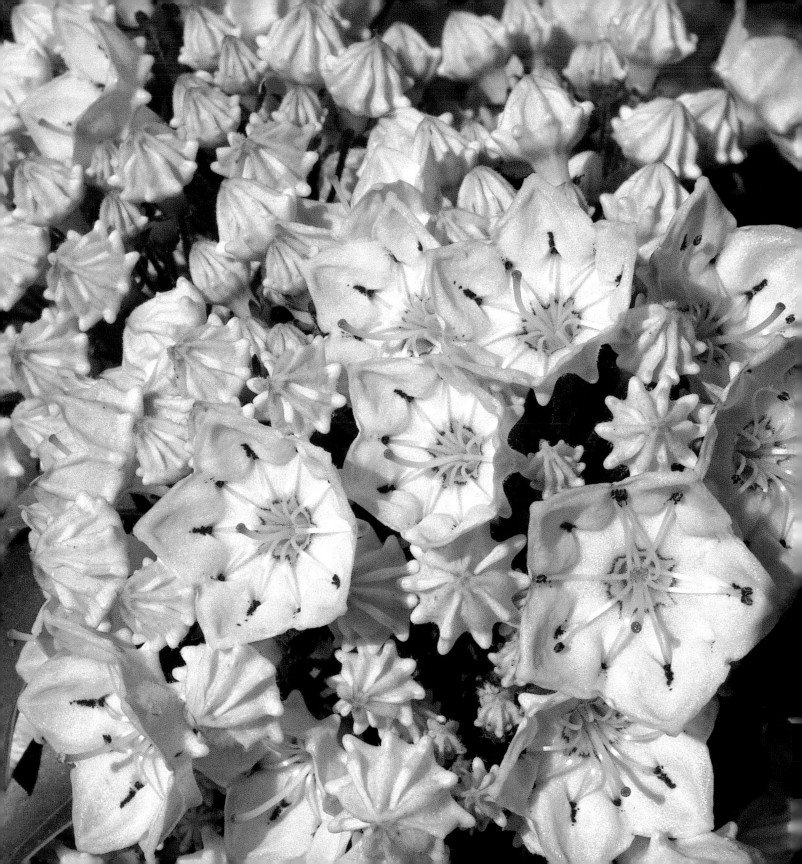

Chapter Twenty-Nine

Laurels

According to an ancient legend, laurel was created in a special way by the Greek gods. It seems that Daphne, a beautiful wood nymph, attracted the wandering eye of Apollo. When she refused his advances, he pursued her through the woods. She prayed to her father, the river god Peneus, who changed her into a laurel tree. This quick thinking on Peneus's part preserved his daughter's virtue, but at the expense of her divinity. One consolation: As a plant, she was given the ability to stay green year-round. Grief-stricken, Apollo made laurel his sacred tree. The Greeks subsequently used laurel wreaths to reward Olympic champions.

Both mountain laurel (*Kalmia latifolia*) and sheep laurel (*Kalmia angustifolia*) grow abundantly in the Pine Barrens and surrounding regions. In fact, when the poet Henry van Dyke wrote of his travels in South Jersey, he entitled the story, "Between the Lupine and the Laurel." In 1910, biologist Witmer Stone wrote that in New Jersey, "… the pines seem to be the chosen land of the heath family which abound there both in species and in individuals. … By the end of June, we may be sure of finding the greatest display of [mountain] laurel that can be found anywhere in the Middle States, even on the mountains themselves which are supposed to be its proper home."

Mountain laurel flowers

The generic name for both laurels comes from Peter Kalm, the Swedish botanist and student of Linnaeus who described them in his travels to South Jersey in the mid 1700s. Kalm wrote that the Swedes who lived here called it "spoonwood" because the Native Americans had made spoons from it.

Pineys and local farmers often referred to laurel as calico bush, because the design and color of its flowers reminded them of calico print and material. Of course, mountain laurel had the calico print first.

Laurel flowers develop into large, showy dome-shaped clusters of pinkish-white flowers. Because of their beauty, Pine Barrens dwellers of the past often brought laurel indoors in June for bouquets. At Christmastime, a Pine Barrens industry developed in gathering and selling laurel to markets in Philadelphia and North Jersey, where they would be made into garlands and sold for Christmas decorations. Today, due to declining populations, it is illegal in most places to harvest laurel, and most garlands are made of synthetic materials.

The stamens of the mountain laurel are unique. Each one is like a tiny spring and held down in a corner of the flower, making the flower resemble the inside webbing of an umbrella. When a bee arrives to gather nectar, its weight releases the springs, they snap up, and the bee is showered with pollen. When the bee

visits its next flower, some of that pollen is rubbed off onto the pistil, thus fertilizing the flower. You can try this experiment yourself in early June: touch a mountain laurel's stamen with a pin when the plant is in full flower. If the plant is healthy, the stamen will spring out and pollen will fly off the anther.

The profusion of mountain laurel in South Jersey has led to a number of place names, such as Mt. Laurel, Laureldale in Hamilton Township, and Calico. Now a ghost town in the Pine Barrens, Calico—located on the east side of the Oswego River in Burlington County—was a small community of workers and their families that supported Martha's Furnace from 1808 to 1834. Martha's Furnace and Calico are gone, but the laurel continues to grow there.

Sheep laurel is much smaller than mountain laurel and has deep crimson-pink flowers. It is also called sheepkill or lambkill, based on an old Piney belief that the foliage of the plant is poisonous, especially to sheep. This is probably true, according to Dr. Cecil C. Still, professor of plant science, Cook College, Rutgers University, in his book, *Botany and Healing*.

The laurel found in South Jersey belongs to a different family than Grecian laurel, but like Apollo's sacred plant it stays green throughout the year. It joins Atlantic white cedar, holly, and pines in bringing beauty to the Pine Barrens in winter.

Below: Mountain laurel in bloom
Right: Closeup of sheep laurel

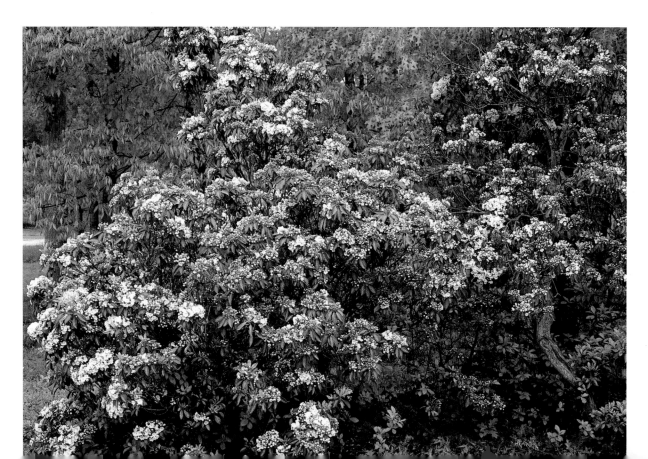

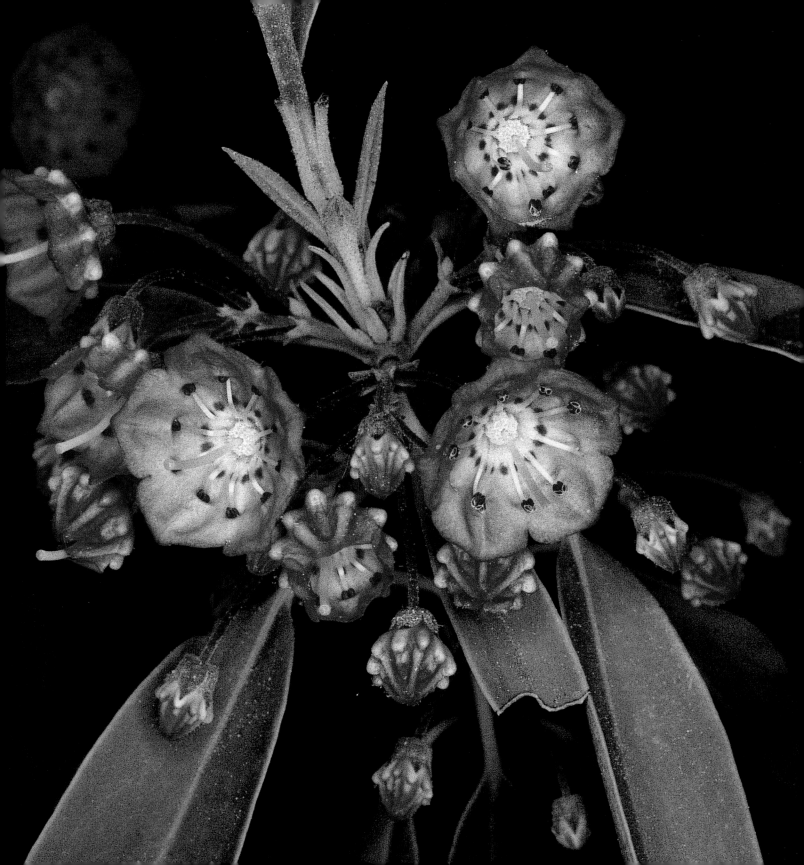

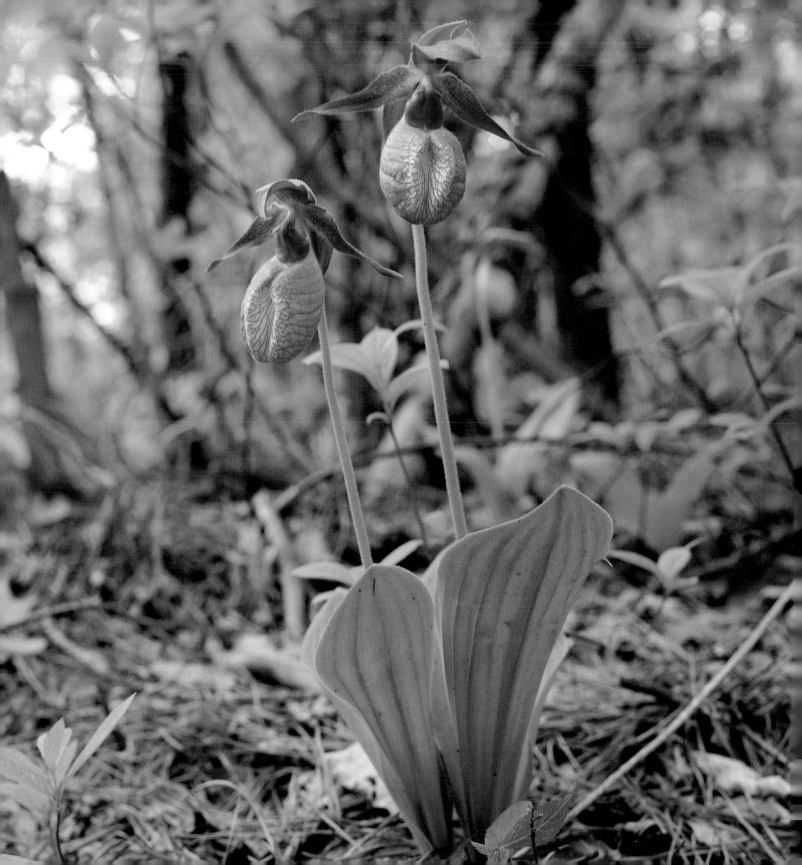

Chapter Thirty

Wild Orchids

Orchids are part of the largest plant family in the world, with some 20,000 varieties representing nearly 10 percent of all plant species. Many orchids grow in South Jersey, and their flowers have come to symbolize the botanical heritage of the Pine Barrens as a result of their beauty and fragility.

People think of orchids as exotic plants that can only be found in the tropics; however, every state in the Union has one or more species of orchids, and Minnesota has officially adopted an orchid as its state flower. Orchids can be found on the chill, bleak meadows of Patagonia and the frigid dales of Alaska, in the Himalayas, and in the deserts of Australia, as well as in our own Pine Barrens.

In the 19th century, orchids were the domain of millionaires in Britain and America and the upper classes in Europe. Hobbyists have learned how to find, grow, and breed orchids; today there are more than two million orchidists worldwide. Throughout South Jersey history, even the poorest of Pinelands dwellers could see orchids that would make the most avid collector green with envy. As Homer House put it in his book, *Wild Flowers*, "It is doubtful if any flower surpasses the orchid in beauty."

Pink lady's slipper

There are many varieties of orchids in the Pine Barrens. The most common is the lady's slipper, which can appear in yellow and white, but is most often pink. Its Latin name, *Cypripedium acaule,* means "shoe of Venus." The lady's slipper's resplendent, cup-shaped blossoms are reminiscent of traditional Dutch wooden shoes. Early settlers in South Jersey called it the "moccasin flower," and it has also been referred to as the silver slipper, the queen's slipper, and the whippoorwill's shoe.

The grass pink orchid, which can be found in fresh-water bogs, has a reversed lip covered with glossy yellow hairs that resemble nectar-laden stamens. Like a number of other orchids, the grass pink orchid attracts bees by deceiving the insect into thinking that a feast awaits it. But because there is no nectar, the bee leaves empty-handed.

The white fringed orchid is the largest and most common member of the fringed orchid family found in the Pine Barrens. It has a large spike of small white flowers with a fringed lip and grows along bogs and wetlands. Called the "prince of the Pinelands" because of its showy flowers, it blooms in July.

The dragon's mouth orchid, *Arethusa bulbosa*, is named after the nymph Arethusa, who was one of the attendants of the goddess Diana. Its magenta-pink blossom has a beautiful lower lip spotted with purple and

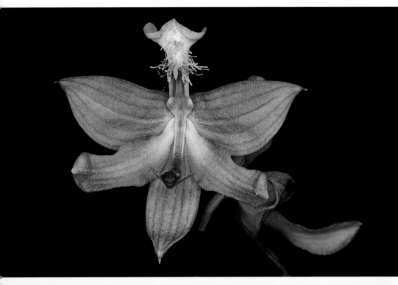

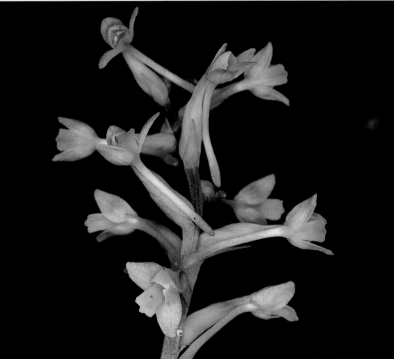

crested with yellow hairs. The lower lip serves as a landing platform for visiting insects, usually bumblebees.

There are approximately twenty-seven other types of orchids that grow in the Pine Barrens, each beautiful in its own way, and each with a different blooming time.

Our fascination with the orchid goes back thousands of years, long before explorers came to the Pine Barrens. In the ancient Middle East, people ate certain types of orchids, while during the Renaissance orchids were used as aphrodisiacs. The Chinese cultivated the cymbidium, a type of orchid, for centuries. The first settlers in South Jersey found that the Lenape Indians used lady's slipper orchids as a medicinal herb. The orchids' roots were boiled with a small amount of sweet substance and the resulting broth was used to treat headaches and other simple maladies.

The first orchid was cultivated in the Western World in 1731. That year, Peter Collinson of England successfully transplanted and cultivated an orchid from the Bahamas. In the 19th century, an orchid craze swept through Europe and America. Plants were gathered by the thousands from all over the globe to fill the greenhouses and gardens of collectors on both sides of the Atlantic. Practical uses were also found—one orchid, the vanilla planifolia, is the original source of commercial vanilla extract. But orchids were grown most often for their rare beauty and the romance and mystery they represented. Wealthy collectors and commercial firms sent adventurers looking for orchids in the

Top Left: Grass pink
Bottom Left: Green woodland orchid
Right: Arethusa or dragon's mouth

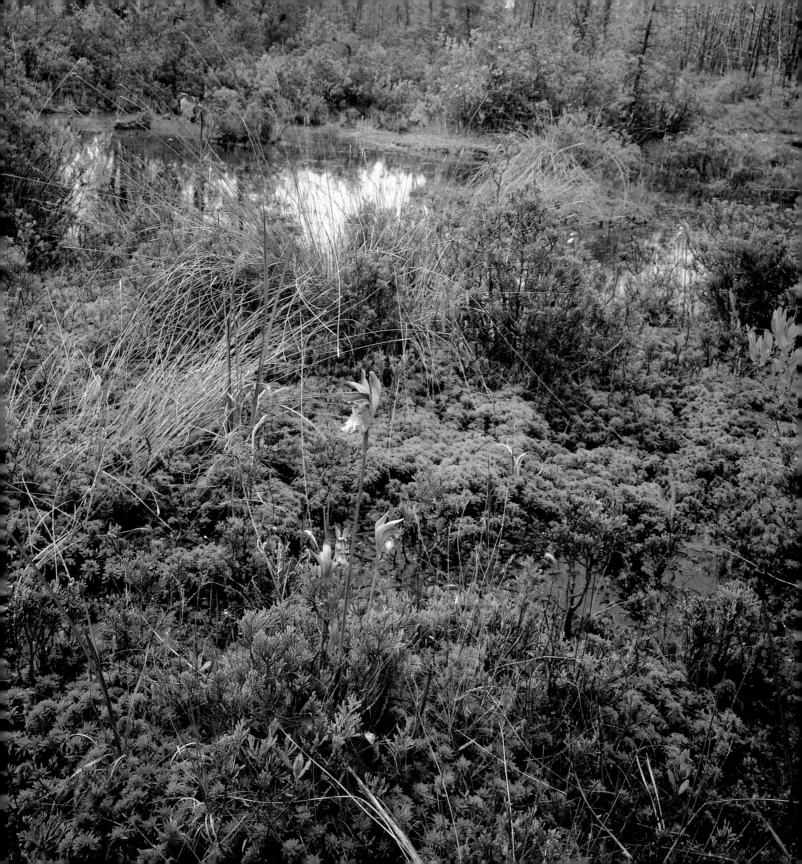

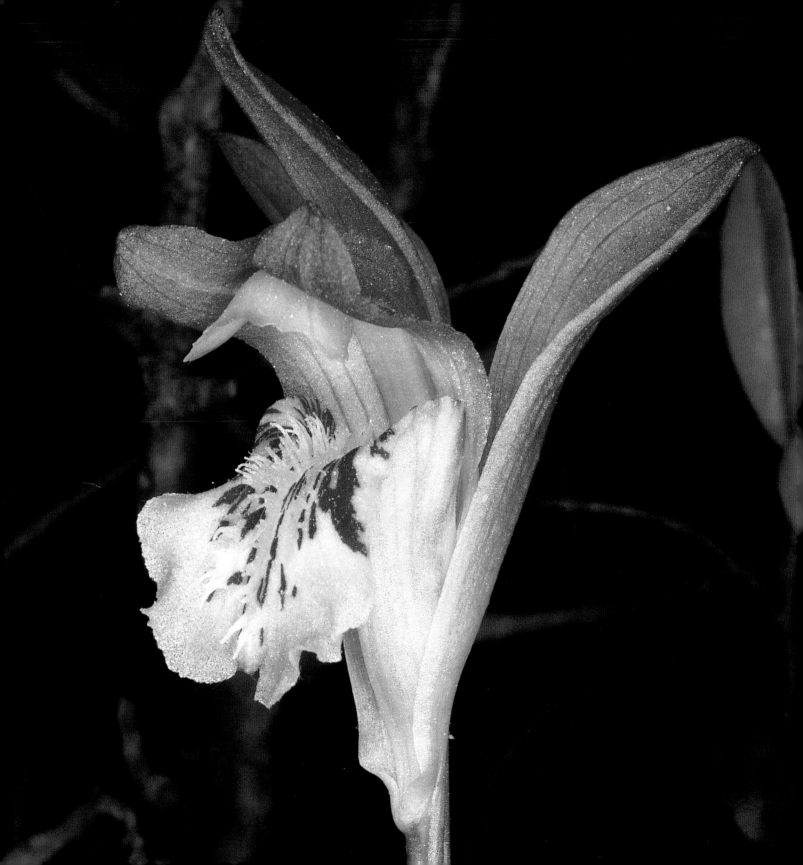

Columbian Andes, India, the Philippines, Malaysia, and the Pine Barrens of New Jersey. Astronomical prices were paid for particularly rare or choice species, with some collections containing up to one million specimens. It was during this period that orchids were nearly gathered to extinction.

You don't have to spend a fortune to search for wild orchids today, but you might pay a hefty fine if you try to dig one up—most orchids are on the endangered species list. Pine Barrens orchids are difficult to transplant anyway, because many have a symbiotic relationship with underground fungus. The orchid supplies the fungi with sugar and receives nutrients in return. The fungus cannot be transplanted, making it almost impossible to move its orchid partner.

How then can you enjoy South Jersey's wild orchids? If you are familiar with local forests, you can search on your own to take a look or a photograph. Another option is to go to Greenwood Forest State Wildlife Management Area, in Lacey Township, Ocean County, where you will find a site known as "the cedar bog at Webb's Mill." The entrance to this site is on Route 539, six miles north of the intersection of Routes 72 and 539. There is public access through a partially burned cedar stand to a circular boardwalk from which orchids and other Pinelands flowers can be viewed. The boardwalk is maintained by the New Jersey Division of Fish, Game, and Wildlife.

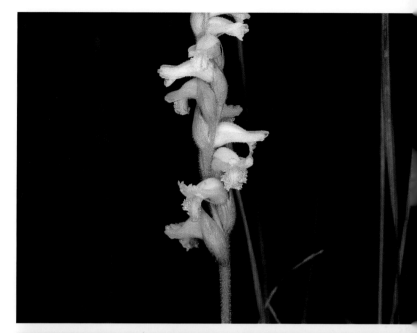

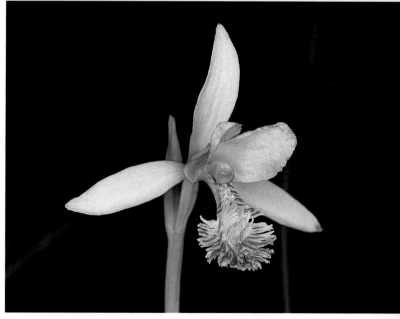

Left: Detail of dragon's mouth
Top Right: Knodding ladies tresses
Bottom Right: Rose pagonia

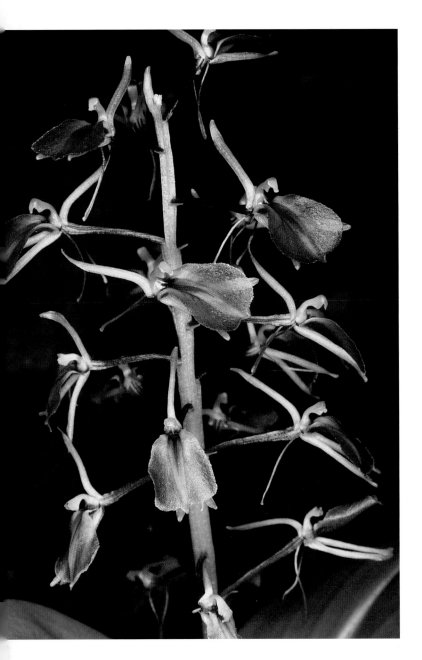

Unfortunately, many other orchid sites previously documented by Witmer Stone in his *The Plants of Southern New Jersey* have gone the way of the bulldozer.

The orchids of South Jersey attract scientists and lay people alike. Because of their beauty and fragility, researchers have come here from all over the world—including as far away as Japan—to study orchids in the Pine Barrens.

Above: Lily leaf-twayblade
Opposite Page
 Left: White-fringed orchid
 Top Right: Southern yellow orchid
 Middle: Ragged-fringed orchid
 Bottom: Yellow-fringed orchid

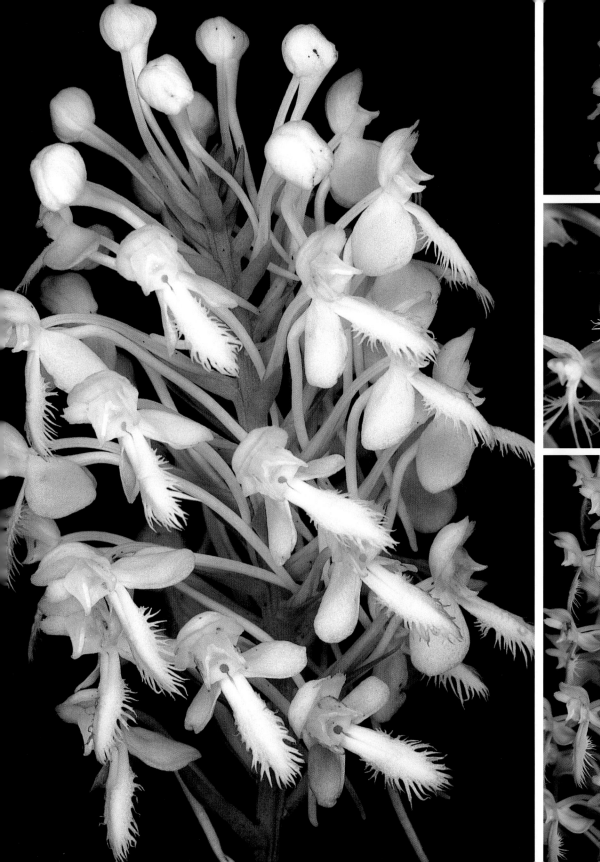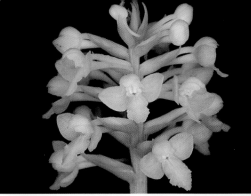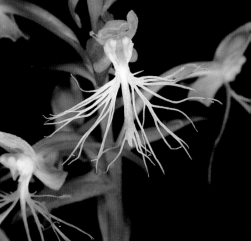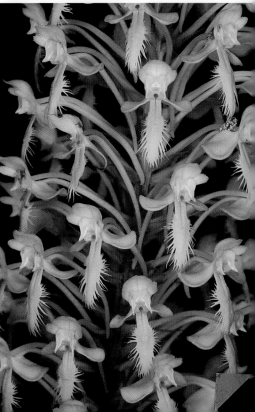

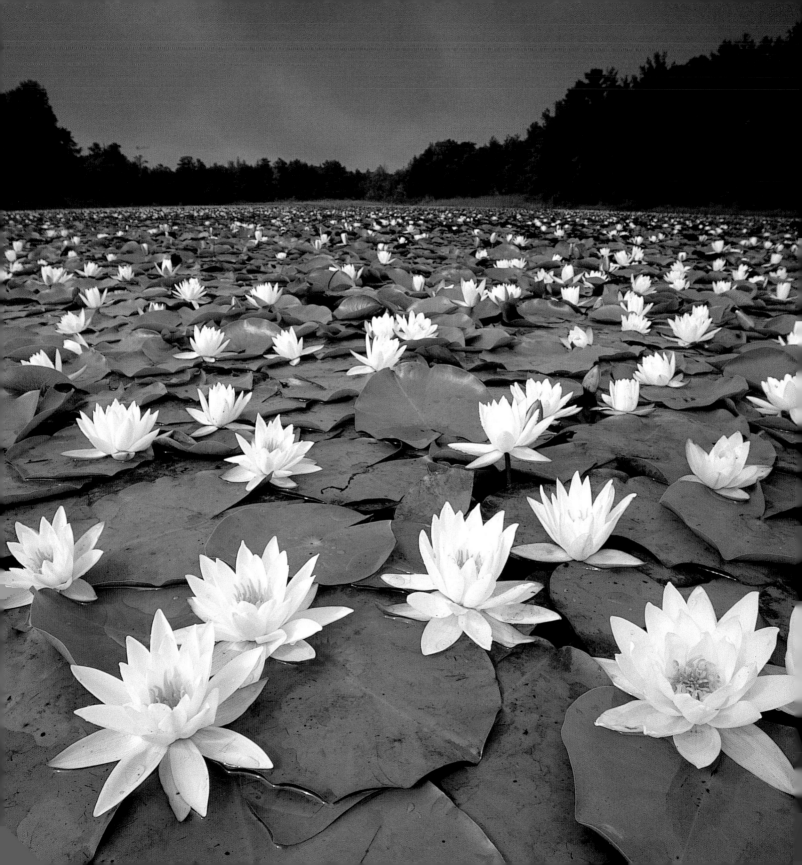

Chapter Thirty-One

Water Lilies

Humans have long been fascinated by the beauty of the water lily, floating in clusters on top of lakes and ponds. Lily pads appear frequently in children's stories, art, and world literature. They are common throughout South Jersey. If you study the water lily closely, you'll find that it does indeed deserve all the attention it gets—and then some.

The water lily is beautifully designed, perfectly created for life both in and out of the water. Like a number of other aquatic plants, it has two kinds of leaves—those that grow under the water and those that either float on or thrust above the surface. The underwater leaves are tough, pliant, and thin, offering little resistance to currents. They are covered with mucus, a coating that both discourages animals from eating them and protects them when currents cause the plants to rub against each other.

The floating leaves, on the other hand, are broad and raft-like, exposing a large surface to the sun and providing a firm base for the flower stalks. If you examine a floating lily leaf carefully you will notice that the two surfaces are quite different—one side designed to be exposed to the air, the other to water. If water is sprinkled on the upper surface, it is repelled. The bottom side, on the other hand, is actually attracted to water.

Water lilies protect the Pine Barrens ecosystem by providing shade for aquatic life in ponds. They are also used as landing areas for frogs and insects. Many homeowners who build ponds today immediately stock them with water lilies—a testimony to the usefulness and beauty of this plant. Water lilies are certain to remain a theme of artists and writers alike, and they are an integral part of the Pine Barrens ecosystem.

Left: Fragrant water lilies (Photograph by Steve Greer)

Chapter Thirty-Two

Bog Asphodel

Unlike some Pinelands plants, many of which have been enjoyed by humans for centuries, the bog asphodel has been little used or treasured. A cluster of bright yellow flowers may have been appreciated by some woodcutter or modern-day hiker, but otherwise bog asphodel has had little interaction with humans.

The bog asphodel is a member of the beautiful lily family. Found mostly in wet, peaty sands or bogs in the heart of the Pine Barrens, it grows in isolated patches. Bog asphodel has small, shiny, star-like flowers in a short spike on top of an eight- to sixteen-inch stalk. A patch of yellow asphodel in early summer is one of the more impressive sights in the Pine Barrens. In the fall, bog asphodel lends some color to the Pine Barrens as the seed capsules turn a rich, reddish brown.

The bog asphodel is now in danger of extinction, not because of overuse or excessive harvesting by man, but because of loss of habitat (today, the plant is found only in The Pine Barrens, with fewer than 20 known populations). As a result, bog asphodel has been placed on the endangered species list, and efforts are underway to guarantee its survival.

When considering endangered species, it may come as a shock to realize that almost 90 percent of all species that have ever existed (if we include the fossil record) are now extinct. In most cases, humans have apparently had little to do with the process. Rather than a trend toward more species and more diversity, we see a trend toward fewer plants and animals. Thus, even though the bog asphodel has been little used by humans, its survival may depend on the choices we make over the next few years. As the famous philosopher-scientist Blaise Pascal once said, "Man is but a reed, but he is a thinking reed. And that makes all the difference."

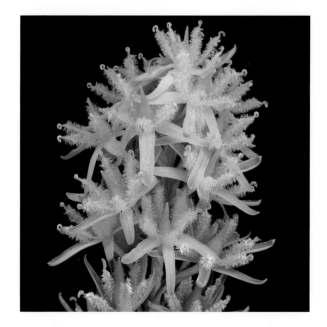

Left: A patch of bog asphodel
Right: Detail of bog asphodel

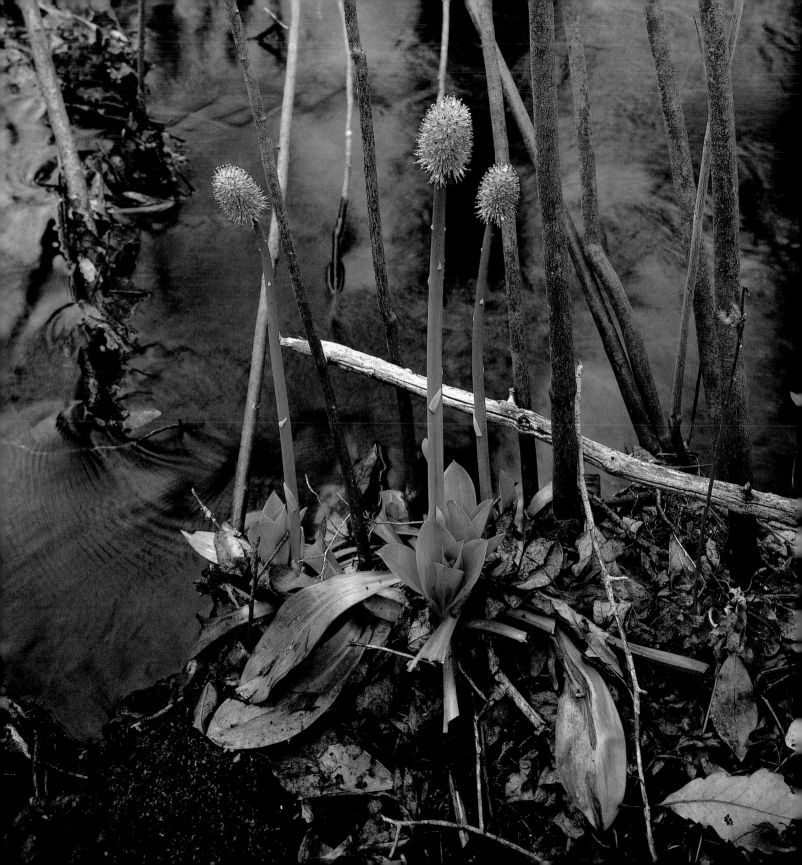

Chapter Thirty-Three

Swamp Pink

One of the first flowers to bloom in the Pine Barrens in spring is the lovely swamp pink. Hence, it is among the "first fruits" brought forth by this deceptively fertile land—fertile, that is, for the right kinds of plants. Swamp pink begins to bloom in mid-April while its flowering head is still close to the ground. It grows out of a center rosette of narrow evergreen leaves. The flower continues to bloom as the stalk grows. By the time the stalk is a foot high, the flowers are in full bloom. Its lilac-pink blossoms, with contrasting blue stamens, create a striking contrast against the brown bogs and forest, still dark and dead-looking from the winter. Many Pine Barrens naturalists consider swamp pink to be the most beautiful of all Pine Barrens flowers. Unfortunately, it is also one of our most endangered plant species.

In the 19th century, Ralph Waldo Emerson wondered about the purpose of a rhodora he encountered while walking in the woods one spring day. Admiring this humble shrub with delicate purplish-pink blossoms, he asked, "Why has God placed such a beautiful flower here hidden from men?" He then answered his own question in his now famous poem, "The Rhodora":

Rhodora! If the sages ask thee why
This charm is wasted on the earth and sky,
Tell them, dear, that if eyes were made for seeing,
Then Beauty is its own excuse for being:
Why thou wert there, O rival of the rose!
I never thought to ask, I never knew:
But, in my simple ignorance, suppose/The self-same
Power that brought me there brought you.

Both the rhodora and the swamp pink are part of the forests that replenish our air. Everything in nature has a purpose, and when one plant or animal is lost, everything else is affected. As English poet Francis Thompson once wrote, "Thou canst not touch a flower without disturbing a star."

Left: The lilac-pink blossoms of the swamp pink, with contrasting blue stamens, create a striking contrast against the brown bogs and forest. Right: Detail of the delicate purplish-pink blossoms

Chapter Thirty-Four

Pine Barrens Gentian

In September, farmers on the fringes of the Pine Barrens hasten their activities as they engage in the end of the harvest. The days grow shorter; autumn is in the air. There are far fewer flowering plants in bloom. As temperatures fall, the growing season wanes. There is little time left for plants to blossom, have their blooms fertilized by insects, allow seeds to ripen, and then allow the winds to scatter them for the following year.

One rare flower, however, defies the normal growing season and blooms in September: the beautiful Pine Barrens gentian, or *Gentiana autumnalis*. The gentian family received its name from King Gentius of Illyria who, according to the Roman naturalist Pliny the Elder, discovered the medicinal quality of its roots as an emetic, cathartic, and tonic.

Naturalist Howard Boyd says that although Pine Barrens gentian was first discovered by William Bartram of Philadelphia in 1758, "undoubtedly from the New Jersey Pine Barrens," it was not properly classified until 1791 from specimens found in South Carolina. Other gentians found in the Pine Barrens include the lance-leaved sabatia, upright and twining bartonia, and soapwort gentian.

Writing of the closely related fringed gentian, American poet William Cullen Bryant describes a flower that "waitest late and com'st alone,/ When woods are bare and birds are flown,/ And frosts and shortening days portend/ The aged year is near his end."

Just as the flower Bryant described looked heavenward at the end of its short blooming season, he prayed that he too "could look to heaven" as he departed. The gentian is a picture of life itself—fragile, beautiful, and short-lived.

Left: Pine Barrens gentian
Right: Closeup of gentian in bloom

Chapter Thirty-Five

Sphagnum Moss

During World War I, when shortages of medical supplies, including bandages, became acute, the hue and cry went out for a substance the Pineys had long known for its marvelous powers of absorption—sphagnum moss.

It's almost impossible to walk into a cedar swamp and not find extensive mats of sphagnum or peat moss. Generally, sphagnum is the name given to the moss before it decays, while peat is the name given to the decayed, compressed moss. Peat is formed over time, as older sphagnum plants decay and become compressed into masses at the bottom of bogs. When dug, the peat can be cut into bricks, dried, and used as fuel. The quality and quantity of Pine Barrens peat moss was never good enough to justify exploitation, in contrast to old Scotland and Ireland, where peat was often the only form of fuel. However, peat bogs here, as elsewhere, contain preserved plant and animal forms that can yield valuable information about past ecological conditions. Peat moss is also used by gardeners to loosen and improve their soils.

But what makes sphagnum moss so unique is its ability to hold large amounts of water. Since sphagnum moss can absorb many times its own weight, it helps to conserve water, prevent soil erosion, and even control floods. Without the absorbency of our sphagnum moss swamps, rainfall would spill over and cause much more erosion than we currently experience.

Until the 1950s, the gathering of sphagnum moss was a major Pinelands industry. In addition to selling the moss for use in surgical dressings, it was sold to florists as a base for floral arrangements. Before the invention of styrofoam, it was the base of choice for florists from Canada to Florida.

Growing like a rug with a golden fringe, sphagnum moss was raked out by Pine Barrens gatherers as part of a seasonal harvesting schedule. Money earned from the moss supplemented their incomes from state jobs, road work, and other Pine Barrens occupations.

The moss gatherers would take wheelbarrows, buckets, pitchforks, and rakes into the swamps, pull the moss off the ground, and hang it up to dry. Sometimes the workers would hang it over the cedar hassocks, or the above-ground root systems that poke out of every cedar swamp. After two or three days, the moss, which could weigh as much as 200 pounds wet, would dry to a mere 15 pounds.

Sphagnum moss was used to absorb liquid in homemade and commercial medical dressings and later in army hospitals on the battlefield. (The Lenape used it to make diapers.) In Ireland, Scotland, and, of course,

Sphagnum moss

South Jersey, moss has long been used in the treatment of boils and wounds. During the Napoleonic and Franco-Prussian Wars, army surgeons recommended sphagnum for patients far from established hospitals. An anecdote from the Russo-Japanese War states that Japanese soldiers were given sphagnum dressings and sent on 10-day trips home unattended. Upon examination, these soldiers' wounds had healed better than those of soldiers who had been bandaged immediately with cotton.

Professor George Nicols of the Sheffield Scientific School lent scientific authority to the use of moss as a medical dressing. According to Professor Nicols, a workman in the peat moors of northern Germany made the original discovery of the curative values of sphagnum. One day, far from town, this workman severely cut himself. With nothing else available to dress the wound, he wrapped his arm in peat. Ten days later he was able to get surgical aid. The physician who examined him was so amazed that he began experiments in Germany on the medicinal value of moss.

During World War I, the British War Office officially adopted sphagnum dressings. In September of 1916, the front cover of the *London Graphic* carried this headline: "Are You Collecting Sphagnum Moss?"

Even if the average English person wasn't collecting moss, you can bet a lot of Pineys were. At this same time, the American Red Cross was providing 20,000 moss dressings a month—a small amount compared to what was being used in Europe.

Today, moss dressings may seem strange, especially when compared to the familiar cotton. But what's the difference between cotton, which grows on a bush, and moss, which grows in carpet form in cedar swamps? Professor Nicols' report does point out one major difference: Sphagnum absorbs liquids three times as fast as absorbent cotton. Whereas a cotton pad will absorb five to six times its weight in water, a pad of sphagnum will take up to eighteen times its weight in water. What this means for patients—especially for those far from civilization (such as on a battlefield)—is that the dressing doesn't need to be changed as often.

Sphagnum wasn't used in World War II because cotton was more plentiful and less expensive. When styrofoam was adopted for use by florists, the bottom fell out from whatever sphagnum market was left.

You won't find sphagnum swabs or bandages in the drug store today, but the next time you get cut out in the woods, consider good old sphagnum moss to dress the wound.

Left: Closeup of sphagnum moss

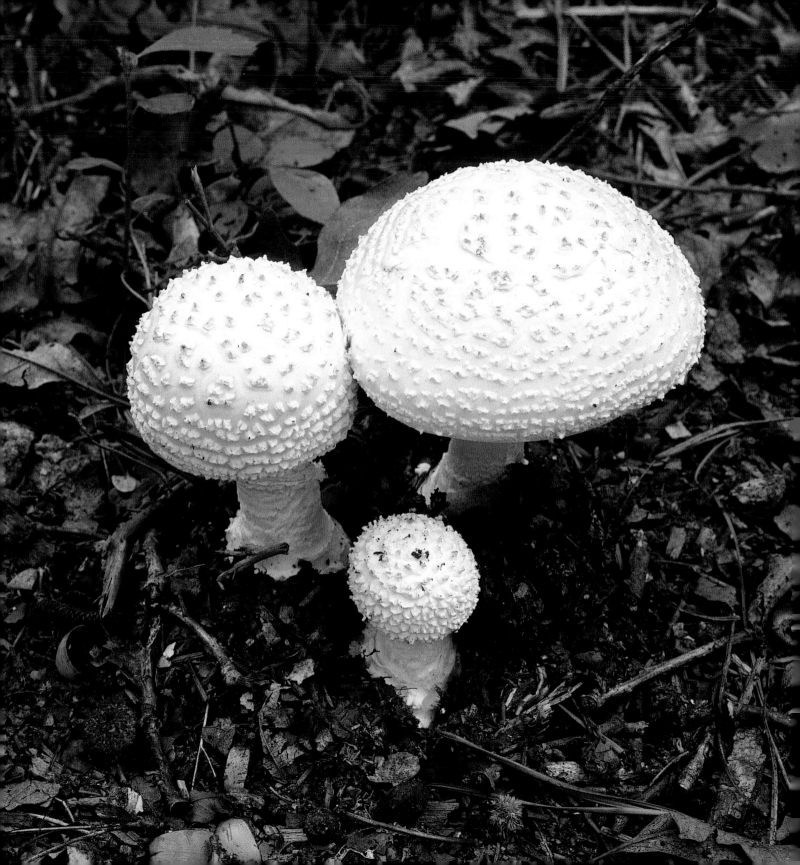

Chapter Thirty-Six

Mushrooms

According to Greek mythology, mushrooms were formed whenever Zeus threw his lightning bolts to the ground. If that's the case, then Zeus must have been angry at someone in the Pine Barrens, because the local woods are full of mushrooms.

Mushrooms grow wherever the ground is moist and there is enough organic matter—pine needles and cones, leaves, and fallen branches—to sustain them. In this world there are two types of creatures: those that make food (green plants), and those that gather food, such as animals and some fungi like mushrooms. Mushrooms "gather food" by feeding on dead organic matter or forming a symbiotic relationship with trees.

The Pine Barrens contains a number of poisonous mushrooms. One is the deadly destroying angel, *Amanita bisporigera*. Another is the yellow-orange fly agaric, *Amanita muscaria*. The fly agaric mushroom was used by American colonists, who cut it up and mixed it with sugar or milk to attract and stun flies.

There are many edible mushrooms in the Pine Barrens as well. People who hunt for wild mushrooms for food are called pot hunters, or formally, mycophagists. Edible local mushrooms include the varied Russula (*Russula variata*), which grows near oak trees and appears in July. The *variata* is a bit larger than the white button mushrooms sold in the store; the color of its cap can be light red, purple, or green. In September, the redcapped scaber stalk can be collected in the Pine Barrens. Pot hunters will dry this mushroom in the sun and then finish the job in an oven set on low. September also yields the honey mushroom, which grows on old oak stumps.

It goes without saying that no one should eat a mushroom grown in the wild without the advice of an experienced mycophagist. In the early 20th century, such mycophagists came to South Jersey from southern and eastern Europe and settled in ethnic communities from Hammonton to Cassville. Italian-Americans tell stories about their grandfathers going out into the woods and hunting for mushrooms. Upon returning, they would boil them with a coin; if the coin turned black, the mushroom was poisonous. (Do not trust this method—it does not work.)

In Cassville, in the northern reaches of the Pine Barrens, Russian-Americans have been harvesting mushrooms from the forest for decades. Mushrooms were important ingredients in Russian cooking in the Old World, and immigrants enjoyed eating familiar

Left: A member of the lepidella *section of the genus*
Page 176: Clavulina corona, commonly called crown's coral fungus
Page 177: A member of the genus Gymnopus *(meaning "naked foot").*
 Many members of this genus are bitter and metallic-tasting.

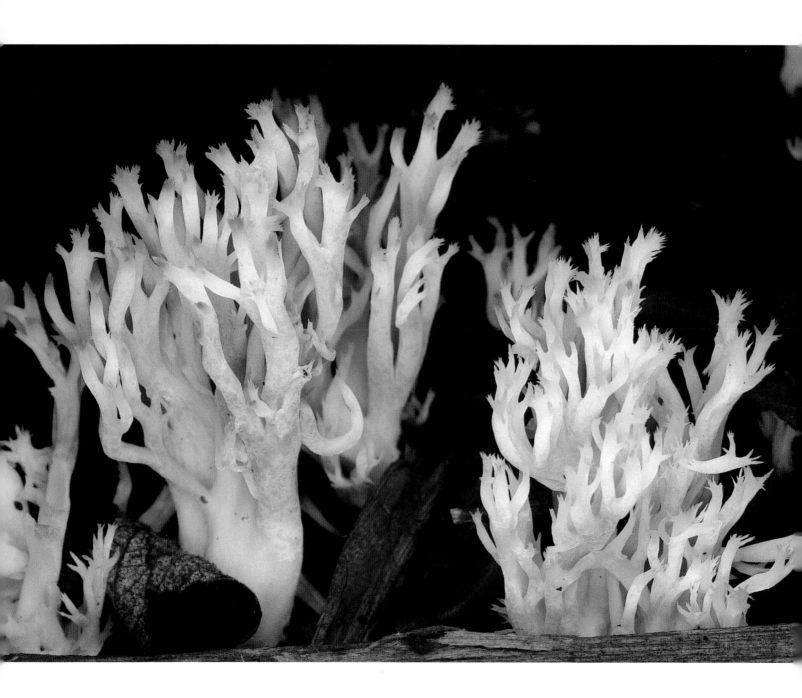

Mushrooms

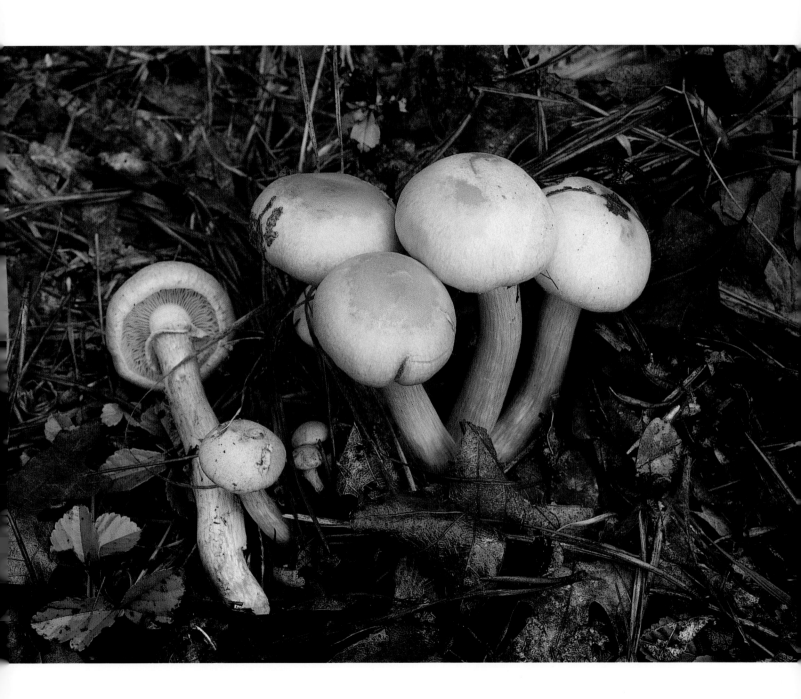

foods here in America. Dried and pickled mushrooms appear in many Russian dishes, especially during the meatless Orthodox Lenten season. Mushroom hunting is a skill that Russian-American girls learned from their mothers and grandmothers. South of Cassville, the good mushrooms are usually found under nut trees and on old stumps.

Writing of life on Earth, the famous French biologist Jaques Monod once quipped: "Man's number came up in the Monte Carlo games." In more recent times, many thinkers have built on this concept and taught that everything in life is based on chance—hence the music of a John Cage or the painting of a Jackson Pollock. An experienced pot hunter, who may have never heard of Cage or Jean-Paul Sartre, would tell you otherwise. "If you pick and eat mushrooms by chance," said one Piney, " yer gonna die." Life apparently is not based on chance, but on intelligent, informed decisions.

The wild mushroom is a reminder that balancing Pine Barrens preservation with development, like life itself, is best not left to chance, but to wise planning and decision making.

Below: A cluster of forest mushrooms
Right: A member of the genus Boletus, *a pine and oak symbiont*

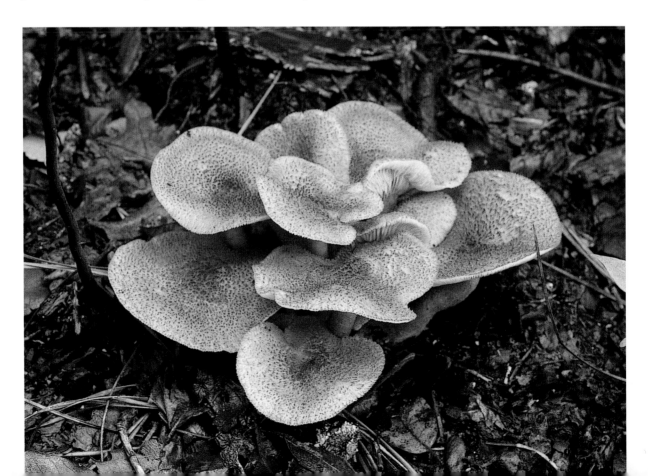

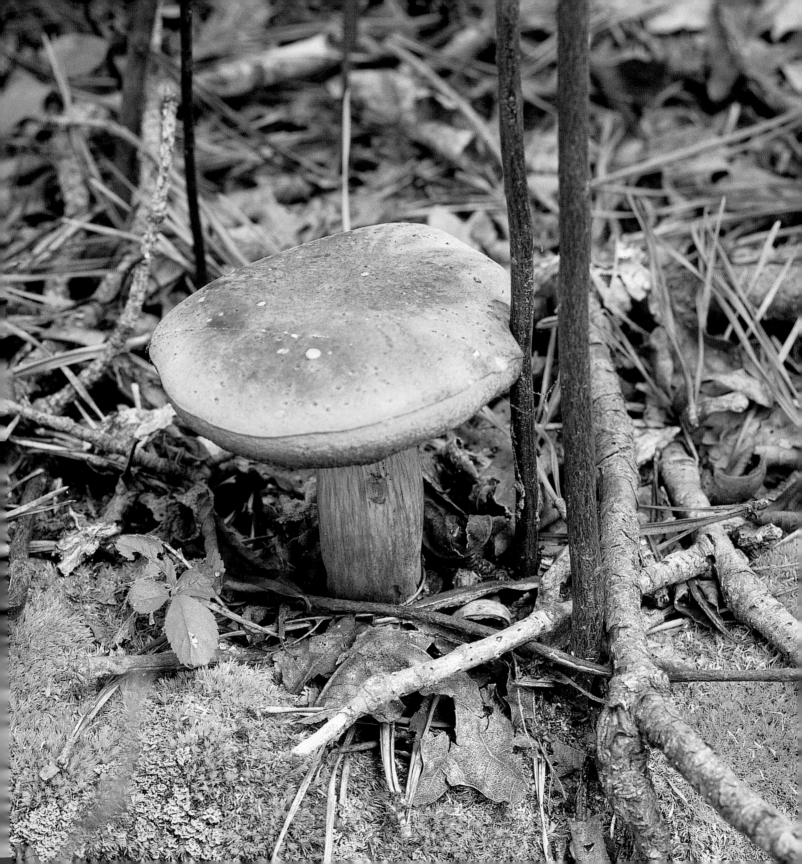

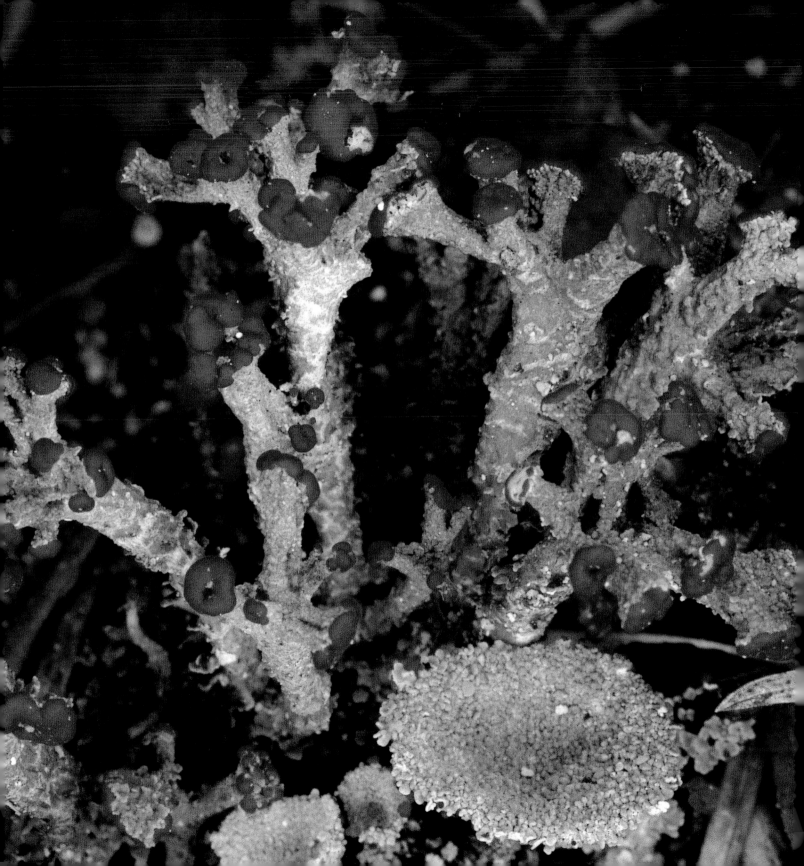

Chapter Thirty-Seven

Lichens

One of the most beautiful decorations on the forest floor of the Pine Barrens is that of lichens. Lichens are dual organisms composed of both algae and fungi growing together in a mutually beneficial relationship. In each lichen, the fungus forms the natural body and provides the water and the minerals. The alga, meanwhile, manufactures food for the lichen because it contains chlorophyll, which the fungus lacks.

The Pine Barrens includes many different types of lichens. There are reindeer (or thorn) lichens, which are gray-green in color and have little branches that resemble reindeer antlers. In Canada and Alaska, these lichens are, in fact, food for reindeer and caribou. Many lichens have been named for their shape—the pixie-cup, slender ladder, and awl lichen among them. Perhaps the most easily recognizable is the British Soldier lichen, whose bright red tops are reminiscent of the red coats worn by British soldiers in the 1700s. Swamp lichen is similar in appearance to British Soldier lichen, while shield lichen looks like gray-green rosettes growing on the sides of trees. Tar lichen resembles black tar poured on the forest floor.

Instead of being devoured by the fungus, the alga finds itself in a healthy situation surrounded by its water-holding threads. (Algae need water to survive.)

British soldier lichen

Because the fungus threads are translucent, the alga inside gets all the light it needs for photosynthesis. The fungus finds itself embracing a food-making organ, since the green alga acts like a green leaf. The lichen is an air plant: It does not need to take nourishment from anything living or dead, and thus can flourish in an utterly sterile place. Hence it is called a "pioneer plant," which grows where nothing else can: on stones, in burned out forests, and in the sand—in other words, in much of the Pine Barrens.

A lichen attaches itself to rock by emitting a powerful acid that dissolves rock crystals, then pushes a tough holdfast into the tiny breech. Chemists have identified more than 140 lichen acids, any of which could be fatal to the organism's protoplasm. The fungus partner generates these acids outside of its cells and the alga partner generates alcohol that converts the acids to salt crystals. In this form, the acids are stored between the threads of the fungus, and the living cells are not harmed. Lichens get their color from the salt crystals, which reflect the spectrum of sunlight like tiny diamonds.

Unlike other plants in the forest, lichens have no genes and thus no descendants. They are not perpetuated directly through spores or seeds. No one ever knows the age of a lichen. As Rutherford Platt, author of *This Green World* (1944), put it, "A lichen is always

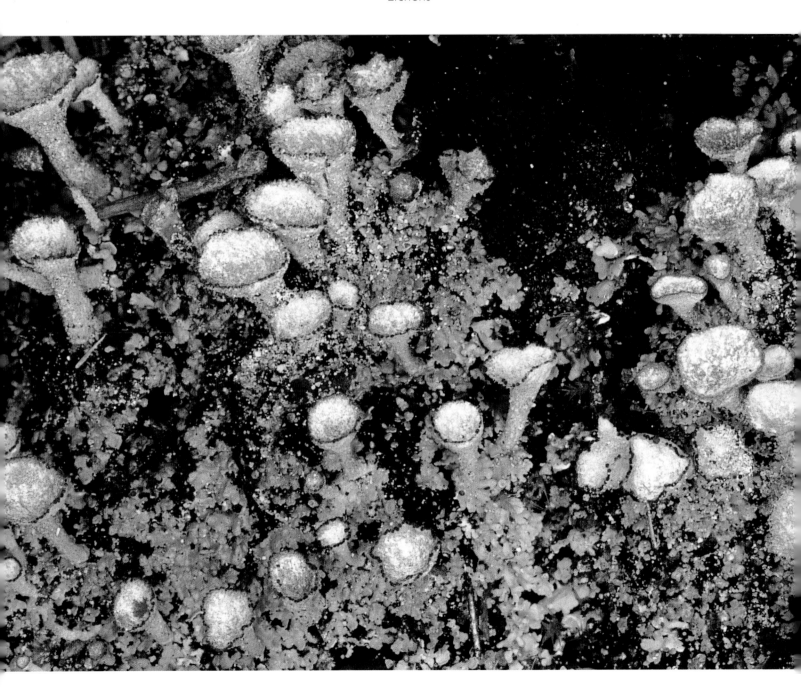

Lichens

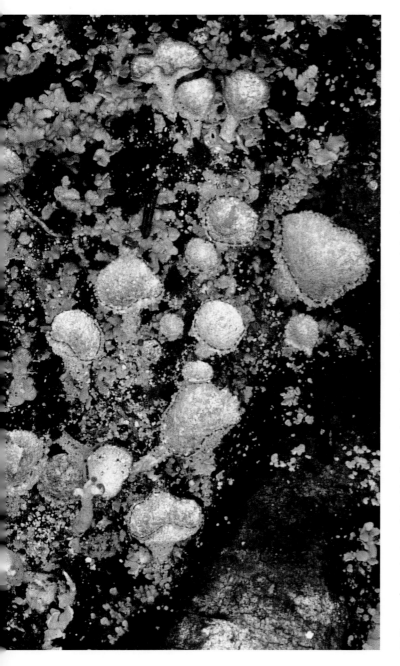

mature, ever full-grown. It has no life cycle between birth and death. Born in the forest leaf carpet, a lichen is the healthiest, most unfailing, most fantastic decoration in the forest. … In terms of survival a lichen is close to perfection." With such perfection, we might wonder why or how any more evolution could occur.

Lichens reproduce in several ways. First, they emit a silvery dust where each grain of dust is one green alga cell wrapped in fungi-like threads. This parcel is left on the outside of the lichen so that when the wind blows, the dust is carried off into the forest. When the parcel lands, it may sprout. Lichens also reproduce when pieces break off and are spread by the wind and elements. Finally, the fungus part of the lichen emits spores, which can link up with green algae. They are produced in astronomical number, and they float everywhere in the forest. By the law of averages, enough meet up to form new lichens. You might wonder how the first alga and fungi got together. Was there a committee? Did one try to devour or absorb the other? Why are these two living things attracted to one another?

One thing is for sure: lichens represent the kind of mutual aid we often see in the Pine Barrens and in the natural world as a whole. The concept of mutual aid (symbiosis on a grander scale) was first advanced by the early Russian naturalist Prince Peter Kropotkin. Kropotkin was of the Russian aristocracy and was trained for the Czarist Army, but he loved the natural

Left: Pyxie-cup lichen
Pages 184–185: Teaberry and lichen

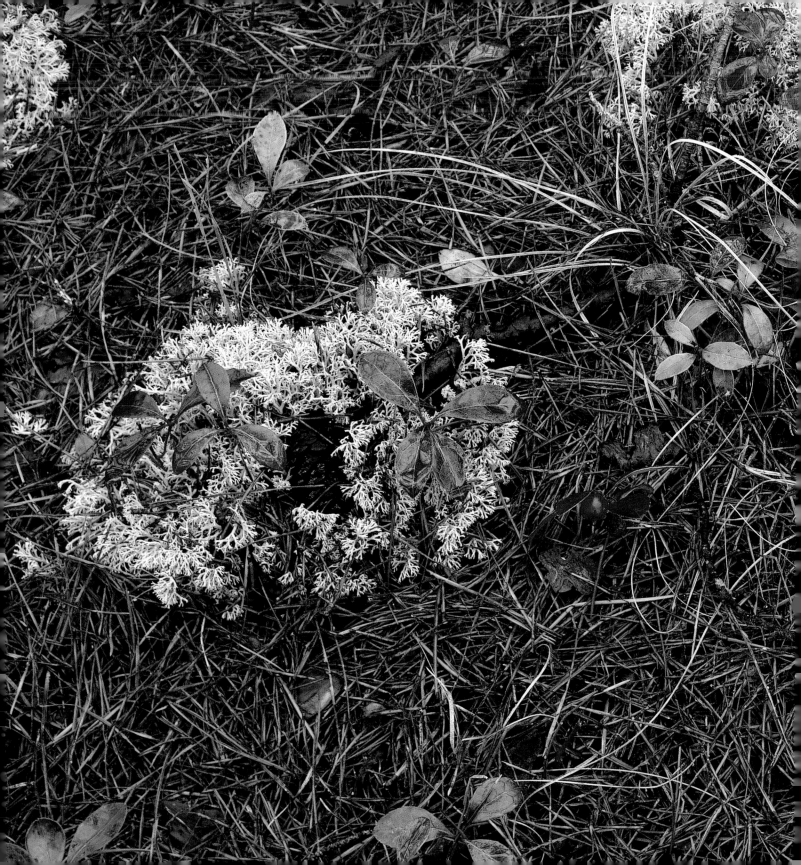

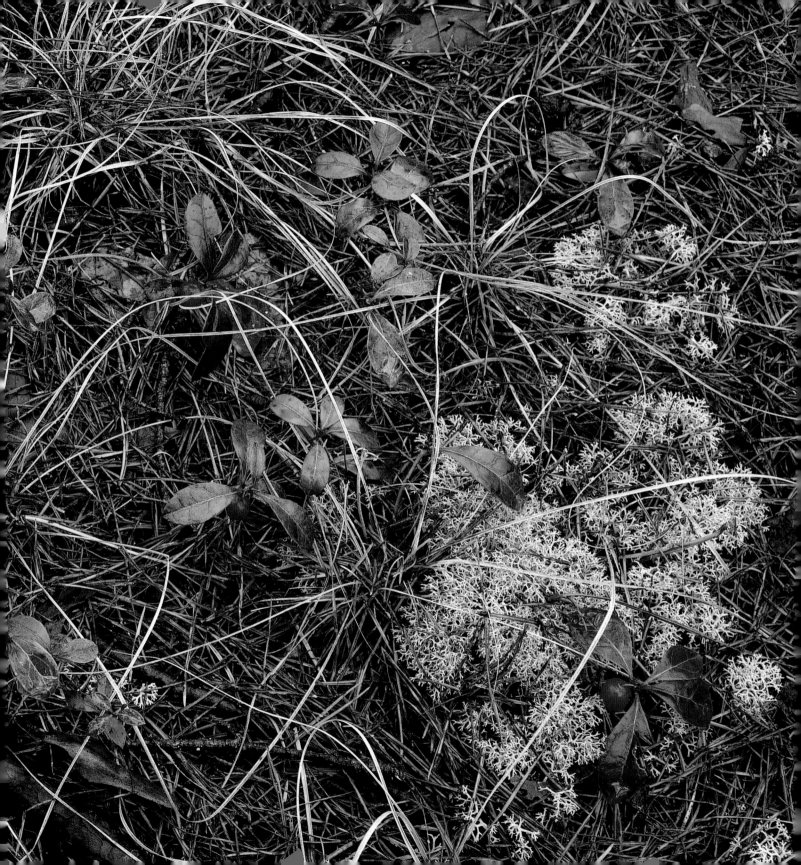

sciences. In order to study nature in its most virgin state, he obtained a commission in a Siberian Regiment. Kropotkin expected to see the wilderness "red in tooth and claw," as Tennyson had written. Instead, what Kropotkin found was just the opposite. He published his findings in a now famous book entitled *Mutual Aid*. In one passage, Kropotkin wrote:

> Wherever I saw animal life in abundance, as for instance, on the lakes where scores of species and millions of individuals came together to rear their progeny; in the colonies of rodents, in the migrations of birds which took place at that time on a truly American scale along the Usuri; and especially in a migration of fallow-deer which I witnessed on the Amur, and during which scores of thousands of these intelligent animals came together from an immense territory, flying before the coming deep snow, in order to cross the Amur where it is narrowest—in all these scenes of animal life which passed before my eyes, I saw Mutual Aid and Mutual Support carried on to an extent which made me suspect in it a feature of the greatest importance for the maintenance of life and the preservation of each species.

Kropotkin went on to show how living creatures worked together for mutual benefit. Kropotkin didn't write about lichens, but perhaps no other plant better represents mutual aid. Actually two plants working together, the lichen is a pioneer plant that helps prepare the ground for new growth and eventually animal life. Lichens thus perform an essential function in the natural rhythm of life.

Left: Slender ladder lichen
Above: False reindeer or thorn lichen

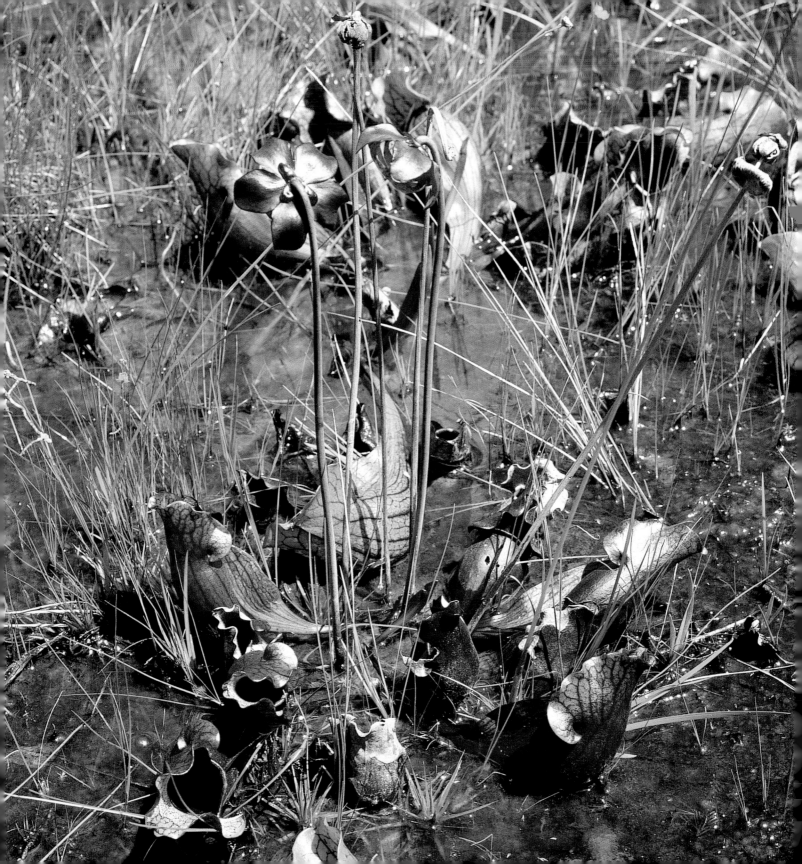

Chapter Thirty-Eight

Carnivorous Plants

In the hey-day of science fiction movies in the 1950s, more than a few featured the horror of "man-eating" plants. There is no record of man-eating plants in the Pine Barrens, but there are plenty of plants that eat insects. Generally, these plants are referred to as insectivorous or carnivorous bog plants and include pitcher plants, sundews, and bladderworts. The first two often find themselves the subject of local art. All are found in acid water in nutrient-poor, boggy sands that lack the basic ingredients—especially nitrogen—needed for healthy plant growth. By trapping insects, they obtain nitrogen and other nutritious elements, allowing them to develop into healthier plants than they would otherwise.

The most famous carnivorous plant is the Venus flytrap, which is not native to South Jersey, but grows farther south in the swamps of North and South Carolina. Because of its unique features it has been a favorite houseplant for years, but those who keep this "pet" may not realize just how sophisticated it is. Each leaf on a Venus flytrap ends in a pair of spiky hinged lobes, and on the inner surface of each lobe there are thin, tiny hairs. When any object touches one of the hairs, the flytrap waits to see whether the first hair is touched again or a second hair is disturbed—a sign that whatever is there is alive. If there is no second touch, the flytrap "forgets" the first touch, but if there is a second touch the lobes snap shut and interlocking spikes form a kind of cage. The plant only feeds on larger prey, such as flies, so the "bars" of the cage are far enough apart to allow ants and other small insects to escape. If the captured object is of no nutritional value—a wind-blown leaf, for example—the jaws slowly open again.

Why the discrimination of a gourmet? Each of the traps on a Venus flytrap can absorb only about three

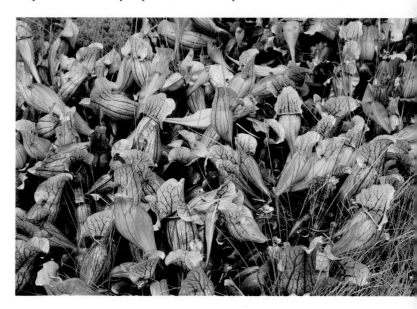

Left and right: Northern pitcher plant

Carnivorous Plants

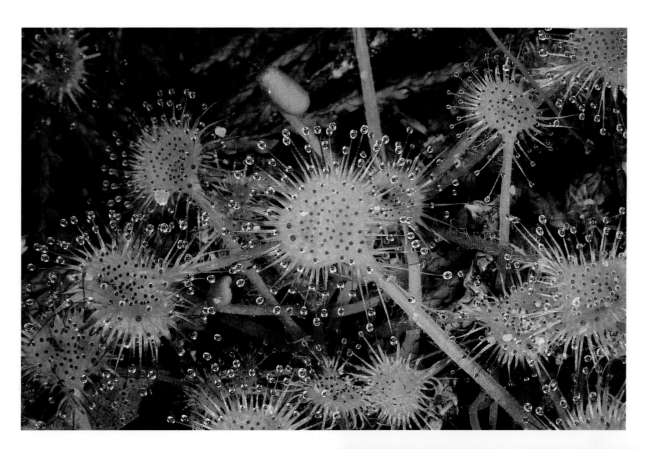

fly-sized insects before it dies. The digestion process takes ten days and consumes so much energy that the flytrap can't afford to work on anything other than a nutritious meal.

Although not as well known as the Venus flytrap, South Jersey bladderworts have an even more sophisticated trap. These herbs grow in water or mud

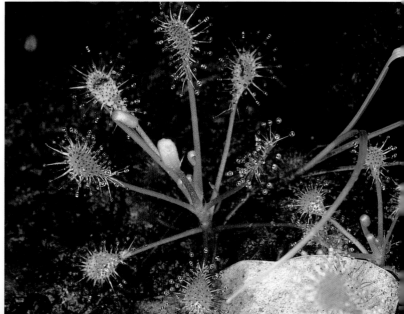

Left: Thread-leaved sundew
Above: Round-leaved sundew
Right: Spatulate-leaved sundew
Pages 192–193: Horned bladderwort

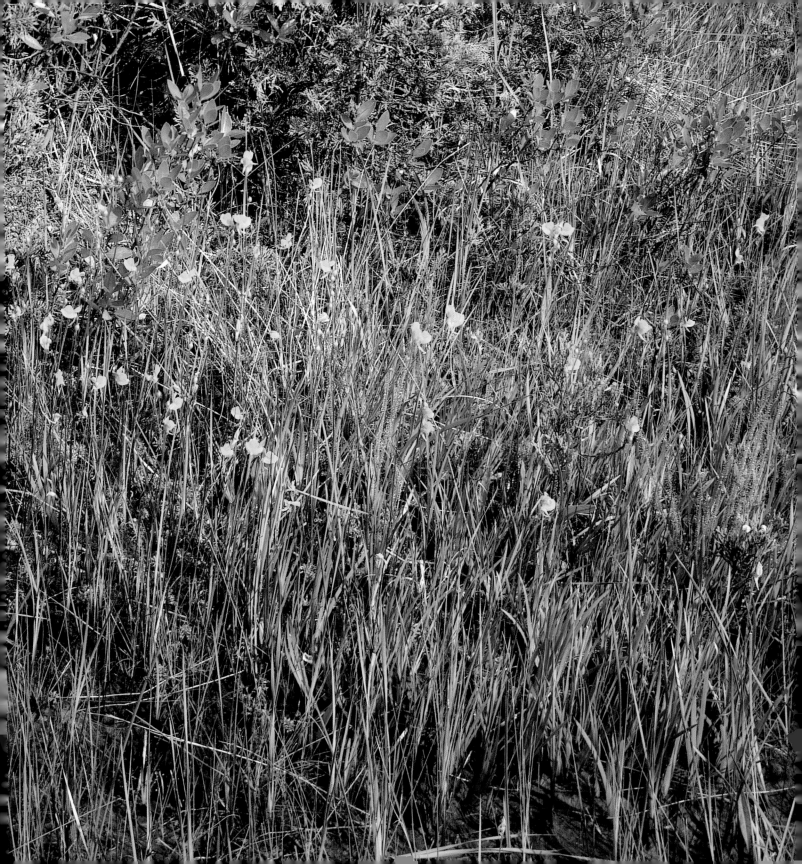

and have yellow flowers along with a mass of submerged leaves with tiny bladders. Each bladder has an inward-opening trap door. Sticking out from the entrance are hairs, and any insect brushing against these hairs opens the trap door. As the water rushes in to fill the empty bladder, it sucks the insect in with it. The bladder then uses special glands to extract the water, allowing the door to close again, leaving the insect trapped and ready to be digested by the plant.

The pitcher plant, another Pine Barrens insectivore, uses slippery "pitfall" traps to catch its prey. This interesting plant has pitcher-shaped, purple-veined green leaves, which are open at the top. Glands on the leaves attract small insects that fall in and cannot retreat because of downward and inward pointing hairs inside the leaf. The insects drown and the pitcher plant absorbs the nutrients.

Finally, there are the sundews, which grow in and around bogs and cedar swamps. The leaves of the sundew are like flypaper; after an insect is caught, it is enfolded by the leaf and digested into the plant. The sundew is also known by its Latin genus, *Drosera*.

While carnivorous plants like the pitcher plant may seem like the best representatives of Charles Darwin's "survival of the fittest" theory, they are in fact beneficial to some insects. Pitcher plants actually serve as hosts for as many as sixteen species of insects and other creatures that may spend an entire life cycle in and around the leaves without becoming trapped. The harmless mosquito *Wycomyia*, for example, lays its eggs and develops its larvae in the moisture inside a pitcher plant. In doing so, it represents what the 19th century Russian naturalist Prince Peter Kropotkin called "natural harmony" and "mutual aid."

So unique are these plants that after studying them Charles Darwin wrote: "What kind of intelligence is this?" The plants, of course, are not intelligent, but reflect evidence of intelligent design. As such, they are another of the many natural wonders that help make South Jersey unique.

As already pointed out, carnivorous plants supplement the nitrogen that they would normally get from the soil. The story of nitrogen is a fascinating one and shows how unique the Earth is for all life—from carnivorous plants to humans. Oxygen is needed by almost all creatures. Too much would be harmful, as strong oxidation would cause the surface of the Earth to become a sea of fire through spontaneous combustion, but too little oxygen would result in the suffocation of most creatures. Therefore, oxygen must be diluted with some inactive gas. The problem is solved because 80 percent of our atmosphere is nitrogen, which is relatively stable. After being gradually transformed into solid and liquid form, nitrogen is the most important nutrient for plants, and indirectly meets the survival needs of animals as well. If other inert gases were to replace nitrogen, Earth's myriad plants and animals would be unable to synthesize protein and could not survive.

Carnivorous Plants

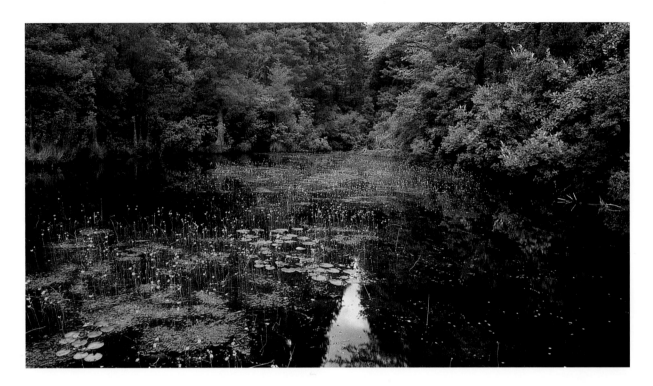

Since nitrogen is so stable, how is it transformed into compounds needed by living things? The mystery lies in another piece of the puzzle, thunder and lightning. In the discharging process of a thunderstorm, the high potential electrical arc turns some nitrogen into ammonia, nitrogen oxide, and nitric acid. These chemical compounds, which are brought to the ground by rain and snow, become fertilizer for plants without polluting the air.

No planet in our solar system has an atmosphere like that of Earth's. Mercury has no atmosphere, because its gravitational pull is too weak. Saturn's atmosphere is composed mostly of hydrogen (90 percent), while Mars has almost no oxygen or nitrogen in its atmosphere. The more we learn, the more we find that the Earth is unique.

Despite the uniqueness and abundance of nitrogen on Earth, some places don't have enough of it—hence carnivorous or insectivorous plants. While the insect-consuming plants of the Pine Barrens may never be featured in a science fiction movie, their unique character shows once again that truth is often stranger than fiction.

Left: Detail of horned bladderwort
Above: Horned bladderwort

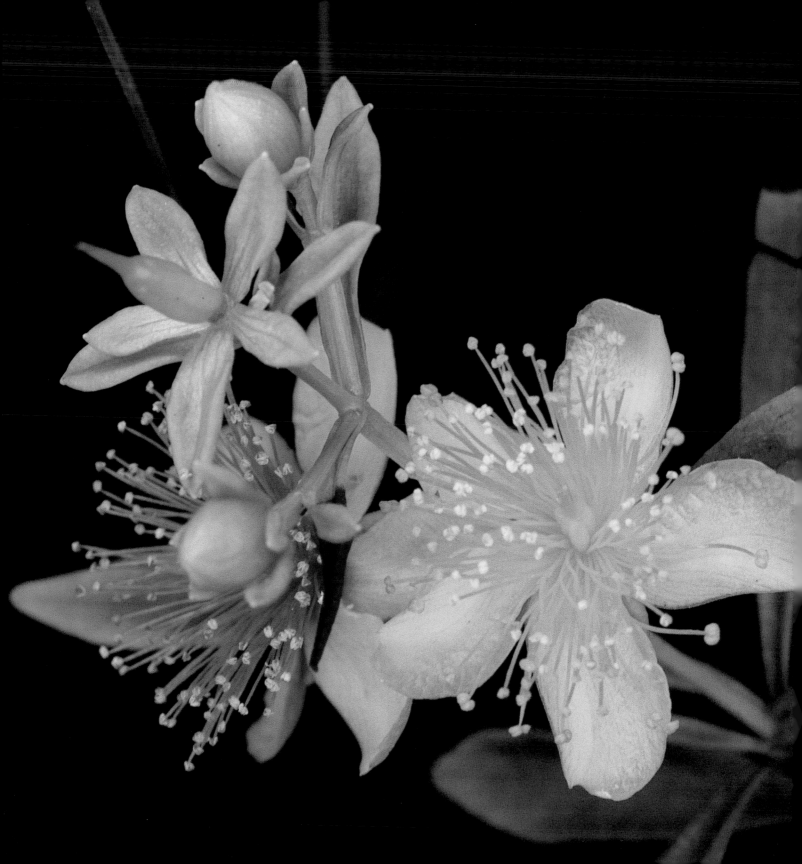

Chapter Thirty-Nine

Wild Herbs

One of South Jersey's most famous native sons was Dr. James Still. Known as "the Black Doctor of the Pines," this brother of Philadelphia abolitionist William Still penned a compelling autobiography of his life in the Pine Barrens. He never earned a medical degree, but learned his craft by observing Native Americans and "folk healers," and through reading books by established doctors. His stock in trade was the use of herbs.

So-called folk healers like Dr. Still apparently used up to 500 indigenous herbs to treat people for various complaints and diseases. One such plant was the dandelion, which is still found abundantly throughout New Jersey. In the wild, this plant, also known as dwarf dandelion, grows in the Pine Barrens' dry, sandy, and sterile areas. It is also grown under cultivation: Vineland is known as "the Dandelion Capital of the World."

Dandelions have been used as an ingredient in everything from a cure for digestive problems to wine. The leaves were once chewed to ease toothaches, while the flowers were used to make a laxative tonic and to enrich the blood supply of anemics. Tea made from the young leaves was used to relieve menstrual cramps, while tea made from the roots was used to treat stomach pain, nervousness, heartburn, and chest pains. My great-grandmother used dandelion leaves as a garnish for potato salad, and my grandmother followed suit. Used as a salad green, the leaves are less bitter if you harvest them before their flowers appear.

Today, herbalists are singing the praises of the dandelion for its high boron content. According to a 1995 National Institutes of Health study, Americans—particularly petite, older women—are at risk for osteoporosis. Two elements that strengthen bone are boron and calcium, and the dandelion is rich in both. Boron helps to raise estrogen levels in the blood, and estrogen helps preserve bone. While cabbage ranks the highest in boron content among leafy vegetables, dandelions run a close second.

Another herb, redroot, was used to make what is still known as "New Jersey Tea," in addition to treating stomach problems, leg and foot injuries, snake bites, and other wounds. Today, herbalists use redroot for sore throat and cough. The active ingredient is tannin. Redroot can contain as much as 10 percent tannin.

Common plantain, which grows abundantly along roadsides in all of New Jersey's coastal and southern counties, has broad dark leaves and a little white flower that grows on stalks in the middle of the plant. Plantain has been used for burns, dandruff, poison ivy, and sunburn. A proven healer of injured skin cells, many herbalists compare it to aloe.

St. John's-wort

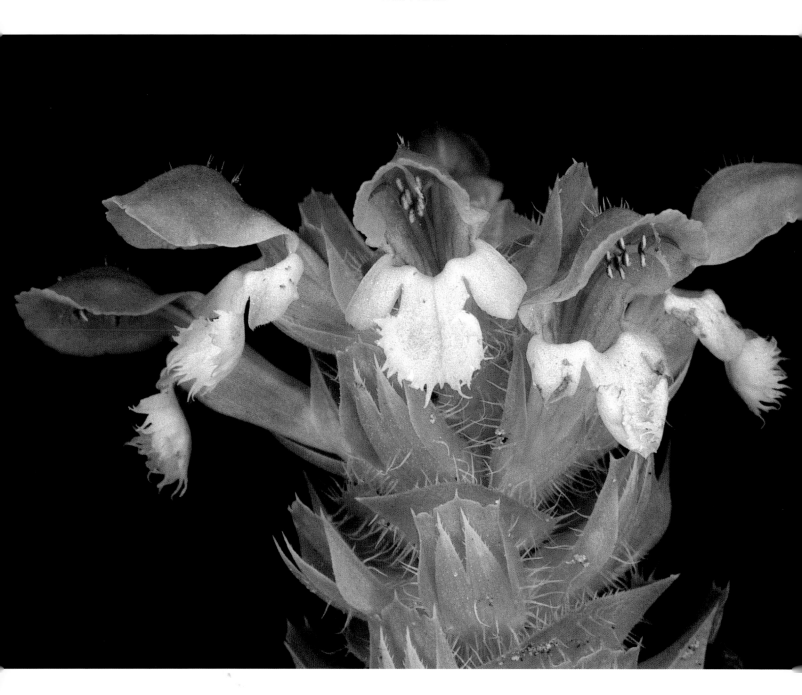

Wild Herbs

Cattails, found in the wetlands in South Jersey, were used by the Lenape for many different complaints. A root tea was made and used to dissolve kidney stones, to stop bleeding, and to heal newborns' navels.

Another Pine Barrens' plant, fireweed, has dark, square, pink petals. This plant is one of the first things to grow after fire rages through the forest. Like some species of pine, fireweed needs fire to propagate itself—the fire allows the seeds to germinate. Fireweed has been purported to help reduce swelling, and, taken internally, to soothe sore throats, gastritis, and urinary tract problems.

Sweet flag root (*Acorus calamus*) was once considered a cure-all. It was chewed, smoked, or rubbed on the skin, and apparently helped to induce sweat and urination. Today, scientists characterize it as an antispasmodic and anticonvulsant, and it has been found to lower cholesterol in animal experiments.

St. John's-wort, common in damp and sandy soils in the Pine Barrens, has been used in folk medicine for centuries. In Europe, this herb was used for the topical treatment of wounds and burns and as a remedy for kidney and lung ailments. St. John's-wort has received newfound attention in the treatment of depression. The herb's active ingredient, hypericum, is now the number one antidepressant, natural or synthetic, prescribed by physicians in Germany. It is also used as an

Left: Prunella, or "heal-all" is used to treat hypertension, goiter, and breast lumps. Below: May apple

anti-inflammatory and in topical lotions for healing wounds and bruises.

Prunella, or "heal-all," also grows in the Pine Barrens and is being used to treat hypertension, goiter, and breast lumps. May apple, foxglove, horsemint, St. Peter's-wort, wintergreen, and many other herbs grow in the Pine Barrens. Perhaps some day a miracle drug will be discovered from the active ingredient of some Pine Barrens herb or plant, much as digitalis became the basis for heart medicine.

Above: Redroot was used to make what is still known as "New Jersey Tea," in addition to treating stomach problems, leg or foot injuries, snake bites, and other wounds.

In the past thrity years, there has been a revival of interest in medicinal herbs. Rutgers University has published *Medicinal Plants of New Jersey*, which covers more than 500 herbs, including many that were used by the aforementioned Dr. James Still. The author, Dr. Cecil Still, is a direct descendant of "the Black Doctor of the Pines."

But perhaps the best medicine is not from an herb or a bottle at all, but requires only a walk in the woods. Dr. Julian Whittaker, nationally known health advisor and owner of the Whittaker Wellness Center in California, says "if you could put the positive benefits of exercise in a bottle and market it, you'd be a very rich man." Combine that with the beauty of the Pine Barrens, and I'd say you'd be a very rich person indeed.

Part Six

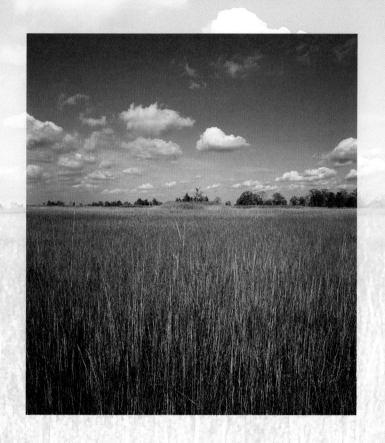

"A Land That Floweth with Milk and Honey"

Deuteronomy 27:3

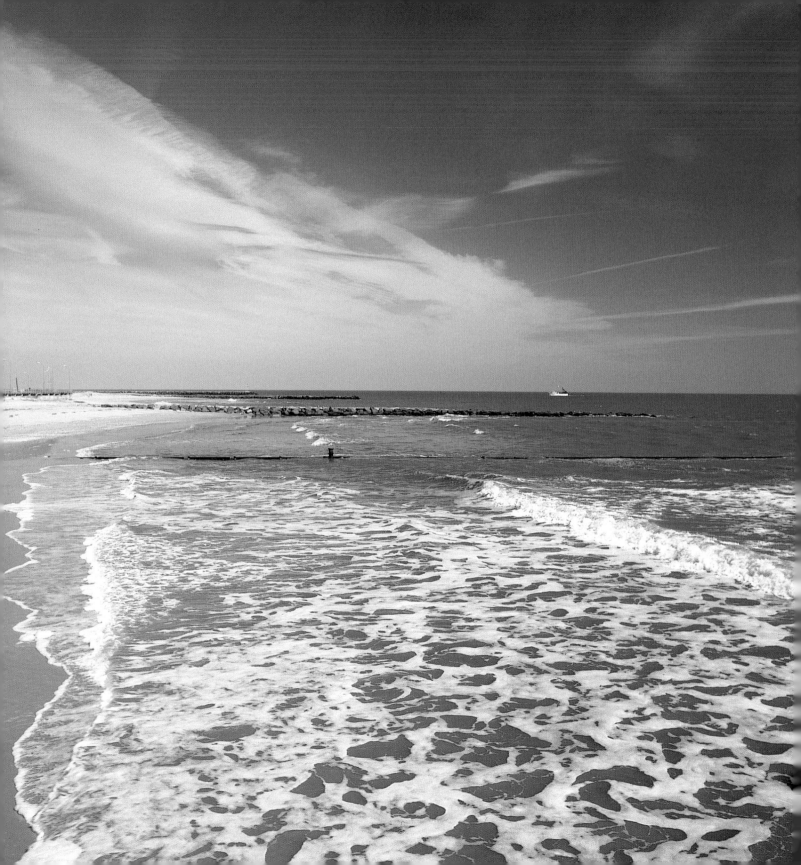

Chapter Forty

Beaches

Today, the Jersey shore attracts so much tourism that in a recent year $14 billion in revenue came in, supporting more than 270,000 jobs and $6 billion in wages and salaries. For years, "the shore" has been the state's top attraction, and thus arguably its greatest natural resource. On any given weekend in the summer, the beaches of Long Beach Island, Brigantine, and Ocean City are filled with people. But it wasn't always that way. Until the middle of the 19th century, when railroad seashore lines were extended across the state, the desolate barrier islands with their wave-washed sandy beaches and mountainous dunes were as remote as any spot on Earth. Virtually uninhabited, these islands were the scene of many a shipwreck during fall and winter storms. The beaches and the barrier islands served as a buffer between the ocean and the mainland, dissipating the force of the waves. It was also a place filled with wildlife, including now endangered species such as the Least Tern, Piping Plover, and Black Skimmer.

The first tourists to come to the Jersey shore were the Lenape Indians, who gave us many of the place names of shore towns, including Manasquan, Mantaloking, Absecon, Tuckahoe, Manahawkin, and Metedeconk. For the Lenapes, who lived along the Delaware River in the winter, summer camping at the shore provided food from the sea, which was a welcome change in their diet. Among the delicacies they relished were oysters, clams, scallops, whelks, mussels, crabs, and fish. Today, discoveries of arrowheads and other artifacts serve as a reminder of the Jersey shore's earliest tourists.

The first Europeans in North America were too busy carving a civilization out of a wilderness to devote much time to relaxation at the Jersey shore. As the barrier islands made excellent natural corrals, it was the cattle that enjoyed the benefits of the shore while their owners were busy on the mainland.

With no federal disaster insurance or flood prevention programs, our forebears knew that living on the barrier islands could be very dangerous. This attitude was reflected in land prices: In 1670, beach property was sold at 4 cents an acre, while mainland property was valued at 40 cents an acre.

All this began to change after the War of 1812. During that conflict and the Revolutionary War before it, the shore had been the scene of much war-related activity, including the making of salt, which was needed for gunpowder. Once the wars were over, Americans increasingly began to turn their attention to the diversions of the shore.

Left: Beach at Atlantic City

Beaches

The nation's first seaside resort was Cape May, with its beautiful beaches touching both the Atlantic Ocean and Delaware Bay. Philadelphians who wanted to enjoy Cape May's amenities would have to depart Camden, New Jersey, at 4 A.M. to reach the Cape by midnight via stagecoach. The first hotels were actually boarding houses, which usually served chicken and fish. Oysters could be found in a heap under the shed where the boarders were free to go and eat as many as they could open. The chief attraction was not swimming, but "sea-bathing." Here, fully covered by clothes or full-length bathing suits, visitors would jump up and down in the surf. "The surf lubricates the joints like oil" was a popular saying. Not only were these full-length suits modest, but they also protected bathers from too much sun. Through much of history, a tan on a woman was considered a sign of being from the working class. Hence the emphasis in story and song on milk white complexions and "snowy" bosoms.

In the 19th century, men and women bathing together was frowned upon. When the white flag on the bathing house was up, the beach was only for ladies; when the red flag went up, ladies beware—the men were on the beach. Eventually, husbands were allowed to bathe with their wives.

Famous visitors to the Jersey shore in the 1800s included Presidents Franklin Pierce, Ulysses S. Grant, Benjamin Harrison, Chester Arthur, and James Garfield.

Grant tried some social dancing at Cape May, but cut such an awkward figure that he told a would be partner, "Madam, I had rather storm a fort than attempt another dance." Grant respected the blue laws of the religious seaside resorts such as Ocean City and Ocean Grove. When the promoters of Ocean Grove wondered if the president would honor their custom of no Sunday carriage driving during one of his stays there, Grant said, "Enforce your rules. When I come to Ocean Grove on Sunday, I will walk in like any other law-abiding citizen."

The shore resorts grew rapidly when the railroads were built in the mid-19th century. There were only eight homes on the island that is now Atlantic City prior to the founding of the Camden-Atlantic line in 1855. Walt Whitman, living in Camden a few years later observed: "The whole route has been literally made and opened up to growth by the railroad." In 1880, a round-trip ticket from Philadelphia to Ocean City cost $1.65.

Shore promoters told people to get out of oppressive, hot, overcrowded Philadelphia for some healthful relaxation at the shore. An 1873 pamphlet advised: "Housetops and pavements reflect back the heat. Nature is parched and lifeless. Man, woman, and beast are all in sweltering discomfort. The invalid, pale and wan, seeks some shady nook and fans away the weary day, dreaming the while of some sequestered spot down by the sea. … So step in a moment, from the suffocation of bricks and mortar to the stimulating breath of old ocean. There are six trains daily with two extras on Sunday."

Left: Brigantine Beach looking south toward Atlantic City

Indeed, New Jersey's beaches—with their fresh air, wildlife, and rolling waves—would have a healing effect on people weary of America's growing industrial cities. By the late 1800s, the shore resorts began to develop some of the things for which they would eventually become famous—the rolling chair, the boardwalk, and salt-water taffy.

In the early 1900s, the automobile made the beaches even more accessible. "Touring" the countryside became popular, and soon a host of stands, billboards, "watering holes," and service stations had been erected. South Jersey's beaches were also the site of some of the nation's first auto races. Back then, there were few good roads and certainly no racetracks. What adventurous spirits around the world soon discovered, however, was that beaches could make excellent raceways. Two pioneering racecourses were Ormond Beach, Florida, and Ostend, Belgium. Eventually, beaches at Cape May and other South Jersey locations were added to the list. The Cape May course became so well known that auto pioneers Louis Chevrolet and Henry Ford were drawn to it.

The Cape May Beach Course, which had been laid out by the Cape May Automobile Club, extended from Madison Avenue to Cold Spring Inlet. The racetracks were located close to the ocean, where the sand was generally hard and smooth. Trophies for the best time in the mile and kilometer were adopted, valued at $1,000 and $500, respectively. One of the trophy cups displayed, in relief, a winged female figure in flowing draperies (symbolic of speed) holding a laurel wreath. On the opposite side of the cup was the image of a beach and boardwalk.

In one early race, participants included Ford, Chevrolet, nationally known racer Walter Christie, and E. Cedrine from Italy. Chevrolet won one race because his closest competitor drove too close to the ocean and was hit by a wave.

Beach racing ended when hard-surfaced roads and race tracks were built after World War I. This was an important development, for auto racing on the beaches could ultimately have destroyed them.

Once one of the remotest places on Earth, New Jersey's beaches are now within a few hours' drive of two of the nation's largest cities, New York and Philadelphia. Millions of tourists visit the shore each year, making it our greatest natural resource. It will continue to be so only with an increasing public commitment to conservation and intelligent planning.

Above: Kimble's Beach, Delaware Bay
Right: The beach in Atlantic City

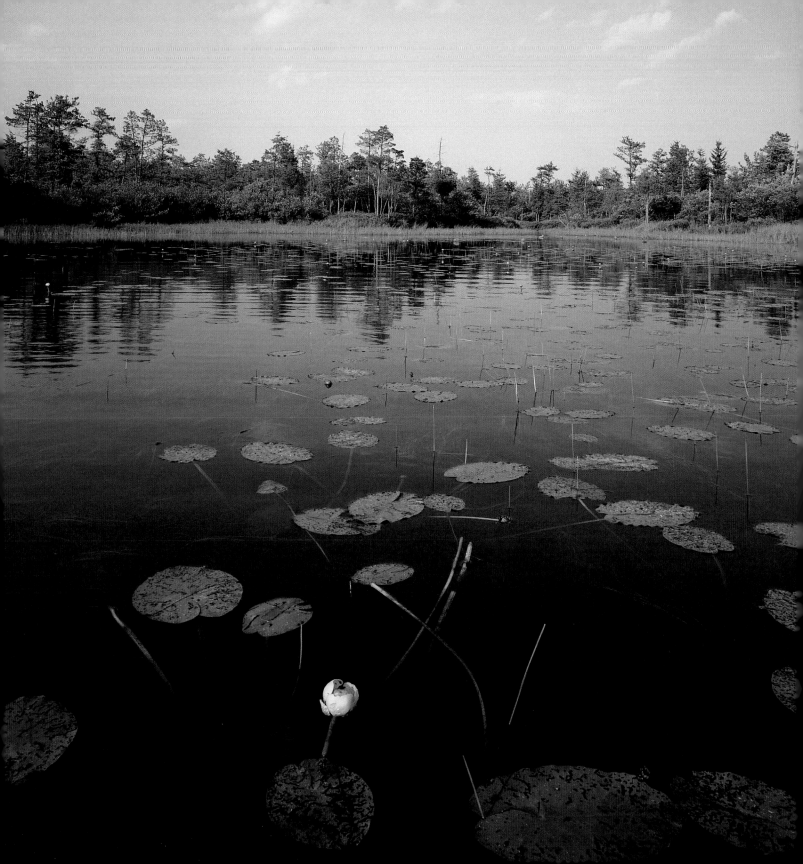

Chapter Forty-One

Wetlands

In the 1960s, Herbert Mills, president of the World Wildlife Fund, was concerned about America's vanishing wetlands and looking for ways to increase public awareness of the problem. His concept of a research institute at the Jersey shore would lead to the establishment of the Wetlands Institute in Stone Harbor, Cape May County.

For more than two centuries, dwellers in the Pines and at the Jersey shore have gone into the wetlands to look for food and earn a living. Local people have hunted waterfowl, served as guides for out-of-state gunning parties, harvested salt hay, trapped turtles and muskrats, and gathered moss to sell at market. In recent years millions have discovered what our ancestors knew all along: that our wetlands are a vital natural resource. Among other things, these wetlands provide flood control, improve water quality, recharge our aquifers, stabilize the flow of streams and rivers, and provide a habitat for fish and wildlife.

In New Jersey, wetlands fall into four different categories: salt marshes, fresh water marshes, woodland swamps, and bogs. Salt marshes and tidal marshes lie along the coast, while freshwater marshes are found adjacent to lakes and rivers. Woodland swamps are wet only part of the year, when they absorb excess rain and snow melt; bogs are full of soggy peat moss and are low in oxygen, which causes dead organic matter to decompose very slowly.

Without wetlands, there would doubtless be more flooding, threatening both animal and human populations. Wetlands plants slow down rushing waters and store large amounts of floodwater. Like some giant automatic valve, wetlands release water gradually to streams and surrounding bodies of water, helping to maintain healthy levels even through periods of drought.

If it weren't for wetlands, droughts would be far more devastating to animal life, but because stored water is released slowly into open water bodies such as streams and ponds, life is preserved. This stored water from wetlands also recharges groundwater, guarding against depletion of underground aquifers.

Wetlands also reduce pollution and help purify the water supply. Eighty percent of the geographic area of New Jersey draws drinking water from aquifers with a limited recharge area, making the state especially vulnerable to groundwater pollution. Wetlands plant life provides pollution treatment by grabbing and using waste nutrients. Moreover, heavy metals bind to sediments, which in turn collect and remain in the

Cranberry reservoir, Whitesbog

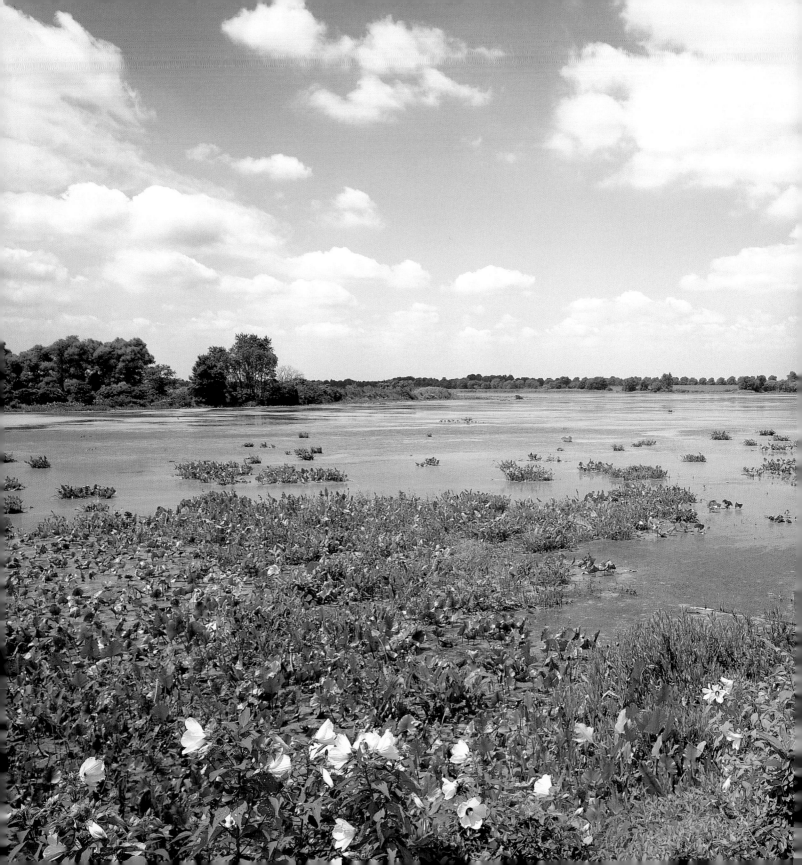

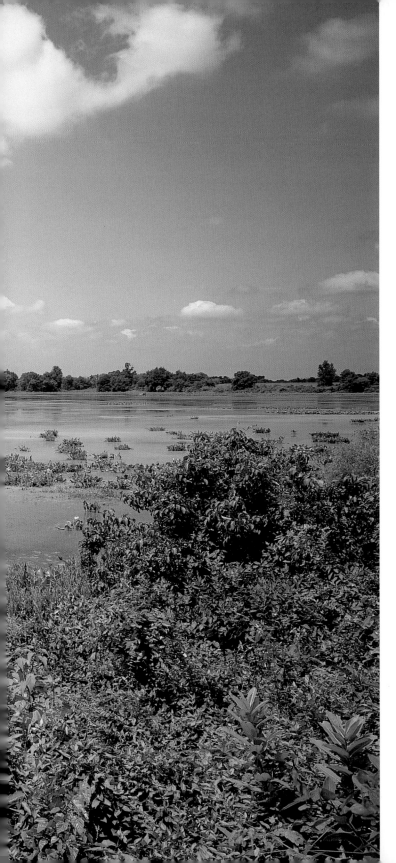

Mannington Meadows along the Delaware Bay

wetlands. Studies have demonstrated that water entering the drinking supply from wetlands shows significantly increased quality compared to the runoff that originally entered it. Of course, this natural filtration system can be taxed only so far.

Well-known South Jersey wetlands include the Edwin B. Forsythe National Wildlife Refuge in Atlantic County and the Whitesbog area of Lebanon State Forest. Without wetlands like these, many creatures that bring beauty and diversity to the animal kingdom would simply cease to exist—among them the great blue heron and the blue-spotted salamander.

The Wetlands Institute, with its headquarters built on the Stone Harbor causeway, was founded to study and preserve the wetlands. To make it happen, conservationist Herbert Mills successfully raised funds and negotiated the purchase of 6,000 acres of tidal wetlands. The land was sold to the state in the late 1960s under the Green Acres program, but unfortunately Mills did not live to witness the opening of the Institute. Instead, the president of the International World Wildlife Fund, Prince Bernhard of The Netherlands, presided over the dedication of the new institute in 1972. Other dignitaries on hand included Roger Tory Peterson, Arthur Godfrey, and Charles Lindbergh. The original building housed a lab, a couple of offices, a lecture hall, and a small area devoted to a bookstore. Trees and shrubs were eventually planted, and new construction included a second-story library, an observation deck, and a tower that is now considered

the Wetlands Institute's signature architectural feature. (The building was designed to resemble an old Coast Guard Station.)

In its earliest days, the Institute has had a close relationship with Lehigh University. Graduate students have worked on articles for journals and doctorates using Institute resources. Today the Institute hosts undergraduate student researchers from colleges across the United States and many Asian countries. The Institute has served as a base to study horseshoe crabs, the fish of Hereford Inlet, bird populations, the diamond-back terrapin, and many other wetlands creatures and habitats.

If Herbert Mills were alive today, no doubt he'd be pleased with what the Wetlands Institute has become. In fact, he'd probably preside over the Wings 'n' Water Festival held there every fall. It's a celebration of those things Mills loved best—the diverse flora and fauna of the Jersey shore area and the wetlands that make such diversity possible.

Left: Redroot, Make Peace Lake
Right: Delaware Bay tidal wetlands at Mad Horse Creek

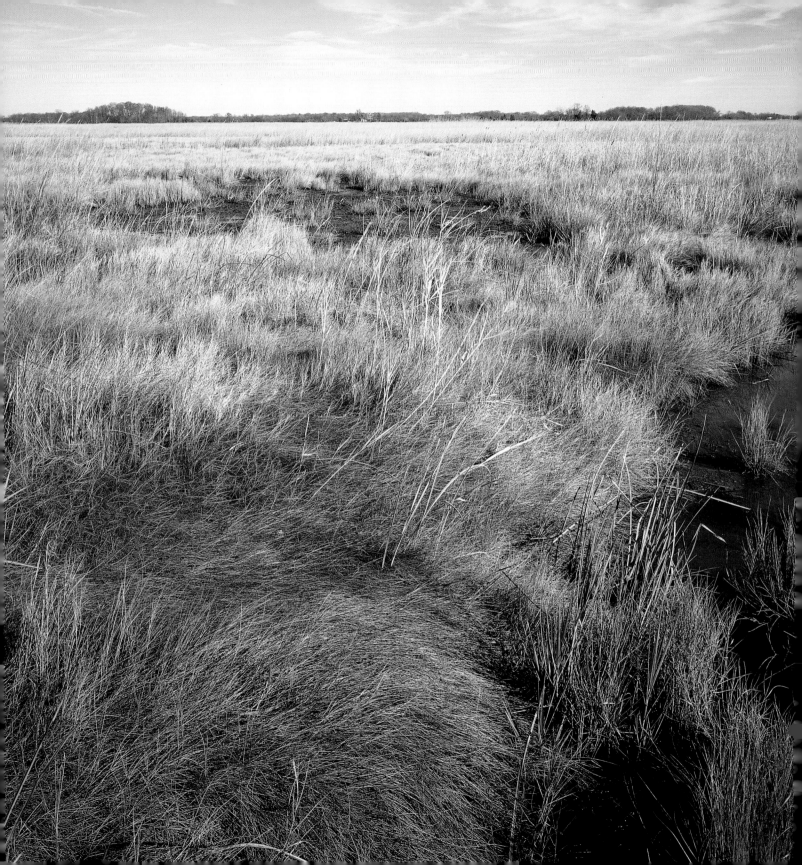

Chapter Forty-Two

Salt Hay

From the earliest days of European settlement to the mid 20th century, one of the more important products South Jerseyans obtained from the salt marshes was salt meadow hay, usually referred to simply as "salt hay." Salt hay is a type of cordgrass (*Spartina*) that, like its mainland namesake sweet hay, has been long-used by man. To the untrained eye, all salt hay may look the same, but it actually comprises several plant species that grow on slightly different elevations. Black grass (*Juncus gerardii*), a rush, grows high on the meadow. Salt grass (*Distichlis spicato*), which has a slightly hollow stem, grows at middle elevations. Finally, yellow saltmeadow hay (*Spartina patens*) is a very fine grass that grows at the lowest elevations. This latter species is the most commonly used by humans.

In its natural state, salt hay is an important land builder along the coast, trapping and holding the tidal mud. Our ancestors found that the plant served as excellent packing material, feed, bedding, and as a component in wrapping paper. Because salt hay doesn't sprout on the mainland, it makes excellent weed-free mulch. At Harrisville, an industrial town in the Pine Barrens (now deserted), it was used to produce as much as a ton of wrapping paper and butcher paper a day. At one time, salt hay farmers even sold their harvest to banana boats in Philadelphia. My great-grandfather used it for packing pottery at the old Egg Harbor City Pottery.

In 1879 the Reverend Allen Brown, a local historian, gave this description of the salt meadows:

> The salt marshes or salt prairies of the coast may be reckoned among the natural privileges, as they produce annually, without cultivation, large crops of natural grasses. The arable land comes down to the sea in the northern portion of Monmouth County, and again at Cape May; but in the long interval the sea breaks upon a succession of low sandy beaches. Between these long narrow islands, and the mainland, which is commonly called 'The Shore,' are salt marshes extending for miles, yet broken and interrupted by bays and thoroughfares. More than 155,000 acres of salt marshes are distributed along the coast from Sandy Hook to the point of Cape May, including also the marshes on the Delaware Bay side of that county. As of old, so now, they furnish good natural pastures for cattle and sheep all the year round, and are highly esteemed by the farmers whose lands border on them, as they constitute also an unfailing source of hay for winter use and a surplus for exportation.

Yellow salt meadow hay, Delaware Bay tidal wetlands

Salt Hay

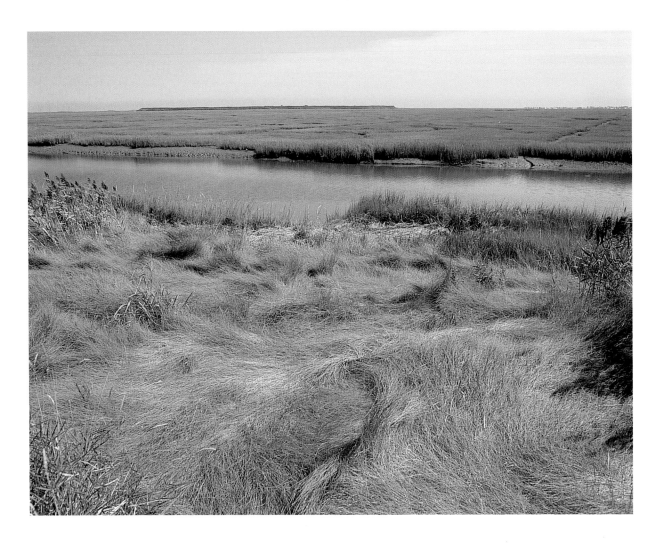

Salt hay is still available and is especially valuable as mulch to the home gardener who wants to conserve water and prevent weed growth. Although generally more expensive than hay or straw, it's very coarse, doesn't blow away in the wind, and can be gathered up and used again.

Above: Summer salt hay
Right: Saltmarsh or smooth cordgrass in bloom

Chapter Forty-Three

Salt Marsh Flowers and Grasses

Tidal marshes along the Jersey coast are among the most productive lands in the world, producing four times more plant growth per acre than a good cornfield. In fact, scientists say that the only lands that are more productive in terms of biomass are the sugar cane fields of Hawaii.

Today, millions drive by these productive areas daily on their way to work or play without giving them a moment's thought. But early South Jerseyans, because they lived close to the land and sea, appreciated what a cornucopia the salt marshes represented.

We looked at salt hay in Chapter Forty-Two, but the marshes yield myriad other useful plants.

Consider, for instance, the various salt marsh flowers. Did you know that the confectionery treat we call marshmallow was first made from a plant? The marsh mallow is a tall, leafy perennial that grows wild in marshy areas: before the development of imitation flavors, the roots of these plants were used in a creamy, puff-like confection. That eventually gave way to such American traditions as Whoopee pies, marshmallow pies, and marshmallows toasted over an open fire.

Native Americans were avid users of another type of salt marsh flower: the common reed, or phragmite.

The stems of these plants, which grow straight and tall, were used for the shafts of arrows. The Lenape would gather them during the summers at the shore. Phragmites, which grow both naturally and in areas that have been disturbed by the actions of humans, have showy seed plumes that are often used in dried floral arrangements.

Cattails, another marsh plant, grow in stands near fresh water and near woodland vegetation. The spikes, called "punks" locally, were once burned to keep insects away.

Left: Cyperus grass and salt marsh fleabane
Right: Sea shore mallow

once commonly used in salads. The plants' swollen green stems turn to bright red in the fall, adding a splash of color to the marshlands. Its salty flavor was popular with early settlers, especially when salt for seasoning was hard to come by.

The most important saltwater grasses, however, include cordgrass, salt marsh grass, and salt hay grass. In their natural state, these grasses play a critical role in maintaining the integrity of sensitive coastal lands.

The salt marsh has long been recognized as an important source of raw material for Pineys, baymen, and farmers—today, we know of its even more vital role in the ecology of the Jersey shore.

An early rheumatism remedy was a long soak in a bath containing the stems and flowers of salt marsh asters, a plant with daisy-like flowers. "Aster" is Greek for star.

Marsh pinks produce a bitter substance that was once used by herbalists to make a bitter (and supposedly healthy) tonic. The pink flowers of this plant bloom from July to October.

The seaside gerardia was named after 16th century herbalist John Gerard. Our ancestors who lived by the sea enjoyed its succulent leaves in salads.

Three types of glasswort are also found in our coastal salt marshes, and all are edible: the slender, woody, and dwarf glasswort. The dwarf glasswort or samphire, which blooms from August to October, was

Page 220: Salt marsh fleabane
Page 221: Sea lavender
Pages 222–223: Salt marsh or smooth cordgrass in bloom
Left: Seaside goldenrod
Right: Smooth cordgrass, Mullica Bay

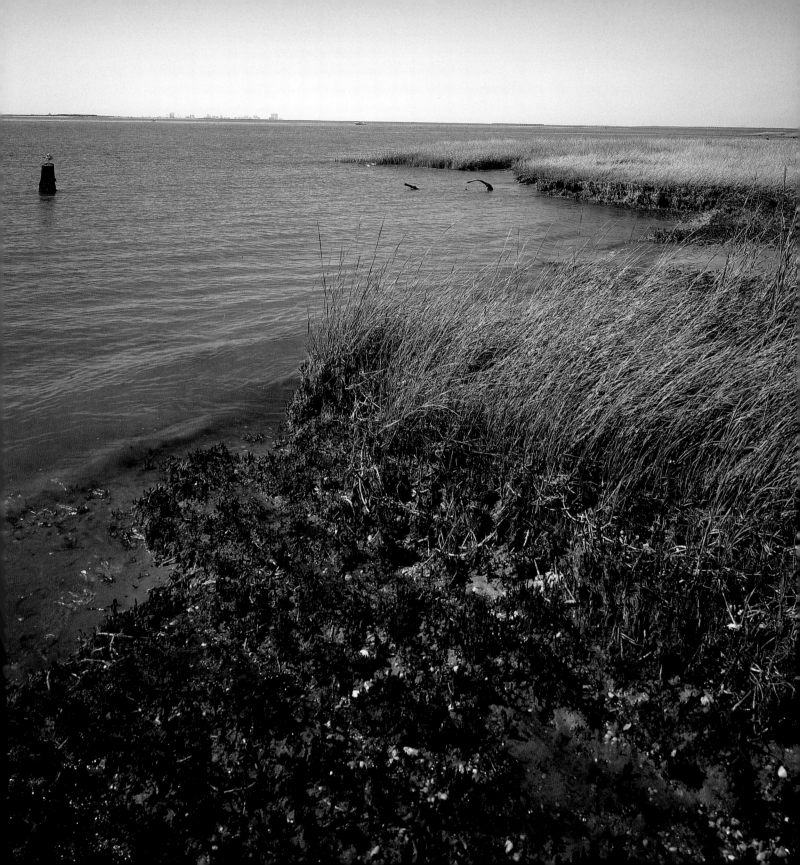

Chapter Forty-Four

Bog Iron

America had at least two significant problems when it began its fight for independence from Great Britain: no commander-in-chief, and no ammunition. Congress rectified the first problem by naming George Washington as general. That left the problem of finding guns, cannon, and ammunition. Providentially, New Jersey's bog iron forges stepped into the breach and became the armory of the Revolution.

In 18th-century New Jersey, there were at least thirteen iron furnaces, most of them in the south. In the Pine Barrens, the industry depended on bog iron, which was produced by a complex series of physical, chemical, and biological processes. Essentially, as vegetation decays, it gives off carbonic acid, which in turn saturates the minute particles of iron which permeate the soil. In time, the gas passes off into the air and the water deposits its burden of iron on the leaves and twigs beneath the water. Found in swamps and bogs, this bog iron was "mined" in the 18th century using flat-bottomed boats. The pine forests provided ample wood for charcoal, and the beaches supplied the "flux" (clam and oyster shell piles left by the Lenape) necessary to transform ore into usable iron. At Batsto, this iron was made into firebacks, which found their way to Washington's Mt. Vernon, and into artillery pieces for the forts defending Philadelphia.

Batsto-made guns weren't practical because they tended to explode when fired, according to some accounts. But guns weren't Batsto's main contribution to winning the war: Our troops needed gunpowder, and an important ingredient in gunpowder was salt. In colonial times, salt was derived from seawater through the use of iron evaporating pans, many of them made at Batsto and nearby Atsion.

Other South Jersey forges active in the colonial and federal periods included Weymouth Furnace, which produced stoves, iron pipes, and plates; Aetna or Tuckahoe Furnace; Gloucester Furnace on the Mullica River; Walker's Forge near Mays Landing; Speedwell Furnace; and West Creek Furnace.

In 1768 William Franklin, the royal governor of New Jersey, reported that his colony had eight blast furnaces, forty-two forges for "beating out" bar iron, one slitting mill, and one plating mill. The iron industry helped develop the colony and later the state. The forests were cut down for charcoal, the cleared land was sold for farms, towns sprang up to serve farmers, and roads were built to take the produce to market. Truly, South Jersey's history has been cast in iron—bog iron, that is.

Mound of bog iron at Batsto Mansion

Bog Iron

Today, George Washington's birthday is no longer celebrated on the actual day he was born, and the most some historians can say about him is that although he served as a volunteer, he "padded his expense account." Meantime, Batsto—the site of one of New Jersey's most important iron forges, is being marketed by the state of New Jersey as a Victorian manor. Historians know that both of these interpretations are incorrect.

New research shows that George Washington did not pad his expense account, and that without his uncanny ability to hold his army together we could not have won the war. And without New Jersey forges like the one at Batsto, America might have lost its bid for independence.

Below: Batsto Mansion
Right: Bog iron

Chapter Forty-Five

Maize

As every American schoolchild knows—or once knew—the Pilgrims were able to survive in 1620 because they discovered maize and were later taught to grow it by their Native American friend, Squanto. Early settlers in South Jersey found that the Lenape also grew maize in their gardens.

Indigenous to the New World, maize is mentioned for the first time in recorded history in the journals of Christopher Columbus. When Columbus landed in Cuba in 1492, two of his sailors brought back a report of "a sort of grain called Maiz." Today, we refer to it as corn—the word used in England for all types of grain including wheat, barley, and oats. Not only did maize sustain the Native Americans and the first European settlers to set foot on these shores, but today it is the most valuable crop grown in the United States—the main ingredient in everything from hominy grits to ethanol fuel.

Native Americans grew all the main types of corn that are raised today. They also raised varieties of corn with red, blue, pink, and black kernels. Some kernels had bands, spots, or stripes. Kernels ranged in size from as small as a grain of rice to as large as a quarter. Native Americans even incorporated this remarkable plant into their religious life. Elaborate ceremonies were held during planting and harvesting, acknowledging the existence of a Superior Being. Corn patterns are commonly seen in Native American pottery, sculpture, painting, and other art forms.

New Jersey's earliest settlers quickly added maize, or corn, into their planting schemes. In the early 1700s, James Steelman, who had a plantation along the Great Egg Harbor River, grew "Indian corn" as one of his major cash crops, along with rye, barley, wheat, and oats. Some colonists used it as currency. People were known to pay their rent, taxes, and other debts in corn, and some even traded it for marriage licenses. Those familiar with America's educational history will recall that some students paid their tuition at Harvard and the College of New Jersey in "college corn."

Until about 1900, corn grown in South Jersey and the rest of the United States was not much different from the plant grown by Native Americans. The first hybrid was produced in 1901, and scientists have tried to improve on the quality of corn ever since. South Jersey is known for the excellence of its corn, but unfortunately this is a crop that significantly depletes the soil. Because our topsoil is not rich, commercial corn farming is on the wane in South Jersey today.

South Jersey cornfield

Maize

Although corn may have saved Plymouth Colony and sustained the Lenape Indians, these groups could not have imagined the many ways we use this plant today. In addition to its versatility as a foodstuff, corn by-products are used in adhesives, cork, felts, plywood, smokeless powder, brake fluids, plastics, and hundreds of other applications.

Above: A developing ear of corn with its distinctive "silk"
Right: Indian corn—a favorite of fall decorators

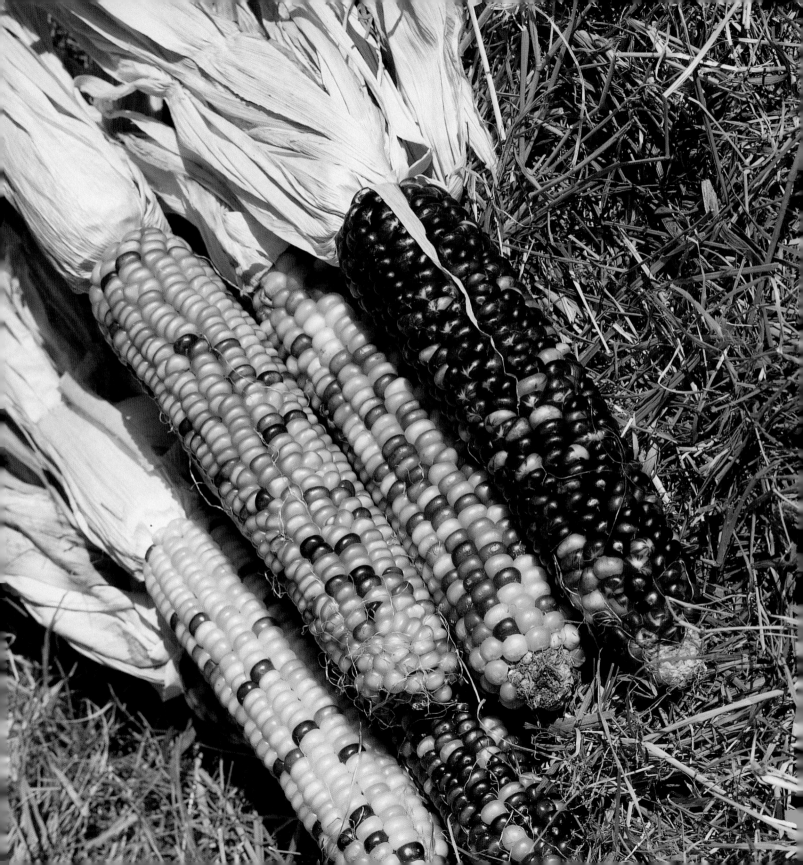

Chapter Forty-Six

Garden Flowers

"To love one's country," said English statesman Edmund Burke, "one's country must first be lovely."

Although first settled by the Dutch and then the Swedes, South Jersey eventually became an English colony. As such, it inherited the English people's love of country and cottage gardening. Thus, when the first English settlers arrived, they already had a rich heritage of gardening. The priority, however, was vegetable and fruit gardens. Gardening in every age and land has developed in a similar pattern: Useful plants are grown before ornamentals, with the latter—including flowers—cultivated first by the rich.

Common flowers in the gardens of colonial Salem, Bridgeton, and Cape May probably included mountain laurel, poppy anemones, field daisies, black-eyed susan, goldenrod, strawflowers, yellow yarrow, honesty plants, marigolds, pink and red celsia, Queen Anne's lace, coreopsis, and calendula.

Colonial housewives brightened up their dark homes in summer with flower bouquets. Peter Kalm, a Swedish naturalist who visited South Jersey in colonial days, wrote: "The ladies in general are much inclined to have fine flowers all the summer long, in or upon the chimneys, sometimes upon a table, or before the windows, either on account of their fine appearance, or for the sake of their sweet scent."

In the 1800s people combined practicality with aesthetics, such as when Pine Barrens "gentlemen" would wear cranberry sprays in their lapels. Although many varieties of flowers grew in the mainland areas of South Jersey, gardeners experimented with flowers (such as hydrangea) that could grow along the new shore and island communities. Elizabeth White of Whitesbog experimented with her garden, trying to bring plants in from the wild. Her goal was to have a

Left: Gardens at Leaming's Run, Cape May County
Right: Daisies

completely natural Pine Barrens garden. Often the reverse happened, where imported flowers, such as the iris or flag, were introduced to the wild. This usually happened by accident, often when someone disposed of garden or potting soil in the woods that contained stray seeds or bulbs.

Wildflowers—in combination with South Jersey's cultivated gardens—make much of the area surrounding the Pine Barrens a veritable paradise. If Edmund Burke was right, South Jerseyans have no excuse not to love their country.

Page 236: Yellow flag
Page 237: Coreopsis
Above: Black-eyed susan
Right: Hydrangea

Chapter Forty-Seven

Cranberries

When the Lenape first showed cranberries to the early settlers, the newcomers imagined that the stem and blossom looked something like the neck, head, and beak of the European crane, hence the name cranberry. The Lenape ate the berries dried and believed that they had certain healing powers.

The cranberry is a vining evergreen that grows naturally in sandy swampy areas of Massachusetts, the upper Midwest, and southern New Jersey. A cranberry bog in full bloom is a beautiful sight: Vines are covered with thousands of blossoms in June, a harbinger of a rich harvest to come in the fall. The early settlers first started cultivating cranberries when sailors found that taking them on long sea voyages helped prevent scurvy. In the 1830s, Benjamin Thomas planted the first cultivated cranberry bog in the Pine Barrens, at Burrs Mill in Southampton Township.

It was left to Andrew Rider, however, to take cranberries from the Pine Barrens bog to Thanksgiving dinner tables. Rider was originally a college administrator at Bryant-Stratton Business College, Trenton branch. Under Rider's leadership, the school became known as Trenton Business College. It became Rider-Moore Business College in 1898 and, finally, Rider College in 1921.

Cultivated cranberries

In 1889, Rider bought a small bog near Hammonton to cultivate cranberries. So captivated was he by the cranberry that he eventually increased his holdings to more than 500 acres. He built a home on Hammonton's main street, Bellevue Avenue, to keep tabs on his farm. Unfortunately, the virtues of the cranberry were little known outside of South Jersey or maritime communities.

Andrew Rider decided to change all that. He resigned as president of Rider-Moore Business College in order to devote the rest of his life to promoting the cranberry. However, instead of advertising here, he decided to go to England. In Rider's day Americans were interested in everything surrounding British royalty. If Prince Albert put up a Christmas tree (as he did) Americans would follow suit. And if British royalty ate cranberries, Rider believed, Americans would too.

In 1893, Rider set out on a British luxury liner, taking with him many crates of cranberries. Rider took only the best berries, ones that "bounced" when dropped. (For as old "Pegleg" John Webb of Ocean County had discovered, bad berries didn't bounce. Indeed, if they were rotten, they plopped.) On the voyage, Rider ate, slept, and drank cranberries. He even talked the head chef into making cranberry sauce for the passengers. And on his lapel, there was always a bouquet of cranberries.

Cranberries

When he reached England, Rider found that although cranberries were well known, they were not well liked—mostly because of the unsatisfactory ways in which they were prepared. In order to improve the situation, Rider published a cranberry cookbook and distributed it to English restaurants. The deal-clincher occurred, however, when Rider's horse, which he had named Cranberry, was a winner at the Ascot Racecourse. The win resulted in an invitation from the Prince of Wales to send a crate of cranberries to his residence. Eventually, some cranberry dishes found their way to Queen Victoria's dinner table. Her response was, "Tell Mr. Rider that I liked the berries from Hammonton."

By the time Rider left England to sail back to South Jersey, England was importing 5,000 barrels of cranberries each year. Rider had put Hammonton and the New Jersey cranberry on the map. In his day, New Jersey produced half the nation's supply. Eventually, no Thanksgiving or turkey dinner would be complete without some kind of cranberry sauce.

Today, cranberries not only make excellent juice and sauce, but they appear to have important health benefits. Recent clinical studies suggest that consuming cranberries helps maintain a healthy urinary tract. Thus, this small berry may indeed possess healing properties—just as the Lenape believed centuries ago.

Below: Cranberry blooms
Right: Cranberry harvest (Photograph by Steve Greer)

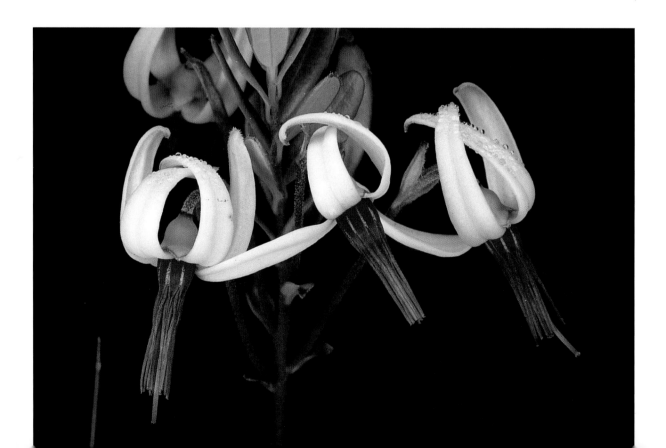

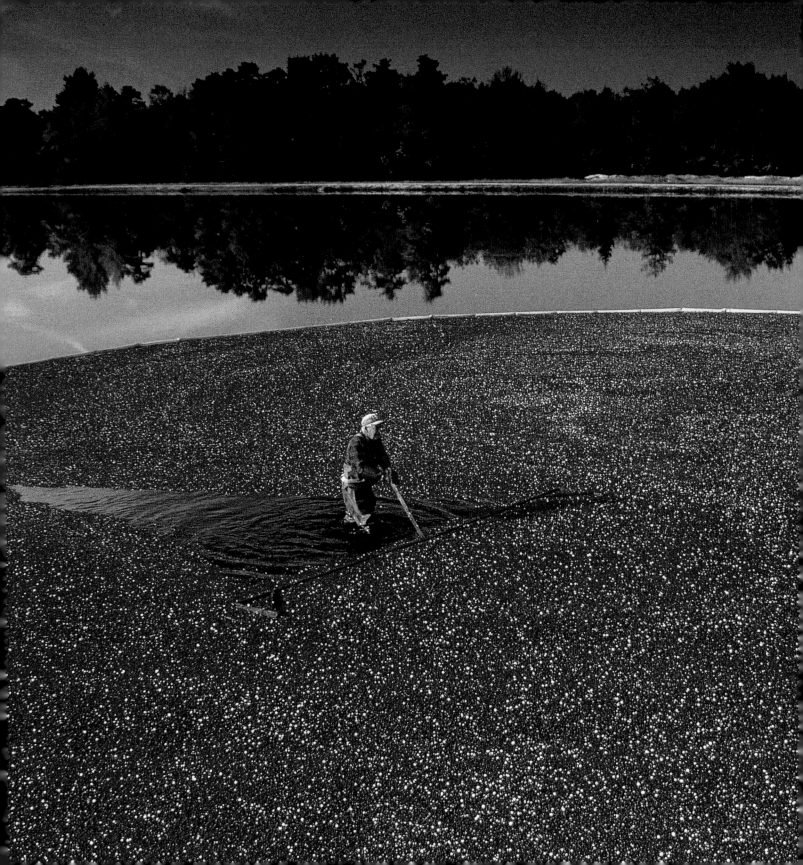

Chapter Forty-Eight

Blueberries

The Lenape believed the "starberry"—what we now call the blueberry—was sent by the Great Spirit to feed hungry children during one of the many famines they experienced. (The name "starberry" comes from its five-pointed white flower.) Records show that the blueberry was a staple of the Lenape diet, that they were often dried, and that the Lenape shared them with the first colonists to help them get through the winter. French explorer Samuel de Champlain recorded that the Lenape would beat the dried blueberries into a powder, adding honey and water to make a kind of pudding. The Lenape also used blueberry root to make tea to be used as a relaxant during childbirth.

Scientists call the blueberry *Vaccinium corymbosum*. Some people today refer to it as the huckleberry. But by whatever name it is called, to many people in Central and South Jersey, the blueberry is as good as gold. First cultivated in South Jersey by Elizabeth White of Whitesbog and Dr. Coville of the U.S. Department of Agriculture, the blueberry is one of New Jersey's major cash crops. In fact, the state is second only to Michigan in blueberry production. So famous is the city of Hammonton in Atlantic County for its blueberry production that *Reader's Digest* once dubbed it "the blueberry capital of the world."

Throughout much of South Jersey history, settlers and farmers would send children out to gather blueberries to use in their own baking. In Egg Harbor City in the early 1900s, German-American bakers would pay local children to go out and pick huckleberries that would be baked into various pies and pastries. With their hit-or-miss methods, most of the berries picked were seedy and lacked "meat." But from time to time varieties were found with larger berries, leading Elizabeth White to conclude that the best varieties of blueberries could be cultivated and shipped to market. (In her day, the only people who ate blueberries lived in or near the swamps of New Jersey, Maine, Michigan, and a few other states.) If the tart cranberry could gain a national market, White reasoned, then certainly the "starberry" from heaven could as well. In 1911 she collaborated with Dr. Coville to grow the first cultivated blueberries in the world. By 1927, blueberries were selling so well and being planted by so many growers that White helped found the New Jersey Blueberry Cooperative Association. After World War II, blueberries became popular and can now be found in everything from Italian ice to Renault Winery's blueberry champagne (which won a gold medal at the Culinary Arts Olympics in Graz, Austria, 1982).

Winter blueberry field

Blueberries

Today, New Jersey has more than 135 blueberry farms, which in a good year send thirty-five million pounds or more of fruit to market. Most of these farms are in Central and South Jersey, including the Pine Barrens. These farms include the Atlantic Blueberry Company, the world's largest blueberry farm, which stretches from Hammonton to Mays Landing. In a recent harvest, Atlantic produced more than ten million pounds of fruit.

Many varieties of blueberries are named for the place they were first discovered or for the person who found them. Hence, there are the Weymouth, Jersey, Rube (named after Rube Leek of Whitesbog), and Duke (named after Duke Galleta of the Atlantic Company) varieties. Duke Galleta, who passed away in 2000, started cultivating blueberries in 1949.

Scientists are now discovering what the Lenape knew long ago—that the blueberry is not just a foodstuff, but a medicine. Recent studies have shown that blueberries have valuable anti-oxidant properties. Supplements are being made with blueberry extract, and advertisements state, "blueberry promotes robust urinary tract tissue and offers powerful antioxidant protection." Thus, while the "starberry" may not be needed to save us from famine, it may help prevent and even cure certain diseases.

Below: Ripening blueberries
Right: Summer blueberry field

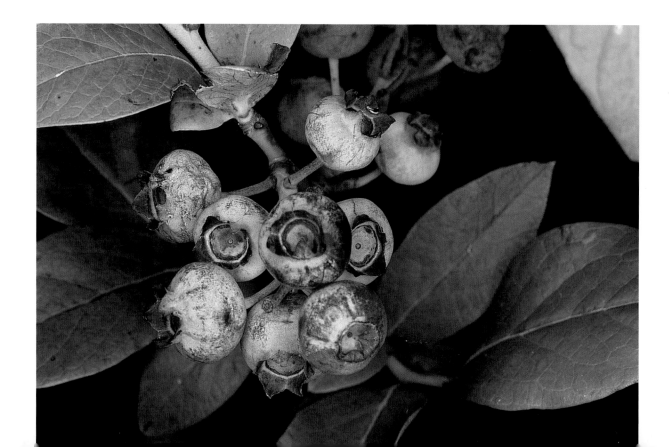

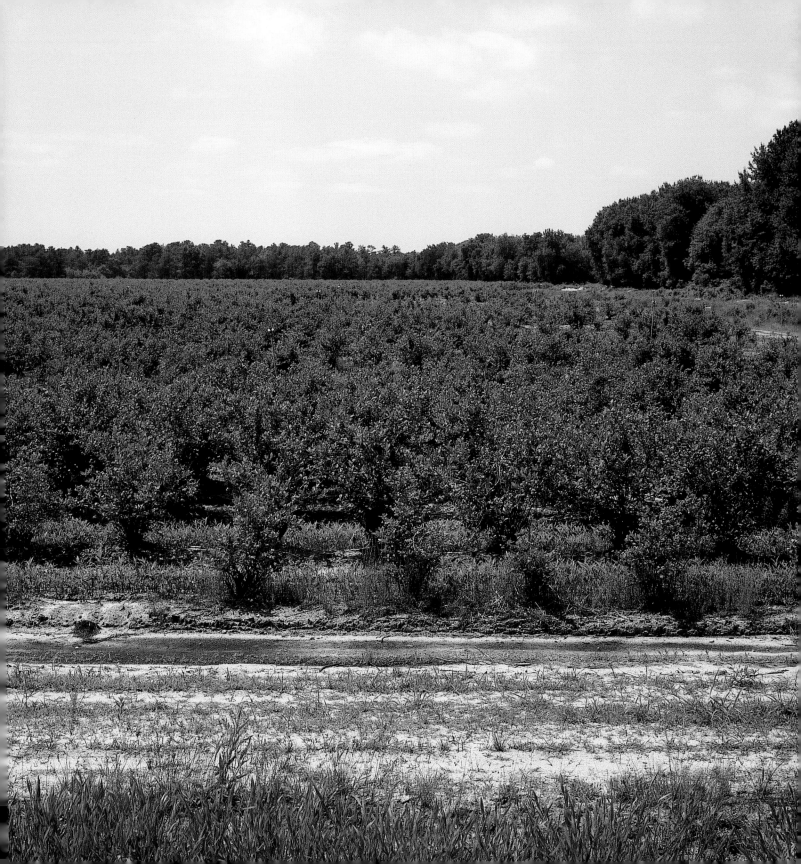

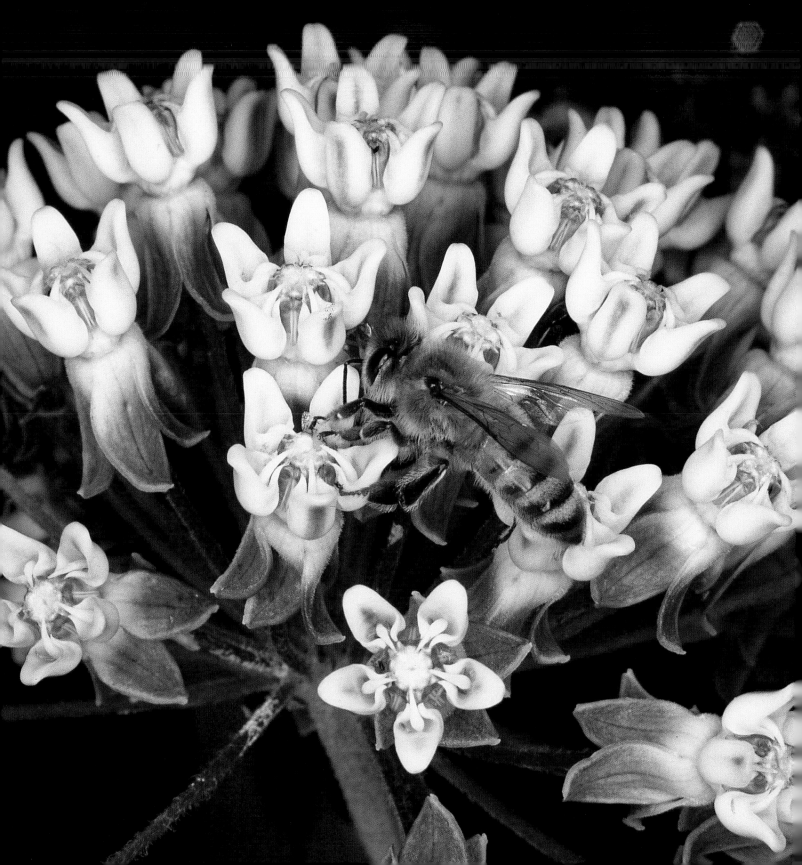

Chapter Forty-Nine

Honeybees

Agriculture has long been a mainstay of South Jersey's economy, and the basis of much of its history and culture. The success of today's blueberry, cranberry and other farms would not be possible, however, without the help of the honeybee. Moving from flower to flower, collecting nectar and pollen, this industrious insect effectively transfers pollen from one flower to the next. Honeybees pollinate more than ninety major agricultural crops, while Americans consume more than 360 million pounds of their honey per year. Insects pollinate nearly one-third of the nations' food supply, with the honeybee leading the pack. In South Jersey, crops like blueberries and cranberries are so dependent on honeybees that farmers pay beekeepers to move hives into their fields when the plants are in bloom. Other local crops that depend on bees include apples, strawberries, cucumbers, pumpkins, squash, peppers, tomatoes, and eggplants.

Clover, alfalfa, and other forage plants need bees to set seed. Without proper pollination, the seeds can't release hormones that cause fruit to ripen and get sweet.

Like most Americans, the honeybee is descended from immigrants, coming from Europe at the end of the 17th century. Gathering pollen in baskets on their legs, honeybees fly from flower to flower, working the flowers' parts with their entire bodies and spreading pollen as they go. Some honeybees collect pollen from as many as 500 flowers in a single trip.

Honeybees employ a sophisticated form of animal communication known as the waggle dance. Genetically programmed into each bee, this dance enables a scout to effectively "tell" the other bees where a sugar-laden blueberry blossom is. If the food is less than 300 feet from the hive, the bee moves in a circle. If it's farther than 300 feet, it moves in a figure eight. Meantime, the direction of the scout bee's body with respect to sunlight and gravity inside the hive reveals the direction that the bees must fly to find the food source. If the scout bee's body is pointed up, the bees fly toward the sun; if it's down, the bees fly away from the sun. This communication system is so elaborate that on cloudy days the bees have a backup mechanism based on their memory of the sun's previous diurnal course in relation to landmarks that are local to the hive. The scout bee must accurately communicate the location of the food to every other bee before they leave the hive, because they take only enough food to reach the first flower. Bees are able to return to the hive by using the sugar found in the flower (if you see a bee limping along near some flowers, you're looking at a creature

Honeybee on common milkweed

Honeybees

that didn't properly receive the message). We know that this behavior is instinctive because bees raised alone and outside of a hive know how to interpret the waggle dance.

Dominated by females, a beehive can support from thirty to sixty thousand bees during the spring honey flow. The source of life in the hive is the queen, which can produce 1,500 to 1,800 eggs per day. Most eggs hatch into females, or worker bees, which specialize in comb building, gathering nectar and pollen, maintaining hive temperature, and taking care of the brood. There are only a few hundred drones (males) whose sole job is to mate with the queen.

Honeybees are less aggressive than wasps, yellow jackets, and hornets, and they seldom sting. When they do, they die. But while honeybees are alive, they make a tremendous contribution to our local ecology and economy. So important is the honeybee to New Jersey that in 1974 it received the highest honor that the legislature can bestow: It was named the state's official insect.

Busy honeybees inside hive

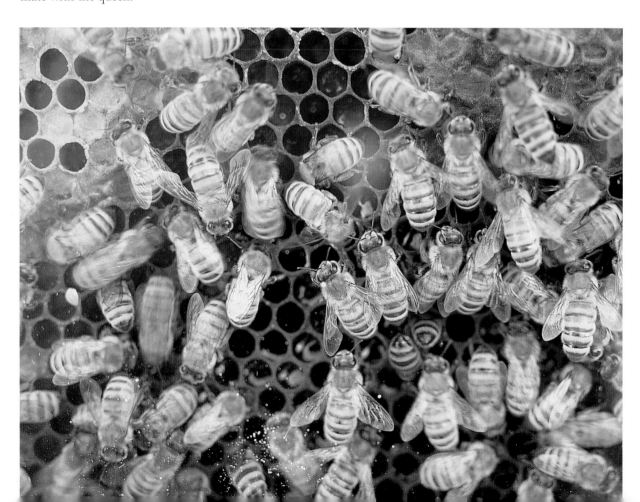

Part Seven

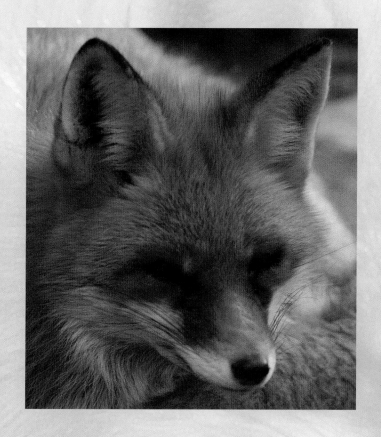

"Beasts of the Earth"

Genesis 1:24

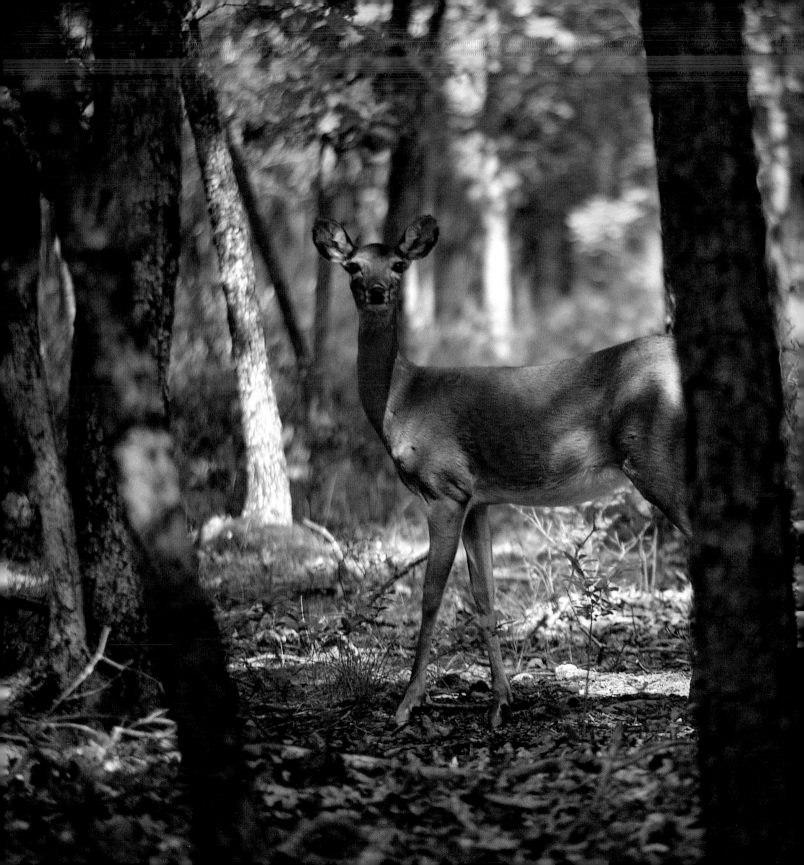

Chapter Fifty

White-Tail Deer

One of the biggest events for many South Jerseyans is held the first week in December. Some residents plan all year for this one week, saving up their vacation time in order to participate. Year-round, clubs hold monthly meetings to prepare for it. In some clubs, membership is so exclusive that it can only be passed from father to son. Just what is this special week? Why, the kick-off to shotgun season, of course, for the beautiful white-tail deer. As the largest game animal in the Pine Barrens, hunters prize this creature for its antlers and especially its meat, referred to as "venison" since the Middle Ages.

White-tail deer are fascinating animals. Often you will see them from your car bounding away through the woods with their tails raised high, waving from side to side like a little white flag. They seem to leap rather than run. Although these deer are not large, standing from three- to three-and-a-half feet high, they consume ten to twelve pounds of diverse vegetation every day.

Bucks begin to grow their antlers in April. Through the summer they are soft and covered in velvet. By early fall, the antlers harden, and the bucks rub them on saplings and small trees to scrape off the velvet (a sign

White-tail doe

hunters like to see as they stake out an area for the hunt). In November and December, the bucks begin to compete with one another for the right to mate. By early February, the antlers fall off, providing valuable nutrients for rodents, small animals, and bone-feeding insects. Fawns are born in the spring, usually in April or May. As long as a fawn nurses, it keeps its white spots.

The average deer spends most of its life in an area composed of just one square mile. Its intimate knowledge of every feature in the woods allows it to survive in even the most challenging situations. If you drive a deer out of its territory, it will try to return at the first chance. Deer will travel, however, to get the number of pounds of food they need each day. The animal is color-blind, so a hunter's red cap does not lessen his chances of killing a deer—although it may lessen the likelihood that he'll be accidentally shot by one of his peers. But if the hunter so much as blinks an eyelash he may lose his quarry, because a deer can detect such minute movements from many yards away.

South Jersey's deer population has always been an important element in our local heritage. The Lenape, for example, fished for shad in the spring, farmed in the summer, collected nuts in the fall, and hunted deer in groups in the winter. The Lenape made keen observations of deer and were familiar with all their characteristics. The

White-Tail Deer

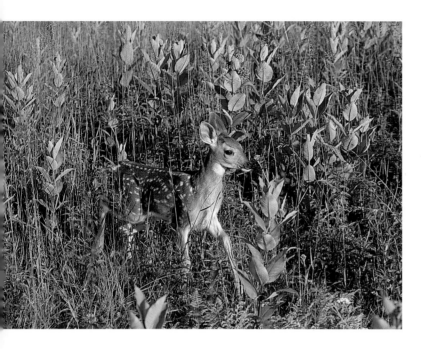

town of Tuckahoe, for example, is Lenape for "where the deer are shy."

The Lenape taught the first Swedish, Dutch, and English settlers how to strip meat from deer and dry it for food. Strips of deer meat were hung on tree branches to dry and saved for future use.

In colonial times, deer were so plentiful that hunters often decorated their homes with antlers as trophies. Carl Steelman, who lived along the Great Egg Harbor River, had a multitude of deer antlers, or racks, hanging on a high fence surrounding his house. According to the Reverend Carl Wrangle, in his account of South Jersey in 1764, it was "a sign that a mighty hunter lived there."

On occasion, a particular deer would gain a local reputation for being hard to catch or for some outstanding characteristic. One such deer was the "White Stag of Shamong" that lived in the forests between Batsto and Indian Mills. According to legend, a fast-moving carriage of Quakers was on its way to Sunday meeting in Tuckerton. Suddenly, a white stag jumped out in front of the carriage, blocking its approach to Quaker Bridge. When the driver disembarked to investigate, he found that the bridge was out. The white stag may well have saved the group from death or serious accident. From that day on, no hunter in the area would ever fire at a white stag.

It may surprise some modern hunters to know that by 1904, due to unrestricted hunting, white-tail deer were virtually extinct in New Jersey. Then, in 1908, the southern counties were restocked with deer from the Delaware Water Gap and from Michigan. A temporary ban was placed on hunting, and later limited to certain times of the year. Eventually, the South Jersey herd was restored, and today the deer's sole predator is man. Thus, thanks to deer from as far away as Michigan, South Jersey hunters can follow in their ancestors' footsteps, enjoying that one special week in December.

Above: White-tail fawn (Photograph by Steve Greer)
Right: Doe and fawn (Photograph by Steve Greer)

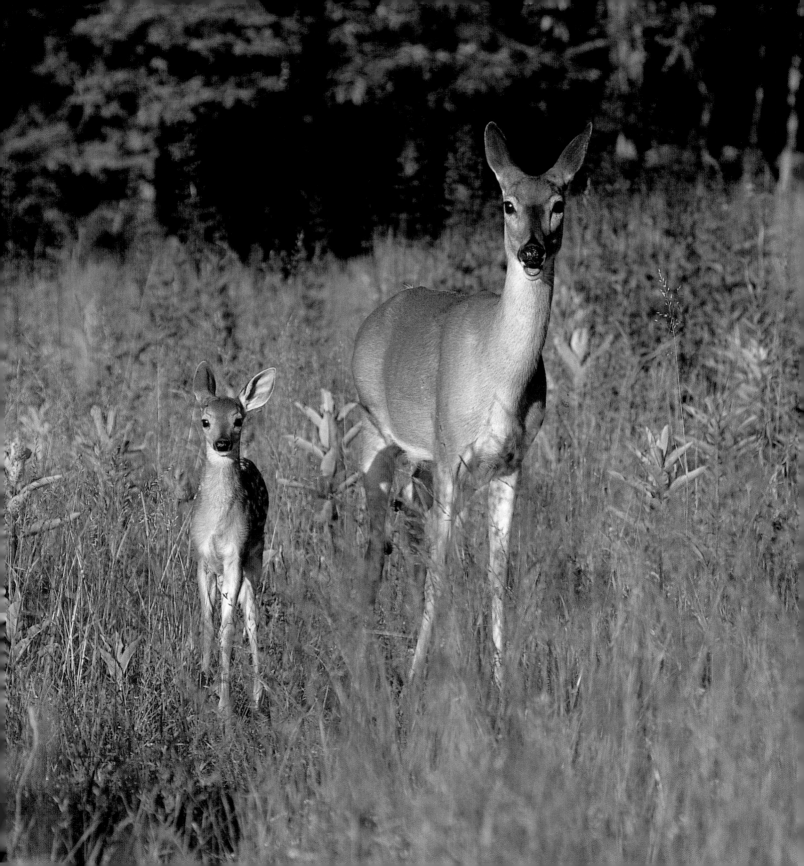

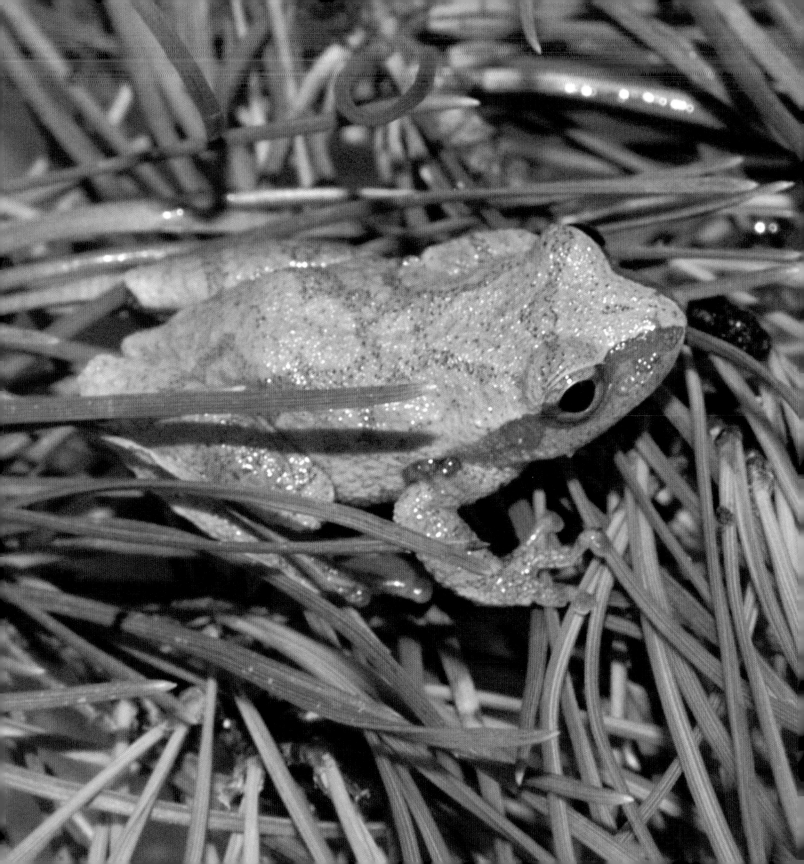

Chapter Fifty-One

Frogs

If you live in the Pine Barrens or surrounding region, you know it's spring when the "peepers" begin their chorus at dusk. For South Jersey residents who look forward to seasonal changes, the call of the peeper is as welcome as daylight saving time in spring, the changing colors of the leaves in fall, or the first dusting of snow in winter. A peeper is actually a frog called the northern spring peeper. This is a tiny, delicate treefrog found in small, temporary ponds or swamps in low brushy wetlands, and it is widespread throughout the Pine Barrens.

Another frog found in abundance here is the green frog—the classic frog depicted in nature paintings and brought to life in children's classics. The green frog dwells in shallow lakes, ponds, streams, and other freshwaters throughout the Pine Barrens. Homeowners in the area who build ponds in their backyards are typically delighted when a green frog shows up to join the newly created ecosystem.

Other common South Jersey frogs include the southern leopard frog and the carpenter frog. The carpenter frog gets its name from its call, which sounds like two carpenters hitting nails a fraction of a second apart. When a whole colony is calling, it sounds like a building crew hammering away in the distance.

Spring peeper

Two frogs that are increasingly threatened by loss of habitat are the New Jersey chorus frog and the Pine Barrens treefrog. The chorus frog is a treefrog that makes a repeated rolling "creek" or "preek" sound during its mating season in April. The chorus frog is found mostly on the perimeter of the true Pine Barrens.

The Pine Barrens treefrog is today found primarily in New Jersey. First discovered in North Carolina, only six individuals had been found anywhere before 1904. Few in number, the treefrog is considered endangered due to destruction of habitat.

Two varieties of gray treefrog are found in the Pine Barrens: The Cope's or Southern gray treefrog—a rare and endangered species—and the much more common Northern gray treefrog. These treefrogs have the ability to change color, from gray to a light brown or green, and thus blend into their surroundings. Both the gray and Pine Barrens treefrogs have another defensive mechanism—a bright orange inner thigh. When the frog sits, it cannot be seen; but when it leaps away, a bright flash of orange may startle an enemy and allow the frog to escape.

Frogs are important to man; they eat mosquitoes, gnats, black flies, and other insects that are a nuisance to humankind. The frogs, in turn, become prey for larger predators.

Frogs

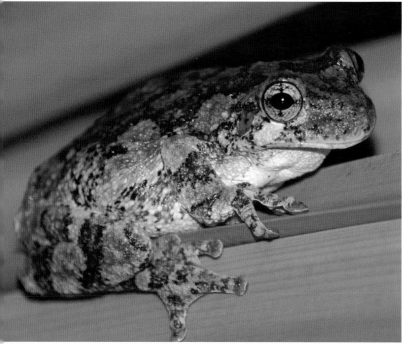

The ancient Egyptians regarded frogs so highly that they worshipped them—hence the irony of the Biblical plague of frogs when the Pharaoh refused to let Israel go to the Promised Land.

In fairy tales, frogs are turned into princes, but in real life something even more incredible happens. Among all the vertebrate animals, no creature undergoes such radical changes as the frog. In its first form, the larval frog, or tadpole, is totally fishlike; as an adult it is a four-legged land dweller. Like a fish, the tadpole breathes with gills; the adult breathes with lungs. The tadpole is a vegetarian, feeding primarily on algae. The adult frog is an omnivore, equipped with a wide, jawed mouth and a long sticky tongue that flicks out to capture insects and other prey. The frog's heart also undergoes major structural changes, transforming from the two-chambered organ typical of fishes to the three-chambered one of the adult frog. Despite such abrupt and unusual changes, each frog develops according to ironclad instructions imprinted on its DNA many millions of years ago.

In the 1800s, a number of thinkers proposed the theory that human beings, in the womb, go through stages similar to the life cycle of a frog, or through other stages of evolutionary development. This theory, called embryonic recapitulation, was championed in Germany by one of Charles Darwin's most ardent supporters, Ernest Haeckel. Unfortunately, it was used by the Nazi's to further dehumanize their victims, especially pregnant women who were forced to submit to the Third Reich's bizarre experiments on them and their unborn children. Modern embryologists, such as Gavin deBeer, have shown conclusively that embryonic recapitulation is a myth, and belongs in the trash heap with the geocentric theory and bloodletting. Yet it is still taught in many science textbooks today. Suffice it to say that the frog's life cycle is unique, as is the development of a human baby.

One thing you can be sure of: Just as a tadpole turns into a frog, when spring comes again the peepers' chorus will begin, reminding us of the importance of frogs to our ecosystem.

Above: Gray tree frog
Right: Pine Barrens tree frog singing (Photograph by Steve Greer)

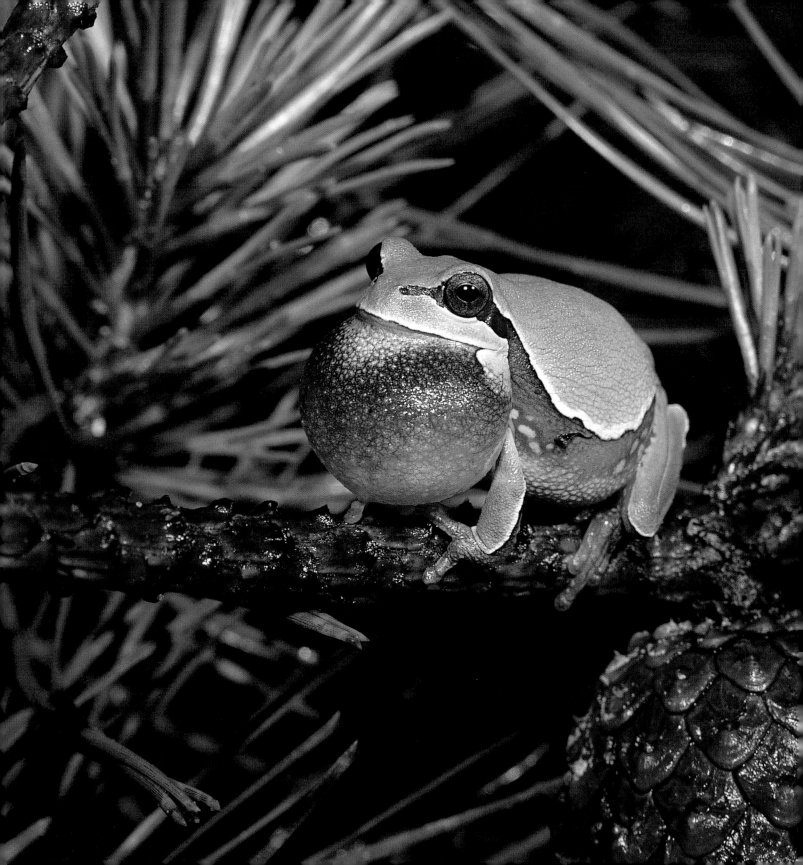

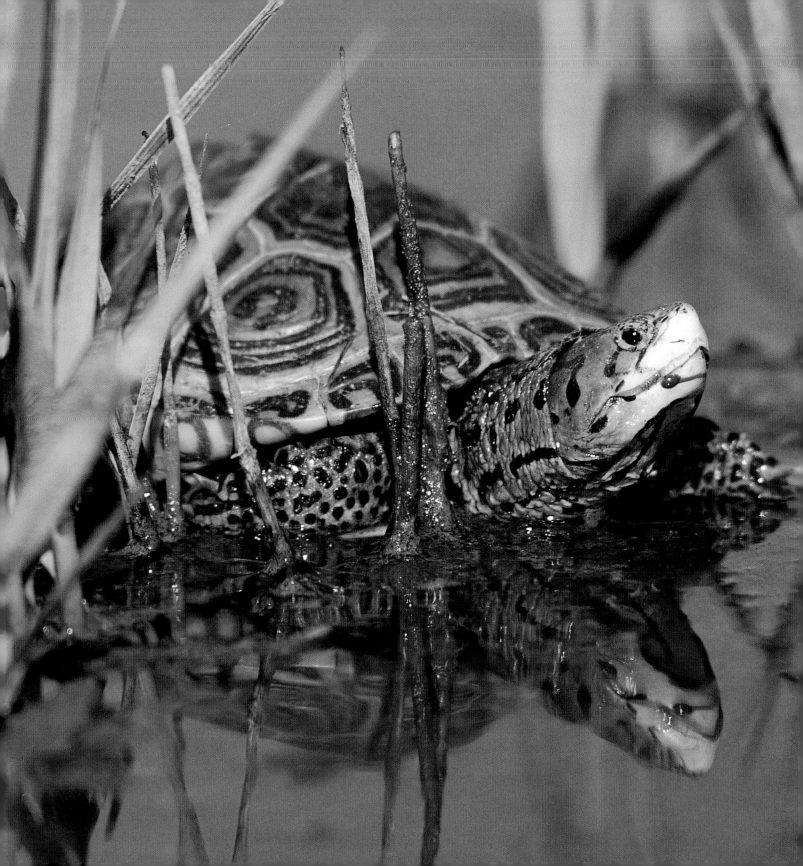

Chapter Fifty-Two

Turtles

Since the beginning of recorded history, the lowly turtle has been the "star" of legend and lore. Aesop's fable of the tortoise and the hare taught the important principle that "slow and steady" wins the race. Years later, when South Jersey's Lenape chose a symbol for their tribe, they picked the turtle. Calling themselves Unami, or "People Down the River," their elders believed the world came from a turtle, which subsequently bore the world on its back. As the people of the turtle, the Lenape believed that the turtle's status as the progenitor of the human race entitled them to lead in governmental affairs.

Turtles have always been abundant in South Jersey, finding the bogs, swamps, and forests to their liking. Because of their abundance, turtles have been used by man for food, for making ceremonial rattles and tools, and as a pattern for everything from flatware to eyeglass frames.

Just what are turtles, tortoises, and terrapins? Turtles are reptiles, like snakes, lizards, and crocodiles. Like other reptiles, they have scaly skins and clawed feet, breathe air, and are cold-blooded. Raymond L. Ditmars, past Curator of Mammals and Reptiles at the New York Zoological Park, once noted that the words tortoise, turtle, and terrapin have been used indiscriminately for years. To end the confusion, Ditmars divided the species as follows: tortoises are the strictly terrestrial or land species; turtles are semi-aquatic and marine species; and terrapins are the hard-shelled fresh water species that are edible and have a recognized market value.

The turtle most familiar to New Jersey residents is the eastern box turtle, so common here in South Jersey that it is often at risk from speeding automobiles. This turtle—named for its ability to close itself completely inside its unique hinged shell—is land dwelling, omnivorous, and lives in the open woodlands. In the past, box turtles were often kept as pets, and in old Philadelphia they were placed in cellars to clean out snails and undesirable insects.

The bog turtle is the smallest North American turtle, growing to an adult length of only 3.5 inches. It is a federally listed threatened species and designated as endangered in New Jersey.

The diamond back terrapin is a small to medium-size turtle found in South Jersey coastal salt marshes and estuaries. These turtles were once highly treasured as a table delicacy, and by the 1930s diamond back terrapins from Louisiana to New England had been greatly reduced by commercial collection.

The stinkpot turtle is only three to four inches long and has as its main defense a strong-smelling musk

Diamond back terrapin (Photograph by Steve Greer)

produced from its glands. The wood turtle was once marketed as food under the name "red-leg." Red-bellied turtles were once sold as food, and they live in the ponds, rivers, and lakes of the Pine Barrens. Very common in this habitat, the red-bellied turtle feeds mostly on aquatic vegetation and on worms, crustaceans, insect larvae, and small fish. The red-eared slider is the little green turtle that was once common in the pet trade. A native of the southern and central states, its presence in New Jersey is due mostly to the release of unwanted pets. The spotted turtle is distinguished by yellow and orange dots, both on its neck and carapace. Abundant in the Pine Barrens, it prefers bogs, swamps, and marshes.

The "granddaddy" of them all is the snapping turtle, which lurks on the bottom of brackish and freshwater ponds and streams in the Pine Barrens. The common snapping turtle, or snapper, can weigh seventy pounds and live more than sixty years. It has a fighting spirit and can inflict a painful, tearing bite. Old timers say that at one point a pond near Waretown was so filled with snappers that no ducks could live there—the snappers continually drowned and ate them.

These turtles are hunted and trapped to make snapper soup, a delicacy often served with sherry on the side. Locally, a big pot of snapper soup is typically laden with hard-boiled eggs and whatever vegetables are at hand.

Eastern box turtle

Turtles

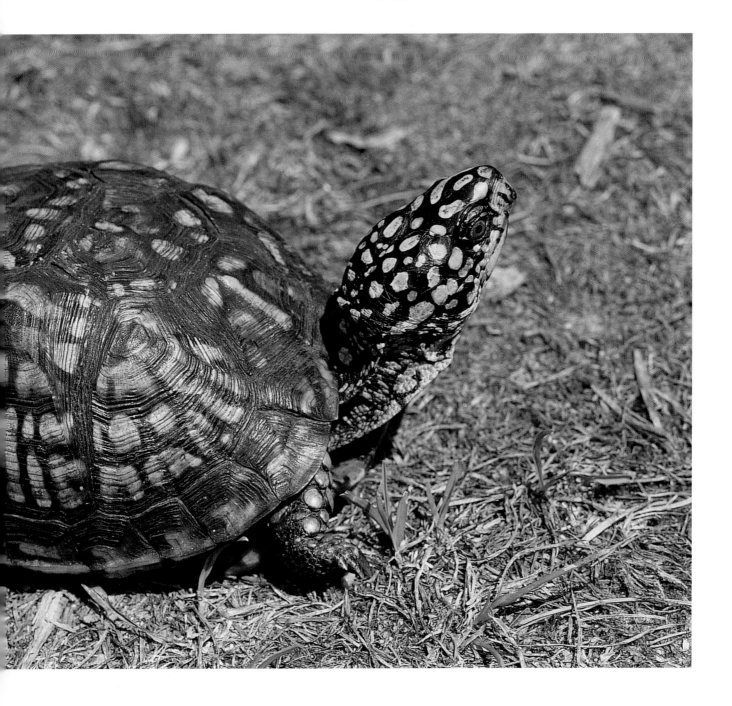

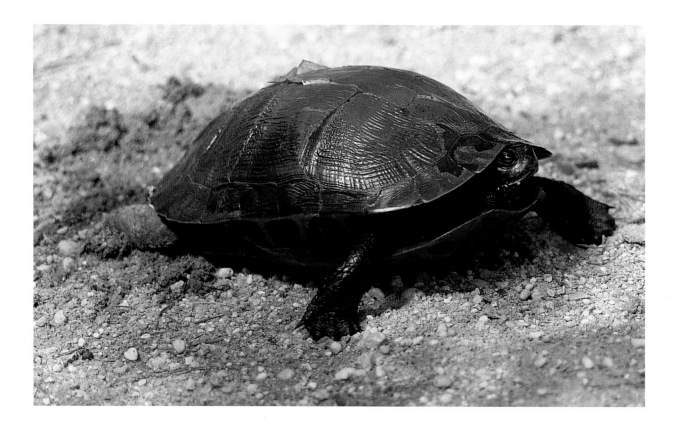

Snappers are trapped using several methods. Snapper hunters watch for air holes on muddy flats, indicating the presence of a snapping turtle. The trapper probes with a large snapper hook until he hits a shell, then hoists the turtle up. Another method involves a "choker set," in which wire is wrapped in a groove around the middle of a four-inch piece of quarter inch wooden dowel. The trapper tucks the stick into a piece of salt eel, fastens the choker to a line, drops it into a pond, and ties the line to a bush or a stake on shore. After the snapper swallows the bait, the choker turns crosswise so that it cannot be disgorged, allowing the reptile to be caught alive.

Today, however, most snappers are caught in a trap called a fyke; this is a net or wire cylinder with a bait box. Once the turtle enters, it can't get out.

Snappers can be coaxed into a fyke with rank meat or fish, but can only be removed with patience and subterfuge. Sometimes the trapper pulls the head back and ties it; other trappers spin a turtle to disorient it. Even after a snapper's head has been cut off, some trappers say it can bite for two days.

Turtles

Years ago, Pineys trapped snappers in order to make a few extra dollars. On March 21, 1913, the *New Egypt Press* reported: "Aaron Warner, of Mt. Holly, recently arrived at Burlington with 19 dozen terrapin caught in Brindletown pond, below New Egypt, which he peddled out to various hotels about Burlington at the rate of 65 cents a dozen."

From the totems of the Lenape Indians to the soup pots of local restaurants, the turtle has long been an integral and celebrated part of life in the Pine Barrens. In the race for the finish line, don't count out old slow and steady.

Left: Red-bellied turtle laying its eggs
Below: Snapping turtle

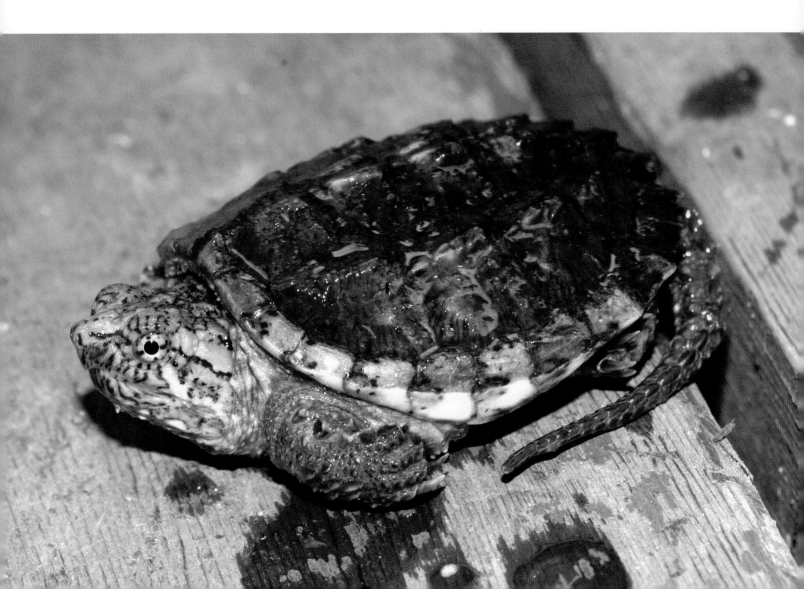

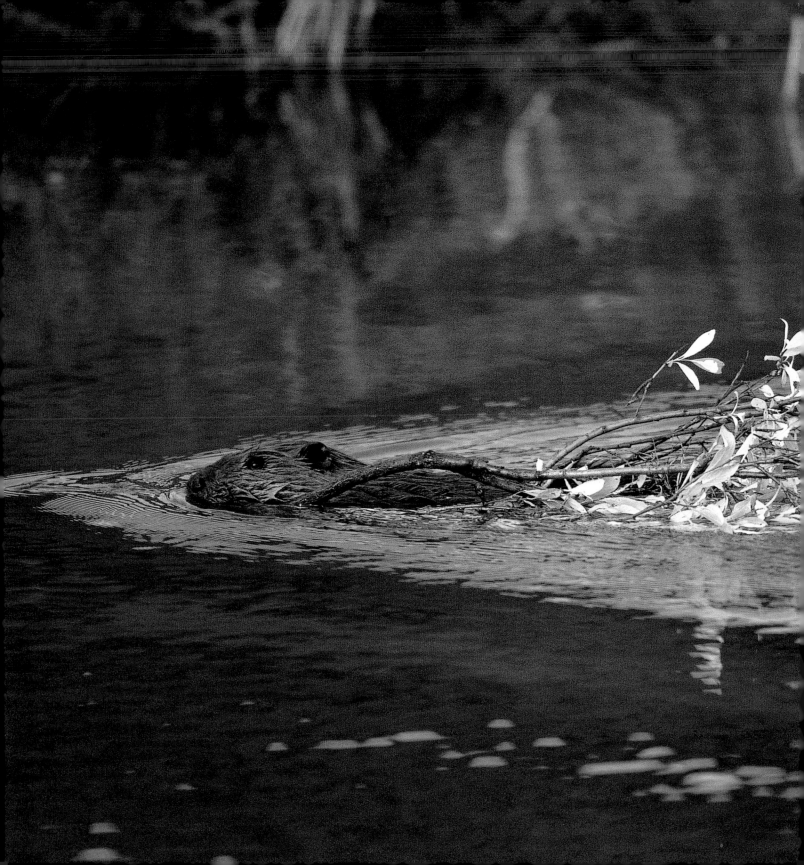

Chapter Fifty-Three

Beaver

When the first settlers came to America they were searching for God, gold, and glory—and one more thing: beaver. For four centuries the world's hats were made almost exclusively from felt manufactured from beaver fur.

Strange as it may seem, the beaver trade—here in South Jersey and then in lands to the west—created fortunes, brought down governments, and launched wars. At one time, the profit from this fur trade constituted half the annual income of Canada. New York City was founded by the Dutch as a fur trading outpost, while another Dutch trading post, Beberwyck (Beavertown in English), was renamed Albany by the English.

The North American continent was opened up by hunters looking for beaver, and the struggle for the beaver market culminated in the French and Indian War.

The Hat Act of 1732 forbade Americans from making hats from beaver fur, and thus became another cause of the Revolutionary War.

Three hundred years ago, there were more beaver than people on the North American continent. The beaver population was about sixty million strong, and South Jersey was a vital habitat.

Beaver (Photograph by Steve Greer)

The Lenape Indians, impressed by the beaver's dam-building skills and their systematic gathering and storing of food, called them "the little men of the woods."

But what made the beaver so valuable to our forebears, and threatened its survival, was its fur. The valuable part of a beaver pelt is the dense, thick under-hair next to the skin. When beaver pelts are prepared for use, the coarse, outer "guard" hairs are plucked out.

By 1845, most of the beaver in the United States were gone and furriers turned to the nutria, a South American mammal. This allowed the beaver population to begin to recover, although in New Jersey the species was nearly extinct by 1920.

Today there are beaver all over New Jersey, in perhaps 200 colonies statewide according to some researchers. Beaver are common in the Pine Barrens, building their dams and lodges on abandoned cranberry bogs and remote stretches of streams and rivers. I recently saw one of the mammals in Union Creek by Kern's Field in Egg Harbor City; while beaver are usually active at night, I encountered this one on a morning walk.

The beaver is an architect, lumberjack, and engineer without peer. Its teeth are so sharp that ancient Europeans and North American Indians used them for knife blades. The beaver's incisors, two pair of protruding

front teeth, act like chisels in stripping and cutting trees. The teeth are constantly worn down but never stop growing.

A beaver can fell a sapling six inches in diameter in ten minutes. When it senses the tree is about to fall, the animal scrambles to safety, then returns to cut it up. The cut trees are then floated down canals and added to the beaver lodge. Beaver never stop working, building, and tending their dams and lodges. Thus, in all nations where beaver are found, people speak of being "as busy as a beaver."

Water is the beaver's refuge. Specifically designed for aquatic life, a beaver can stay submerged for up to fifteen minutes. Underwater, the heart rate slows and airtight valves close off the ears and nostrils.

The narrowest part of a river or stream is selected for constructing the dam, which is used by the beaver to raise or lower the water level. Many sections of the country have seen underground water tables fall from twenty-five to fifty feet in recent years. Beaver sometimes unknowingly address this problem by essentially keeping rainfall on hand until it is needed. For example, in 1954, when drought turned much of the surrounding farmland into a miniature dust belt, Bear Mountain State Park, in New York, remained a green oasis because of water supplies preserved by its twenty beaver colonies. Beaver can also help to reduce the danger of flood. In some remote areas of the West, when the headwaters of a creek or river are in need of a restraining influence, beavers are dropped by parachute in wooden cages that open automatically upon landing. These "paratroopers" go immediately to work, damming up everything in sight.

The beaver's lodge is constructed for shelter and raising young. Built of mud, sticks, bark, leaves, and grass, the lodge is dome-shaped and accessed from underwater. The lodge has storage areas for food to be used during the winter. The rest of the year, the beaver cuts extra twigs and bark from aspen, birch, willow, poplar, and maple to eat during the winter. In winter, the outside of the beaver lodge freezes, conserving the warmth of the water below and the body heat of its occupants.

Some ecologists believe that much of America's topsoil was created from old, decayed beaver dams and lodges, which acted as natural compost piles, and from the silt that collected in abandoned beaver ponds.

The beaver is a shy creature, and only one colony or family occupies a lodge. Adolescents are driven out of the colony at age two, prior to the birth of a new litter. These adolescents generally start another colony within six miles of their parents' lodge. Individuals usually mate for life, and, other than humans, they have few natural predators.

The restoration of beaver in New Jersey is a wildlife management success story. While dams built by these creatures can cause flooding, they also stabilize stream flows, maintain water level, control soil erosion, and create valuable wetlands. The beaver may not launch wars or great journeys of discovery today, but it makes an important contribution to the health of our environment.

Right: Beaver lodge (Photograph by Steve Greer)

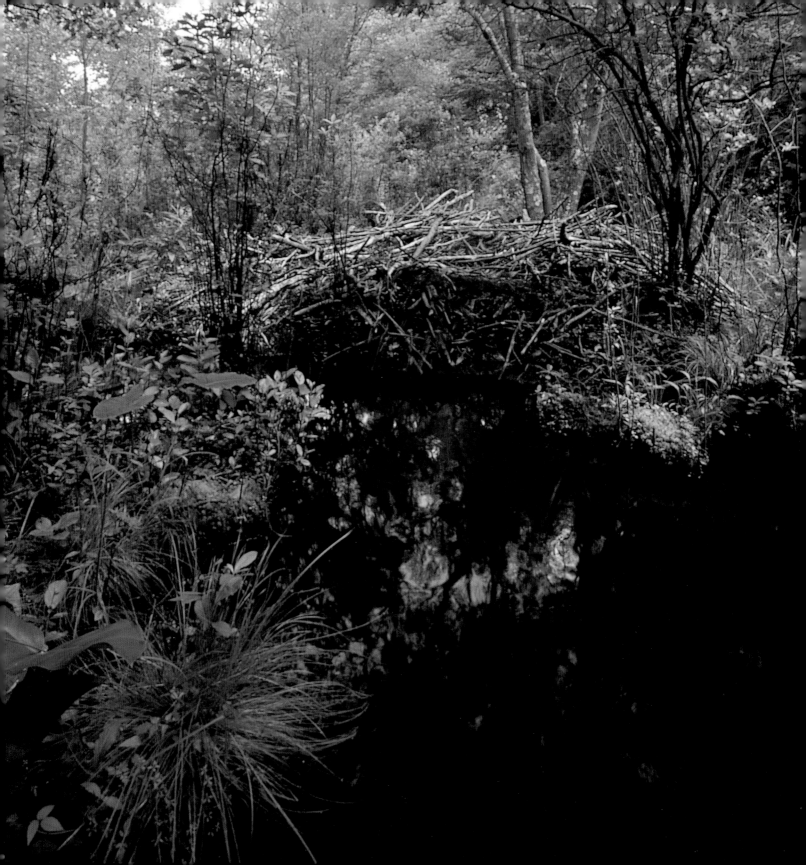

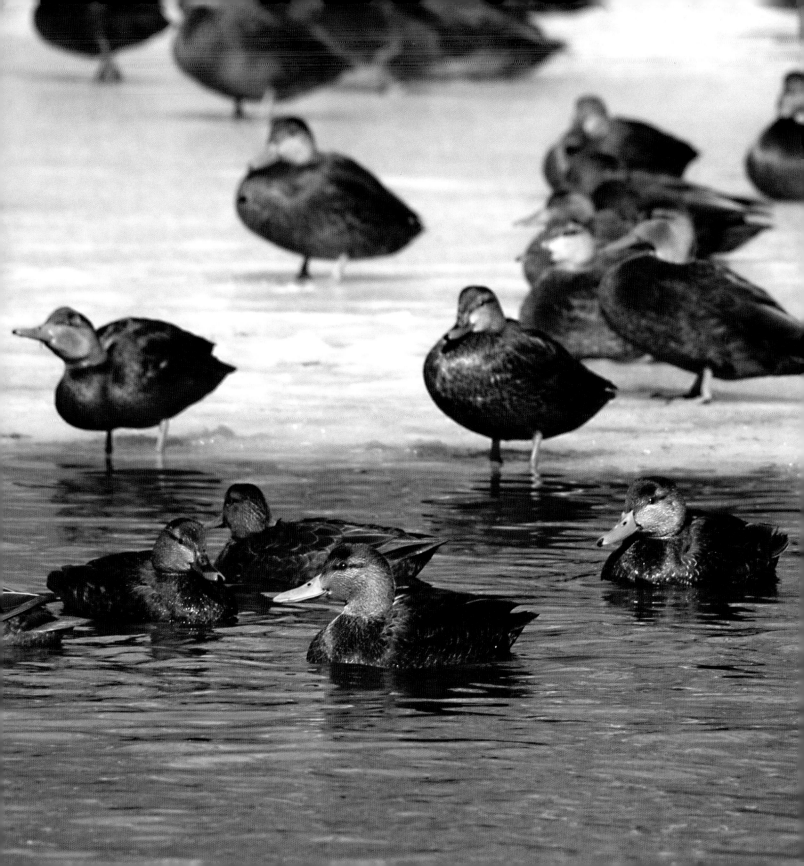

Chapter Fifty-Four

Ducks

It's a story as old as romance itself: a female is getting ready to tie the knot with her intended, and then suddenly another male comes along and sweeps her off her feet. Or, in this case, her webbed feet.

Both the mallard and the black duck are common throughout South Jersey. Increasingly, our female black ducks are mating with mallard drakes, so much so that the numbers of mallard ducks are increasing while those of black ducks are on the wane.

A third common duck—the wood duck—refuses to join in and make this a real soap opera.

Instead, the wood duck nests in the forest in old tree cavities—hence its name. Usually a summer resident, the wood duck spends its winters in Florida and Georgia. In the spring, wood duck hens are as particular about picking a nest site as any human house-hunter in the New Jersey suburbs. If at all possible, they will choose a nest with the following characteristics: It has to have a southern exposure, it has to be dry, it has to be difficult for a predator to enter, and it has to be close to water. Once a nest is chosen and she begins to lay eggs, the female instinctively increases her consumption of invertebrates due to their high protein content. Once incubation begins, she reverts to a vegetarian diet.

You might wonder if New Jersey's resident duck population gets "cold feet" by living on and around cold water. Fortunately for ducks, they do not, because of a heat conservation mechanism that could have been devised by the world's best engineers. First, ducks are insulated by a thick layer of down, which is kept dry by an outer covering of oil-coated feathers. (The eider duck has down with such excellent insulating properties that no man-made substance has been able to match it.) The duck's oil gland is located near its tail. With its broad bill, the duck strokes the oil gland and smears the oil all over its feathers in the behavior known as preening. Since oil and water don't mix, the feathers are kept dry. Next, a unique circulatory system helps to minimize heat loss in the exposed legs and feet. Veins and arteries in the legs touch one another so that hot blood heading to the feet automatically transfers heat to blood headed back to the body. Finally, the feet themselves have very little flesh to actually get cold, being made partly of bone and partly of connective tissue.

Ducks can dive to the bottom of deep waters and not get wet—a remarkable feat. They can dive down as far as one hundred feet (the height of a ten-story building), and swim under water for three hundred feet

Black ducks

| 272 |
Ducks

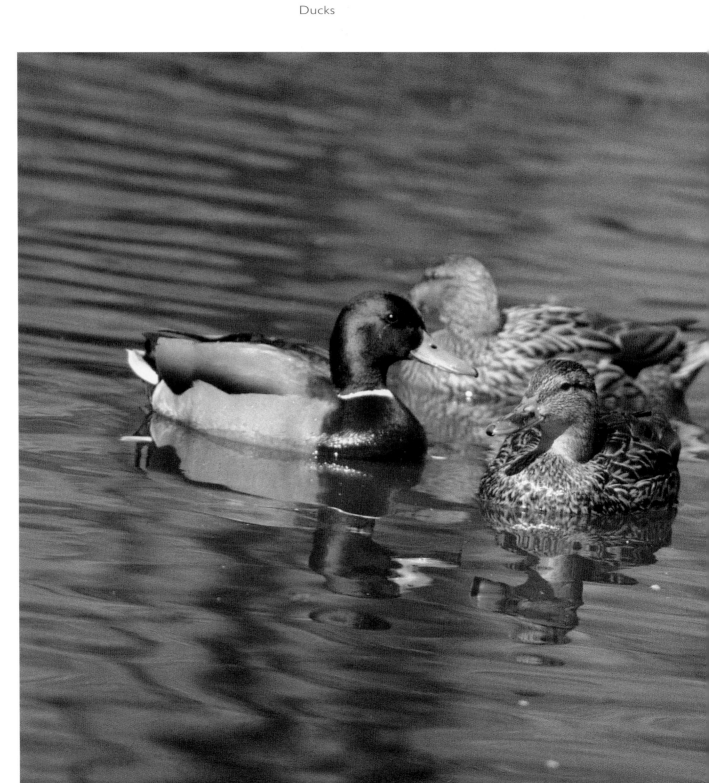

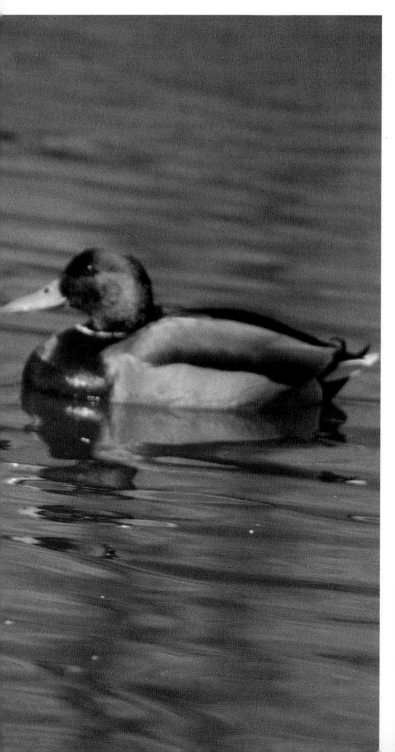

(the length of a city block). Yet when they come up for air, they are still dry.

But enough of hard science. Let's return to our story of love and betrayal. Mallard and black ducks are similar in size and shape; however, the black duck drake lacks the classic looks of the mallard: the glossy green head, the white neckband, and rusty back. It may not seem fair, or it may seem fickle, but the female black duck responds more enthusiastically to the bright plumage of the mallard drake than to her own drake's drab appearance. Their offspring, unlike some hybrids, are not sterile, and merge well into the mallard population, having similar coloration. If the present trend continues, black ducks may disappear and merge back into the prototype duck that was presumably the ancestor of all modern ducks before genetic isolation gave rise to the many different species we see today.

Left: Mallard ducks
Below: Wood duck

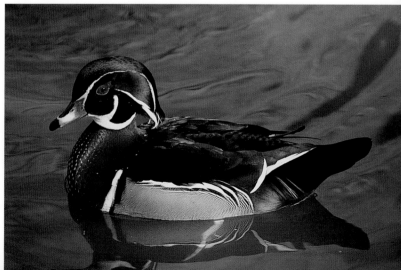

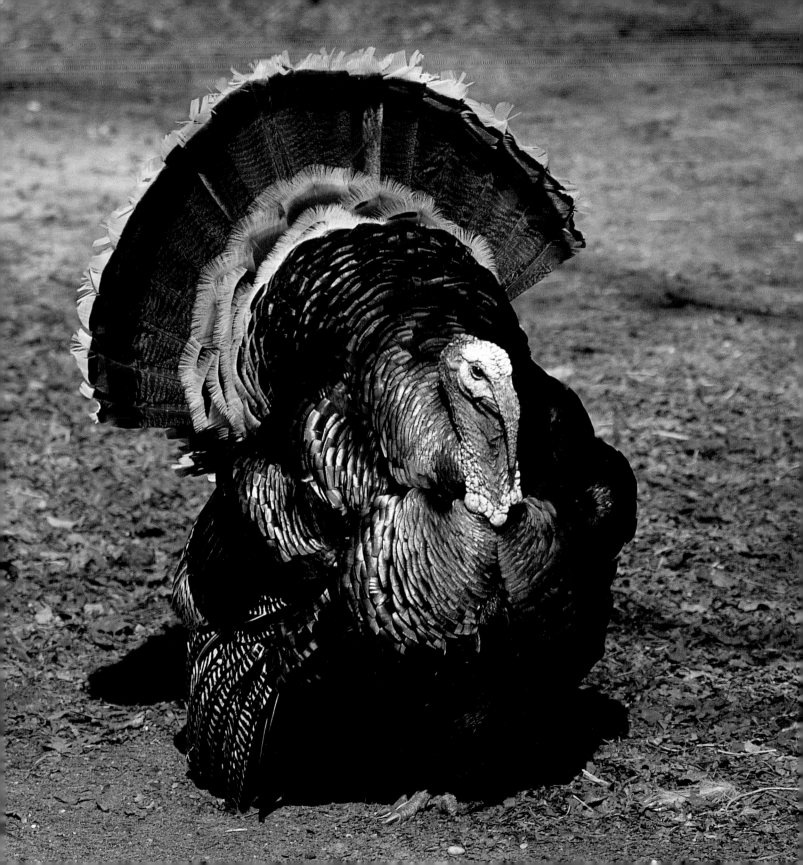

Chapter Fifty-Five

Eastern Wild Turkeys

Farm-raised turkey appears on most Thanksgiving tables in America today. But it was the wild turkey that was in abundance in early South Jersey. Native to North America, more than twelve million wild turkeys once roamed through virgin forests that are now the site of small towns like Tuckerton, Egg Harbor, and Folsom. Ranging from southern Mexico to the eastern Rocky Mountains, and from Maine to Florida, wild turkeys were successful in a variety of habitats and climates.

Six subspecies of wild turkeys have been identified, and each is specific to a certain type of habitat. The Eastern wild turkey is the most widespread and numerous of the six subspecies, and doubtless this is the bird that both the Pilgrims and South Jersey's ancestors hunted and ate. (A Mexican subspecies domesticated by the Aztec Indians more than 2,000 years ago is the ancestor of all domestic turkeys.) So plentiful and so "American" was the Eastern wild turkey in the 18th century that Ben Franklin suggested it be the symbol for the new nation.

As New England, South Jersey, and other areas in the states were developed by man, forests fell before his axes and fires. In addition to losing their habitat, wild turkeys were hunted relentlessly for food to be used here and in Europe. By 1850, wild turkeys had virtually disappeared from the Northeast, and in 1900 the estimated population nationwide stood at just 100,000.

By the mid-20th century, however, reforestation efforts, live trapping and transfer, and other programs spearheaded by wildlife biologists helped the wild turkey make a comeback. In New Jersey, wild turkeys were reintroduced in 1977 and, today, live trapping and transfer has resulted in more than 5,000 wild turkeys flourishing in seventeen New Jersey counties. Restoration efforts, often funded by local hunters, mean that one of the denizens of the unsettled New World forest is coming back with flying colors.

The size of the Eastern wild turkey—one of the world's largest game birds—made it highly prized by America's first settlers. These birds, however, are notoriously hard to find and kill because of their superb vision and outstanding hearing. They prefer to flee from predators on foot, sometimes running at speeds as high as twenty-five miles an hour. When surprised, turkeys can fly away at speeds of up to fifty miles per hour for as far as a mile. In addition to human hunters, predators of wild turkey include foxes, coyotes, and bobcats; the bird has a high mortality rate and short life expectancy, living less than three years on average.

Eastern wild tom, or male, turkey (Photograph by Steve Greer)

Eastern Wild Turkeys

Fortunately, the wild turkey's high mortality rate is offset by a large reproductive capacity. Most hen turkeys nest each year, laying a clutch of ten to twelve cream-colored eggs camouflaged with small brown spots. The toms are polygamous, breeding with as many hens as possible, and take no part in rearing the young.

Young wild turkeys leave the nest within twelve hours of hatching and accompany the mother wherever she goes. Once they reach adulthood, they communicate with a vocabulary of more than thirty distinct calls.

According to an early account of the Pilgrims' experience on Cape Cod, wild turkey was indeed featured at the first Thanksgiving. But it was not the main course—that distinction goes to venison. Actually, at the first Thanksgiving only a few Native American leaders were invited, and when nearly one hundred showed up, the chief dispatched several braves into the woods to kill deer. The deer they shot helped provide enough food for the three days of feasting, games, and giving of thanks to God. Other foods at the first Thanksgiving included eel pie, frumenty (a pudding), grapes, lobster, clams, plums, and corn pudding. One thing the settlers missed, however, was their English ale and beef.

In the late 19th and early 20th centuries, many local people had chicken or goose as the main course at this most American of holidays. But by the time of World War II, as celebrated in Norman Rockwell's famous painting, "Freedom from Want," Thanksgiving turkey had made an impressive comeback.

Below: Wild turkey and young
Right: Wild tom and his harem (Photograph by Steve Greer)

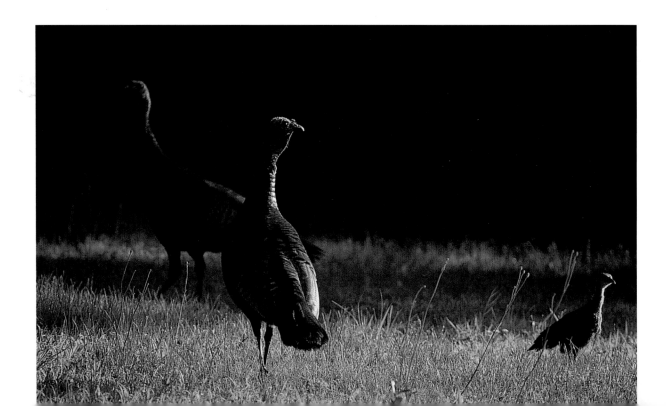

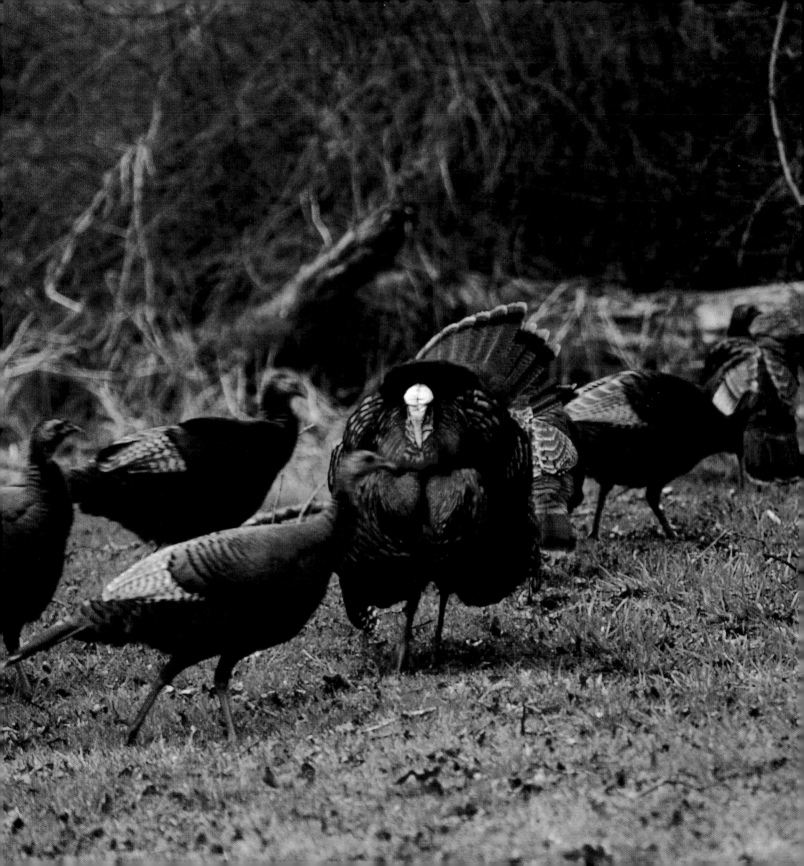

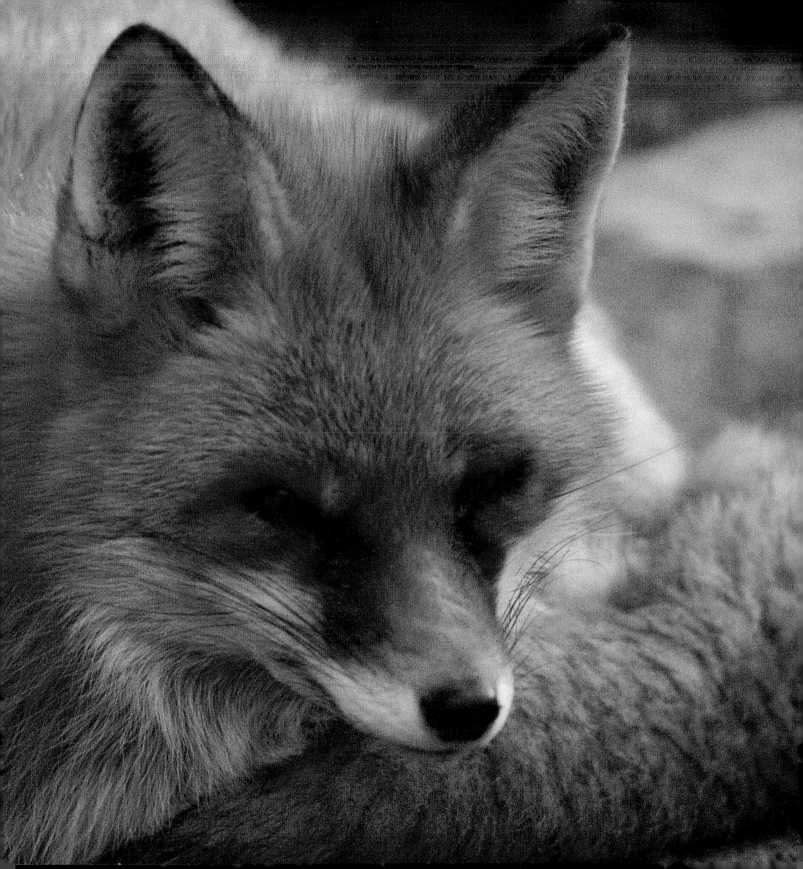

Chapter Fifty-Six

Red Foxes

Although there are not as many red foxes in New Jersey today as there once were, this animal has managed to survive because of its cleverness and resourcefulness, despite widespread land development.

The red fox weighs only eight to ten pounds and is forty inches in length, including its bushy tail. This fox can actually have several coat colors, which vary depending on weather and geography. With the exception of Florida, the red fox is found throughout the United States and as far north as the Arctic tundra. In New Jersey, the animal prefers to live among open hardwoods and at field edges and has a home range of one to two square miles. However, changing weather and the availability of food can determine how far a red fox will travel. It is not unusual for a fox to travel as many as ten miles during a night of hunting.

The red fox is an omnivore, eating plant material, such as berries and grains, and meat. Mice are probably the most important food item in the red fox's diet, but it also eats rabbits, squirrels, weasels, chipmunks, and a variety of small birds. The fox will pounce on its prey, pinning it to the ground with its front feet and killing it with one quick bite. If the fox misses the target, it may rise up on its hind legs to get in a better position to locate and once again pounce. The area around a red fox den often reveals that the inhabitant is not overly particular about what it eats.

The fox begins to seek a mate in January. Called a vixen, the female selects a den site and gives birth to six to eight "kits" in mid-March. Both the male and female fox care for the kits. During the first few weeks, the female stays with the young almost constantly, while the male hunts and brings food to her. As summer approaches, the kits follow the parents to learn how to hunt.

The red fox is the smallest member of the dog family, but it has never been man's best friend. In both the Old Country and in early South Jersey, foxes preyed on chickens and other small domestic animals. In good times, foxes were a nuisance; in bad times they were a real threat to a farm family's sustenance. To lose four or five chickens was a major loss. As a result, foxes were often hunted down and killed.

Eventually, group foxhunts became social events as well as practical wildlife management tools. In England, the wealthy got into the act and created a whole culture based around the sport of foxhunting, or "riding to hounds." To re-create their English heritage and control the fox population, early settlers in South Jersey and Philadelphia formed the Gloucester Fox Hunting Club

Red fox

| 280 |
Red Foxes

in 1760. Several young men from Philadelphia set up the club's headquarters at Hugg's Tavern in Gloucester Town, New Jersey. In those days, there was no bridge; one took a ferry from Philadelphia to Gloucester. Once in the South Jersey countryside, the huntsmen would undertake the classic chase of a fox on horseback. Like their English counterparts, they trained hounds to follow the scent and do the stalking for them while they reveled in the thrill of the chase. Styling themselves after English country gentlemen, these hunters were taking part in an activity they couldn't have enjoyed in the Old Country. America was, after all, a peasant society. (Most people who came here wouldn't have left Europe if they had been rich!) If the hunt here was like the hunt still practiced in England, some forty to fifty riders followed twelve to twenty-four hounds on the track of the fox's scent. Foxes are fast runners—they can travel up to forty-five miles per hour when being pursued. The tracks of a fox are similar to a dog's, save in one respect: the foxes' tracks form a straight line; a dog's tracks appear side by side. When cornered, a fox will play dead to try and fool its attackers. When the fox is finally trapped and killed, the fox hunt is drawn to a close.

The Gloucester Hunt Club eventually evolved into the First Troop, Philadelphia City Cavalry, which boasts of having acted as an escort to every president of the United States from George Washington to modern presidents. It's an honor that no other private organization in the country can boast. And it owes it all to that small, resourceful creature, the red fox.

Red fox walking in the snow (Photograph by Steve Greer)

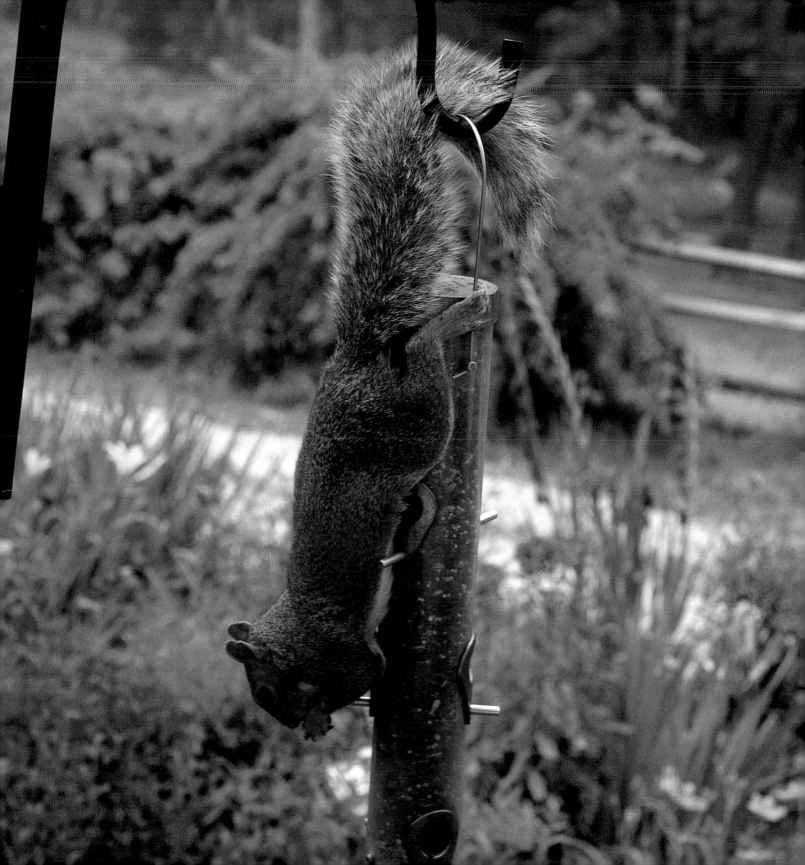

Chapter Fifty-Seven

Gray Squirrels

The gray squirrel is the "Johnny Appleseed" of the oak forest—a relentless worker. Usually up before dawn gathering nuts, the squirrel is active throughout the day and, after a brief mid-afternoon break, continues gathering and burying nuts until it is dark. Yet for all their effort, most squirrels can't remember where many of their nuts are buried. No matter; the result is that many trees and forests grow from long-forgotten acorns.

Thus, contrary to popular belief, squirrels don't have a specific hidden cache or store of nuts and acorns. What saves the gray squirrel in winter is that it buries so many nuts and acorns that its keen sense of smell is able to locate a good portion of them. Moreover, a gray squirrel will not hesitate to dig up acorns buried by other squirrels.

Because gray squirrels have always been abundant in South Jersey, they often were the first game to which young hunters were introduced. The Lenape taught their young braves to hunt squirrels, and squirrel meat could often be found in their lodges. The meat was dried, carried on long journeys, or saved for winter.

Gray squirrels have many other predators in addition to humans, including snakes, hawks, owls, foxes, raccoons, and even cats and dogs. Squirrels rely on their keen eyesight and scamper up trees at the first sign of trouble. If they can't reach their nest, squirrels are expert at circling the trunk, keeping the tree between themselves and the potential threat. The automobile is another "predator" that should be mentioned. In recent years, there has been much more roadkill than in the past. As the population of South Jersey and traffic increases, this trend will doubtless continue.

Gray squirrels are small mammals, weighing one to one-and-a-half pounds. These squirrels build their nests from leaves and twigs and locate them among the branches or in the holes of the trees. They usually live within a ten-acre area and seldom go beyond it. They breed twice a year, once in February and again in May. The litter is usually two to four young, and the male squirrel plays no part in raising the offspring.

Although squirrels can be troublesome, they are fascinating to watch. And who knows? Your favorite tree may have been planted by a Jersey squirrel.

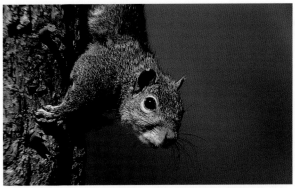

Gray squirrel

(Photograph by Steve Greer)

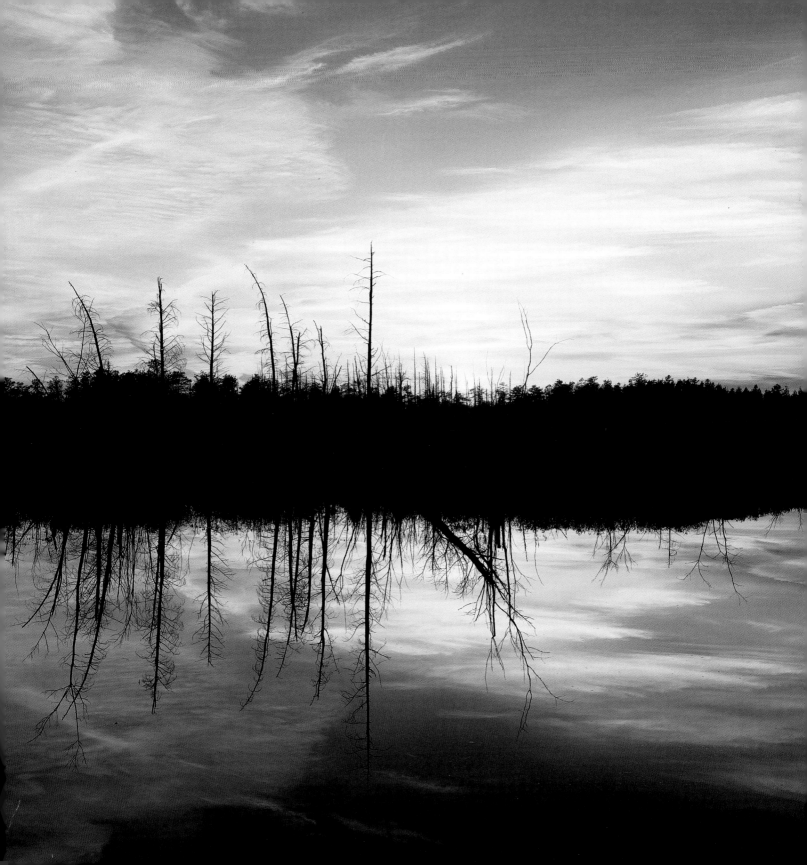

Bibliography

We are indebted to the authors of the following fine publications for their research and insights.

Amos, William. *The Life of the Pond*. New York: McGraw-Hill 1967.

Boyd, Howard. *A Field Guide to the Pine Barrens of New Jersey*. Medford, NJ: Plexus Publishing, Inc. 1991.

Boyd, Howard. *A Pine Barrens Odyssey*. Medford, NJ: Plexus Publishing, Inc. 1997.

Buchholz, Margaret Thomas, ed. *Shore Chronicles*. Harvey Cedars, NJ: Down the Shore Publishing. 1999.

Cawley, James and Margaret. *Exploring the Little Rivers of New Jersey*. New Brunswick, NJ: Rutgers University Press. 1961.

Cunz, Dieter. *Egg Harbor City: New Germany in New Jersey*. N.P. Report of The Society for the History of the Germans in Maryland. 1956.

Eckhardt, Gertrude M. *The History of Folsom, New Jersey, 1845-1976*. Egg Harbor City, NJ: The Laureate Press, 1975.

Fowler, Michael, and William Herbert. *Papertown of the Pine Barrens*. Eatontown, NJ: Environmental Education Publishing Service. 1976.

George, Jean. *Marvels and Mysteries of Our Animal World*. Pleasantville, NY: The Reader's Digest Association. 1964.

Green, Charles F. *Pleasant Mills, New Jersey; Lake Nescochague, a Place of Olden Days: An Historical Sketch. [N.p., ca 1920]. Third Edition. Mullica Township Area of Atlantic County. Much Pine Barrens Lore*. Published: 1920.

Jahn, Robert. *Down Barnegat Bay: A Nor'easter Midnight Reader*. Medford, NJ: Plexus Publishing, Inc. 2000.

Kross, Peter. *New Jersey History*. Wilmington, DE: The Middle Atlantic Press. 1987.

McCormick, Jack. *The Life of the Forest*. New York: McGraw-Hill. 1966.

McCormick, Richard P. *New Jersey from Colony to State: 1609-1789*. Princeton, NJ: D. Van Nostrand, Inc. 1986.

McMahon, William. *Pine Barrens Legend, Lore and Lies*. Wilmington, DE: The Middle Atlantic Press. 1980.

McMahon, William. *South Jersey Towns: History and Legend*. New Brunswick, NJ: Rutgers University Press. 1973.

McMahon, William. *The Story of Hammonton*. Hammonton, NJ: The Historical Society of Hammonton. 1960.

Moonsammy, et al. *Pinelands Folklife*. New Brunswick, NJ: Rutgers University Press. 1987.

Niering, William A. *The Life of the Marsh*. New York: McGraw-Hill. 1966.

Palmer, F. Alan. *This Place Called Home*. Upper Deerfeld Township, NJ: Upper Deerfeld Township Committee. 1985.

Pierce, Arthur D. *Family Empire in Jersey Iron*. New Brunswick, NJ: Rutgers University Press. 1964.

Platt, Rutherford B. *The Great American Forest*. Englewood Cliffs, NJ: Prentice-Hall, Inc. 1965.

Still, Dr. Cecil C. *Botany and Healing*. New Brunswick, NJ: Rutgers University Press. 1998.

Studley, Miriam V. *Historic New Jersey Through Visitors' Eyes*. Princeton, NJ: D. Van Nostrand Co., Inc. 1964.

Weiss, Harry B. *Life in Early New Jersey*. Princeton, NJ: D. Van Nostrand Co., Inc. 1964.

About Robert A. Peterson

Robert A. Peterson, Jr., until his death on August 1, 2003, was a dedicated educator, journalist, historian, and sportsman. The author of more than 2,000 articles, Bob served for more than 22 years as headmaster of The Pilgrim Academy in Egg Harbor City, New Jersey, where he lived with his wife, Susanna, and their seven children. A frequent speaker to historical, educational, and church groups, in 1988 he was named "Citizen of the Year" in his hometown.

In addition to this book, Bob authored *In His Majesty's Service* (Huntington House, 1995); *Patriots, Pirates, and Pineys* (Plexus Publishing, Inc., 1998), now in its second printing; and contributed chapters to *Public Education and Indoctrination* (1992), *The Spirit of Freedom: Essays in American History* (1994), and *The Industrial Revolution* (1992), all published by the Foundation for Economic Education, New York.

The following tribute to Bob Peterson was written by his children, Rebecca, Robert, Joseph, James, David, Priscilla, and Rachel. It appeared in The Egg Harbor News, *August 20, 2003, and is reprinted by permission.*

Why our Father was the Best Man we ever Knew

Editor's Note: The late Robert Peterson, Jr., was a writer for this newspaper for many years, chronicling the area's history in a weekly column "Our South Jersey Heritage" on this page.

By **ROBERT PETERSON'S CHILDREN**

Special to The News

Three years ago this September, Robert Peterson Jr., wrote an article in this column entitled, "Why My Father Was the Best Man I Ever Knew." Now, in the wake of his own home-going on Aug. 1, we, his children, feel compelled to echo those same sentiments.

For more than 20 years, Dad wrote biographical sketches of men and women from South Jersey and around the world who colored our local history and heritage. Many of these were expanded into chapters of his book "Patriots, Pirates, and Pineys."

As a historian, Dad was interested in all kinds of men and women, but his favorites were always those with conviction and character strong enough to rise above their time and serve as role models for himself and his students. It never occurred to him, but Dad is worthy to stand in that company, and had he possessed enough pride, he might have "sketched" his own life in that light.

Dad was so many things to so many different people, as was evidenced at his viewing and funeral. That's because he made people his business.

As a citizen, he always laid stress on the power of community. Some of our oldest memories are of driving down main street with Dad in Egg Harbor City and hearing, "Hi, Bob," over and over again. When exiting the barbershop or the pizzeria—after pleasant conversation with the proprietor and customers—he would look at us, smile, and say, "I love this town. It's like Mayberry."

As a teacher and administrator, he poured his life into the education of the next generation. From personally interviewing each prospective family and speaking in churches on the value of Christian education, to such extreme measures as climbing onto desks and dressing up as historical figures—his passion drove him to view each individual student as a commitment and kept him from falling into the daily grind of his job.

His unique balance of gifts was apparent as he coached his high school soccer team in the championship game one year. At half-time, he called the guys over, turned on the soundtrack of "Henry V," and delivered a rousing rendition of "Upon St. Crispian's" speech. Needless to say, his boys charged onto the field and won the day.

A South Jersey man to a fault, his desire to provide services for other schools in our area propelled him to the top of New Jersey's Christian education movement.

Dad had many other facets, which time and space would not permit, but his favorite pastime was his family. He would often tell us, "Your real friends are your family. They will tell you the truth and always be there for you."

Dad's philosophy led us to spend a lot more time with extended family than the typical teenager. At times we would get together two or even three times a week. In contrast to so many current thought trends, Dad taught us that the family is the building block of society.

Dad had no qualms about enlarging the bounds of his family either. It was not uncommon for there to be two or three extra people sharing dinner and spending the night. In looking through his planner the other day, we located a list of ways to be continually improving his family life. There were things he wanted to do with the whole family, and even individual activities for one-on-one time with each of us.

Dad was the busiest man we've ever known, but that didn't make him lose sight of his priorities—he taught us with his life what things were important, and that's not easy to do.

If Dad were here, though, he would faithfully point out that the only thing that makes a flawed man great is the power of Christ. To quote daughter Rebecca's eulogy, "My Dad was only 'good' because he followed the one true Good Man—Jesus Christ." The source of Dad's wisdom and strength lay in reliance on God.

Dad followed—no, embodied—the biblical injunction, "Be all things to all men." Whether it was sitting on the floor in the family garage trying to change a tractor tire, or discussing worldviews in literature with intellectuals from across the nation, he could make anyone feel right at home.

To us, he was a father, teacher, coach, teammate, headmaster, boss, co-worker, writer, paintball rival and just one of the guys. A large part of our South Jersey heritage goes with him and we can only pray that we might have as powerful an impact in twice as many years. He was the best man we ever knew.

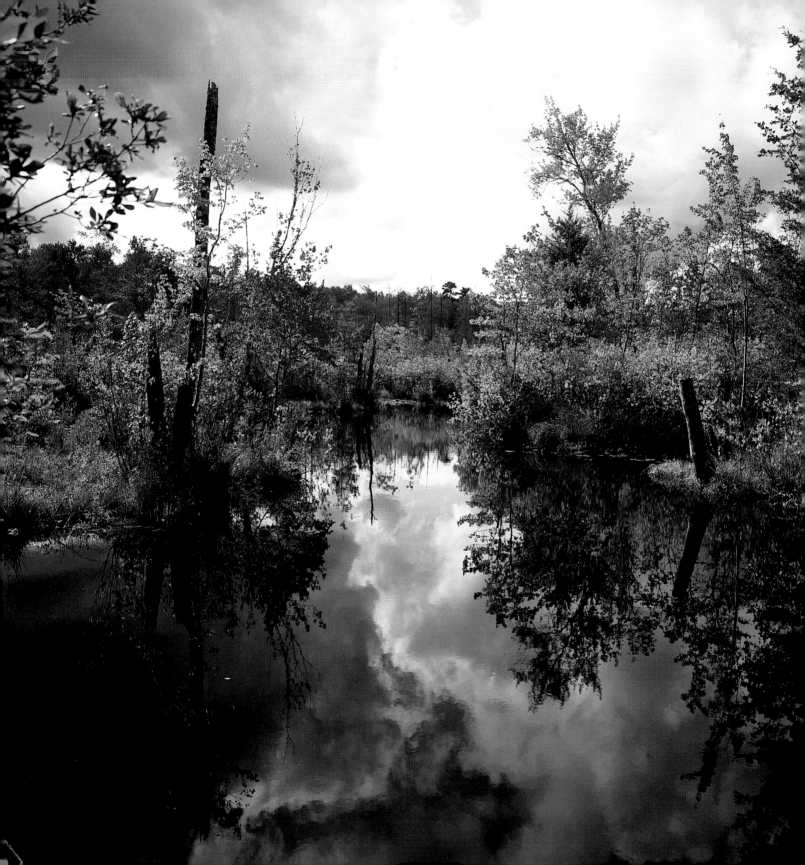

About Michael A. Hogan

Michael Andrew Hogan began photographing the southern New Jersey Pine Barrens in the early 1980s. As he photographed the area, his interest in its history and unique ecology grew. He began to explore and photograph inaccessible places in the Pine Barrens, traveling by foot, canoe, and Jeep with his 4x5-format view camera.

With grants from the New Jersey Department of Environmental Protection, Michael has completed ten watershed photo-documentary projects in southern New Jersey. He has taken more than 18,000 photographs of the watersheds and produced numerous educational slide presentations for area schools and organizations.

Michael's large-format fine art photographs of southern New Jersey can be found in many corporate, public, and private art collections including those of Johnson & Johnson, McGraw-Hill, Price Waterhouse, the John Templeton Foundation, and the New Jersey Department of Environmental Protection.

Many of the photographs that appear in this book are available as fine art prints. Visit Michael's Web site at www.hoganphoto.com for a selection of his photography of the Pine Barrens, Delaware Bay and River, wild orchids, and rare wildflowers.

About Steve Greer

Additional photography appearing in *Natural Wonders of the Jersey Pines and Shore* was provided by another talented South Jersey-based photographer, **Steve Greer**. Growing up in the Canadian Rockies, Steve found in the mountains a magical place to learn the fundamentals of landscape photography. Since moving to Southern New Jersey in 1996, he has devoted an increasing amount of his time to documenting the region's natural history, specializing in all forms of Garden State flora and fauna.

Steve's images are seen on dozens of magazine covers, calendars, and greeting cards, and have appeared prominently in advertising and educational materials. His editorial credits include *Birder's World, National Wildlife, Outside, Photo Life, Birds and Bloom, Bird Watchers Digest, Reptile, Photo Techniques,* and *Wildbird*. He has won the Grand Prize and First Place Awards at the prestigious National Wildlife Annual Photography Competition for four years in a row.

Steve credits his artistic vision to the unconditional love and support he receives from the two most special ladies in his life: his wife, Cindy, and their daughter, Olivia. The Greers currently live in Moorestown, New Jersey. For more information about Steve's photography, visit www.agpix.com/stevegreer.

Page 284: Goshen pond at sunset
Left: Tuckahoe River in the fall
Page 290: Great Egg Harbor River at Inskip

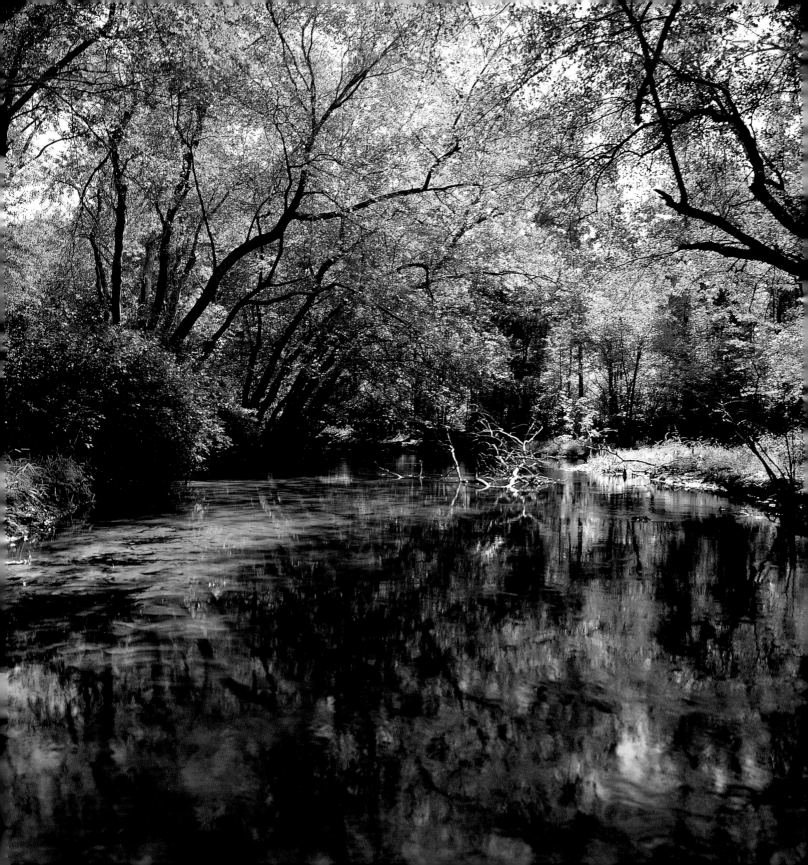

Index

Page numbers for photographs are in *italics*

A

A. J. Meerwald, 9, *96*
Absecon, 203
Absecon Island, 79, 99
acorns, 122, 143–144, *144*
Acorus calamus (sweet flag root), 199
Acrtic terns, 38
Aetna Furnace, 227
agriculture, 105, 231–232
Amanita bisporigera (destroying angel), 175
Amanita muscaria (fly agaric), 175
American hollies, *138, 140, 141*
Anatidae, 42
Anderson, Hattie Adams, 33
Annelsy, John, 133
ants, woodpecker diet, 57
Apple Pie Hill, *120*
Ardeidae, 53
Arethusa bulbosa (dragon's mouth orchid), 155–156, *157, 158*
Arnold, Matthew, 7
Artificial Island, Delaware Bay, *22*
Asbury Park Press, 139
asphalt shingles, 133
asters, 224
Atlantic City, 99, *202, 207*
Atlantic County, 113
Atlantic Flyway, 37, 139
Atlantic white cedar trees, *132,* 133, *134, 135,* 137
Atsion, iron forges, 119
auto racing, 206

B

Back to Basics (Reader's Digest), 105
bald eagles, *44,* 45–47, *46, 47*
barn owls, 61
Barnegat bay, 17
barred owls, 61, *63*
barrier islands, 99
Bartram, John, 140

Bartram, William, 140
Batsto
 iron forges, 119
 lumber harvesting, 143
 munitions factories, 227
Batsto County Living Fair, *136*
Batsto Mansion, *228*
Batsto Museum, *226*
Batsto River, *29*
Batsto Village, *110*
baymen, 17, 21
Bayside, Delaware Bay, *18, 19, 103*
beaches, *202,* 203, 205–206
Bear Mountain State Park, 268
beaver lodge, *269*
beavers, *266,* 267–268
Bentley, Wilson Alwyn, 115–116
Berkeley, William, 110
Bernhard, Prince of the Netherlands, 211
Big Timber Creek, 25
bird migrations, 15, 37–39. *see also* Atlantic Flyway
birds. *see also specific* birds
 bird-watching, 37
 carvers of, 21
 cover for, 127
Bivalve, Delaware Bay, 3, *8, 9*
black ducks, *270,* 271, 273
black-eyed Susans, *238*
black grass *(Juncus gerardii),* 215
black skimmer, 203
bladderworts, 191, *192–193,* 194, *195, 196*
blast furnaces, 227
Blizzard of 1888, 96
Blizzard of 1996, *117*
blizzards, 96, 112, *117*
blue claw crabs *(Callinectes sapidus),* 10, 11–13, *12*
blue flag, *27*
Blue Heron Pines, 53
blue holes, *32,* 33–34, *34*
blue-spotted salamanders, 211
blueberries, 26, *244,* 245–246, *246*
Blueberry Cooperative Association, 245
"board banks," 4
Boardman, Alexander, 79
boat-building industry, 21–22, 99
boats, 4, *6–9, 8, 30, 96,* 111

boatyards, 21–22, 25, 99, 145
bog asphodel, *164,* 165
bog iron, *226,* 227–228, *229*
bogs
 carnivorous plants, 188
 cedar, 159
 orchids in, 155
 sundews, 194
Boletus sp., *178*
boron, 197
Boyd, Howard, 113, 169
Brigantine, 37, 203
Brigantine Beach, *204*
British soldier lichen, *180,* 181
broad-winged hawks, 49
Brown, Allen, 215
Brugger, Ken, 73
Bryant, William Cullen, 169
Bryant-Stratton Business College, 241
Buchholz's dart moth, 122
Buena Vista Township, 33
Bull's Island, *106*
Burke, Edmund, 235
Burrs Mill, Southhampton Township, 241
butterfly bush, *72*
buzzards. *see* turkey vultures

C

Calico, town of, 152
calico bush, 151
California condors, 64
Callinectes sapidus (blue claw crab), 10, 11–13, *12*
Camden-Atlantic line, 205
Camden docks, 112
Canada geese, 41, *42, 43*
Cape May, 37, 205
Cape May Automobile Club, 206
Cape May Beach Course, 206
Cape May County, 38, 93
Cape May County Gazette, 95
carnivorous plants, *188,* 189–195
carpenter frog, 257
carving, 21
Cassville, 175, 178
cast iron, 227

caterpillars, monarch, *74*
cattails, 219
Cavulina corona (crown's coral fungus), *176*
cedar bogs, 159
cedar forests, 95
cedar shingles, 133
cedar swamps, 171
Cedrine, E., 206
Champlain, Samuel de, 245
charcoal, 119, 130, 227
Charcoal Hill, 33
cherries, 105
"cherrystones," 3
Chesapeake bay, 17
Chevrolet, Louis, 206
chitin, 12–13
chorus frog, 257
chowder clams, 3
Christie, Walter, 206
Christmas, holly for, 139
Christmas Bird Count, 37
clam rakes, 4
Clam Town. *see* Tuckerton, New Jersey
clambakes, 3
clamming industry, 3
clamming licenses, 4
clams, 3–4
clamshells, 3
Clarks Landing, 26
clouds, weather prediction, 90
coal boats, 119
codling moths, 57
Cohansey, Chief, 105
Cohansey Aquifer, 105
Cohansey River, 7
Cold Spring Inlet, 206
Cold Spring Village, 93
colliers, 122, 124
Collinson, Peter, 156
Columbus, Christopher, 231
common reeds, 219
cones, conifer, 127, 129
"Conserve Wildlife" license plates, 58
Cooper's hawks, *48*, 49
cordgrass (*Spartina*), 215, *217*, *222–223*, *224*, *225*
coreopsis, *237*
corn. *see* Indian corn; maize
Corville, Dr., 245
crabbing, 11
crabs, *10*, 11–13
cranberries, *240*, 241–242, *242*, *243*
cranberry bogs, 26, 30, *84–85*, *208*
Crassostrea virginica (oysters), 4, *5*, 7, 9, 205

Cresse, David, 93
crickets, weather prediction, 89–90
Crowleytown, 80
crown's coral fungus (*Cavulina corona*), *176*
Cyperus grass, *218*
Cypripedium acaule (lady's slipper), *154*

D

daisies, *235*
dandelions, 197
Daphne, mythology, 151
Darwin, Charles, 194
DDT, eagle eggs and, 45
decoy carving, 21
deer, 25, *252*, 253–254, *254*, *255*
Delaware Bay
 Artificial Island, *22*
 Bayside, *18*, *19*
 description, 17
 Fortescue Beach, *16*, *92*
 Kimble's Beach, *21*, *98*, 206
 low tide, *23*
 tidal wetlands, *213*
 winds, *94*, 95
 yellow salt meadow hay, *214*
Delaware Bay Schooner Project, 9
Delaware River
 fog, *86–87*
 Gloucester, 90
 near Bull's Island, *106*
 winds, *92*
Dennis Creek, Cape May County, 133
Dennisville, 133
Department of Environmental Protection, 45
Dermo parasite (*Perkinsus marinus*), 7, 9
destroying angel (*Amanita bisporigera*), 175
Devils Coffin. *see* sneakboxes
DeVries, David Peterszen, 37
diamond back terrapin, *260*, 261
Distichlis spicato (salt grass), 215
Ditmars, Raymond L., 261
Division of Fish and Wildlife, New Jersey, 12, 159
Dog Heaven, 34–34
Domesday Book, 143–144
downy woodpeckers, *58*
dragon's mouth orchid (*Arethusa bulbosa*), 155–156, *157*, *158*
dredge boats, 4
Drosera sp., 194
duck hunters, 21
ducks, 21, *270*, *271*, *272*, *273*

duff, composition, 122
Duke blueberry, 246
dunes, 203
Durand, Victor, 80
dwarf forests, 127
dwarf glasswort, 224

E

eagles, *44*, 45–47
East Point, Delaware Bay, 95
East Point Light, Delaware Bay, *82*
eastern box turtles, 261, *262–263*
eastern screech owl, *60*
eastern wild turkeys, *274*, 275–276, *276*, *277*
Edwin B. Forsythe National Wildlife Refuge, *20*, 37, 42, 211
Egg Harbor City, 25, 80, 106, 245
Egg Harbor City Historical Society, 25
Egg Harbor City Pottery, 215
Egg Harbor Township Tercentenary Committee, 33
Einsiedel, Edmund, 113
Emerson, Ralph Waldo, 167
English Creek, 99
Estel Manor, Atlantic County, *89*
Etna, iron forges, 119
evergreen trees, 127
Ewing, Lemuel, 93

F

false reindeer lichen, *187*
Fenwick, John, 143
Fenwick's oak tree, 148
ferries, history, 99
fire, *118*, *120*, *121*
 aftermath, *122*
 forest regrowth after, *124*
 pitch pine life cycle and, 124, 129
 swamps as barrier to, 137
fireweed, 199
firewood, 130
fishing boats, *8*, *9*, 111. *see also* oyster boats
Fleming, Ambrose, 109
Fluck, Paul, 49
fly agaric (*Amanita muscaria*), 175
fog, *86–87*
folk healers, 197
food chains, 45
Ford, Henry, 206
forest regrowth, *124*
forges, bog iron, 227–228

Forks, The, 99
Fortescue Beach, Delaware Bay, *16, 92*
foxglove, 200
Franklin, Benjamin, 90, 105
Franklin, William, 227
Franklinia tree, 140
frogs, *256,* 257–258, *258, 259*
frost, wetland grasses, *88*
fur trade, 267
furniture making, 146, 148

G

Galileo, on tides, 101
Galleta, Duke, 246
garden flowers, *234–239, 235, 238*
Garden State Parkway, 95
Gateway National Recreation Area, 139
geese, *40,* 41, *41,* 41–42, *42, 43*
Gentiana autumnalis (Pine Barrens gentian), *168,* 169, *169*
Gerard, John, 224
glass making, 79, 119
glassblowers, 79
Glassboro, 30
Glasshouse Museum, *81*
glasswort, 224
Gloucester Fox Hunting Club, 279, 280
Gloucester Furnace, 227
Gloucester Landing, 143
gnats, 69
Godfrey, Arthur, 211
Goshen, Cape May County, 93
Goshen pond, *284*
grass pink, *156*
grasses, frost on, *88*
gray squirrels, *282,* 283, *283*
Gray tree frog, 257, *258*
Great Blizzard of 1889, 112, 115, 116
great blue herons, *52,* 53–54, *54, 55,* 211
Great Egg Bay, 17
Great Egg Harbor River, *26, 31, 290*
 blue hole, *32*
 course, 30
 Steelman plantation, 231
 Van Sants Boatyard, 145
great horned owls, 61–62, *62*
Great Swamp, 133
Greeley, Adolphus, 113
Green Acres program, 211
green woodland orchid, *156*
Greenwood Forest State Wildlife Management Area, Lacey Township, Ocean County, 159
Gymnopus sp., *177*

H

Haeckel, Ernest, 258
Hammonton, 29, 106, 241
Hammonton Lake, 106
Haplasporidium (MSX parasite), 7, 9, 22
hard clams *(Mercenaria mercenaria),* 3–4
Harrisville, 215
Harrisville Lake, *108*
Harrisville papermills, 26
hawks, *48,* 49–51
herbs, wild, 197, 199–200
herons, 211
Heston, Thomas, 80
Higbee Beach, 37
Historic Cold Spring Village, Cape May County, 9
History of the Swedes in South Jersey (Latrobe), 69
Hogan, Mike, 34
Holly Forest, 139
Holly Haven nursery, 140
Holly House, 140
Holly Society of America, 140
homes, water requirements, 105
homing pigeons, 38
honeybees, *248,* 249–250, *250*
horned bladderwort, *192–193, 195, 196*
horsemint, 200
horseshoe crabs *(Limulus polyphemus), 14, 15,* 212
House, Homer, 155
Hudson, Henry, 45
Hugg's Tavern, 281
humidity, weather prediction and, 83
hunting
 fox, 279, 280
 squirrel, 283
 white-tail deer, 254, 255
hunting parties, 21
hurricane winds, 95
hydrangeas, *239*
hypericum, 199

I

ice, *84–85,* 90, *108,* 109–111
ice boxes, 111
ice chests, 111
ice cutting, 110, 111
icehouses, 110, *110, 111*
imprinting, goslings, 42
Indian corn, *233*
Industrial Revolution, 148
industry, water requirements, 106

Insect Migration Association, 73
Inskeep, John, 33
Inskip, 33, *290*
iron forges, 119–228, 227
iron furnaces, 4
Island Beach State park, 37

J

Jersey blueberry, 246
Jersey Devil, 33
Juncus gerardii (black grass), 215

K

Kalm, Peter, 69, 133, 151, 235
Kalmia angustifolia (sheep laurel), 151, 152, *153*
Kalmia latifolia (mountain laurel), *150,* 151, *152*
Kimble's Beach, Delaware Bay, *21, 98, 206*
kitchen gardens, water requirements, 105
Knodding ladies tresses, *159*
Kogi Indians, 106
Kropotkin, Peter, 183, 187, 194

L

lady's slipper *(Cypripedium acaule), 154*
Latrobe, Charles, 69
laughing gulls, *36*
laurals, 151–152
Laureldale, Hamilton Township, 152
Leaming's Run, *234*
Leaming's Run Gardens, 38
least tern, 203
Lebanon State Forest, 211
Leek, Rube, 246
Leek family, 145
Lehigh University, 212
Lenape Indians
 acorn meal use, 143
 beaver and, 267
 blue holes and, 34
 blueberry use, 245
 crabbing, 11
 cranberry use, 241
 deer and, 253–254
 heron hunting, 54
 King Nummy, 105
 lady's slipper orchid use, 156
 maize use, 232
 Mullica River and, 26
 oyster harvests, 4

Lenape Indians (*cont.*)
 salt marsh plant use, 219
 shore areas, 203
 sphagnum moss use, 171
 squirrel hunting, 283
 turtles and, 261
lepidella, *174*
Liberty Cut Glass, 80
lichens, *180, 182, 183–187*
lightning strikes, 122, 195
Lily leaf-twayblade, 160
lily pads, 163
lime, oyster shell, 4
Limulus polyphemus (horseshoe crabs), *14, 15*, 212
Lindbergh, Charles, 211
Little Egg Bay, 17
little green turtles, 262
Little Ice Age, 110
"littlenecks," 3
London Graphic, 173
Long Beach Island, 99, 203
long-eared owls, 61
lumber harvesting, 143

M

Mad Horse Creek, *213*
maize, *230*, 231–232, *233*
Make Peace Lake, *211–212*
mallards, 271, *272–273*, 273
Manahawkin, 203
Manasquan, 203
Mannington Meadows, *210–211*
Maple Lake, *89, 90*
marshes, 25, 219
Martha's Furnace, 152
Mason, J. L., 80
Mataloking, 203
Maurice River, Cumberland County, 25, 30, *97*
May apple, *199*, 200
Mayflower, oak trim, 143
McPhee, John, 105
Medford, 143
medicinal herbs, 197
Medicinal Plants of New Jersey, 200
Mediterranean Sea tides, 99, 101
Mercenaria mercenaria (hard clams), 3–4
Metedeconk, 203
milkweeds, 73, *248*
mills
 papermills, 26
 shingle mills, *136*
 water, 99

 wind powered, 93, 95
Mills, Herbert, 209, 211
mills, tide power for, 99
Millville, 30, 80, 119, 140
Millville Holly Farm, 140
Milne, A. A., 61, 62
moccasin flower, 155s
monarch butterflies, 72, *72, 73–76, 76*
Monroe Township, *32, 34*
moon, influence on tides, 101
mosquitoes, 69, 71
mosquitoes *(Wycomyia)*, 194
mountain laurel *(Kalmia latifolia), 150,* 151, *152*
MSX parasite *(Haplasporidium),* 7, 9, 22
Mt. Laurel, 152
Mullica, Eric, 26
Mullica Bay, *225*
Mullica River, *27*
 leaves on, *24*
 Leek family on, 145
 Lenape and, 26
 Nescochague branch, *30*
 snow on wetlands, *112*
 Sweetwater Casino, 17
Mulliner, Joe, 26
munitions, 227
mushrooms, *174*, 175, *176–178*
Mutual Aid (Kropotkin), 187

N

Neschochague Creek, Atlantic County, 25
New Egypt Press, 265
New Jersey Courier, 112
New Jersey State Geologist, 122
New Jersey Tea, 197, *200*
Newport Creek, 29
Newton, Isaac, 101
Nicols, George, 173
nitrogen, atmospheric, 194–195
northern pitcher plants, *188, 189*
Noyes Museum, Galloway Township, 71
Nummy, King of the Lenapes, 105

O

oak trees, *142, 147*
Ocean City, 99, 203, 205
Ocean Grove, 205
Ocean Yachts, 26
odors, weather prediction, 89
Ole Hansen and Sons, 53
ornithologists, 37

Oswego River, 26, *107*
Owen, Michael, 80
owls, 49, 60–63
oxygen, need for, 194
oyster boats, *6, 7, 8, 9,* 30, *96*
oyster dredges, 4
oyster rafts, 99
oysters *(Crassostrea virginica), 4, 5, 7, 9,* 99, 205

P

papermills, 26
parasites, oyster, 7, 9
Parfit, Michael, 106
Parker's pipewort, 25
peat, 133, 171
Peck's Island, 99
Penny Pot, 29–30
peregrine falcons, *36*
Perkinsus marinus (Dermo parasite), 7, 9
Peterson, Roger Tory, 211
phragmite, 219
Pine Barrens, The (McPhee), 105
Pine Barrens gentian *(Gentiana autumnalis), 168,* 169, *169*
Pine Barrens Odyssey, A (Boyd), 113
Pine Tree flag, 130
Pine Tree shilling, 130
pine trees, 127, 129–130
pine warbler, *38*
Pinelands, fire in, 119, 122, 124
piping plover, 203
pitch pines, *126*
 cones, 119
 forest of, *128, 129*
 sap release, *130, 131*
pitcher plants, *188, 189,* 194
pixie moss, 122
plantain, 197
Plants of Southern New Jersey, The (Stone), 160
Platt, Rutherford, 181
Pleasant Mills, 26
pollution
 goose droppings, 41–42
 reduction in, 3
 wetlands in control of, 209, 211–212
Port Norris, Cumberland County, 4, 17
Port Republic, 26
post oak, *146*
Press, Thomas, 93
Prometheus myth, 124
prunella, 198

purple martins, *68, 69, 70, 71*
pygmy pitch pines, 127
Pyxie-cup lichen, *182–183*

Q
"quahogs," 3
Quakers, 79, 110

R
racecourses, 206
ragged-fringed orchid, *161*
railroads, 205
rain, *89, 90*
Rancocas River, 26
red-bellied turtles, 262, *264*
red-bellied woodpeckers, *59*
red-eared slider, 262
red foxes, *278, 279, 280–281*, 281
red-tailed hawks, 49, *50*
redheaded woodpeckers, *56, 58*
redroot, 197, *200*, 211–212
Renault Winery, 245
Revolutionary War
 beach activity during, 203
 bog iron forges, 227–228
 Mullica River and, 26
 Pine Tree flag, 130
rhodora, 167
rice, water requirements, 105
Rider, Andrew, 241, *242*
Rider College, 241
Rider-Moore Business College, 241
river otters, 25
roads, clamshell surfaces, 3
Rockwell, Norman
rodents, hawks and, 49
rose pagonia, *159*
Round House, Egg Harbor City, 25
round-leaved sundew, *191*
Rube blueberry, 246
ruby-throated hummingbirds, 38
ruddy turnstones, *36*
Russula *(Russula variata),* 175

S
salamanders, 211
Salem County, 143
Salem oak, *148*
Salisbury, F., 195
salt, gunpowder and, 227
salt grass *(Distichlis spicato),* 215

salt hay, *214,* 215–216, *216, 217,* 224
salt marsh asters, 224
salt marsh cordgrass, *222–223*
salt marsh fleabane, *218, 220*
salt marsh flowers, *218, 219*
salt marsh grass, 224
salt spray horizons, 139
salt works, 99
saltmarsh, *217*
samphire, 224
sand, *78, 79*–80
Sandburg, Carl, 119
Sanderlings, *39*
Sandy Hook, 139
saw-whet owls, 61
sayings, weather prediction, 83
screech owls, 61
scrub pine, 127
sea lavender, *221*
Sea shore mallow, *219*
Seaman, Hazelton, 21
seaside goldenrod, *224*
sharp-shinned hawks, 49, *51*
sheep laurel *(Kalmia angustifolia),* 151, 152, 153
shellfish, 3–9, 17
shingle mill, *136*
shingle mining, 133
Shinnecock rakes, 17
ship-building industry, 145
ships, 4
short-leaf pine, 127
silica sand, 79
Silica Sand Company, 140
slender ladder lichen, *186*
smelting, 119
Smith, Charles, 25
smoke, weather prediction and, 83
smooth cordgrass, *222–223,* 225
snapping turtles, 262, 264, *265*
sneakboxes, 21–22
snow, *112, 114, 115, 116*
snow geese, *40,* 41
snowflakes, 115–116
soil, acidic, 139
Sommers Point, 30
South River, Weymouth Township, *104*
southern leopard frog, 257
southern yellow orchid, *161*
Spartina (cordgrass), 215, *217,* 222–223, 224, *225*
Spartina patens (yellow salt meadow hay), *214,* 215
spatulate-leaved sundew, *191*

Speedwell Furnace, 227
sphagnum moss, *170,* 171, *172,* 173
spoonwood, 151
spotted turtles, 262
spring peepers, *256,* 257
spring tides, 102
Springer's Mill, 93
squirrels, *282*
St. John's-wort, *196,* 199–200
St. Peter's-wort, 200
St Martin's Day, 41
starberries, 245
stars, weather prediction, 89
Steelman, Carl, 254
Steelman, James, 4, 231
Stevenson, Robert Louis, 30
Still, Cecil C., 152, 200
Still, James, 197, 200
stinkpot turtles, 261–262
Stone, Witmer, 151, 160
Stone Harbor, Cape May County, *102,* 209, 211
Stranger, Jacob, 80
Stranger brothers, 80
sun, influence on tides, 102
sundews, *190, 191,* 194
swamp pink, 25, *166,* 167, *167*
swamps, *132*
Swedish settlers, 68, 151
sweet flag root *(Acorus calamus),* 199
Sweetwater Casino, 17
swimming safety, 34

T
tadpoles, 258
tannic acid, 144
tannin, 144–145, 197
tanning industry, 144
teaberry, *184–185*
terrapins, *260. see also* turtles
Thanksgiving. *see* Turkeys
Thermodynamics, second law of, 116
This Green World (Platt), 181
Thomas, Benjamin, 241
Thompson, Francis
thorn lichen, *187*
thread-leaved sundew, *190*
tidal creek, *100, 101*
tidal marshes, 219
tides, *98,* 99–102, *213*
Tom's River, 112
Tordoff, Harrison B., 49
tourism, history, 205–206

Treasure of Sierra Madre, The, 76
tree frogs, 257, *259*
trees, weather prediction, 89
Trenton Business College, 241
Tuckahoe, 203, 254
Tuckahoe Furnace, 227
Tuckahoe River, *288*
Tuckerton, New Jersey, 3, 17
Tuckerton Seaport Museum, 17, 22
turkey vultures, *64*, 65–67, *66*, *67*
turkeys, *274*
turtles, 261–262

U

Union Creek, 25, 267
Urquhart, Fred, 73
U.S. Army, Sandy Hook and, 139

V

Van Dyke, Henry, 26, 151
Van Sant Boatyard, 99, 145
vanilla planifolia, 156
Venus flytrap, 188, 191
Vineland, 197
Virginia pine, 127

W

Wadding River, 26
Walker's Forge, 227
War of 1812, 203
Warner, Aaron, 265
Warren Grove, Ocean County, 127
Washington, George, 227, 228

water
 cedar swamps, 137
 home usage, 105
 industrial usage, 106
 wetlands and, 208–213
water lilies, 25, *162*, 163, *163*
water mills, 99
Watson, John Whitaker, 113
weather, 83–91
weather prediction, 89, 90
Webb, John "Pegleg," 241
Webb's mill, 159
Weekstown, 26
Went, F. W., 119
West Creek Furnace, 227
wetlands, *208*, 209, *210*, 211–212, *212–213*, *214*
Wetlands Institute, 209, 211, 212
Weymouth blueberry, 246
Weymouth Furnace, 227
Weymouth Township, 29, 30, *104*, 119
Wheaton, T. C., 80
Wheaton Glass and Plastics Company, 80
Wheaton Village, *80*, *81*
Wheaton Village Museum, Cumberland County, 9
White, Elizabeth, 140, 235, 245
white-fringed orchid, 155, *161*
White Horse, Chief, 105
white juniper trees, 133, 137
white oak, 143, *144*, *145*
White Stag of Shamong, 254
white-tail deer, *252*, 253–254, *254*, *255*
Whitesbog, *208*, 211
 Franklinia shrubs, 140

gardens, 235
ice on, *84–85*
Whitman, Walt, 205
Whittaker, Julian
Whittaker Wellness Center
Wild Flowers (House), 155
wild orchids, *154*, 155–156, *156–159*, 159–160
wild rice, 25
windfall trees, 133
Windmill Island, 95
windmills, 93, 95
winds, 90, *92*, 139
Wings 'n' Water Festival, 212
Winnie the Pooh (Milne), 61, 62
Winslow blue hole, 34
wintergreen, 200
Wistar, Caspar, 79, 80
Wistarburg, 79
Wolf, Clarence, 140
wood ducks, 271, *273*
wood turtles, 262
woodcutters, 122
woodpeckers, *56*
World Wildlife Fund, 209
Wrangle, Carl, 254
Wycomyia (mosquitoes), 194

Y

yellow flag, *236*
yellow-fringed orchid, *161*
yellow pine, 127
yellow salt meadow hay *(Spartina patens)*, *214*, 215